life on mars

55TH CARNEGIE INTERNATIONAL

Douglas Fogle, Curator

Carnegie Museum of Art
Pittsburgh, Pennsylvania

Douglas Fogle, Curator
Heather Pesanti, Assistant Curator
Karin Campbell, Curatorial Assistant

Advisory Panel

Daniel Birnbaum
Director, Städelschule Art Academy
and Portikus, Frankfurt am Main, Germany

Richard Flood
Chief Curator, New Museum, New York

Eungie Joo
Director and Curator of Education and
Public Programs, New Museum, New York

Chus Martínez
Director, Frankfurter Kunstverein,
Frankfurt am Main, Germany

Carnegie Prize and Fine Prize Jury of Award

Richard Armstrong, Pittsburgh
Daniel Birnbaum, Frankfurt am Main
Richard Flood, New York
William Hunt, Pittsburgh
Eungie Joo, New York
Chus Martínez, Frankfurt am Main
Juliet Lea H. Simonds, Pittsburgh

Writings

Major support for the 2008 *Carnegie International* has been provided by the A. W. Mellon Charitable and Educational Fund, the Friends of the *Carnegie International*, The Henry L. Hillman Fund, The Fine Foundation, and the Jill and Peter Kraus Endowment for Contemporary Art.

Major gifts have also been provided by The Andy Warhol Foundation for the Visual Arts, Highmark Blue Cross Blue Shield, Bayer Corporation, the Henry L. Hillman Foundation, the Juliet Lea Hillman Simonds Foundation, the Kraus Family Foundation, the Dimitris Daskalopoulos Collection, Greece, The Fellows of Carnegie Museum of Art, The Pittsburgh Foundation, and the Woodmere Foundation.

Additional support for the exhibition is provided by Heika Burnison, The Morby Family Charitable Foundation, William I. and Patricia S. Snyder, the Alexander C. & Tillie S. Speyer Foundation, the Buncher Family Foundation, the National Endowment for the Arts, Sibyl Fine King, The Associates of Carnegie Museum of Art, the Beal Publication Fund, the Dedalus Foundation, The Grable Foundation, the Harpo Foundation, and the Trust for Mutual Understanding.

Foreword

Richard Armstrong
The Henry J. Heinz II Director of Carnegie Museum of Art

By reputation and location Pittsburgh would seem an unlikely host to the country's longest running exhibition of contemporary art, yet since 1896 the *Carnegie International* has been organized and presented here. Carnegie Museum of Art does so again in 2008; this exhibition marks its 55th incarnation.

Nearly every aspect of this daunting effort has changed since its origins late in the 19th century, but the central tenet of offering audiences a discriminating overview of contemporary art remains a constant and worthy endeavor. Similarly, as our notions of the world of art have enlarged–geographically and materially–over the past century, so too have our expectations of artists and their work. Synthesizing such realities is an institutional role, one largely accomplished through the empathetic labors of the exhibition's curator. In Douglas Fogle's capable hands and infused with his lively intelligence, this balance has been achieved.

Under the rubric *Life on Mars,* he has brought together forty artists from around the world in an effort to elucidate life today. In proposing a title, Fogle offers a schema for us to consider as we view the work of these artists collectively. An elusive continuum of creativity emerges that extends from certain works of the 1970s to the present and brings questions of change—both the how and why—to mind. As we are discovering in politics, similarities between this moment and that era are striking.

Andrew Carnegie, though not a collector, recognized the power of a regularly scheduled exhibition of art of the time as a site for inquiry and as a sustained attempt at fostering imagination and an appreciation of a world beyond national borders. He believed that art was an "international language" capable of spreading "goodwill among nations." His principal charitable causes—literacy and peace—could be enhanced through the exhibition he envisioned. The Board and staff of Carnegie Museum of Art remain committed to such values and join in saluting the ambitions and success of the 2008 *Carnegie International*, an event coincident with the city's 250th anniversary.

We are indebted to the exhibition's many generous funders and lenders. Challenged, inspired, and instructed by the work of the artists in this exhibition, we recognize anew their powers.

Is There Life on Mars?

Douglas Fogle

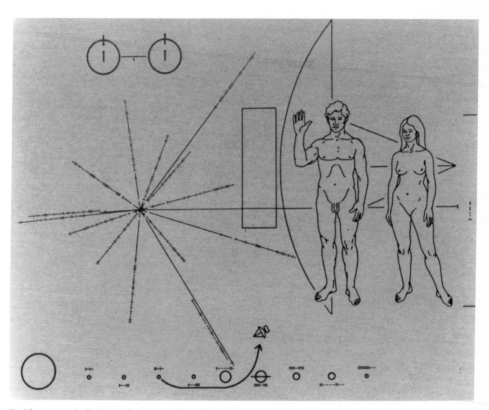

Carl Sagan, Linda Saltzman Sagan, and Frank Drake, *Pioneer 10* plaque, 1972

On January 23, 2003, the last weak signal was received from the *Pioneer 10* spacecraft some thirty years after its launch. Its power source drained and its distance from Earth too great to overcome, a great silence fell upon this first man-made object to reach beyond the gravitational confines of our solar system. Having admirably fulfilled its original task of photographically documenting the megaplanet Jupiter, *Pioneer 10* is now nothing more than an inert grain of sand on a lonely trip to nowhere. As it treks through the vast immensity of interstellar space, it has become an extraterrestrial that is no longer capable of phoning home. Yet the engineers who created this vehicle assigned it another, more modest function altogether—an inversion, in this case, of its original mission. Rather than producing and transmitting photographic images, as was intended, it would now be the bearer of images in the form of a metal plaque bolted to the underside of its infrastructure. After much discussion by scientists, this plaque was inscribed with a set of simple line drawings depicting the likenesses of male and female humans as well as graphic representations of our solar system in relationship to the rest of the galaxy. This miniature Lascaux would become a modest, low-tech time machine carrying with it a kind of galactic Rosetta stone, an intimate key to the existence of a civilization that will long have been rendered mute by the staggering distances of interstellar space. While it may be true that in space no one can hear you scream, in the end it is our human desire to connect with an unknown other that draws us to even this most irrational leap into the void.

It is telling that the form taken by this cosmological message in a bottle was that of a simple, graphic line drawing. It is the heartbreaking modesty of this medium, this most intimate and immediate form of human expression, that creates such a sense of disproportion between the message of *Pioneer 10* (our collective whisper in the dark: "We are here!") and the immensity of its context on the shoals of the vastness of interstellar space. It is as if we were trying to have a very quiet and extremely private conversation with some unknown mathematical god. Perhaps we can repurpose an expression coined by the French philosopher Gaston Bachelard in his book *The Poetics of Space* (1958) and refer to this all too human condition as one of an "intimate immensity."

Artists throughout modernity have attempted to grapple poetically with the phenomenological and ontological dimensions posed by this intimate

1. Mario Merz interviewed by Tommaso Trini in *Data* 1, no. 1 (September 1971), 21; reprinted in Richard Flood and Frances Morris, eds., *Zero to Infinity: Arte Povera 1962–1972* (Minneapolis: Walker Art Center; London: Tate Modern, 2001), 252.

immensity. It is this connection between a modesty of formal means and the larger questions of existence put forward by the fate of *Pioneer 10*, for example, that the Italian Arte Povera artist Mario Merz began investigating in the 1960s when he adopted the Fibonacci mathematical series as a motif in his work. Discovered in the 13th century by the Italian mathematician Leonardo of Pisa, who was also known as Leonardo Fibonacci, the numerical series that bears his name runs 1, 1, 2, 3, 5, 8, 13, 21, and so on to infinity, with each number being the sum of the two numbers preceding it. To his amazement, Fibonacci found that this mathematical progression of numbers could be used to describe many different phenomena in the natural world, including the spatial dimensions of nautilus shells and the dispersion patterns of seeds in fruit. When asked by the critic Tommaso Trini in 1971 why he became interested in the Fibonacci series, Merz replied: "It is the proliferation of numbers. Numbers reproduce themselves like men, bees, or rabbits. If they did not reproduce, they would cease to exist. The series is life. The numbers 1, 2, 3, 4, 5, 6, 7, 8, and 9 are the enumeration of dead elements. Instead, the [Fibonacci] series is mathematics in expansion, that is to say living mathematics."[1] For Merz, this sequence was a kind of biological code speaking back to humanity. Moving into infinity without any boundaries, these numbers, as drawn in the artist's own hand, would be rendered by Merz in neon. When affixed to his very basic and intentionally crudely rendered sculptures, including that most simple form of human shelter, the igloo, these numbers would serve as a constant reminder of both the fragility and the awe-inspiring resilience of human life in the larger context of the biosphere. In effect, a few years before the launch of *Pioneer 10*, Merz was creating his own kind of sculptural spacecraft bearing a coded message in the form of a neon drawing whose numeric sequence announces nothing less than "life" itself.

The same kind of modest attempt to deal with the intimate immensity of human existence can be found in the work of the American artist Paul Thek. If the Arte Povera artists of Milan and Turin in the 1960s and 1970s attempted to simplify their means by adopting degraded or "poor" materials, Thek might be thought of as their American fellow traveler. Working at precisely the same historical moment as Merz, Thek constructed installations and environments that presage an entire generation of young contemporary artists who would emerge in the 1990s. Thek's installations, like those of the Arte Povera artists, purposefully employed materials not easily associated with "fine" art, including discarded newspaper, sand, broken pieces of wood, and all other manner of detritus. He used these materials to construct environments that would evoke such mythologically laden archetypal forms of shelter as a cave, the Tower of Babel, and (at

Mario Merz, *Luoghi Senza Strada* (Places without streets) (detail), 1987

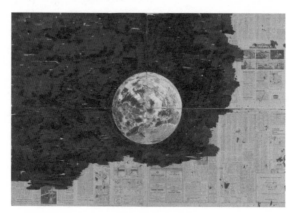

Paul Thek, *Untitled (Earth Drawing I)*, c. 1974

least in American literary history) Uncle Tom's Cabin. The conflict between humankind's technological achievements and the tendency of said achievements to transform themselves into the sins of a new Babylon rests at the center of Thek's work. His ameliorative to this cultural condition was to infuse his work with a touching sense of almost naive playfulness and deliberately poor materials while at the same time expressing a desire for humanity to take collective responsibility for its own existence in the world.

Thek's preoccupation with the travails of the human condition would continue in the early 1970s with his practice of loosely drawing pictures in acrylic on the surface of discarded newspapers. These cartoonlike images of dinosaurs, prunes, and even a portrait of St. Augustine as a steaming-hot potato evoked at the same time a sense of undeniable humor and a profound melancholia in the face of a harsh world. It was, however, in his 1974 acrylic image of Earth as seen from space that our story comes full circle. Meagerly and loosely painted onto the financial pages of four open sheets of a daily newspaper, Thek's Earth does not even come close to completely covering the oppressive reality of the economic and political events that make up the contents of both the newspaper and our conscious lives as social beings. This view of our planet from outer space is, however, a revolutionary one. It is a collective self-portrait of humanity colliding with the quotidian grind of daily existence. What is the viewer's position when looking at this work? Are we approaching Earth or leaving it? Or are we caught somewhere in between, sending our own codes and signals out into the void, hoping against hope that someone might answer our call? In Thek's world, we are profoundly alone but paradoxically together as life goes on. This is the conundrum of our existence as humans. As I look more closely at Thek's drawing, though, I begin to ask myself other more vexing questions that are provoked by the fate of Pioneer 10. These are questions that move from the metaphysical to the social in a few accelerated steps. Are we alone in the universe? Do aliens exist? Or are we, ourselves, the strangers in our own worlds?

If the events of the last few years have taught us anything, it is that many of us are indeed strangers in our own worlds. It was impossible, for example, to sit in front of one's television set in the days after Hurricane Katrina devastated New Orleans and not feel pangs of empathy for the victims displaced by that catastrophe. The aftermath of this event, with the inept and perhaps criminally negligent response of the American Federal Emergency Management Agency (FEMA), shook our collective faith in the ability of a government to care for its own people. As the victims wrote

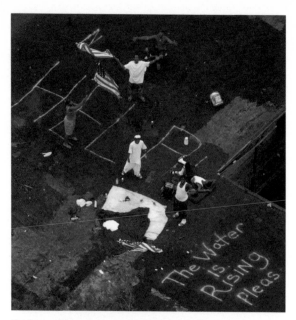

Hurricane Katrina survivors, September 1, 2005

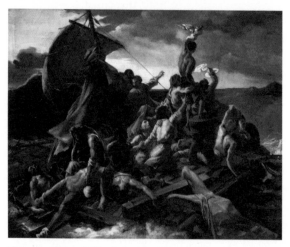

Théodore Géricault, *The Raft of the Medusa*, 1818–1819

imploring messages such as "help us" on their rooftops, they called out into the void of the televisual airwaves as if attempting to communicate with an alien culture without the aid of a universal language translator. With the waters rising above the houses, these rooftops became lifeboats, a series of ad hoc "rafts of the *Medusa*" for the 21st century.

The American federal government's inability to respond quickly and ably to this tragedy brings to mind Jonathan Swift's "modest proposal" for the salvation of 18th-century Ireland, one of the most devastating pieces of political satire ever to be written in the English language. Swift's suggested remedy for the widespread poverty that plagued his native country was the institutionalization of an epicurean culture devoted specifically to the culinary preparation of children. Poor children, that is, as they were seen to be the ones who placed the greatest burden on the social welfare of the state. He explained: "I have been assured by a very knowing American of my acquaintance in London, that a young healthy child well nursed is at a year old a most delicious, nourishing, and wholesome food, whether stewed, roasted, baked, or boiled; and I make no doubt that it will equally serve in a fricassee or a ragout."[2] In the logically expedient language of a pragmatic politician, Swift not only offered a solution to the problem of poverty in Ireland by culling the lower classes of their very needy and expensive surplus of children but also pointed out the added benefit (for the British) of reducing the number of Catholics on that island. Swift was, of course, employing the rhetorical strategy of hyperbole in his modest, cannibalistic proposal (which really wasn't quite so modest after all). What was at first written as a satirical critique of British colonial brutality becomes, in light of current events, a kind of allegory for life in our contemporary world. Written nearly three centuries ago, Swift's text speaks with surprisingly lucidity to the situation we find ourselves in today, at the beginning of the 21st century. As evidenced by the events of September 11 and the inhumane debacle of Abu Ghraib, we still eat our own children. Rereading Swift in this light, we see that he inverts Karl Marx's assertion that history repeats itself, the first time as tragedy and the second time as farce. Today, the comic precedes the tragic in a contemporary revival of the theater of the absurd. It is here, where humanity and history intersect with comedy and tragedy, that we can locate the moment in which we become strangers in our own worlds and the dark, alien part of the human condition manifests itself in the garb of a zombie.

2. Jonathan Swift, "A Modest Proposal," in *A Modest Proposal and Other Satires*, with an introduction by George R. Levine (New York: Prometheus Books, 1995), 259; reprinted in this volume on pages 31–35.

George A. Romero, *Night of the Living Dead* (film still), 1968

The zombie holds a special place in the artistic imagination. We might consider the case of Francisco de Goya, for example, who created his so-called Black Paintings toward the end of his life when his health was failing, his position at the Spanish court was tenuous, and his psychological state was fragile at best. Known for their deeply disturbing content and their almost violently expressive painterly qualities, these works were inward-looking in a very modern way and were never meant for public consumption. Among them is *Saturn Devouring One of His Sons* (1821–1823), a painting of shockingly brutal simplicity and utter horror. Taking its subject from the mythological story of Saturn, who, it was prophesied, would be overthrown by one of his children, this painting depicts a savage act of filicidal cannibalism. A rabidly mad Saturn rips the head off one of his children with his mouth, leaving a gaping, bloody red swath of flesh at the top of the headless torso. This is a tortured painting, depicting an act of completely inhuman cruelty, and it was one of many works that would lead scholars to ascribe to Goya the mantle of modernity. If modernity is in part defined by the clash between reason and terror, between humanity and horror, then yes, indeed, this is a very modern picture. Nonetheless, I prefer to think of *Saturn Devouring One of His Sons* as reflecting a cannibalistic impulse that lies anxiously at the heart of the human condition. As a result, this work must be seen as perhaps the first zombie painting of a modern world in which we collectively eat our own children.

I write this introduction from Pittsburgh, the home of Carnegie Museum of Art and a place that knows a thing or two about the undead. In 1968, this city of three rivers became ground zero of the American zombie-film genre when the director George A. Romero shot his now-classic film *Night of the Living Dead*. Sharing with Goya both a chiaroscuro visual palette and a keenly humanistic sensitivity to the social and political travails of the modern world, Romero imbued his low-budget horror film with a wry social commentary. In the film, an unknown toxic spill causes the recently departed to rise from the dead and turn on the living for their sustenance. An African American protagonist leads a group of otherwise white survivors, who have barricaded themselves in a house in the countryside outside Pittsburgh. Through a series of acts of stupidity arising from conflicts within the group, this band of survivors is weeded out one by one, as the zombies take their fill of human flesh. In the end, our protagonist manages to escape and spots what he believes to be sanctuary among a bunch of gun-toting rednecks, policemen, and good ol' boys who are leading a zombie clean-up operation that would put the Blackwater contractors in Iraq to shame. As our black hero makes his way up

toward the police line, he is "mistaken" for a member of the undead and summarily shot in the head, offering an allegorical commentary on the state of race relations in 1960s America. Who exactly, Romero asks, are the true undead cannibals?

Goya, of course, expressed a similar skepticism about the state of so-called civilized society and human rights, addressing the inhuman brutality of the Napoleonic invasion of Spain, which invoked the rule of Enlightenment, Reason, and the Rights of Man as its justification. The artist's iconic series of etchings *The Disasters of War* (1810–1820) speaks with excruciating clarity to the horror of this occupation. In light of this, we might see *Saturn Devouring One of His Sons* in a new light (or rather, darkness). Rather than regarding this work simply as one of the first depictions of the tortured nightmares of the modern psyche, we might also see it in relation to the cannibalistic excesses of the French Revolution, the Jacobin Reign of Terror, and its aftermath. If, as is suggested by another one of Goya's images, "the sleep of reason brings forth monsters," maybe those monsters are in fact the undead, or zombies.

Perhaps the greatest recent evocation of Goya's brand of horror as seen in his Black Paintings was by someone who is not a painter at all (at least in the traditional sense). Cormac McCarthy's 2006 novel *The Road*, a literary meditation on the hopefulness of humanity in the face of total despair and utter devastation, is so visually vivid that its decidedly economic prose paradoxically verges on the painterly. The author tells the story of a nameless boy and a man as they move across a postapocalyptic landscape of soot and ash after some unnamed and unspeakable global catastrophe. These two vulnerable and wayward survivors spend their time trying to avoid gangs of almost feral humans, who in the midst of the pestilence and famine of this charred landscape have turned to the only kind of protein available to them: other people. McCarthy's novel is at once poetic and painfully prophetic, employing language that is as beautiful as it is spare in order to paint a dark portrait of humanity simultaneously at the limits of its own identity and, in both a literal and metaphorical sense, at the brink of its own extinction. This is a world in which Samuel Beckett meets George Romero, or perhaps it is *Waiting for Godot* with zombies playing the roles of Estragon and Vladimir. It is not all about despair, though. There is hope at the end of this dark night of the soul, as the conclusion of McCarthy's novel offers us a glimmer of compassion and the possibility of humanity's collective redemption.

Like the characters in Beckett's play, we find ourselves today waiting as well, for ours is a culture of zombies in which we are slowly and at times deliberately eating ourselves to death. Where do the horrors of extraordinary rendition, Abu Ghraib, and Guantánamo Bay end and those of the world of literary and painterly imagination begin? Goya presciently evoked those disasters nearly two hundred years ago. Today, however, we have our own portrayals. One thinks, for example, of the photograph of the hooded Iraqi "detainee" standing on a box and holding electrical wires in his hand. This will stand among our very own "disasters of war." Writers, filmmakers, and other artists know that these horrors, both real and imagined, have a special place in our collective psyches and might even be programmed into our genetic makeup. In depicting them, they offer their own "modest proposals." As Goya did, they "paint" from the cultural shadows in order to show us the glimmering possibility of hope. They write symphonies for the devil that show us we are not bound to the same fate as Faust. As Richard Flood concludes in his essay in this volume, "while art is far too fragile a creation to significantly alter the course of history, it can allow us, if only for a moment, to draw perilously close to an understanding of what history and life have done to those fellow pilgrims we share it with."[3]

There are myriad possible artistic responses to our current historical situation that might foster the kind of understanding invoked in the passage above. Many of these responses are made manifest by the artists included in *Life on Mars*, the 55th *Carnegie International*. Underlying each of them is an attempt to come to grips with what it means to be human today. For the most part coming of age in the decades following Merz and Thek, many of these artists are the inheritors of an artistic legacy that seeks to produce not the monumental but the momentary, the ephemeral, and the modest. One sees in their work not a discredited universal humanism but a real connection to the human condition expressed with an economy of means that is at once fragile and powerful.

The artists included in this exhibition, each in his or her own way, metaphorically ask, "Is there life on Mars?" Forgoing any universal answers to this question, they investigate particular vicissitudes of the human condition, moving along paths that are both introspective and worldly while poetically traversing the dramatic spectrum from tragedy to comedy. In the end, the

3. Richard Flood, "Shadowland," page 217 in this volume. A version of this essay was previously published in *Afterall*, no. 7 (2003), and adapted from its original publication in the exhibition catalogue *no place (like home)* (Minneapolis: Walker Art Center, 1997).

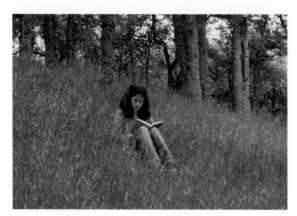

Sharon Lockhart, *Pine Flat* (film still), 2005

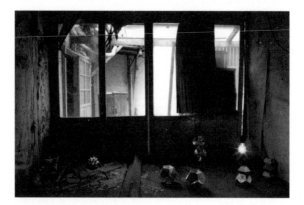

Haegue Yang, *Sadong 30*, 2006

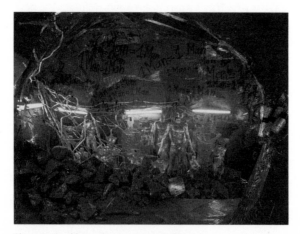

Thomas Hirschhorn, *Cavemanman*, 2002

question "Is there life on Mars?" is a rhetorical one posed in the face of an increasingly accelerating world, in which global events, at once political, social, natural, and economic, seem to challenge and threaten to overtake our most basic forms of everyday existence. Rather than indicating a literal search for extraterrestrial intelligence, this question ought to be seen as a metaphorical quest to explore what it means to be human in this radically unmoored world. Moving from the micro to the macro levels of experience, and from formal to narrative modes of address, these artists provide multiple perspectives and myriad responses to this 21st-century dilemma. Like Merz, they seek shelter from the storm. Like Thek, they don't want to be alone. Like *Pioneer 10*, they embrace the intimate immensity of a universe in which they collectively ask, "Is anyone out there?" In so doing, they transport us aesthetically to other worlds with the hope that each of us can in turn learn to start loving the alien.

My journey in the preparation of *Life on Mars* began in a darkened film-editing suite in Burbank, California, where I viewed Sharon Lockhart's meditative and poignantly beautiful cinematic portrait of the children of the Californian mountain community of Pine Flat. It continued to an abandoned and decrepit house in an industrial zone of Inch'ŏn, South Korea, where Haegue Yang had colonized this crumbling structure with a poetic and hallucinatory installation of light strings and origami in her work *Sadong 30*. It ends in the decidedly lo-fi, man-made grotto of Thomas Hirschhorn's installation *Cavemanman*, built in the galleries of Carnegie Museum of Art in Pittsburgh on the occasion of this exhibition. On the walls inside one of these humble caves cobbled together from cardboard, packing tape, and aluminum foil, we see another kind of 21st-century Lascaux: the artist has inscribed over and over again, with a declarative fervor, the phrase "one man = one man." The simplicity of this gesture, with its egalitarian overtures, could itself be the contemporary equivalent of the plaque attached to the *Pioneer 10* spacecraft. One man = one man. This is the real answer to the question "Is there life on Mars?" We are not alone.

Portions of this text are adapted from the following essays, which served as early explorations of some of the themes presented here: "What Is to Be Done?" in *Thomas Schütte* (Stockholm: Jarla Partilager, 2006); "Is There Life on Mars?" in Midori Matsui, ed., *The Age of Micropop: The New Generation of Japanese Artists* (Tokyo: Parco Publishing, 2007); and "Symphony for the Devil," in Heidi Zuckerman Jacobson, ed., *Avner Ben-Gal* (Aspen, CO: Aspen Art Museum, 2008).

A Modest Proposal

Jonathan Swift

Reprinted with permission from Jonathan Swift, *A Modest Proposal and Other Satires*, with an introduction by George R. Levine (New York: Prometheus Books, 1995). Notes are by Levine.

A MODEST PROPOSAL FOR PREVENTING THE CHILDREN OF POOR PEOPLE IN IRELAND FROM BEING A BURDEN TO THEIR PARENTS OR THE COUNTRY, AND FOR MAKING THEM BENEFICIAL TO THE PUBLIC. 1729.

It is a melancholy object to those who walk through this great town[1] or travel in the country, when they see the streets, the roads, and cabin doors, crowded with beggars of the female sex, followed by three, four, or six children, all in rags and importuning every passenger for an alms. These mothers, instead of being able to work for their honest livelihood, are forced to employ all their time in strolling to beg sustenance for their helpless infants: who as they grow up either turn thieves for want of work, or leave their dear native country to fight for the pretender in Spain,[2] or sell themselves to the Barbadoes.[3]

I think it is agreed by all parties that this prodigious number of children in the arms, or on the backs, or at the heels of their mothers, and frequently of their fathers, is in the present deplorable state of the kingdom a very great additional grievance; and, therefore, whoever could find out a fair, cheap, and easy method of making these children sound, useful members of the commonwealth, would deserve so well of the public as to have his statue set up for a preserver of the nation.

But my intention is very far from being confined to provide only for the children of professed beggars; it is of a much greater extent, and shall take in the whole number of infants at a certain age who are born of parents in effect as little able to support them as those who demand our charity in the streets.

As to my own part, having turned my thoughts for many years upon this important subject, and maturely weighed the several schemes of our projectors,[4] I have always found them grossly mistaken in their computation. It is true, a child just dropped from its dam may be supported by her milk for a solar year, with little other nourishment; at most not above the value of 2*s*., which the mother

may certainly get, or the value in scraps, by her lawful occupation of begging; and it is exactly at one year old that I propose to provide for them in such a manner as instead of being a charge upon their parents or the parish, or wanting food and raiment for the rest of their lives, they shall on the contrary contribute to the feeding, and partly to the clothing, of many thousands.

There is likewise another great advantage in my scheme, that it will prevent those voluntary abortions, and the horrid practice of women murdering their bastard children, alas! too frequent among us! sacrificing the poor innocent babes, I doubt, more to avoid the expense than the shame, which would move tears and pity in the most savage and inhuman breast.

The number of souls in this kingdom being usually reckoned one million and a half, of these I calculate there may be about 200,000 couples whose wives are breeders; from which number I subtract 30,000 couples who are able to maintain their own children (although I apprehend there cannot be so many, under the present distresses of the kingdom); but this being granted, there will remain 170,000 breeders. I again subtract 50,000 for those women who miscarry, or whose children die by accident or disease within the year. There only remains 120,000 children of poor parents annually born. The question therefore is, how this number shall be reared and provided for? which, as I have already said, under the present situation of affairs, is utterly impossible by all the methods hitherto proposed. For we can neither employ them in handicraft or agriculture; we neither build houses (I mean in the country) nor cultivate land; they can very seldom pick up a livelihood by stealing, till they arrive at six years old, except where they are of towardly parts; although I confess they learn the rudiments much earlier; during which time, they can however be properly looked upon only as probationers; as I have been informed by a principal gentleman in the county of Cavan, who protested to me that he never knew above one or two instances under the age of six, even in a part of the kingdom so renowned for the quickest proficiency in that art.

I am assured by our merchants, that a boy or a girl before twelve years old is no saleable commodity; and even when they come to this age they will not yield above 3*l.* or 3*l.* 2*s.* 6*d.* at most on the exchange; which cannot turn to account either to the parents or kingdom, the charge of nutriment and rags having been at least four times that value.

I shall now therefore humbly propose my own thoughts, which I hope will not be liable to the least objection.

I have been assured by a very knowing American of my acquaintance in London, that a young healthy child well nursed is at a year old a most delicious, nourishing, and wholesome food, whether stewed, roasted, baked, or boiled; and I make no doubt that it will equally serve in a fricassee or a ragout.

I do therefore humbly offer it to public consideration that of the 120,000 children already computed, 20,000 may be reserved for breed, whereof only one-fourth part to be males; which is more than we allow to sheep, black cattle or swine; and my reason is, that these children are seldom the fruits of marriage, a circumstance not much regarded by our savages,[5] therefore one male will be sufficient to serve four females. That the remaining 100,000 may, at a year old, be offered in sale to the persons of quality and fortune through the kingdom; always advising the mother to let them suck plentifully in the last month, so as to render them plump and fat for a good table. A child will make two dishes at an entertainment for friends; and when the family dines alone, the fore or hind quarter will make a reasonable dish, and seasoned with a little pepper or salt will be very good boiled on the fourth day, especially in winter.

I have reckoned upon a medium that a child just born will weigh 12 pounds, and in a solar year, if tolerably nursed, will increase to 28 pounds.

I grant this food will be somewhat dear, and therefore very proper for landlords, who, as they have already devoured most of the parents, seem to have the best title to the children.

Infant's flesh will be in season throughout the year, but more plentifully in March, and a little

before and after; for we are told by a grave author, an eminent French physician, that fish being a prolific diet, there are more children born in Roman Catholic countries about nine months after Lent than at any other season; therefore, reckoning a year after Lent, the markets will be more glutted than usual, because the number of popish infants is at least three to one in this kingdom: and therefore it will have one other collateral advantage, by lessening the number of papists among us.

I have already computed the charge of nursing a beggar's child (in which list I reckon all cottagers, labourers, and four-fifths of the farmers) to be about 2s. per annum, rags included; and I believe no gentleman would repine to give 10s. for the carcass of a good fat child, which, as I have said, will make four dishes of excellent nutritive meat, when he has only some particular friend or his own family to dine with him. Thus the squire will learn to be a good landlord, and grow popular among the tenants; the mother will have 8s. net profit, and be fit for work till she produces another child.

Those who are more thrifty (as I must confess the times require) may flay the carcass; the skin of which artificially dressed will make admirable gloves for ladies, and summer boots for fine gentlemen.

As to our city of Dublin, shambles[6] may be appointed for this purpose in the most convenient parts of it, and butchers we may be assured will not be wanting; although I rather recommend buying the children alive than dressing them hot from the knife as we do roasting pigs.

A very worthy person, a true lover of his country, and whose virtues I highly esteem, was lately pleased in discoursing on this matter to offer a refinement upon my scheme. He said that many gentlemen of this kingdom, having of late destroyed their deer, he conceived that the want of venison might be well supplied by the bodies of young lads and maidens, not exceeding fourteen years of age nor under twelve; so great a number of both sexes in every country being now ready to starve for want of work and service; and these to be disposed of by their parents, if alive, or otherwise by their nearest relations. But with due deference to so excellent a friend and so deserving a patriot, I cannot be altogether in his sentiments; for as to the males, my American acquaintance assured me, from frequent experience, that their flesh was generally tough and lean, like that of our school-boys by continual exercise, and their taste disagreeable; and to fatten them would not answer the charge. Then as to the females, it would, I think, with humble submission, be a loss to the public, because they soon would become breeders themselves: and besides, it is not improbable that some scrupulous people might be apt to censure such a practice (although indeed very unjustly), as a little bordering upon cruelty; which, I confess, has always been with me the strongest objection against any project, howsoever well intended.

But in order to justify my friend, he confessed that this expedient was put into his head by the famous Psalmanazar,[7] a native of the island Formosa, who came from thence to London above twenty years ago: and in conversation told my friend, that in his country when any young person happened to be put to death, the executioner sold the carcass to persons of quality as a prime dainty; and that in his time the body of a plump girl of fifteen, who was crucified for an attempt to poison the emperor, was sold to His Imperial Majesty's prime minister of state, and other great mandarins of the court, in joints from the gibbet, at 400 crowns. Neither indeed can I deny, that if the same use were made of several plump girls in this town, who without one single groat to their fortunes cannot stir abroad without a chair, and appear at playhouse and assemblies in foreign fineries which they never will pay for, the kingdom would not be the worse.

Some persons of a desponding spirit are in great concern about that vast number of poor people, who are aged, diseased, or maimed, and I have been desired to employ my thoughts what course may be taken to ease the nation of so grievous an encumbrance. But I am not in the least pain upon that matter, because it is very well known that they are every day dying and rotting by cold and famine, and filth and vermin, as fast as can be reasonably expected. And as to the young labourers, they are now in as hopeful a condi-

tion; they cannot get work, and consequently pine away for want of nourishment, to a degree that if at any time they are accidentally hired to common labour, they have not strength to perform it; and thus the country and themselves are happily delivered from the evils to come.

I have too long digressed, and therefore shall return to my subject. I think the advantages by the proposal which I have made are obvious and many, as well as of the highest importance.

For first, as I have already observed, it would greatly lessen the number of papists, with whom we are yearly overrun, being the principal breeders of the nation as well as our most dangerous enemies; and who stay at home on purpose to deliver the kingdom to the Pretender, hoping to take their advantage by the absence of so many good Protestants, who have chosen rather to leave their country than stay at home and pay tithes against their conscience to an Episcopal curate.

Secondly, The poor tenants will have something valuable of their own, which by law may be made liable to distress and help to pay their landlord's rent, their corn and cattle being already seized, and money a thing unknown.

Thirdly, Whereas the maintenance of 100,000 children, from two years old and upward, cannot be computed at less than 10s. a-piece per annum, the nation's stock will be thereby increased £50,000 per annum, beside the profit of a new dish introduced to the tables of all gentlemen of fortune in the kingdom who have any refinement in taste. And the money will circulate among ourselves, the goods being entirely of our own growth and manufacture.

Fourthly, The constant breeders, beside the gain of 8s. sterling per annum by the sale of their children, will be rid of the charge of maintaining them after the first year.

Fifthly, This food would likewise bring great custom to taverns; where the vintners will certainly be so prudent as to procure the best receipts for dressing it to perfection, and consequently have their houses frequented by all the fine gentlemen, who justly value themselves upon their knowledge in good eating; and a skilful cook, who understands how to oblige his guests, will contrive to make it as expensive as they please.

Sixthly, This would be a great inducement to marriage, which all wise nations have either encouraged by rewards or enforced by laws and penalties. It would increase the care and tenderness of mothers toward their children, when they were sure of a settlement for life to the poor babes, provided in some sort by the public, to their annual profit or expense. We should see an honest emulation among the married women, which of them could bring the fattest child to the market. Men would become as fond of their wives during the time of their pregnancy as they are now of their mares in foal, their cows in calf, their sows when they are ready to farrow; nor offer to beat or kick them (as is too frequent a practice) for fear of a miscarriage.

Many other advantages might be enumerated. For instance, the addition of some thousand carcasses in our exportation of barrelled beef, the propagation of swine's flesh, and improvement in the art of making good bacon, so much wanted among us by the great destruction of pigs, too frequent at our table; which are no way comparable in taste or magnificence to a well-grown, fat, yearling child, which roasted whole will make a considerable figure at a lord mayor's feast or any other public entertainment. But this and many others I omit, being studious of brevity.

Supposing that 1,000 families in this city would be constant customers for infants' flesh, beside others who might have it at merry-meetings, particularly at weddings and christenings, I compute that Dublin would take off annually about 20,000 carcasses; and the rest of the kingdom (where probably they will be sold somewhat cheaper) the remaining 80,000.

I can think of no one objection that will possibly be raised against this proposal, unless it should be urged that the number of people will be thereby much lessened in the kingdom. This I freely own, and it was indeed one principal design in offering it to the world. I desire the reader will observe, that I calculate my remedy for this one individual kingdom of Ireland and for no other that ever

was, is, or I think ever can be upon earth. Therefore let no man talk to me of other expedients:[8] *of taxing our absentees at 5s. a pound: of using neither clothes nor household furniture except what is of our own growth and manufacture: of utterly rejecting the materials and instruments that promote foreign luxury: of curing the expensiveness of pride, vanity, idleness, and gaming in our women: of introducing a vein of parsimony, prudence, and temperance: of learning to love our country, in the want of which we differ even from LAPLANDERS and the inhabitants of TOPINAMBOO: of quitting our animosities and factions, nor acting any longer like the Jews, who were murdering one another at the very moment their city was taken: of being a little cautious not to sell our country and conscience for nothing: of teaching landlords to have at least one degree of mercy toward their tenants: lastly, of putting a spirit of honesty, industry, and skill into our shopkeepers; who, if a resolution could now be taken to buy only our negative goods, would immediately unite to cheat and exact upon us in the price, the measure, and the goodness, nor could ever yet be brought to make one fair proposal of just dealing, though often and earnestly invited to it.*

Therefore I repeat, let no man talk to me of these and the like expedients, till he hath at least some glimpse of hope that there will be ever some hearty and sincere attempt to put them in practice.

But as to myself, having been wearied out for many years with offering vain, idle, visionary thoughts, and at length utterly despairing of success, I fortunately fell upon this proposal; which, as it is wholly new, so it has something solid and real, of no expense and little trouble, full in our own power, and whereby we can incur no danger in disobliging ENGLAND. For this kind of commodity will not bear exportation, the flesh being of too tender a consistence to admit a long continuance in salt, although perhaps I could name a country[9] which would be glad to eat up our whole nation without it.

After all, I am not so violently bent upon my own opinion as to reject any offer proposed by wise men, which shall be found equally innocent, cheap, easy, and effectual. But before something of that kind shall be advanced in contradiction to my scheme, and offering a better, I desire the author or authors will be pleased maturely to consider two points. First, as things now stand, how they will be able to find food and raiment for 100,000 useless mouths and backs. And secondly, there being a round million of creatures in human figure throughout this kingdom, whose whole subsistence put into a common stock would leave them in debt 2,000,000*l.* sterling, adding those who are beggars by profession to the bulk of farmers, cottagers, and labourers, with the wives and children who are beggars in effect; I desire those politicians who dislike my overture, and may perhaps be so bold as to attempt an answer, that they will first ask the parents of these mortals, whether they would not at this day think it a great happiness to have been sold for food at a year old in the manner I prescribe, and thereby have avoided such a perpetual scene of misfortunes as they have since gone through by the oppression of landlords, the impossibility of paying rent without money or trade, the want of common sustenance, with neither house nor clothes to cover them from the inclemencies of the weather, and the most inevitable prospect of entailing the like or greater miseries upon their breed for ever.

I profess, in the sincerity of my heart, that I have not the least personal interest in endeavouring to promote this necessary work, having no other motive than the *public good of my country, by advancing our trade, providing for infants, relieving the poor, and giving some pleasure to the rich.* I have no children by which I can propose to get a single penny; the youngest being nine years old, and my wife past child-bearing.

1. Dublin.
2. A reference to the fact that many Irish were recruited to fight in the Spanish and French armies against England. "The Pretender" is the son of James II who had been forced from the English throne in the Glorious Revolution of 1688.
3. Many Irish emigrated to the Barbadoes to improve their lot.
4. In the eighteenth century, the word "projector" meant more than simply "planner." It also referred to someone who proposed foolish projects.
5. I.e., the Irish.
6. A slaughterhouse, a butcher shop.
7. George Psalmanazar, a pseudonym for a French contemporary of Swift who became notorious for a series of impostures. In 1704, he published a "description" of Formosa where he claimed, falsely, that he had been born.
8. These expedients were, in fact, measures that Swift had seriously proposed in earlier pieces he had written.
9. England, obviously.

Heart and Mouth Disease

Thomas Schütte
April 9, 2001

Originally published in Lynne Cooke, ed., *Thomas Schütte: Scenewright, Gloria in Memoria, In Medias Res,* exhibition catalogue (New York: Dia Center for the Arts in association with Richter Verlag, Düsseldorf, 2002), 150–51. Reprinted by permission of Dia Art Foundation and the artist.

I don't know if it's true—and
 even if it's not—
it does make a good story.
The doctor told my son, who
 didn't like his checkup—
much suffering from a heavy
 cold—
he told him, the most busy
 muscle is the heart—
the muscle in place number two,
 the tongue—
third place wasn't clear, the
 eyelid,
maybe the index finger, or the
 uvula.
Paul, the boy, didn't have to say
 anything to that,
and so he said his favorite
 sentence in difficult situations.

WeeWee Botty PoohPoohs,
and reluctantly suffered through the process of the checkup.
Sticking his tongue out and saying Aaah and so forth.
After the purchase of a bottle of cough medicine, the
 afternoon was clear.
Paul was playing with cars and I read the daily paper.
The page with the jokes was okay.—After ten minutes
of concentrated search for sense even I got a little tired—
putting the glasses aside, staring out the window—
the green or gray or whatever it was blurred into mud.
A cup of coffee giving a tiny kick in the right direction—
horizontal—nothing—calm winds.
A couple of headlines I was able to decipher—
eyes continuously looking for sense—
for a chuckle, at least.
Paul has been droning along for an hour—with the toy cars—
and I was contemplating—was the doctor right
about his Top-of-the-Pops list of the most busy muscle?
I had trouble concentrating
and was longing simply for that—
that which I had been longing for all day, actually—
the most important thing of every day for years now, really—
closing the eyes and drifting away—
among that, aloud, the child's question: what is "dog"
 backwards?
Everything quite in order and quite funny.
I was getting more tired and dulled by the minute and
 couldn't grasp
anything anymore—the words at least didn't mean anything
 and
 everything else was there or wasn't or somehow far away.
"Kids and Cattle" was the front-page story of today's paper—
 maybe I got contaminated somehow—

every night a frothy mouth, and tingling fingertips in the
 morning.
What to do? Che fare?
But permanently too tired and confused to do anything
 sensible—
first the uvula, then the tongue, then the heart—
a sense of anxiety crept up.
Something similar to paralysis—like just for once not
 watching out
and crashing into the door frame—a walk through heavy
 marshes
in the head with both feet on the table.
Journalists are one-hit wonders—but how long lasts a hit?
Business as usual.
In the meantime, over a plate of spaghetti, the child told
his latest phrase: A feast for the eyes—look!
and had his face decorated with dangling noodles.
It was nerve-wracking, and I was waiting for some relief—
the mother should be here by now—I couldn't go on.
Luckily good wines keep overnight and taste good
even the next day.
Finally—now I was released—I collapsed onto the sofa
among the mud and fog in my brain and too unable to pick up
 the phone,
shooed away its ringing.
With sweat coming down my side, and with a humming mind,
put my feet up, staring out of the window—
it was quite dark and quite quiet.
It was too late—whom could I call now?
I had to talk to somebody.
Heart or tongue or mouse finger, eyelid the shutter.
Real questions …
Or?

Questions

Peter Fischli and David Weiss

Script from *Questions*, 2002–2003, 50th Venice Biennale, 2003

1.
A1 203 Is my ignorance a roomy cave?
B1 269 Should I build a hut in the woods and live there alone and in
 poverty?
A2 223 Is everything i have ever forgotten as big as a house?
 Drawing
B2 3 Do opinions come by themselves?
A3 123 Should I roam, dazed and drifting, around the neighborhood?
C2 185 Have I never been completely awake?
B3 176 Is indecisiveness proof of free will?
A4 186 Why do I always agree with everything?
 Drawing
B4 320 Why does nothing never happen?
C4 124 Does everything take care of itself?
A5 162 Will happiness find me?
B5 190 Should I fly to India in a balloon?
C7 278 Do I need something sweet?
A7 72 Why are there bad people?
B6 23 Should I give everything away and roam the world as a beggar?
C6 265 Do I have to be cheerful?
A8 240 Am I too soft?
C5 144 Is everything half as bad?
B7 202 Is my stupidity a warm coat?
C8 239 Was I a good child?
B5 28 Am I connected with everything?
A9 158 How far can one go?
B8 64 Should I get drunk?
A6 22 Should I slaughter my pig?
B9 125 Where will I end up today?

2.
Drawing
B10 300 Should I sow malice, hate and spite?
A11 295 Is my camouflage lousy?
C10 254 Should I buy a big hammer?
C5 268 Should I go to another city and rent an apartment under a false
 false name?
A12 32 Where is the nearest police station?
C11 136 Isn't everything always against me?
B12 10 Should I eat chalk?
A13 171 Will they blame me for everything?
C12 181 Can I twist and turn everything the way I feel like?
B13 137 Whey do they want to know where I was yesterday at 2:30 pm?
A16 48 Why is it so quiet all of a sudden?
A14 71 Shall I tell the truth?
B14 102 How much does my soul cost?

C14 306 | Is my lawyer honest with everybody?
A15 234 | Should I buy a gun?
B15 114 | Is any means justified to stave off a bad mood?
B16 56 | Would it help me to dig a hole?
A16 74 | Is it all a question of time?
C16 262 | Should I launch an investigation?
C18 107 | Why do I always know better?
A17 91 | Would I make a good policeman?
C17 47 | Did I say something wrong yesterday?
C9 282 | Should I secretly rent a room in Fairfield?
A18 141 | Should I trash everything?
A21 60 | Why is everyone else always better off?
B18 36 | Will something leak out?

3.
C24 205 | Am I being exploited?
B19 304 | Why am I always the center of attention?
A20 312 | Did they manage to make me conform?
C19 308 | Must I be ashamed of having no opinion about most things?
B20 309 | Am I leading a modern, timely life?
B4 40 | I can be content, can't I.
C27 62 | Am I loved?
B21 14 | Am I somebody else in private?
? 89 | Am I eccentric?
A22 277 | Could something else have become of me?
B22 106 | Why am I always right?
C22 183 | Am I too good to work?
A23 288 | Should I have a photographer take a good picture of me?
B23 168 | Am I suffering from good taste?
C23 100 | Am I one of the chosen ?
A24 303 | Will children sing songs about me in a hundred years?
A27 33 | Am I abusing my power?
C13 247 | Have I already been under surveillance for long?
B25 138 | Am I a bloated windbag?
C25 51 | What do they know about me?
B25 112 | Why is everybody so nice all of a sudden?
A26 58 | Am I naïve?
C26 251 | Have they kept my royal origins a secret from me?
B26 80 | Am I too well groomed?
A27 45 | Shall I go under?
C27 296 | Is my lair of lies a masterpiece of innovation and engineering?
B27 88 | Do they see through me?

4.
B3 77 | Is freedom alive?
Drawing

③

A29 95	Do I have to stay outside?
C28 153	Am I a sponge?
B29 101	Am I transparent?
A30 289	Do galaxies separate me from the others?
C29 302	Why won't they let us talk about things we don't understand?
A31 29	Is everything fluid?
A31 69	What happened 4.56 billion years ago?
? 184	Drawing
B31 53	Has the last bus gone?
C31 155	How much is 43 X 87?
A32 26	Who owns Paris?
B32 ? 117	How much for everything at Macy's?
C32 ? 63	When is the money coming?
A33 41	Who runs the city?
C33 86	How long is the Nile?
B33 27	Is seven a lot?

Drawing

B34 140	Why do I let myself be ordered around?
C34 253	Are they eating everything away from me?
C36 291	Should I pay less attention to my worries?
13	Is it presumptuous to ask for a little soup after a hard day's work?
B35 59	Why don't they leave me in peace/alone?
A36 313	Could I put my everlasting efforts at being normal to better use?
B17 297	Can I reestablish my innocence?
A28 270	Am I caught in a web?

5.

A37 211	Does my car get filled with feelings on the road? / when I drive?
B37 187	Am I musically homeless?
A38 274	Do spiders weave their webs by touch?
C37 163	Do I have to imagine death as a landscape with a house that you can walk into and there's a bed in it where you can sleep?

Drawing

A39 180	Why is the forest silent?
C39 156	Does that dog bark all night?
C40 89	Is a witch riding me?
A40 189	Why can't I sleep?
B42 243	Do souls wander?
B40 7	Should I take a walk outside at night in a storm in winter with a fever and
C41 227	Why is it called daybreak?
A41 12	Does a ghost drive my car at night?
B41 ? 35	What does my dog think?
B39 94	Am I my soul's sleeping bag?
A42 215	What is this forest called?

(4)

C 42 83	Where is my bed?
? 16	When will it get light?
A43 301	Should I remove my muffler and drive around the neighborhood at night?
B43 231	Is an invisible person in my bedroom?
C43 175	Am I a hotel?
A44 178	Does everything on television have something to do with me?
C44 122	Am I like my car?
C 54 272	Can she tell?
A45 37	Should I put myself under surveillance?
C45 315	What does my soul do while I'm at work?
B45 39	Can I be calm myself down with music?

6.

A46 245	Who's nibbling at my house?
Drawing	
A47 120	Why do I always fall out of bed at night?
C46 73	Do you have to look at things soberly?
B47 260	What is in my apartment when I'm not there?
A48 177	Should I be put in chains?
C47 316	Is my soul the ghost that's driving my car around at night?
B48 307	Why is everything so far away?
A49 165	Is Mr. Insanity at the door?
Drawing	
B49 25	Can ghosts see me?
C49 76	Is carelessness good for melancholy?
A50 248	Can I let my wife admire the criminals she sees on television?
B50 317	Does my soul sometimes drive around at night without a muffler?
C50 266	Am I needlessly torturing myself?
A51 92	Where are all those rats coming from?
C51 ? 24	Does my car know me?
B51 ? 157	Why can't I sit still?
A52 98	Why do I always have to fight?
C52 258	Is sleeping the only way to fight fatigue?
B52 179	Should I swallow less?
C53 115	Can't somebody else do that for me?
A53 42	Am I slowly losing my mind?
A54 238	Should I stay in bed?
B53 132	Do we sometimes have to do things we don't understand?
C38 116	Should I believe everything that's on television?
229	Is somebody hiding in my bedroom?

7.

Drawing

B55 318	Is it still possible to live in a cave with a woman nowadays?

A56 259 Is my soul bedded on straw?
C55 ? 166 Is this brown lump edible?
C58 61 How should I decorate my tree?
B57 46 Is there any farm life left in the family?
C59 142 Are animals people?
C57 97 Is hunger an emotion?
B59 66 Is the earth a mother?
A59 90 Does a hidden tunnel lead directly to the kitchen?
B56 30 Are countries living creatures?

Drawing

A59 ? 267 Do we go through a wall when we fall asleep?
A58 110 Am I a farmer in winter?
A60 118 Would it be illegal to eat Neanderthal meat?
B44 310 Should I show more interest in the world?
B60 188 Do we see the dark side of the world on television at night?
C60 217 Will we be kidnapped by aliens and forced to live in slavery?
A61 ? 267 Do we go through a wall when we fall asleep?
C61 93 Would I like to be a mysterious person full of secrets?
B61 273 Why aren't the stars evenly distributed?
A62 111 Is one single, specific spirit predominant?
C62 143 Is a mistake around today that's as big as the idea of the earth being flat?
B62 126 Are there no limits to the impossible?
A63 31 Is everything drifting apart?
C63 192 What's dozing in secret?
B63 103 Did something go wrong shortly after the big bang?

8.

A64 8 Why does the earth turn around once a day?
B64 224 Do I have to imagine subatomic space as something big and dark that you can climb down into?
A65 11 Do I have to put myself at the disposal of research?
C64 228 Are there a lot of things the principle of yeast can be applied to?
B65 172 What percent of me is animal?
B68 68 Are the edges of reality diffused?
B66 54 Will insects overtake us?
271 Is it hard to imagine an empty universe?
A67 321 Do I have to think of time as a worm?
C66 220 Are the aliens going to abduct us to paradise?
B67 128 Is the realm of possibility getting smaller and smaller?
C69 127 Is everything a hopeless, shitty mess?
A68 290 Should I build myself a world of illusion?
B9 225 Is the world as it is part of a conspiracy?
C68 67 Can reality be designated as such?
A69 146 Why is my blanket so heavy?
C71 193 Am I doomed to wander through the vale of tears as a clown?

Drawing

A70 250	Is it more important for the world or for me to be doing well?
B71 50	Why do we stick to the ground?
B70 293	Does reality really deserve such distrust?
A71 109	Should I slowly sneak away?

Drawing

C67 283	Do facts check up on me?
A72 34	Is life a weird cave system?
C72 210	What's waiting for us in the depths of the universe?
216	Can everything be thought?

9.

C73 133	Could we complain about most things?
A19 221	Am I a lousy stinking rat?
A74 167	Why can't I be really cheerful?
B73 280	Why does the earth afford the luxury of having me?
C75 113	Should I invade Russia?
C74 298	Should I let myself go?
A75 286	Is my digestive system a wonderful thing?
B7 263	Should I put my well-being at the center of my activities?
A76 57	Is it time for an overthrow?
44	Should I walk around in rags?
B76 ? 314	Is normality an indication of laziness?
B46 ? 284	Is a ghost marching next to me?
C76 139	Is everybody else crazy?
B77 279	Am I being snubbed?
B76 17	Should I pay less attention to my feelings?

Drawing

C78 276	Do I know almost everything about myself? Do I always see myself in the mirror?
B80 305	Do I have to go through all of that again?
A77 311	Why doesn't anybody appreciate that I behave normally?
A73 246	Am I a donkey?
9	How do I look?
A57 237	Am I stuffed?

Drawing

C80 ? 242	What does my invisible companion want?
A81 170	Is the stench coming from outside?
A80 135	Is the devil satisfied with me?
257	Why is everything so radiant?

On Human Nature: A Polyphony

Daniel Birnbaum

Giorgio Agamben, "State of Exception in Today's World of Affairs (from Guantánamo to Auschwitz)," 2005, YouTube

"Heidegger and the Future: 'The End of Philosophy and the Task of Thinking,'" 1969, YouTube

"Adorno about Beckett and the Deformed Subject," YouTube

Nam June Paik's 1971 contribution to the German journal *Interfunktionen*, "Expanded Education for the Paperless Society," starts with a note on what he calls great thinkers: "It is a blunder, bordering on a miracle, that we have no, or very few, images and voices of the great thinkers of the recent past on record, especially as the 16mm talkie was readily available." Where, asks Paik, are Edmund Husserl, Sigmund Freud, Marcel Proust, James Joyce, Wassily Kandinsky, Maurice Merleau-Ponty, Ludwig Wittgenstein? Why do we not have documentation of these people speaking about their work? He adds, "Even Nietzsche and Tolstoy lived well into the film age." This blunder, a negative miracle according to Paik, is the biggest waste of instructional resources, and nothing is more urgent than documenting the major thinkers of today. The interviewer should be a qualified philosopher, says Paik, the team as small as possible, "so that Jaspers or Heidegger can talk as naturally as 'Chelsea Girls.'"[1]

Has Paik's vision now become reality? An e-mail arrives:[2] "Have you seen Michel Foucault on YouTube, that legendary discussion with Noam Chomsky in Holland?[3] I don't know when it's from, the 1970s probably. And by the way, have you seen this little film: *Death in the Seine*?"

A second e-mail elaborates a possible connection: "Foucault's question about Man and his skepticism towards Chomsky's idea of innate ideas and a fixed human nature seems compatible with the film. Check out the Theodor W. Adorno clip on Samuel Beckett[4] and the mutilated subject, could be relevant. P.S. Also check Deleuze on Wittgenstein.[5] Hilarious."

Death in the Seine (1988, 40 min.) is attached to the e-mail (in really bad quality, but still). The film is by Peter Greenaway, so naturally I'm skeptical, but I learn a few new things about the end of the 18th century and the beginning of the 19th: Between the years 1795 and 1801, 306 corpses were found in the part of the river Seine that runs through Paris. Through careful investigations, a majority of these often severely injured bodies were identified. A protocol signed by two mortuary servants, Messrs.

1. Nam June Paik, "Expanded Education for the Paperless Society," *Interfunktionen*, no. 7 (1971): 63–64.
2. The exploration of the polyphony of philosopher's voices on YouTube was a project at the Städelschule in Frankfurt am Main during 2007. All e-mails quoted in this piece are from the correspondence that took place between the participants in this theory circle. The e-mail on the Chomsky/Foucault debate initiated the exploration into the ghostly presence online of Theodor W. Adorno, Giorgio Agamben, Hannah Arendt, Alain Badiou, Roland Barthes, Simone de Beauvoir, Gilles Deleuze, Martin Heidegger, Max Horkheimer, Julia Kristeva, and Paul Virilio.
3. Noam Chomsky and Michel Foucault, http://www.youtube.com/watch?v=hbUYsQR3Mes.
4. Theodor W. Adorno, http://www.youtube.com/watch?v=UdmAAUXasXE.
5. Gilles Deleuze, http://www.youtube.com/watch?v=kt24h_la2UA.
6. The nature of writing and the world of ghosts are the themes in several appearances of Jacques Derrida on YouTube. See, for instance, http://www.youtube.com/watch?v=0nmu3uwqzbl.
7. Michel Foucault, http://www.youtube.com/watch?v=kAwWwQZ_3FG.

Bouille and Daude, provides us with a thorough description of the bodies: sex, age, color of hair, injuries, scars, and deformities. Every piece of clothing is scrutinized. Pockets are emptied and their contents analyzed and taken note of. Greenaway's fictive documentary is an illustration, almost two hundred years later, of this protocol. Corpse after corpse is dragged out of the water and examined: a bricklayer, a coachman, a fourteen-year-old girl, a baker, and a thirty-five-year-old woman with a crucifix, two keys, and a knife in her pocket. Witnesses are summoned, and the bodies are identified. Name, date of birth, profession, and address are added to the report, and in rare cases also the cause of death. This is a film about writing and death.[6]

What is a human being? How is a person shaped by the social, legal, and economic structures in which he or she is inscribed? *Death in the Seine* responds, it seems to me, to such queries in an imaginative way. Based on a few sparse details—a name, a profession, and brief testimony from a relative—an individual life seems to come into view. The mortuary protocol does not contain far-reaching speculations, but occasionally one gets a glimpse of a narrative and of the presumed cause of death, often a quite violent one. The lives of these unknown people emerge out of the anony-mous murmurings of history in the very moment they disappear: they become defined as subjects in the same formal document that declares them dead. It is hardly a coincidence that Greenaway chose a legal record dating from the period just after the French Revolution, that is, from the time when modernity was born. If one chooses to accept the philosophical view that "Man" is a formation of recent date, a formation determined by the power structures of society and scientific institutions, then one may want to conclude that these bureaucratic documents, signed by mortuary servants, can also be read as one elaborate birth certificate. Who or what emerges here? To put it in a formulaic way: the modern self.

Many aspects of this film make one think of the work of Michel Foucault.[7] What is related here is neither History's heroic narrative nor the glorious stories of grand Politics but all those minor events—the micropolitics, perhaps—that shape the lives and deaths of ordinary men and women. What is being scrutinized is the multiplicity of local stories and everyday practices through which a subject comes to be. This is a recurring theme in Foucault's works, approached from a variety of angles: How does a subject emerge in relationship to societal and legal power structures? And what is emergence? In the small essay "Lives of Infamous Men," a text from 1977 that is reminiscent of *Death in the Seine,* Foucault provides an account of the encounters with the justice system of a series of criminals—

Chomsky vs. Foucault, Part 1: "Human Nature: Justice vs. Power," 1971, YouTube

On Human Nature: A Polyphony

traitors, thieves, and murderers. Having been virtually unknown throughout their lives, these individuals become visible only through their contact (in court records and sentences) with the law. They are defined as legal subjects by a machinery that will, in the next moment, annihilate them. Like the bodies in *Death in the Seine*, they are dragged out of the anonymous current of history and inscribed into a protocol implying death. Thus the Law is engraved violently in flesh and blood, and the subjected body is turned into something more than a body, in accordance with the logic of "subjectivation" reminiscent of Friedrich Nietzsche's provocative explorations in *On the Genealogy of Morals*. What is Man? Let us return to the polyphony on YouTube:

> Foucault: If you say that a certain human nature exists, that this human nature has not been given in actual society the rights and the possibilities which allow it to realize itself ... that's really what you have said, I believe.

> Chomsky: Yes.

> Foucault: And if one admits that, doesn't one risk defining this human nature—which is at the same time ideal and real, and has been hidden and repressed until now—in terms borrowed from our society, from our civilization, from our culture?[8]

Chomsky's belief in a human nature that has not been allowed to fully realize itself is challenged by Foucault, who instead regards power as productive and finds inspiration in Nietzsche's view on "humanity" as arising from an originary violence that is subsequently refined, sublimated, and made invisible. The issue, says Nietzsche (whose presence on YouTube is worth a separate essay), is to explain the existence of an "animal" with a soul." The first premise for what we call mental life or subjectivity is the capacity to remember. And memory can, Nietzsche believes, be brought about only by pain: "If something is to stay in the memory it must be burned in; only that which never ceases to hurt stays in the memory."[9] He continues: "Man could never do without blood, torture, sacrifice when he felt the need to create a memory for himself." The animal-man has become "internalized" by creating a painful inner space, nourished by subtle doses of self-torture (what is usually called conscience). Instead of acting out its aggressions, it turns them inward and increases the suffering: "All

8. Chomsky and Foucault, http://www.youtube.com/watch?v=VXBfOxfmSDw.
9. Friedrich Nietzsche, *On the Genealogy of Morals*, trans. Walter Kaufmann and R. J. Hollingdale (New York: Random House, 1967), all citations are from part II.

instincts that do not discharge themselves outwardly turn inward—this is what I call the internalization of man: thus it was that man first developed what was later called his 'soul.'"

This theory about the inner space of the subject as a product of an originary violence and of aggressive forces turned back on themselves was further developed by Foucault in a series of books on institutions such as the prison and the hospital.[10] Whereas Foucault most of the time restricts his analyses to the processes of subjectivation of past epochs, in order to shed light on our present and question our preconceptions, Gilles Deleuze goes one step further and predicts future forms of subjectivation: posthumanist constellations of life. Who comes after Man? "It is a problem where we have to content ourselves with very tentative indications if we are not to descend to the level of cartoons," cautions Deleuze in a prophetic text on the formation of the future.[11] It will be neither Man nor God, he contends, that is, neither a being defined through constitutive finitude nor one characterized by divine infinity. Rather, what we may expect is an entirely new kind of "fold"—a constellation of forces involving silicon rather than carbon and producing a being that, one must hope, "will not prove worse than its two previous forms." This is Deleuze at his most futuristic: "The forces within man enter into a relation with forces from the outside, those of silicon which supersedes carbon, or genetic components which supersede the organism, or agrammaticalities which supersede the signifier." This new "agrammatical" life-form is, according to Arthur Rimbaud's formula, the man who is "in charge of the animals." But that is not enough. Rather, for Deleuze, it is man "in charge of the very rocks, or inorganic matter (the domain of silicon)."

"An emergent property of a system," according to Wikipedia, "is one that is not a property of any component of that system, but is still a feature of the system as a whole."[12] How is it possible for something entirely new to emerge, something that dodges our given categories, what the philosopher Nicolai Hartmann called a "categorical novum"? Listen to the Internet speculate about itself:

Although strong emergence is logically possible, it is uncomfortably like magic. How does an irreducible but supervenient downward causal power arise, since by definition it cannot be due to the aggregation of the micro-level potentialities? Such causal powers would be quite unlike anything within our scientific ken. This not only indicates how they will discomfort reasonable forms of materialism. Their mysteriousness will only heighten the traditional worry that emergence entails

illegitimately getting something from nothing. (Mark A Bedau, quoted on Wikipedia: "Emergence")

If we take as a starting point a certain form of experimental "constructivism" (one that has found inspiration in Walter Benjamin's declaration that the human perceptual apparatus, far from being a natural given, is historically and technologically conditioned), then we can perhaps think about our digital environment as a river that is even richer than the Seine and out of which new modes of subjective life emerge. In some of the most daring essays from the 1930s, Benjamin envisioned a novel form of subjectivity in sync with the latest technologies of mechanical reproduction—a form of collectivized subject that has left traditional notions of creativity and aesthetics behind in order to renegotiate the function of art in terms of politics and new forms of mass production and distribution. His "constructivist" approach toward the question of a future subject—full of optimism and difficult to reconcile with the melancholic gaze and the interest in obsolescence typical of the majority of his writings—bears certain similarities to more recent speculations concerning new constructions of the self that are less collectivistic but carried forward by a similar rhetoric of liberation. Could one even relate them productively to Deleuze's prophecy of a form of life after Man?

"We have to promote new forms of subjectivity," said Foucault, who spelled out a program of refusal and resistance: "Maybe the target nowadays is not to discover what we are, but to refuse what we are."[13] This is certainly a risky strategy that demands journeys into uncharted terrain. The electronic environment in which a polyphony of voices—Martin Heidegger, Adorno, Paul Virilio—is as ready at hand as any everyday piece of information (today's specials at the Chinese restaurant around the corner) provides the materials out of which we can construct ourselves. Perhaps this can take place without the "blood, torture, sacrifice" that Nietzsche viewed as obligatory, but it will certainly not be without dramatic transformation. Paik's electronic globalism has arrived, as has his philosophical polyphony, but if "I" am not here, living in this body, feeling with these hands, and seeing with these eyes, then I am either everywhere or nowhere. Virilio sums up our predicament in a series of questions: "For if man's sphere of activity is no longer limited by extension or duration or even opaqueness

10. Michel Foucault, http://www.youtube.com/watch?v=Xk9ulS76PW8.
11. Gilles Deleuze, Foucault, trans. Seán Hand (London: Continuum, 2006), 129–32.
12. http://en.wikipedia.org/wiki/Emergence.
13. Michel Foucault, "The Subject and Power," in Hubert L. Dreyfus and Paul Rabinow, *Michel Foucault: Beyond Structuralism and Hermeneutics* (Chicago: University of Chicago Press, 1982), 216.

"Deleuze on Wittgenstein: A 'Massive Regression' of All Philosophy," 1989, YouTube

Paul Virilio, "Dromology and Claustrophobia," 2007, YouTube

Daniel Birnbaum On Human Nature: A Polyphony

of obstacles barring his way, where is his presence, his real presence, located? 'Tele-presence,' no doubt, but where? From what starting point or position? Living-present, here and there at the same time, where am I if I am everywhere?"[14]

Again, who are "we" today? Giorgio Agamben (talking to us in Reykjavik, São Paolo, or Kyōto—it doesn't matter) spells out the "state of exception" in which we live and asks questions such as this.[15] What is Man and what is Animal today? What are the distinctive features of life after History, and who are we, breathing this posthistorical air, taking advantage of the lightness, and writing the postscript to historical Man? In a footnote to his lectures on G. W. F. Hegel's *Phenomenology of Spirit*, held in Paris in 1938–1939, the Hegel disciple Alexandre Kojève elaborated on this theme and drew a few remarkable conclusions. The historical process of work and negation, as analyzed by Hegel and then, in a different fashion, by Karl Marx, is what turned the animals of the species Homo sapiens into humans, but this process has come to a close. We have reached the end of History yet, it seems, we are still around. Kojève goes on: *The disappearance of Man at the end of History is not a cosmic catastrophe.* Perhaps the electronic documents cited here, the polyphony of philosophical voices trying to grasp the nature of Man, attest to the appearance of new ways of being in the world and novel modes of subjectivity. Man, animal, God? Is this the river Seine? Is there life on Mars?

14. Paul Virilio, *Polar Inertia* (London: Sage, 2000), 83; see also http://www.youtube.com/watch?v=-pMzYTm0VP8.
15. Giorgio Agamben, http://www.youtube.com/watch?v=KWPf2zIRkho.

Non-re. Re!

Thomas Hirschhorn
Aubervilliers, 2007

Translated from the French by Annabelle Grusq

<u>I am Non-resigned and Non-reconciled</u>. These are two conditions that are essential for me to do my work as an artist today. My work as an artist consists in giving Form, asserting that Form, and defending that Form against all and against everything.

What does it mean to <u>give Form</u>? To give Form means to do only what comes from myself, to do only what I see, to do only what I am capable of doing, and to allow myself to do it. Giving Form is working with myself alone—that is the act of giving, that is the gift, that is the Form. <u>That's the work</u>—it is <u>my</u> work!

What does it mean to <u>assert the Form</u>? To assert the Form means to stand up for the Form in an outburst of joy and movement, without self-restraint, without thought or consideration of the consequences. It means to heave the Form up, to hold it up high, show it off, and be proud of it. To assert Form also means <u>refusing to see oneself working</u>. To assert Form is to be like a "Stalker," to set the challenge far ahead of oneself and then follow it. Asserting Form is a liberating act, without calculation or safeguards. In order to assert Form, I must be brave and accept being ridiculous and silly.

What does it mean to <u>defend the Form</u>? Defending the Form means: believing in Form, believing in that which has become a Form and thus can be challenged, criticized, or rejected because it is a Form. Defending the Form means believing above all in the force that has brought something into being as a Form! Defending the Form also implies agreeing <u>with everything</u> related to that Form. Defending the Form is the act of a warrior, and it is absolutely necessary and constitutive to being an Artist. It is the very condition of standing oneself up as an Actor, as an Artist. Defending the Form is not a lost fight even if this fight is not a victorious one. The fight to defend the Form is never lost, never.

I am Non-reconciled and Non-resigned because I refuse to be <u>trapped by information</u>. The trap of information has no effect on Art. The trap of information wants me to give in to the facts. Facts, only Facts, that's what I mean! No, on the contrary, it's about acting beyond facts, neither for nor against, but beyond, in order to constitute a Truth through the new Form. A Form that reaches the universe with its <u>ambition</u> and that touches beyond History through its <u>evidence</u>. For me, as an artist, the problem is this: How can <u>I</u>, <u>here</u> and <u>now</u>, take a Position, give Form to this Position, which wants to reach beyond aesthetic, political, social, and cultural Particularism? How can I, with the Form, create a Truth? Create a Truth that is not validated by debate, discussion, communication, or analysis, but a Truth that asserts itself through its capacity to enlighten the Form itself. A Form has the capacity of enlightenment if it <u>involves</u> me,

if it creates the condition of contact, if I can touch it, start a dialogue with it, or confront it. A Form that enlightens me without neutralizing me leaves space for me not to understand.

As an artist, I want to work on giving forms that are made with the Will of Precision and the Will of Excess. I want to be precise, but I also want to work in excess, overwork, and haste. For I know that this is the only way for me to have a chance of working in the chaos, to clarify it and confront the miraculous, incommensurable, unnamable. I want to work in the chaos, which means understanding Art as a tool for confronting Reality, knowing the world, and living in my own time. And chaos is everywhere. Therefore, I want to enter chaos, not as a means of escape, but rather to fight it and structure it. I want to work in chaos because it is the only way for a possible resistance, Resistance to Facts, to Information, to Opinion. Art itself is a way of Resistance, and Art does resist because it is Art. That's the essential thing. But it is also the difficulty—as an artist, it is difficult to have faith in the constitutive resistance of Art and not turn toward architecture, design, graphics, or fashion.

I want to try to do work that remains open to what isn't positive. I want to do work that isn't negative but confronts what is not given, what is not to be touched, what is nonpositive. Through my work, I want to dare to touch what is untouchable. I want to work on the Edge of the untouchable. In the end, I want to be able to give Form to the urgent and irresistible requirement: Each wound is my wound! Each death is my death. Each disparity is my disparity. Each injustice is my injustice. Each sorrow is my sorrow.

All attempts of explanation and information must be relentlessly countered: Who is the victim? Who is the torturer? I am the torturer and the victim is me; it's me and no one else. I alone am responsible. I am responsible for everything. I want to give Form to the assertion that I am responsible for each inflicted wound everywhere. I want to insist and repeat myself. Insisting seems inevitable to me, Repeat, Review, Rethink, Remake. Re!

Written by Max Andrews (MA) and Heather Pesanti (HP)

Doug Aitken

"Our way of living today is expanded, fragmented, kaleidoscopic," Doug Aitken has said. "We have huge amounts of information coming at us ... [and] I don't think we see life in ways that have clear beginnings and ends."[1] Correspondingly, the preeminent refrains of Aitken's practice are its concern with stimuli and stories that are asynchronous and fractured, through the orchestration of multiscreen moving-image installations. These works have frequently touched on themes of urban isolation and emotional alienation. They have also probed expansive natural wilder-nesses, as in the icy *new ocean* (2001), for example, which employs camerawork that might constitute an epic documentary on the seasons. The artist has visited locations as particular as a Caribbean island imme-diately after a volcanic eruption (Montserrat in *eraser*, from 1998) or as anonymous as common spaces of conveyance (transit stations, airports). The "characters" he has directed—whether humans, machines, or land-scapes—often exhibit uncanny behavioral tics or issue gnomic statements, lending Aitken's immersive audiovisual environments the sense of an unfolding waking dream.

His work has encompassed photography, collage, objects, events, and publications, yet when he simultaneously, and characteristically, uses up to a dozen or more projectors, monitors, and speakers, he offers a multi-media experience for our time that suggests a separate category, some-where between cinema and architectural sculpture. The lush imagery of his work often has the sophistication of a feature film, and it consciously draws on other forceful dynamics of the contemporary image-making apparatus. In this way, Aitken—alongside fellow artists Matthew Barney with his *Cremaster Cycle* (1994–2002) and Douglas Gordon and Philippe Parreno with *Zidane: A 21st Century Portrait* (2006)—allies himself with a new ambition in the visual arts of the last decade that seeks to engage a broad audience by operating beyond the typical parameters of the gallery and museum.

1. Quoted in Jori Finkel, "MoMA's Off-the-Wall Cinema," *New York Times*, January 7, 2007.
2. See Noel Daniel, ed., *Broken Screen: Expanding the Image, Breaking the Narrative—26 Conversations with Doug Aitken* (New York: D.A.P./Distributed Art Publishers, 2005).

The scale and reach of Aitken's project were recently writ large over a section of midtown Manhattan. His *sleepwalkers* (2007) consisted of seven 13-minute video sequences that were silently projected at night on the vast facades of the Museum of Modern Art and adjacent buildings, temporarily turning the block into a rival to nearby Times Square, with its electronic billboards. Each of the dislocated narratives of Aitken's "broken screen" corresponded to each of the New York boroughs and traced the routine of five fictional city dwellers as they awoke and headed to work.[2] *Sleep-walkers* draws as much attention to abstract close-ups as to the story that is played out through the almost hypnotic cadences of its protago-nists' parallel rituals. In *Migration: 365 Hotel Rooms* (2008), Aitken takes the viewer on an odyssey through a contemporary American landscape of seemingly abandoned roadside hotels and nondescript executive airport suites. The monotonous, sterile room interiors are inhabited, or haunted, by indigenous, migratory mammals and birds. Some of the animals curiously seem to adapt to their modern synthetic environments, yet others stand in reflected silence, gazing out through the hotel windows on a world that is strangely posthuman. (MA)

Born 1968, Redondo Beach, California
Lives and works in Los Angeles, California

Doug Aitken studied at Marymount College, Rancho Palos Verdes, California, from 1986 to 1987 and graduated from the Art Center College of Design, Pasadena, California, in 1991 with a BFA. His work has been featured in solo exhibitions at venues such as Museum of Modern Art, New York (2007, cat.); 303 Gallery, New York (2007, 2002, 1998, 1997, 1994); Aspen Art Museum, Colorado (2006); Musée d'Art Moderne de la Ville de Paris, Regen Projects, Los Angeles, and Galerie Eva Presenhuber, Zürich (all in 2005); Sala Rekalde, Bilbao (2004); Taka Ishii Gallery, Tokyo (2004, 2000, 1998, 1996); Kunsthalle Zürich (2003, cat.); Victoria Miro Gallery, London (2003, 1999); Kunsthaus Bregenz, Austria (2002, cat.); Kunstmuseum Wolfsburg (cat.) and Serpentine Gallery, London (both in 2001); and Vienna Secession (cat.), Berkeley Art Museum, University of California, and Dallas Museum of Art (all in 2000). Aitken's recent group exhibitions include *Playback*, Musée d'Art Moderne de la Ville de Paris, and *Silence: Listen to the Show*, Fondazione Sandretto Re Rebaudengo, Turin (both in 2007, cats.); *Beyond Cinema: The Art of Projection*, Hamburger Bahnhof—Museum für Gegenwart, Berlin (2006, cat.); *Universal Experience: Art, Life, and the Tourist's Eye*, Museum of Contemporary Art, Chicago (2005–2006, cat., traveled to Hayward Gallery, London, and Museo d'Arte Moderna e Contemporanea di Trento a Rovereto, Italy); *Modern Masters and Collection*, 21st Century Museum of Contemporary Art,

Kanazawa, Japan, *Spiritus* Magasin 3, Stockholm Konsthall (cat.), *fast forward*, ZKM/Zentrum für Kunst und Medientechnologie, Karlsruhe, and *Eden*, La Colección Jumex, Mexico City (all in 2003); *remix*, Tate Liverpool (2002); *Let's Entertain: Life's Guilty Pleasures*, Walker Art Center, Minneapolis (2000–2001, cat., traveled to Kunstmuseum Wolfsburg and Portland Art Museum, Oregon); Whitney Biennial, Whitney Museum of American Art, New York (2000, 1997, cats.); Biennale of Sydney, Museum of Contemporary Art, Australia, and *Flight Patterns*, Museum of Contemporary Art, Los Angeles (both in 2000); Venice Biennale (1999, cat.); and *Unfinished History*, Walker Art Center, Minneapolis (1998, cat.).

Selected Bibliography

Anton, Saul. "A Thousand Words: Doug Aitken Talks about Electric Earth." *Artforum* 38, 9 (May 2000): 160–61.
Birnbaum, Daniel. "Doug Aitken." In *Chronology*, 2nd ed., 104–14. Berlin: Sternberg Press, 2007.
Birnbaum, Daniel, Amanda Sharp, Jörg Heiser, Jorge Luis, and Doug Aitken. *Doug Aitken*. London and New York: Phaidon, 2001.
"Doug Aitken." Special section. *Parkett*, no. 57 (1999): 20–61.
Fogle, Douglas. "No Man's Land." *Frieze*, no. 39 (March–April 1998): 56–61.
Vanderbilt, Tom. "City of Glass." *Artforum* 45, no.5 (January 2007): 45–46.

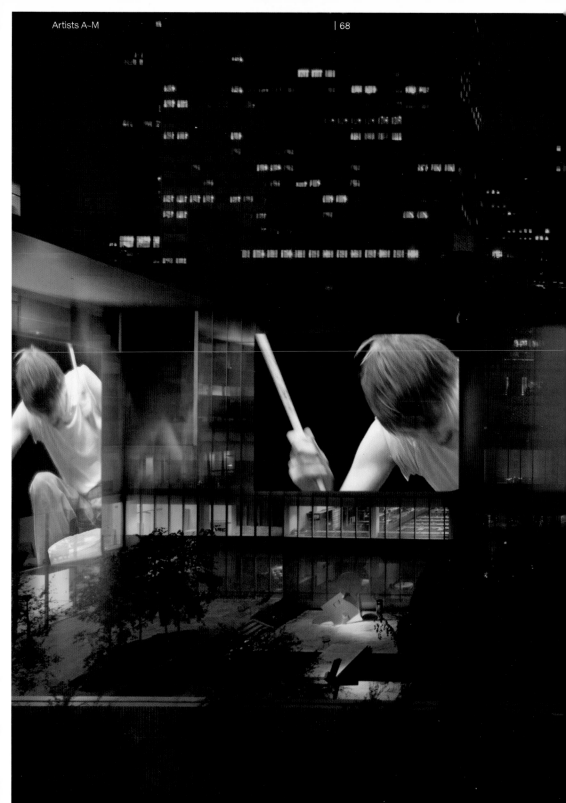

Doug Aitken *sleepwalkers* (installation view), 2007

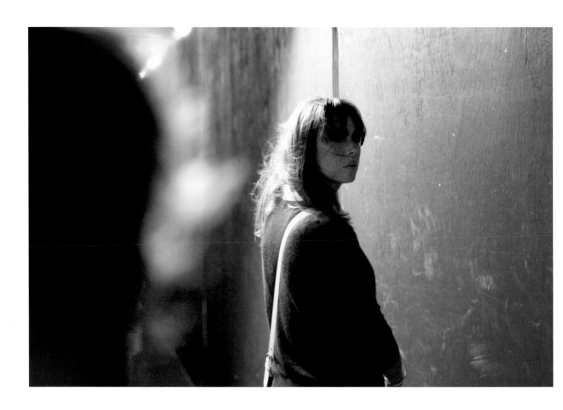

Doug Aitken *sleepwalkers*, 2007

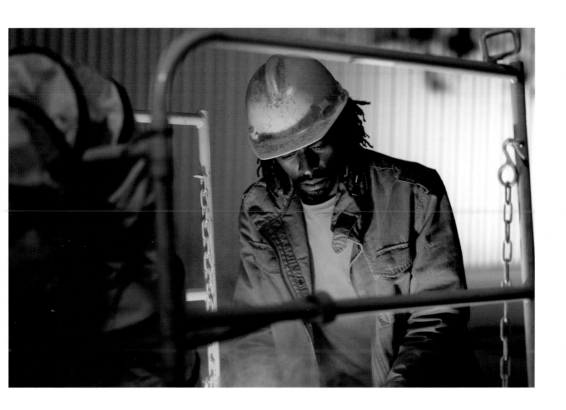

Doug Aitken *sleepwalkers*, 2007

Kai Althoff

The ethereal, haunting figures of Kai Althoff's paintings and the seductive chaos of his installations and mise-en-scènes reflect a struggle with complex and dialectical notions of love and hate, sexuality, and interior and exterior worlds. Here, violence, depravity, and abjection perpetually threaten to obliterate love, spirituality, and beauty in the fragile interplay between good and evil. Perhaps the artist best encapsulated this tension when he commented that "the only thing that interests me about other people is how they deal with something as questionable as existing in this world without going mad."[1] As an installation artist, painter, musician, writer, and occasional actor (in his own films), Althoff epitomizes the "art-as-life" practitioner, concerned as much with the collective social experience of antiauthoritarian, youth, rock, or avant-garde artistic groups as with fostering a particular canon of beauty through his aesthetic decisions. His work combines an emotional appeal generated by color, form, and deceptively naive gestures with a deliberately untranslatable quality or inaccessibility that forces the viewer into unfamiliar territory. At the center of it all is an impetus for storytelling, though the narratives are intentionally incomplete and opaque, blending fragments of characters and symbols from religion and history with those from his personal and imagined experience. Collaboration—real and invented—appears throughout the artist's oeuvre, reiterating the importance he places on shared experience.[2]

Complex installations, reminiscent of "the leftovers of a small but wild teenage party,"[3] make up a large part of Althoff's production. Drenched in colors such as deeply arresting blood reds and browns, filled with prolif- erations of collected or constructed items, and generating all-encompassing environments that both welcome and repel the viewer, these take the form of elaborate stage sets with figures, props, and all the accoutrements of a

1. Artist interviewed by Olaf Karnik in Nicholas Baume, ed., *Kai Kein Respekt (Kai No Respect)*, exhibition catalogue (Boston: Institute of Contemporary Art; Miami Beach: Bridge House Publishing, 2004), 42.
2. Althoff has collaborated with, among others, the musical groups Workshop and Ashley's, his own filmic collaborative Filmgruppe West, and numerous other artists as well as with invented alter egos. See Nicholas Baume, "Feel It All," in Baume, *Kai Kein Respekt (Kai No Respect)*, 6–36.
3. Francesco Bonami, "Winterspelt," in Baume, *Kai Kein Respekt (Kai No Respect)*, 53.
4. *Urian*, in old German, translates as "devil." Both Diedrich Diederichsen (p. 76) and Nicholas Baume (pp. 21, 22) discuss this in *Kai Kein Respekt (Kai No Respect)*.
5. Artist's statement, in e-mail correspondence with the author, January 9, 2008.

room. Paintings, too, are crucial, both as stand-alone objects and as components of his installations, in styles ranging from abstract to realist, from elegant to raw. *Ein noch zu weiches Geweese der Urian-Bündner* (A still too soft bearing on the part of the Urian Brotherhood), an installation from 1999 comprising photographs, gouache paintings, sculptures, and text, obliquely recounted the artist's mythical fable of an underground society of men whose pact with the devil has corrupted them into violent, depraved individuals.[4] Angels, represented by sculptures made of carpet, represent their only possible salvation. The degeneration and decay of previous innocents into incarnations of abjection form a metaphor for the destructive—and seductive—forces of life. In *Untitled* (2007), a cavernous red room encloses a tall female doll draped in a Romanesque gown. Behind her stands a delicate grid of scaffolding, while in front, a glossy resin sculpture divided by a churning trench occupies the center of the room as the object of her gaze. This "sculpture of degradation," according to the artist, reflects his waking dream of an imposing woman of ambiguous disposition, "wise, knowing, handsome ... and with what they'd call 'daredevilishness,'" the central solitary figure in an installation rife with sexuality and potentially demonic revelations.[5] Here, the symbolic manifestations of opposing powers, metaphorically pushing and pulling on body and mind, feverishly collapse good and evil into a unified and potentially dangerous whole. (HP)

Born 1966, Cologne, Germany
Lives and works in Cologne

Kai Althoff's work has been featured in solo exhibitions at venues such as Kunsthalle Zürich (cat.) and Gladstone Gallery, New York (both in 2007); ACME, Los Angeles (2005, 2000); Institute of Contemporary Art, Boston, and Museum of Contemporary Art, Chicago (both in 2004, cats.); Diözesanmuseum Freising, Germany (2003, cat.); Kunstverein Braunschweig (2002, cat.); Anton Kern Gallery, New York (2001, cat., 1997); Galerie Daniel Buchholz, Cologne (2001, cat., 1998, 1995); Galerie Neu, Berlin (2000, 1998); and Galerie Christian Nagel, Cologne (1999, 1996, 1995). Althoff's recent group exhibitions include *Painting in Tongues*, Museum of Contemporary Art, Los Angeles, and *Heart of Darkness*, Walker Art Center, Minneapolis (both in 2006, cats.); Venice Biennale (2003, 1993, cats.); *Drawing Now: Eight Propositions*, Museum of Modern Art, New York, and "*Dear Painter, Paint Me...*": *Painting the Figure since Late Picabia*, Musée National d'Art Moderne, Centre Georges Pompidou, Paris (both in 2002, cats.); *Neue Welt*, Frankfurter Kunstverein, Frankfurt am Main (2001, cat.); *German Open: Contemporary Art in Germany*, Kunstmuseum Wolfsburg (1999, cat.); *Heetz, Nowak, Rehberger*, Museu de Arte Contemporânea da Universidade de São Paulo (1997, cat.); *Wild Walls*, Stedelijk Museum, Amsterdam (1995, cat.).

Selected Bibliography

Baume, Nicholas, ed. *Kai Kein Respekt (Kai No Respect)*. Exhibition catalogue. Boston: Institute of Contemporary Art; Miami Beach: Bridge House Publishing, 2004.
Holbert, Tom. "Band of Outsiders: The Art of Kai Althoff." *Artforum* 41, no. 2 (October 2002): 124–29.
"Kai Althoff." Special section. *Parkett*, no. 75 (2005): 68–103.
"Kai Althoff: Solo für eine befallene Trompete (Solo for an Afflicted Trumpet)." Artist's section. In Philippe Verge, ed., *Heart of Darkness: Kai Althoff, Ellen Gallagher and Edgar Cleijne, Thomas Hirschhorn*, 51–76. Exhibition catalogue. Minneapolis: Walker Art Center, 2006.
Rosenberg, Angela. "Kai Althoff: General Rehearsals for a New Language." *Flash Art*, no. 224 (May–June 2002): 94–97.

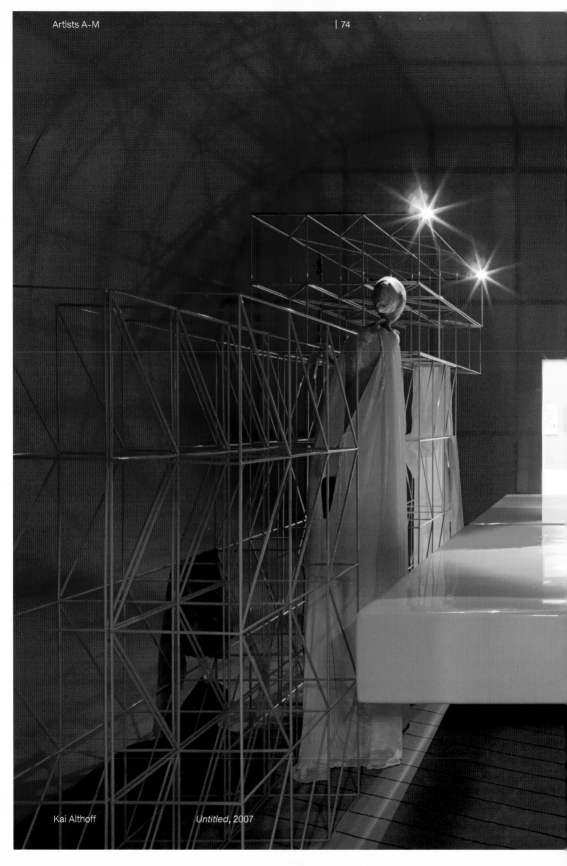

Kai Althoff *Untitled*, 2007

Kai Althoff *Untitled*, 2007

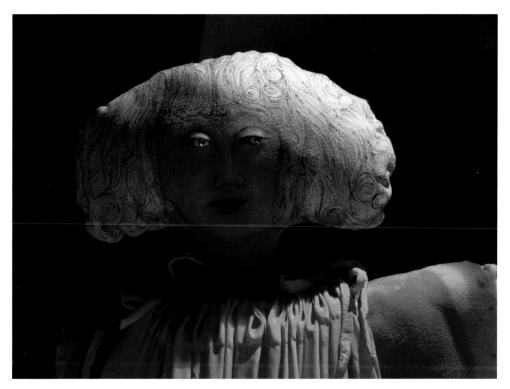

Kai Althoff *Untitled* (detail), 2007
 Ich meine es auf jeden Fall Schlecht mit ihnen (detail), 2007

Mark Bradford

Appropriating ephemera and imagery from his surroundings, Mark Bradford pairs an examination of the formal issues of abstraction and figuration with sociological questions regarding systems of culture, communication, and exchange in his Los Angeles neighborhood. Alongside videos, paintings, prints, and sculptural installations, he creates mixed-media works on canvas that combine techniques (collage, painting, sanding) and materials (ephemera, paint). Found elements that make their way into his paintings include permanent-wave endpapers; hair; foil; remnants of posters from abandoned lots, telephone poles, and fences; and pieces of paper that are torn, ripped, or cut into squares and affixed to the canvas. The use of endpapers was originally inspired by his mother's beauty salon; he then expanded his sight lines to other areas of his urban landscape. In this way, Bradford is an ethnographer, culling from the material culture of his environment and incorporating this evidence into his artistic practice. Collaged ephemera have become increasingly characteristic of his work, enabling what the artist sees as a more fluid discourse between the formal and social aspects of his art making. This shift was first seen in *The Devil Is Beating His Wife* (2003), which consists almost entirely of found materials.[1] In an apt moment of form following function, the collaged materials take on the character of almost cartographic grids and lines on his canvases, an appropriate metaphor for the cultural mapping from which they emerged.

In a multilayered process, after collaging materials onto canvas, Bradford then either paints or sands away elements, often retracing underlying text. The method of applying ripped or cut materials to a surface and then removing them is indebted to Surrealist *décollage* (cutting away) and *affichiste* (torn poster) techniques of the 1950s, when artists such as Mimmo Rotella, Jacques Mahé de la Villeglé, and Raymond Hains (as part of the Nouveau Réaliste movement) used posters and advertisements to create

1. As noted in Shamim M. Momin, *Mark Bradford: Very Powerful Lords*, exhibition brochure (New York: Whitney Museum of American Art at Altria, 2003), 5.
2. See, for example, Pierre Restany, *Rotella: Dal decollage alla nuova immagine* (Milan: Edizioni Apollinaire, 1963); and Hal Foster et al., *Art Since 1900: Modernism, Antimodernism, Postmodernism* (London: Thames & Hudson, 2004), 434–37.
3. Mark Bradford, e-mail message to author, September 4, 2007.
4. Mark Bradford interviewed by Eungie Joo, in *Free Trade*, exhibition brochure (Claremont, CA: Pomona College Museum of Art, 2002), 3.

shredded and uneven "painterly" surfaces.[2] Bradford explains that his collage work departs from that of his predecessors: "The found paper is not precious … it becomes material for another conversation albeit the history clings to its edges."[3] Other aspects of Bradford's work have historical threads. His uniformly dispersed grids echo the all-over compositions of Abstract Expressionists such as Jackson Pollock and, in some instances, Willem de Kooning. Likewise, one might invoke the work of Land artist Robert Smithson, whose "non-sites" consisted of elements removed from a specific site and then placed in the gallery, as a precedent to the appropriative and ethnographic practices Bradford regularly uses. Both Smithson and Bradford engender a conceptual connection between the two sites— the object and its source—that exists outside the bounds of normative time and space. History aside, appropriating material from one's surroundings is an action that links a thing to its immediate present. As Bradford says, "I use the aesthetic of southeast Los Angeles to highlight that region and all it carries, not in a romantic sense but to explicate its tenacity and complexity."[4] For Bradford, the complexity of composition, technique, and material in his work reflects the communities and activities around him and, perhaps more broadly, global culture as a whole. (HP)

Born 1961, Los Angeles, California
Lives and works in Los Angeles

Mark Bradford graduated from the California Institute of the Arts, Valencia, in 1995 with a BFA and in 1997 with an MFA. His work has been featured in solo exhibitions at venues such as Sikkema Jenkins & Co., New York (2008, 2005); Whitney Museum of American Art, New York (2007, cat.); LAXART, Los Angeles (2006); REDCAT, Los Angeles (2004, cat.); Whitney Museum of American Art at Philip Morris, New York (2003); and Pomona College Museum of Art, Claremont, California (cat.), and Susanne Vielmetter Los Angeles Projects (both in 2002). Bradford's recent group exhibitions include *Eden's Edge: Fifteen LA Artists*, UCLA Hammer Museum, Los Angeles, and *Street Level: Mark Bradford, William Cordova, and Robin Rhode*, Nasher Museum of Art at Duke University, Durham, North Carolina (both in 2007, cats.); *USA Today*, Royal Academy of Arts, London, Bienal de São Paulo, Whitney Biennial, Whitney Museum of American Art, New York, and Busan Biennale, South Korea (all in 2006, cats.); *inSite 05: Art Practices in the Public Domain*, San Diego Museum of Art and Centro Cultural de Tijuana (2005, cat.); California Biennial, Orange County Museum of Art, Newport Beach (2004, cat.); *Mirror Image*, UCLA Hammer Museum, Los Angeles (2002, traveled to Center for Curatorial Studies Museum, Bard College, Annandale-on-Hudson, New York); and *Freestyle*, Studio Museum in Harlem (2001, cat., traveled to Santa Monica Museum of Art, California).

Selected Bibliography

Andrews, Max. "Mark Bradford." In *2006 Whitney Biennial: Day for Night*, 184–85. Exhibition catalogue. New York: Whitney Museum of American Art, 2006.
Garrels, Gary. "Mark Bradford." In *Eden's Edge: Fifteen LA Artists*, 70–76. Exhibition catalogue. Los Angeles: UCLA Hammer Museum, 2007.
Joo, Eungie, ed. *Bounce: Mark Bradford and Glenn Kaino*. Exhibition catalogue. Valencia: California Institute of the Arts, 2004.
Nelson, Steven. *Mark Bradford*. Exhibition catalogue. New York: Sikkema Jenkins & Co., 2005.
Vergne, Phillipe. "Mark Bradford." In *Ice Cream: Contemporary Art in Culture*, 60–63. London and New York: Phaidon, 2007.

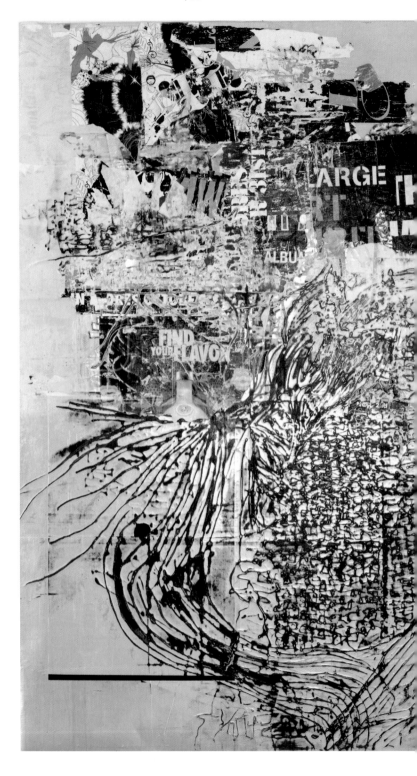

Mark Bradford *Noah's Third Day*, 2007

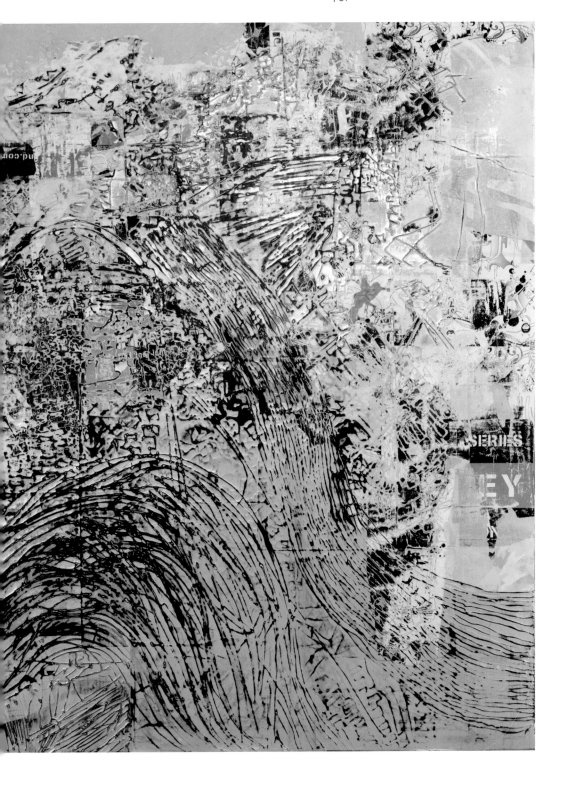

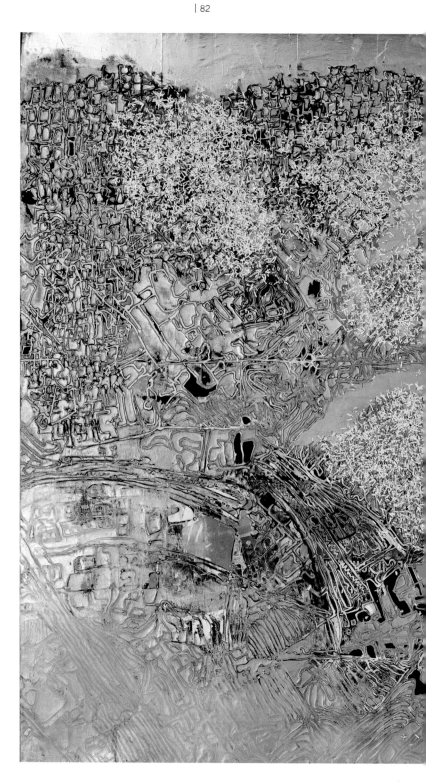

Mark Bradford *If caught outside*, 2007

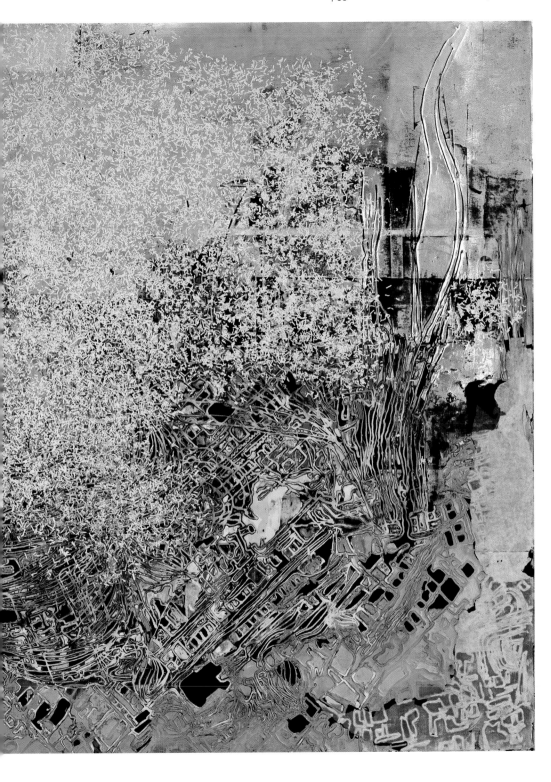

Cao Fei

Cao Fei's visually stunning and cinematically rich work is imbued with the prodigious phenomenon that is the contemporary Chinese city and touched by the interior lives of a generation of young people growing up in the frenetic post-Communist era. Initiated in 2007, Cao's *RMB City* could be seen as the project toward which all of the previous works in her incandescent career to date seem to have been pointing. RMB City is a location that is nowhere yet one can visit it from anywhere and has millions of potential residents yet is populated by nobody: it is an island destination built by the artist in the Internet-based virtual universe Second Life. Taking the moniker "China Tracy" for her Second Life avatar—a young Chinese woman like her real-world self—Cao has created a realm in which boundless capitalist speculation and lucid hallucinatory fantasies appear to have taken root among the ruins of Maoist symbols.

RMB City is at once a self-perpetuating documentary film, a social experiment, and a business venture (units in the virtual city complex are available for two-year lease) that has been manifested in videos, models, and installation environments. Christened with the abbreviation for the currency of the real China (RMB, or renminbi, meaning "people's money"), the city purloins iconic architecture from the near future of the actual city of Beijing, including the China Central Television Headquarters, which here dangles from a crane as "People's Entertainment Television," and the "Bird's Nest" Olympic Stadium, which here becomes a "People's Park." A plethora of tunnels, waterfalls, and maglev train lines weave among a thicket of skyscrapers, an embedded airliner, a flooded Tiananmen Square ("People's Water Park"), a slum, and a temple: all of which constitutes a sort of funhouse urban tumor, a master plan of "overabundant symbols of Chinese reality."[1]

A precursor to *RMB City*, *i.Mirror* (2007) is an elegiac 28-minute film recorded entirely within Second Life in which China Tracy explores the vistas, opportunities, and characters of this digital realm. It centers on a

1. China Tracy [Cao Fei], "RMB City: Online Urbanisation," in *Cao Fei/China Tracy: RMB City*, ed. Hu Fang and Cao Fei (Guangzhou: Vitamin Creative Space, 2008), no pagination.

series of tender meetings and typed dialogues with a fellow avatar, Hug Yue—a love story, even. Elaborating on the sensibilities of her earlier work, the film locates a yearning state of mind and documents an estranged landscape that befits the Real Life diaspora—in the sense both of culture that has been dispersed across the globe and of "antiheroes" who displace themselves from reality into fantasy worlds. In the video *COSPlayers* (2004), for example, teen "costume players" from Guangzhou are dressed up as characters from their favorite role-play console games or animated tales. After doing frantic mock battle in front of huge construction sites and city skylines—a backdrop as hyperreal as any computer-generated mise-en-scène—the "warrior" and "assassin" adolescents return to the everyday reality of their parents' homes. Likewise, Cao's film *Whose Utopia* (2006–2007) enabled workers from a lightbulb factory in Foshan to digress into graceful, otherworldly dances between the assembly-line machines, while *PRD Anti-Heroes* (2005) extended her repertoire into the realm of theater—it comprises an exuberant production fusing traditional Beijing Opera, Cantonese pop music, and kitschy soap operas. (MA)

Born 1978, Guangzhou, China
Lives and works in Beijing, China

Cao Fei graduated from the Guangzhou Academy of Fine Arts in 2001. Her work has been featured in solo exhibitions at venues such as Le Plateau, Paris (2008, cat.); Lombard-Freid Projects, New York (2008, 2006, cat., 2005); Orange County Museum of Art, Newport Beach, California (2007); and Museum Het Domein, Sittard, the Netherlands (cat.), and Para/Site Art Space, Hong Kong (both in 2006). Cao's recent group exhibitions include *Laughing in a Foreign Language*, Hayward Gallery, London (2008, cat.); *Brave New Worlds*, Walker Art Center, Minneapolis, *China Power Station: Part II*, Astrup Fearnley Museet for Moderne Kunst, Oslo, International Istanbul Biennial, and Biennale d'Art Contemporain de Lyon (all in 2007, cats.); Venice Biennale (2007, 2003, cats.); *China Power Station: Part 1*, Battersea Power Station and Serpentine Gallery, London, Busan Biennale, South Korea, and Biennale of Sydney (all in 2006, cats.); *Follow Me! Contemporary Chinese Art at the Threshold of the Millennium*, Mori Art Museum, Tokyo, Guangzhou Triennial, and *I Still Believe in Miracles, Part II: Derrière l'Horizon*, Musée d'Art Moderne de la Ville de Paris (all in 2005, cats.); *Between Past and Future: New Photography and Video from China*, International Center of Photography and Asia Society, New York (2004, cat.); Gwangju Biennale, South Korea (2002, cat.); and Berlin Biennial for Contemporary Art (2001, cat.).

Selected Bibliography

"Cao Fei." Special section. *Art It* (Tokyo) 5, no. 2 (Spring–Summer 2007): 50–67.
Cotter, Holland. "Video Art Thinks Big: That's Showbiz." *New York Times*, January 6, 2008.
Danby, Charles. "Cao Fei: China Girl." *I-D Magazine* (London) (May 2006): 40.
Hou Hanru. "Cao Fei: A Mini-Manifesto of New New Human Beings." *Flash Art*, no. 224 (May–June 2005): 126–27.
Obrist, Hans Ulrich. "Cao Fei." *Artforum* 65, no. 5 (January 2006): 181.
Pi Li and Waling Boers. "City Report: Beijing." *Frieze*, no. 96 (January–February 2006): 138–43.

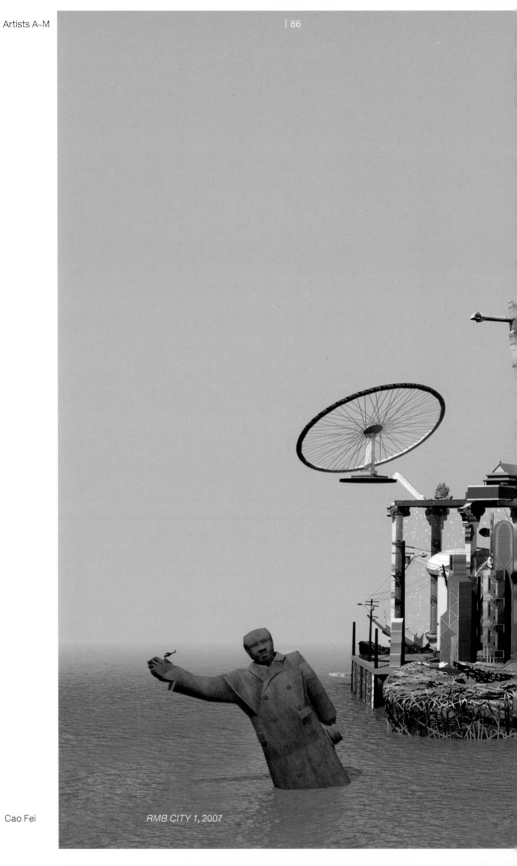

Cao Fei *RMB CITY 1*, 2007

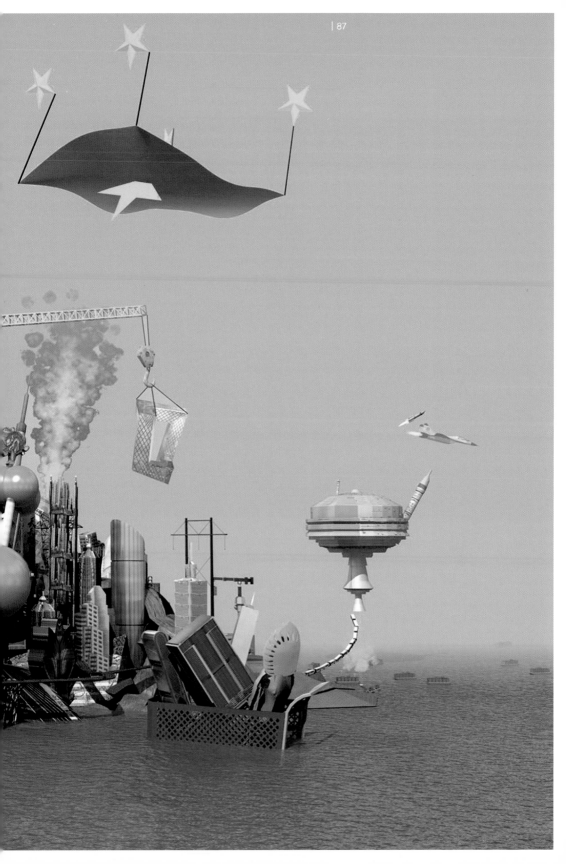

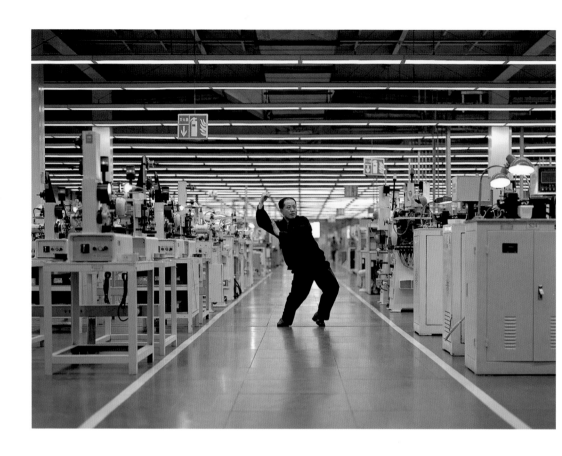

Cao Fei *My Future is Not a Dream 03*, 2006

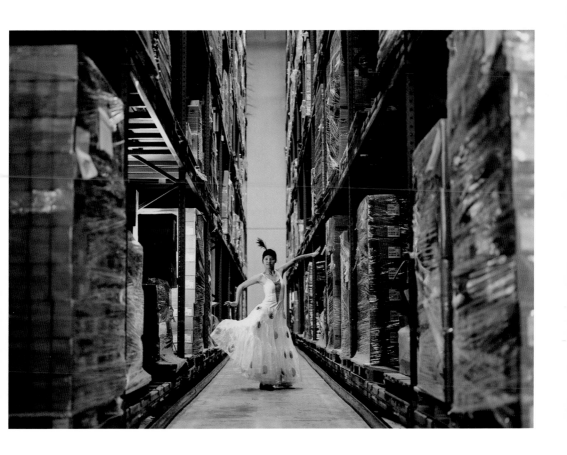

Cao Fei *My Future is Not a Dream 02*, 2006

Vija Celmins

"Many people moved on from abstract-expressionist painting—so did I. I decided to go back to looking at something outside of myself. I was also going back to what I thought was this basic, stupid painting. You know: there's the surface, there's me, there's my hand, there's my eye, I paint. I don't embellish anymore, I don't compose, and I don't jazz up the color."[1] Vija Celmins thus characterized the beginnings of her mature work of the mid-1960s in a conversation with fellow artist Chuck Close. In the ensuing decades, her paintings, drawings, and occasional sculptures—all characteristically rendered in muted tones, blacks, and whites—likewise have explored the furthest reaches of restraint and representation. Her art seems to bear witness as well to the very limits of human experience through its predominance of imagery that points toward uninhabitable, desolate, and unbound beauty.

The ocean, the desert, and the night sky are subjects that appear repeatedly in her art. Or rather, photographs of them, not the expanses themselves, have formed the direct basis for her work—photographs the artist clipped from magazines or shot herself and then kept as one might keep a souvenir. In the case of her many seascapes, featureless waves often derive from those the artist once photographed off the coast of Venice, California, her home for many years. Yet the resultant images resolutely declare "the ocean" without evoking any particular locale. Although her pictures give us the impression of looking up to observe the constellations at night, gazing out to sea, glancing down at our feet to a desiccated desert plain, or even, somehow, studying a lunar surface (the artist committed the moon to paper and pencil using NASA imagery of 1969), Celmins represents place in its very abstraction and, paradoxically, in its nonspecific "placelessness."

Celmins has used paint, graphite, and more recently, charcoal, but it does not necessarily follow that she makes categorical paintings or drawings: her works' honed and layered appearance shows no trace of brushstrokes or lines. In a process the artist has frequently compared to masonry or

1. Vija Celmins, interviewed by Chuck Close, in *Vija Celmins*, ed. William S. Bartman (Los Angeles: A.R.T. Press, 1992), 8.

brickwork, she laboriously deposits and constructs, as well as sands or erases, monochromatic pigment to create charged and cerebral planes. To borrow the title of one of her few three-dimensional objects, Celmins operates "to fix the image in the memory."

As is the case with all of her paintings, the *Night Sky* works are at once ostensibly "of" their photographic sources—a detail of a flat page from a magazine—yet their horizonless depths are imperfectly "scanned" and translated by Celmins onto the impassable canvas in a way that implies a seductively held tension of surface and depth, detail and illusion. They openly invite myriad connotations, from philosophical meditations on humanity's place in the cosmos to starry allusions to the "final frontier" in television and cinema. (MA)

Born 1938, Riga, Latvia
Lives and works in New York, New York

Vija Celmins graduated from John Herron Art Institute, Indianapolis, in 1962 with a BFA and from the University of California, Los Angeles, in 1965 with an MFA. Her work has been featured in solo exhibitions at venues such as UCLA Hammer Museum, Los Angeles (2007, cat.); Musée National d'Art Moderne, Centre Georges Pompidou, Paris, (2006, cat.); Metropolitan Museum of Art, New York (2002, cat.); McKee Gallery, New York (2001, 1996, 1992, 1988, 1983); Cirrus Gallery, Los Angeles (2000, 1994); Anthony d'Offay Gallery, London (1999); Institute of Contemporary Arts, London (1996–1997, cat., traveled to Museo Nacional Centro de Arte Reina Sofia, Madrid, Kunstmuseum Winterthur, Switzerland, and Museum für Moderne Kunst, Frankfurt am Main); Fondation Cartier pour l'Art Contemporain, Paris (1995, cat.); and Institute of Contemporary Art, University of Pennsylvania, Philadelphia (1992–1994, cat., traveled to Henry Art Gallery, University of Washington, Seattle, Walker Art Center, Minneapolis, Whitney Museum of American Art, New York, and Museum of Contemporary Art, Los Angeles). Celmins' recent group exhibitions include *The Painting of Modern Life*, Hayward Gallery, London, and *The Third Mind*, Palais de Tokyo, Paris (both in 2007, cats.); *Magritte and Contemporary Art: The Treachery of Images*, Los Angeles County Museum of Art, and *Plane/Figure*, Kunstmuseum Winterthur, Switzerland (both in 2006, cats.); *The Undiscovered Country*, UCLA Hammer Museum, Los Angeles (2004, cat.); *Happiness: A Survival Guide for Art and Life (Harmony)*, Mori Art Museum, Tokyo (2003, cat.); Whitney Biennial, Whitney Museum of American Art, New York

(2002, 1997, cats.); *The Inward Eye: Transcendence in Contemporary Art*, Contemporary Arts Museum, Houston, and *Les Années Pop: Cinéma et Politique: 1956–1970*, Musée National d'Art Moderne, Centre Georges Pompidou, Paris (both in 2001, cats.); *Examining Pictures: Exhibiting Paintings*, Whitechapel Art Gallery, London (1999, cat., traveled to Museum of Contemporary Art, Chicago); *Sunshine & Noir: Art in L.A. 1960–1997*, Louisiana Museum for Moderne Kunst, Humlebaek, Denmark (1997, cat., traveled to Kunstmuseum Wolfsburg, Castello di Rivoli Museo d'Arte Contemporanea, Turin, and UCLA Hammer Museum, Los Angeles); and *Birth of the Cool: American Painting*, Deichtorhallen, Hamburg (1997, cat., traveled to Kunsthaus Zürich).

Selected Bibliography

Bartman, William S., ed. *Vija Celmins*. Los Angeles: A.R.T. Press, 1992. With an interview by Chuck Close.
Relyea, Lane, Robert Gober, and Briony Fer. *Vija Celmins*. London and New York: Phaidon, 2004.
Rian, Jeff. "Vija Celmins: Vastness in Flatland." *Flash Art*, no. 189 (Summer 1996): 108–11.
Schjeldahl, Peter. "Dark Star." *New Yorker*, June 4, 2001, 85–86.
Tannenbaum, Judith, Douglas Blau, and Dave Hickey. *Vija Celmins*. Exhibition catalogue. Philadelphia: Institute of Contemporary Art, University of Pennsylvania, 1992.
"Vija Celmins." Special section. *Parkett*, no. 44 (1995): 24–57.

Vija Celmins *Night Sky #1*, 1990–1991

Vija Celmins *Night Sky #6*, 1993

Vija Celmins *Night Sky #12*, 1995–1996

Vija Celmins *Night Sky #2*, 1991

Phil Collins

Acting as a director, photographer, interviewer, and producer, Phil Collins uses photography and video to explore individual and collective processes of representation and the ambivalent relationship between the camera and its subjects. He frequently sites his projects in geographical locations in the midst of social and political turmoil, eschewing heavy-handed political messages in favor of intimate, vulnerable portrayals of individuals within a community. Influenced by the history of documentary photography, television, portraiture, and avant-garde filmmaking, Collins questions the ethical nature of visual media by placing his subjects in the spotlight in exchange for control and ownership of their images. The artist invariably appears in his pieces, often not as the protagonist but as a behind-the-scenes presence—a presence felt in the work's intelligently constructed conceptual premise, carefully staged setting, highly calculated cinematic choices, and specific, predetermined subject matter. More ephemerally, the work always conveys the sense that it is Collins who allows his subjects to reveal themselves so fully to the camera.

A fascination with the subculture of reality television and its aftereffects, combined with a pervading engagement with the universal implications of pop culture, especially music, is a consistent theme in Collins' recent work. For *gerçeğin geri dönüşü* (the return of the real) (2005), a multipart video and photographic installation, he staged a press conference and interview session with individuals who, after appearing on Turkish reality-television shows, suffered adversities in their lives. Though some of the subjects told benign stories, many relayed horrifying tales involving abuse, rape, or other crimes that were exacerbated by or resulted directly from their being on television, exposing what the artist has referred to as "the blind spot of television, how it betrays people, how it lets people down, how it upsets and disturbs."[1]

Reflecting a lighter side of the artist's pop-culture sensibility is *the world won't listen* (2004–2007), an exhaustive, four-year project in which he

1. From *Phil Collins: Three-Minute Wonder*, video (3:30 min.), directed by Emily Dixon on the occasion of the Turner Prize 2006, aired November 27, 2006, on Channel 4, Britain, and available online at www.tate.org.uk/britain/turnerprize/2006/philcollins.htm.

recruited and then videotaped volunteers performing karaoke to songs from the compilation album of the same name by the British 1980s rock band The Smiths. Individually titled *el mundo no escuchará* (2004), *dünya dinlemiyor* (2005), and *dunia tak akan mendengar* (2007) (translations of the phrase "the world won't listen" in Spanish, Turkish, and Indonesian) and completed in Bogotá, Colombia, Istanbul, Turkey, and Jakarta and Bandung, Indonesia, respectively, the videos—presented as a simultaneous three-projection installation—depict a series of alternately hilarious, poignant, awkward, and moving renditions of each of the songs on the album. In the videos, which were filmed in front of kitschy forest and tropical backdrops, music becomes a catalyst and signifier for a cross-cultural love of a band that, for Collins, epitomized the angst and ambivalence of an entire generation of disaffected youths.

Collins' work mirrors a contemporary society whose identity is constructed through images of itself in the media, seen up close but always at a distance. For the artist, a return of the real suggests a desire to understand and expose the relationship between public and private notions of identity, as well as the complex notions of intimacy and distance, apathy and fascination, and self-consciousness and narcissism that drive contemporary culture. (HP)

Born 1970, Runcorn, England
Lives and works in Glasgow, Scotland

Phil Collins graduated from the University of Manchester in 1994 and the University of Ulster, School of Art and Design, in 2000. His work has been featured in solo exhibitions at venues such as Dallas Museum of Art (cat.), Victoria Miro Gallery, London, and Carnegie Museum of Art, Pittsburgh (all in 2007); San Francisco Museum of Modern Art, Sala Rekalde, Bilbao, Tate Britain, London, Tanya Bonakdar Gallery, New York, and Stedelijk Museum voor Actuele Kunst, Gent (all in 2006); Milton Keynes Gallery, Milton Keynes, England (cat.), and Wexner Center for the Arts, Ohio State University, Columbus (both in 2005); Espacio la Rebeca, Bogotá (2004); and Kerlin Gallery, Dublin (2004, 2002). Collins' recent group exhibitions include *Breaking Step: Displacement, Compassion and Humour in Recent Art from Britain*, Museum of Contemporary Art, Belgrade (cat.), *War and Discontent*, Museum of Fine Arts, Boston, and Auckland Triennial, Auckland Art Gallery (cat.) (all in 2007); *Turner Prize 2006*, Tate Britain, London (2006, cat.); International Istanbul Biennial, Deniz Palas Apartments, and *Populism* (opened concurrently at Stedelijk Museum, Amsterdam, Frankfurter Kunstverein, Frankfurt am Main, and Contemporary Art Centre, Vilnius, Lithuania) (both in 2005, cats.); *Universal Experience: Art, Life, and the Tourist's Eye*, Museum of Contemporary Art, Chicago (2005–2006, cat., traveled to Hayward

Gallery, London, and Museo d'Arte Moderna e Contemporanea di Trento a Rovereto, Italy; *Witness: Contemporary Artists Document Our Time*, Barbican Art Gallery, London (2003); Tirana Biennial, Albania (2001, cat.); and Manifesta: European Biennial of Contemporary Art, Moderna Galerija, Ljubljana (2000, cat.).

Selected Bibliography

Edelsztein, Sergio. "Phil Collins." In *Ice Cream: Contemporary Art in Culture*, 88–91. London and New York: Phaidon, 2007.
Farquharson, Alex. "Minority Report." *Frieze*, no. 94 (October 2005): 196–201.
Gioni, Massimiliano, and Michele Robecchi. "Phil Collins: Face Value." Interview. *Flash Art*, no. 222 (January–February 2002): 84–86.
Mitrović, Siniša, ed. *Phil Collins: yeah.....you, baby you*. Exhibition catalogue. Milton Keynes, England: Milton Keynes Gallery; Hove, England: Shady Lane Publications, 2005.
Molesworth, Helen. "Man with a Movie Camera: The Art of Phil Collins." *Artforum* 46, no. 5 (January 2008): 232–39.
Weaver, Suzanne, and Siniša Mitrović, eds. *Phil Collins: the world won't listen*. Exhibition catalogue. Dallas: Dallas Museum of Art; New Haven, CT: Yale University Press, 2008.

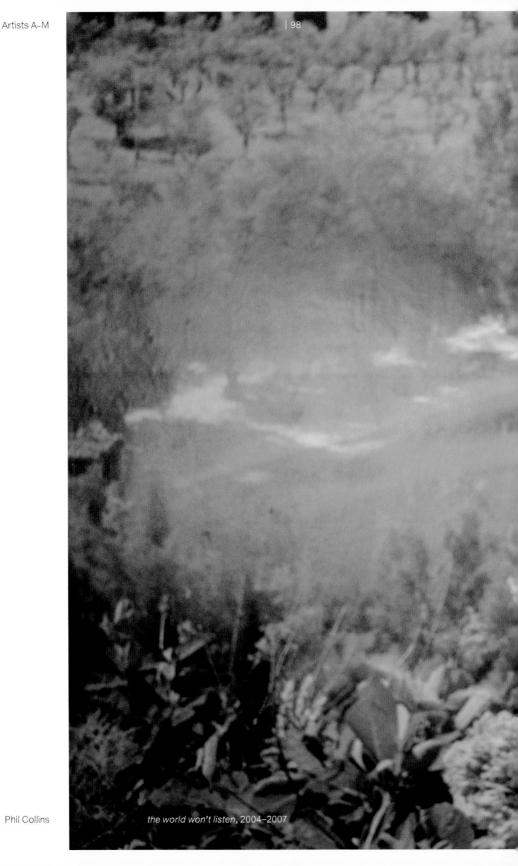

Phil Collins *the world won't listen*, 2004–2007

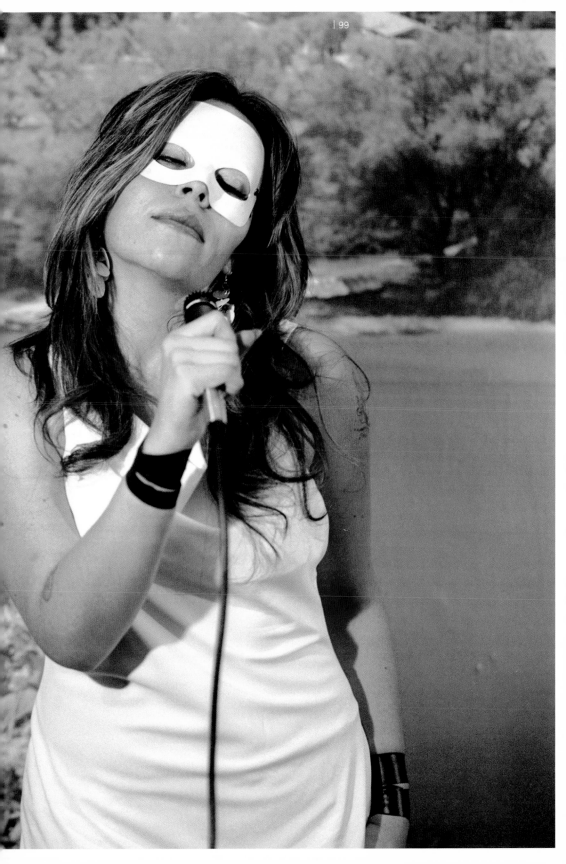

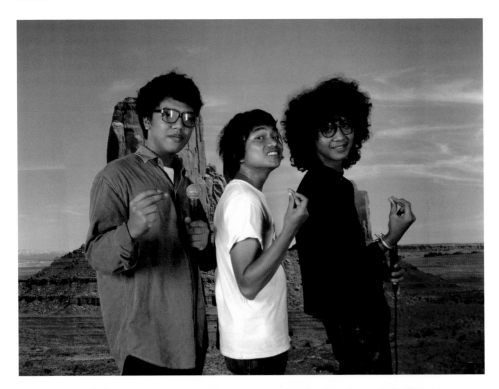

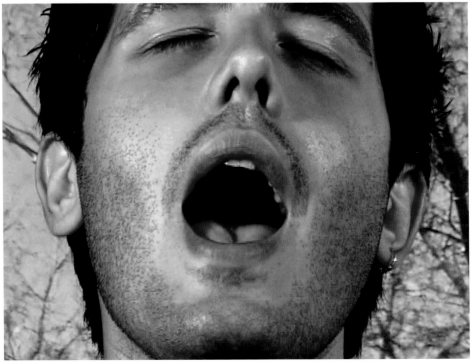

Phil Collins *the world won't listen*, 2004–2007
 the world won't listen, 2004–2007

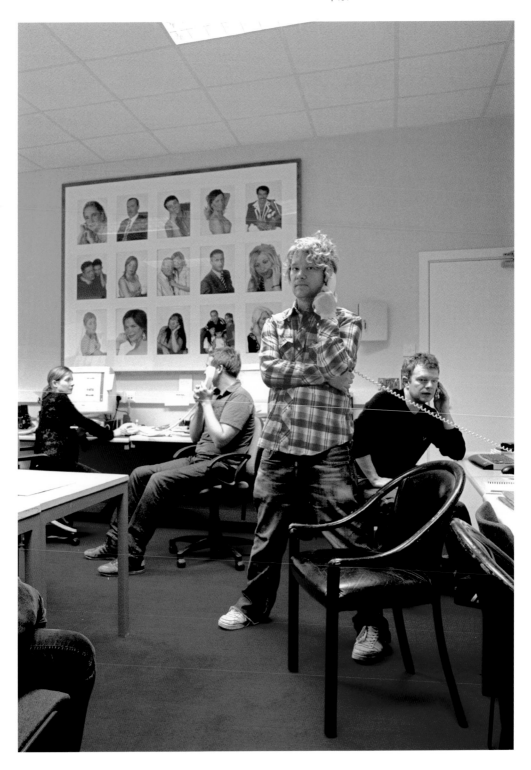

Phil Collins *shady lane productions* (installation view), 2006

Bruce Conner

By the time of Bruce Conner's third one-person exhibition in San Francisco in 1959, he had already passed away—or so it seemed from the black-edged invitation that announced works "by the late Bruce Conner." Deadly serious pranks litter this most expansive of artist's six-decade career, which has encompassed sculptures, collages, prints, paintings, photographs, drawings, short films, and actions. His oeuvre is fractured and volatile, evincing his strong aversion to commercialism, celebrity, and easy assimilation—not least expressed in the works of Conner the experimental filmmaker, who today is nevertheless the most widely known of the many pioneering and influential "Bruce Conners." Decoy strategies and propaganda as well as allusions to obliteration and renewal run throughout his practice. Such tendencies might well be traced to some pervasive narratives present in the artist's America: mass-media and consumer culture burgeoning in the wake of World War II and the dread and paranoia of the cold war.

Whether in an encounter with atom bombs or surfing, the Kennedy assassination, Western movies, Ray Charles, inkblots, Christian iconography, outer space, Marilyn Monroe, mushrooms, or television advertising, Conner has always refused a characteristic technique and disputes the value of consistency: "I never wanted to get locked into a style of work that I would be identified with to the point that I couldn't do anything else," the artist observed during his first major survey exhibition, which toured the United States in 1999 and 2000.[1]

Accordingly, he would later abandon the original mode of work—assemblage—that had earned his reputation as an artist associated with Beat culture and the so-called San Francisco Renaissance, but from which by 1964, perhaps with its official designation as "Contemporary American Sculpture" in an exhibition of the same name in New York, he wanted to free himself. As if taken from Miss Havisham's decaying house in Charles Dickens' *Great Expectations* (1861) by way of Kurt Schwitters' "Merz"

1. Quoted in Amei Wallach, "The Favorite Word in His Vocabulary Is 'Undermine,'" *New York Times*, October 1, 2000, Arts & Leisure sec.

constructions of the 1930s, Conner's sculptures from the 1950s and 1960s comprise hoarded and often shrouded conglomerations of common objects, images, and scraps of materials such as glass, cardboard, wax, lace, string, and nylon.

Conner produced the *ANGEL* series of photograms between 1972 and 1975. By standing in front of large sheets of light-sensitive paper that were then exposed to the beam of a slide projector, the artist summoned ethereal partial silhouettes of his body into being. The cameraless apparitions that resulted from the quasi-mystical capture of pure light energy recall the phantasmic "spirit photographs" of the late 19th and early 20th centuries in their apparently supernatural mediation of an invisible presence—or, indeed, they might suggest the Shroud of Turin, which is said to show the image Christ. As the visual memory of an elusive artist who has continually disrupted attempts by art history to pin him down—and who for many years refused to be photographed—the *ANGELS* are an affirmation of the ineffable, the ungraspable, and the extraordinary. (MA)

Born 1933, McPherson, Kansas
Lives and works in San Francisco, California

Bruce Conner graduated from the University of Nebraska in 1956 and from the University of Colorado in 1957. His work has been featured in solo exhibitions at venues such as Michael Kohn Gallery, Los Angeles (2007, 2006, 2005, 2004); Susan Inglett Gallery, New York (2007, 2004, 2003, 2000); Gallery Paule Anglim, San Francisco (2005, 2002, 2000, 1993); Gladstone Gallery, New York (2005); San Francisco Museum of Modern Art (2004); Norton Simon Museum of Art, Pasadena, California (2002); Kohn Turner Gallery, Los Angeles (2000, cat., 1999, cat., 1997, cat., 1995, 1991, 1990, cat.); Curt Marcus Gallery, New York (2000, 1998, 1995, 1992); and Walker Art Center, Minneapolis (1999–2000, cat., traveled to Modern Art Museum of Fort Worth, Texas, M. H. de Young Memorial Museum, San Francisco, and Museum of Contemporary Art, Los Angeles). Conner's recent group exhibitions include *The Third Mind*, Palais de Tokyo, Paris (2007, cat.); Berlin Biennial for Contemporary Art (2006, cat.); *The Last Picture Show: Artists Using Photography, 1960–1982*, Walker Art Center, Minneapolis (2004–2005, cat., traveled to UCLA Hammer Museum, Los Angeles, Museo de Arte Contemporánea de Vigo, Spain, Fotomuseum Winterthur, Switzerland, and Miami Art Central); *Site and Insight: An Assemblage of Artists*, P.S. 1 Contemporary Art Center, Long Island City, New York (2003); *Unknown Quantity*, Fondation Cartier pour l'Art Contemporain, Paris (2002, cat.); *The Universe: Creation, Constellations, and the Cosmos*, Norton Simon Museum of Art, Pasadena, California (2001); Whitney Biennial, Whitney Museum of American Art, New York, and *Scene of the Crime*, UCLA Hammer Museum, Los Angeles (both in 1997, cats.); *Hall of Mirrors: Art and Film since 1945*, Museum of Contemporary Art, Los Angeles (1996, cat., traveled to Wexner Center for the Arts, Ohio State University, Columbus, Palazzo delle Esposizioni, Rome, and Museum of Contemporary Art, Chicago); *Beat Culture and the New America: 1950–1965*, Whitney Museum of American Art, New York (1995–1996, cat., traveled to San Francisco Museum of Modern Art and Walker Art Center, Minneapolis).

Selected Bibliography

Aitken, Doug. "Bruce Conner." In Noel Daniel, ed., *Broken Screen: Expanding the Image, Breaking the Narrative—26 Conversations with Doug Aitken*, 86–95. New York: D.A.P./ Distributed Art Publishers, 2005.

Boswell, Peter, Bruce Jenkins, and Joan Rothfuss. *2000 BC: The Bruce Conner Story, Part II*. Exhibition catalogue. Minneapolis: Walker Art Center, 1999.

Marcus, Greil. "Bruce Conner: The Gnostic Strain." *Artforum* 31, no. 4 (December 1992): 75–79.

Schwabsky, Barry. "Documents for a Secret Tradition: Bruce Conner and His Inkblot Drawings." *Print Collector's Newsletter*, November–December 1993, 175–77.

Selwyn, Marc. "Bruce Conner/Marilyn and the Spaghetti Theory." Interview. *Flash Art*, no. 156 (January–February 1991): 94–97.

Bruce Conner *Night Angel*, 1975

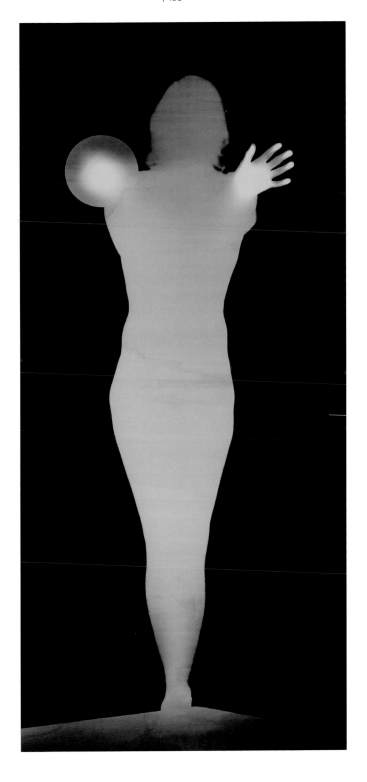

Bruce Conner *Angel*, 1975

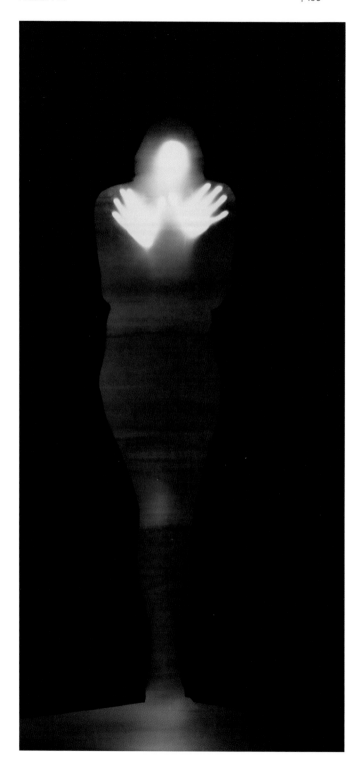

Bruce Conner *Blessing Angel*, 1975

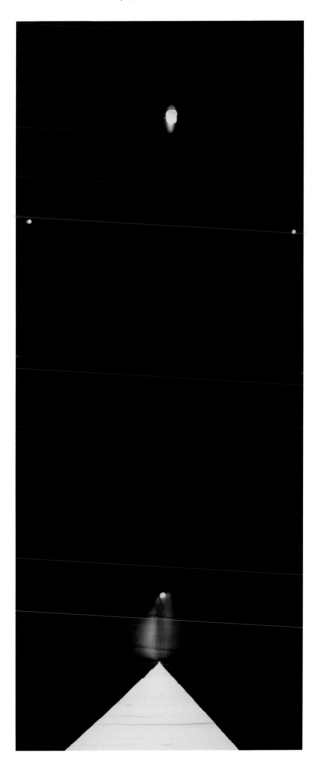

Bruce Conner *Kiss Angel*, 1975

Peter Fischli
David Weiss

Working in a wide range of media, including photography, sculpture, video, film, and installation, the collaborative artists Peter Fischli and David Weiss use ordinary objects and materials to infuse a childlike sense of wonder into the banality of everyday life. A team since 1979, they employ deceptively amateurish materials and methods—for example, making sculptures with unfired clay or eschewing high cinematic techniques in favor of more lo-fi ones—in a conscious effort to democratize and demystify the boundaries between "high" and "low" art. According to Weiss, much of the duo's work is "an attempt to idealize the common, to accept it, or just to see it."[1]

Though diverse in appearance, subject matter, and technique, their works are unified by an interrogatory philosophical underpinning, an exploratory playfulness, and a persistent, wry sense of humor. In one of their earliest collaborations, *Wurstserie (Sausage Series)* (1979), the artists photographed comical, figurative mise-en-scènes constructed from lunch meat and hot dogs, giving new meaning to the notion of "sculpture in the expanded field."[2] This humorous trajectory continued with their *Quiet Afternoon* series (1984–1985), sculptures made from household objects, precariously assembled and then photographed on the brink of collapse. The artists' consistent questioning took literal form with *Questions*, a series of grandiose and prosaic inquiries that first appeared in 1980 and culminated with *Die grosse Fragenprojektion (The Big Projection with Questions)*, their slide-show installation at the 2003 Venice Biennale in which they projected questions onto the walls of a dark room. First printed in a 2002 "black book" by the artists titled *Findet mich das Glück? (Will Happiness Find Me?)*, these queries included such thoughtful, poignant, and often gut-wrenchingly funny lines as "What good is the moon?" "Is it true that traces of aliens have been found in yogurt?" and "Do souls wander?"

1. Peter Fischli and David Weiss interviewed by Beate Söntgen, in Robert Fleck, Beate Söntgen, and Arthur C. Danto, *Peter Fischli, David Weiss* (London and New York: Phaidon, 2005), 33.
2. Rosalind Krauss, "Sculpture in the Expanded Field," *October* 8 (Spring 1979): 30–44.

The works of Fischli and Weiss often reveal beauty in the mundane, as in *Kanalvideo (Canal Video)* (1992), in which they spliced together found footage of the underground sewage system in Zürich. Filmed in real time and projected large-scale, this surveillance footage is transformed into visual spectacle, reiterating an overarching theme in their art: a desire to slow viewers down so that they might experience in a new light ordinary things that are taken for granted. As with so much of the artists' work, *Kanalvideo* never loses its sense of discovery; the slow, meandering pace of the camera continually leaves us wondering what might be around the next bend. Beneath their playful sense of discovery and use of banal, lowbrow materials, the artists pose a set of unanswerable, introspective questions that, as we consider them, are able to provoke revelations of the miraculous. (HP)

Peter Fischli, Born 1952, Zürich, Switzerland
David Weiss, Born 1946, Zürich, Switzerland
Live and work in Zürich

Peter Fischli studied at the Accademia di Belle Arti, Urbino, Italy, from 1975 to 1976 and at the Accademia di Belle Arti, Bologna, from 1976 to 1977. David Weiss studied at the Kunstgewerbeschule, Zürich, from 1963 to 1964 and at the Kunstgewerbeschule, Basel, from 1964 to 1965. Their work has been featured in solo exhibitions at venues such as Matthew Marks Gallery, New York (2007, 2006, 2003, 2002, 2001, 1999, cat.); Galerie Eva Presenhuber, Zürich (2007, 2005); Tate Modern, London, Kunsthaus Zürich, and Deichtorhallen, Hamburg (all in 2006, cats.); Musée d'Art Moderne de la Ville de Paris (2007, 1999, cats.); Museo Tamayo Arte Contemporáneo, Mexico City (2005); Sprüth, Magers & Lee, London, and Museum Boijmans Van Beuningen, Rotterdam (both in 2003); Museum Ludwig, Cologne (2002, cat.); Museu de Arte Contemporânea de Serralves, Porto, Portugal (cat.), and Monika Sprüth/Philomene Magers, Munich (both in 2001); Galeria Monika Sprüth, Cologne (1998, 1995); Kunstmuseum Wolfsburg and Institute of Contemporary Art, Boston (both in 1998, cats.); Walker Art Center, Minneapolis (cat.), Institute of Contemporary Art, University of Pennsylvania, Philadelphia (cat.), and Serpentine Gallery, London (all in 1996); Swiss Pavilion at Venice Biennale (1995, cat.); Kunsthalle Zürich (1993); and Musée National d'Art Moderne, Centre Georges Pompidou, Paris (1992, cat.). Fischli and Weiss' recent group exhibitions include the Guangzhou Triennial, China (2005, cat.); and *Universal Experience: Art, Life, and the Tourist's Eye*, Museum of Contemporary Art, Chicago (2005–2006, cat., traveled to Hayward Gallery, London, and Museo d'Arte Moderna e

Contemporanea di Trento a Rovereto, Italy); Venice Biennale (2003, 1988, cats.); Skulptur Projekte Münster (1997, 1987, cats.); *Nowhere*, Louisiana Museum for Moderne Kunst, Humlebaek, Denmark (1996, cat.); *Cloaca Maxima*, Museum der Stadtentwässerung, Zürich (1994, cat.); *Post Human*, Museé d'Art Contemporain, Pully/Lausanne (1992, cat., traveled to Castello di Rivoli Museo d'Arte Contemporanea, Turin, Deste Foundation Centre for Contemporary Art, Athens, Deichtorhallen, Hamburg, and Israel Museum, Jerusalem); Bienal de São Paulo (1989, cat.); *Carnegie International*, Pittsburgh (1988, cat.); and Documenta, Kassel (1987, cat.).

Selected Bibliography

Bishop, Clair, and Mark Godfrey. "Fischli and Weiss: Between Spectacular and Ordinary." *Flash Art*, no. 251 (November–December 2006): 74–77.

Curiger, Bice, Peter Fischli, and David Weiss, eds. *Fischli Weiss: Flowers & Questions—A Retrospective*. Exhibition catalogue. London: Tate Publishing, 2006.

"Fischli and Weiss." Special section. *Parkett*, no. 17 (1988): 1–4 and 20–87.

Fischli, Peter, and David Weiss. "Real Time Travel: Rirkrit Tiravanija Talks with Fischli and Weiss." *Artforum* 34, no. 10 (Summer 1996): 78–87.

Fleck, Robert, Beate Söntgen, and Arthur C. Danto. *Peter Fischli, David Weiss*. London and New York: Phaidon, 2005.

Heiser, Jörg. "The Odd Couple." *Frieze*, no. 102 (October 2006): 196–205.

Peter Fischli and David Weiss *An Unsettled Work*, 1987–2004
 An Unsettled Work, 1987–2004

Peter Fischli and David Weiss *An Unsettled Work*, 1987–2004
 An Unsettled Work, 1987–2004

Peter Fischli and David Weiss *Untitled*, 2005

Ryan Gander

Operating within a paradigm of contemporary conceptualist practices, Ryan Gander uses everyday experience as the substance of his frequently self-reflexive works. His process varies greatly from one project to the next as he explores a range of probing ideas and questions, relating to politics, social systems, the media, modernist histories, and the verbal and visual semiotics that make up the world around us. For the artist, this constant flux "acts like smelling salts, wakes me up, and puts me in a position where I have to start thinking from zero again."[1] The variety and fluidity of Gander's oeuvre, which has ranged from a scripted proposal for a television series to sculptural installations to a deck of two-sided playing cards, are best exemplified by his "Loose Associations" lectures—presentations of tangentially linked concepts based on subtle linguistic and visual observations culled from his lived environment. In one lecture, the artist connects the controversial African American vernacular language of Ebonics, a British teaching aid from the 1970s outlining Cockney dialect as a reflection of that region's history of social change, and the fabricated Elvish language in J. R. R. Tolkien's *Lord of the Rings*.[2] While drawing poetic, free-form, and unconventional relationships among independent facts or observations, these lectures ultimately demonstrate the artist's acute and enviable attention to the unobvious. In a sense, Gander's approach as a whole functions like a macrocosmic "Loose Association" lecture, connecting a jumble of potentially disparate ideas and elements through conceptual means. The artist has compared this process to "a box full of possibilities, some are words, some are objects, some are places or events in history, but it's not knowing why they are intrinsically interesting that's the problem, the problem is getting them in the right order."[3]

Gander persistently unravels linguistic frameworks and subverts traditional means of communicating information. For *Ghostwriter Subtext (Towards a*

1. Ryan Gander, e-mail message to the author, November 3, 2007.
2. Ryan Gander, "Loose Associations Lecture," in Ryan Gander and Stuart Bailey, *Appendix* (Amsterdam: Artimo, 2003), 102.
3. Quoted in Daniele Perra, "Ryan Gander," *Tema Celeste*, no. 110 (July 2005): 54.
4. Douglas Fogle, "Denied Parole: Douglas Fogle on the Art of Ryan Gander," *Artforum* 45, no. 6 (February 2007): 258.
5. Sigmund Bode [Brian O'Doherty], "Excerpt from Placement As Language (1928)," in *Conceptual Art: A Critical Anthology*, ed. Alexander Alberro and Blake Stimson (Cambridge, MA: MIT Press, 1999), 18.

Significantly More Plausible Interrobang) (2006), he filmed two prominent art-world figures being interviewed by a "ghostwriter"—an anonymous stand-in for the artist—about their own interviewing methods. The work's incongruity comes from the fact that the individuals are filmed only before speaking or when observing others. By directing the camera's focus on the "interstitial moments in ordinary communication,"[4] Gander creates an uncomfortable zone in which the voice and its source are dislocated. This technique recalls what early conceptualist writer and artist Brian O'Doherty (under the pseudonym of Sigmund Bode) referred to as "invisible grammar,"[5] whereby the pauses between people, objects, words, and abstractions can be read as pregnant with meaning. Like the indefinable gaps between ideas in his lectures, for Gander, these interstitial spaces provide the content whereby both the artist and the viewer embark on uncharted thought processes. They are the conceptual stepping-stones from one idea to the next, or the source from which as-yet unformed ideas can potentially emerge. (HP)

Born 1976, Chester, England
Lives and works in London, England

Ryan Gander graduated from the Manchester Metropolitan University in 1999 with a BA; he completed postgraduate study at the Jan van Eyck Akademie, Maastricht, the Netherlands, in 2000 and at the Rijksakademie van beeldende Kunsten, Amsterdam, in 2002. His work has been featured in solo exhibitions at venues such as Ikon Gallery, Birmingham, England (2008); Museum Moderner Kunst Stiftung Ludwig, Vienna, and Stedelijk Museum, Amsterdam (both in 2007); STORE Gallery, London (2006, 2005, and 2003); Annet Gelink Gallery, Amsterdam (2006, 2004); and Galleria d'Arte Moderna di Bologna (2006, cat.). Gander's recent group exhibitions include Performa 07, New York (cat.), and *Wouldn't It Be Nice...*, Centre d'Art Contemporain, Geneva (both in 2007); Biennale d'Art Contemporain de Lyon (2007, cat.); *Don Quijote*, Witte de With Center for Contemporary Art, Rotterdam, *Un Touchable (The Transparency Ideal)*, Villa Arson, Nice (cat.), and Tate Triennial, Tate Britain, London (cat.) (all in 2006); and Torino Triennale, Castello di Rivoli Museo d'Arte Contemporanea, Turin (cat.), *Beck's Futures*, Institute of Contemporary Arts, London (cat.), and *Post No Bills*, White Columns, New York (all in 2005).

Selected Bibliography

Beasley, Mark. "Ryan Gander." *Frieze*, no. 86 (October 2004): 150.
Fogle, Douglas. "Denied Parole: Douglas Fogle on the Art of Ryan Gander." *Artforum* 45, no. 6 (February 2007): 256–59.
Fox, Dan. "Co-Pilots." *Frieze*, no. 107 (May 2007): 31–34.
Gander, Ryan, and Stuart Bailey. "Loose Associaton Lectures." In *Appendix*. Amsterdam: Artimo, 2003.
Perra, Daniele. "Ryan Gander." *Tema Celeste*, no. 110 (July 2005): 52–57.

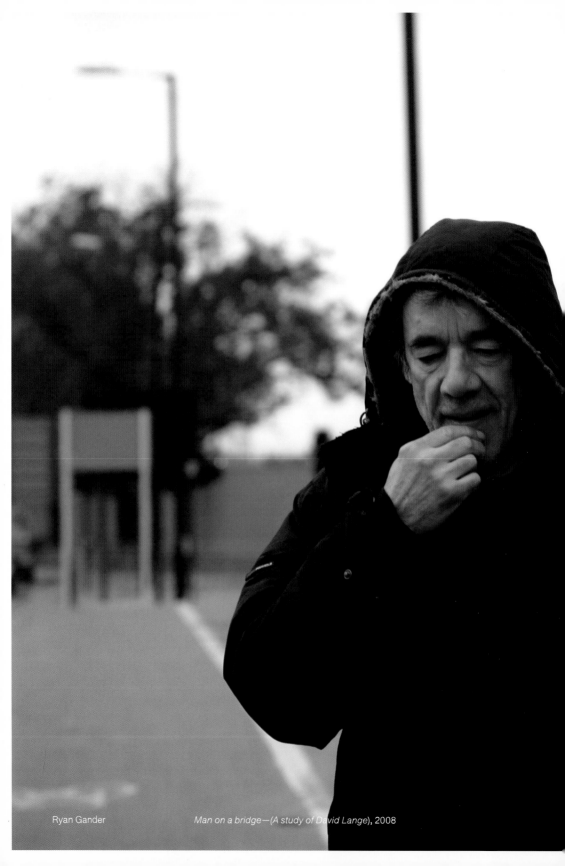

Ryan Gander *Man on a bridge—(A study of David Lange)*, 2008

Ryan Gander *He walked ahead, leading her through a blizzard of characters*, 2008

Ryan Gander *A sheet of paper on which I was about to draw, as it slipped from my table and fell to the floor* (detail), 2008

Daniel Guzmán

VIAJE AL FINAL DE MI NOCHE (Journey to the end of my night) reads a scrawled signpost on one of the pages of Daniel Guzmán's book of drawings *Lost & Found* (2006). This legend might be as good a guide as any for an encounter with the artist's practice, announcing its mood of wakeful dreaming or crashed-out, party's-over melancholy. As the phrase also hints, Guzmán's wayward work is anguished and intimate, yet also bitterly ironic.

As if regurgitating an adolescent impulse toward the grotesque, the macabre, and the obscene, the artist's collections of drawings and phrases run the psychological gamut of kitsch and disillusionment, unspeakable urges and dark frustrations. Skulls and eyeballs, commercial logos, Aztec symbols, cartoon creatures, serial killers, swastikas, centerfolds, and fireballs populate his leaves of paper. The mainstay of Guzmán's practice has typically been installations of these multiple pen and pencil drawings, but he has also produced unique sculptures, short videos, and unkempt accumulations of found objects. In 2002, the artist presented a series of works in the context of his own live-work space in Mexico City. Surrounding a lone canvas-covered object positioned at the center of a room that recalled a street vendor's stall, a series of arrangements reeked of further rootlessness, abandonment, and unknowable narratives: a tabletop heart formed from beer bottle caps, women's names spelled out in wire, plastic plants, and faux-gold chains, mirrors, and plastic stars.

Like his contemporaries Gabriel Orozco and Damián Ortega, Guzmán in his art has frequently reflected on Mexican culture's condition of colonization and the customization of mass-market, often American icons. In this respect, two unlikely ambassadors of cultural hybridization almost take on the status of existential philosophers: the glam-metal band Kiss and the superhero Spiderman, giving rise to the characteristic painted faces and webbed masks that run throughout Guzmán's work. Indeed, rock music masquerade and comic-book lore, respectively, seem to precariously anchor the artist's aesthetics of charismatic lawlessness. For *Pirate*

1. *Pirate Love* was shown at Trans>area, New York; the other exhibition venue was Lombard-Freid Projects, New York.

Love (2004), shown as part of a two-venue exhibition in New York in 2004,[1] Guzmán installed a free jukebox stocked with bootlegged CDs alongside a jumble of record-cover drawings, tequila bottles, shopping bags, and street-stall constructions, among other items—a miscellany of unlicensed pleasure and mercantile chaos.

Guzmán's series *La búsqueda del ombligo* (The search of the navel) (2005–2007) references a 1945 set of drawings titled *La verdad* (The truth), by the celebrated Mexican muralist José Clemente Orozco. The twenty-eight large-scale black-and-white diptychs that make up Guzmán's entire series fuse mythical and historical sources with contemporary provocations, extending still further his delirious and vertiginous graphic universe. Pre-Hispanic symbols such as the moon, the pyramid, and the rabbit join with caricatures of politicians, cosmic imagery, and rock music icons in a vomiting-up of hope and greed, good and evil, pleasure and violence. (MA)

Born 1964, Mexico City, Mexico
Lives and works in Mexico City

Daniel Guzmán studied at the Escuela Nacional de Artes Plásticas, Universidad Nacional Autónoma de México (UNAM), Mexico City, in 1993. His work has been featured in solo exhibitions at venues such as kurimanzutto, Mexico City (2007, 2006, 2002); The Bakery at Annet Gelink Gallery, Amsterdam, Lombard-Freid Projects, New York, and Trans>area, New York (all in 2004); Vilma Gold Gallery, London, and Herbert Read Gallery, Canterbury (2002); Museo de las Artes, Guadalajara, Mexico (2000); 3/4 Face, Lyon (1998); and Galería Arte Contemporáneo, Mexico City (1996). Guzmán's recent group exhibitions include *Double Album: Daniel Guzmán and Steven Shearer*, New Museum, New York (2008, cat.); *Playback*, Musée d'Art Moderne de la Ville de Paris, and *Escultura Social: A New Generation of Art from Mexico City*, Museum of Contemporary Art, Chicago (both in 2007, cats.); International Istanbul Biennial and Torino Triennale, Turin (both in 2005, cats.); *Faces in the Crowd/Volta Nella Folla*, Whitechapel Art Gallery, London, and Castello di Rivoli Museo d'Arte Contemporanea, Turin (2004, cat.); Venice Biennale (cat.), *Happiness: A Survival Guide for Art and Life*,

Mori Art Museum, Tokyo (cat.), and *Killing Time and Listening between Lines*, La Colección Jumex, Mexico City (all in 2003); and *How Extraordinary That the World Exists!* CCA Wattis Institute for Contemporary Arts, San Francisco, and Gwangju Biennale, South Korea (both in 2002, cats.).

Selected Bibliography

Flood, Richard, ed. *Double Album: Daniel Guzmán and Steven Shearer*. Exhibition catalogue. New York: New Museum, 2008.
Molon, Dominic. "Daniel Guzmán." In *Vitamin D: New Perspectives in Drawing*, edited by Reena Jana, 128–29. London and New York: Phaidon, 2005.
Paynter, November. "Daniel Guzmán." In *9th International Istanbul Biennial*. Exhibition catalogue, 64–65. Istanbul: ISKV, 2005.
Widholm, Julie Rodrigues. "Daniel Guzmán." In *Escultura Social: A New Generation of Art from Mexico City*. Exhibition catalogue, 138–43. Chicago: Museum of Contemporary Art, 2007.

Daniel Guzmán

El cobrador de impuestos (The tax collector), 2006, from the series
La búsqueda del ombligo (The search of the navel), 2005–2007

Daniel Guzmán *Negro* (Black), 2006, from the series *La búsqueda del ombligo* (The search of
 the navel), 2005–2007

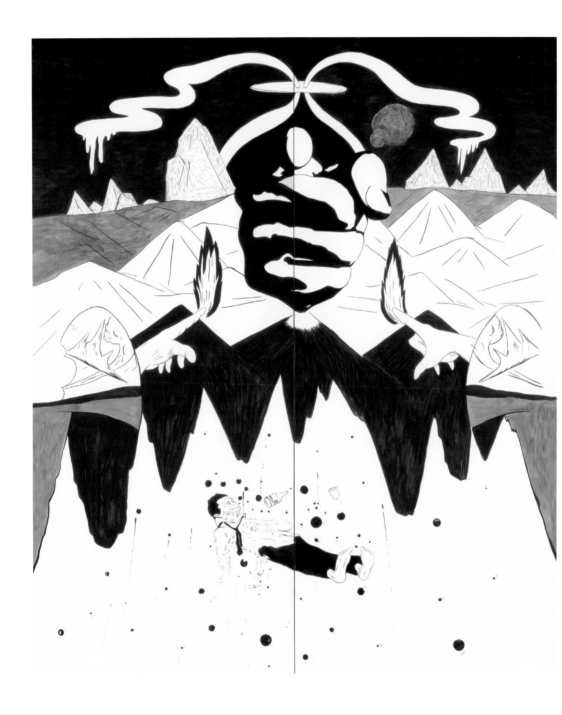

Daniel Guzmán *Fuck you too*, 2007, from the series *La búsqueda del ombligo* (The search of the navel), 2005–2007

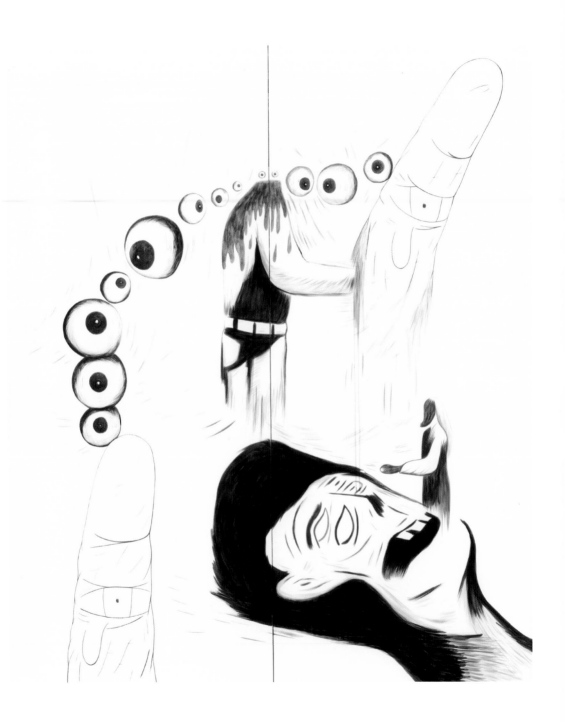

Daniel Guzmán *Decapitado* (Decapitated), 2006, from the series *La búsqueda del ombligo* (The search of the navel), 2005–2007

Thomas Hirschhorn

Thomas Hirschhorn produces impassioned, voracious, and deliberately overabundant sculptural works, public projects, and immersive environments in incredible proliferation. As he has stated, he is interested only in art with "total, 100% energy."[1] His frequently confrontational work is dedicated to resistance and the voicing of his discontent with the politics and public discourse of today, while at the same time trusting in the transformative potential of art and philosophy. Neglecting the material qualities of "fine art," he instead uses the impoverished dross of consumerism (such as cardboard, plywood, and polystyrene) and frequently festoons his tableaux with images of advertisements, pornography, and global news journalism, as well as copious photocopied texts from radical writers such as Georges Bataille and Antonio Negri. "I am against work of quality," Hirschhorn has declared. "Energy, yes! Quality, no!"[2]

A recent "display" (a term the artist prefers to "installation") titled *Concretion Re* (2007) featured Hirschhorn's characteristic strategy of utilizing containers that are part kiosk, part vitrine, and part shrine, suggesting both vernacular shop fronts and modernist exhibition pavilions. They were filled with a harrowing inventory of images from print and the Internet: diseased, disfigured, or dismembered body parts; abstract geological formations such as stalactites; and a presentation seemingly culled from a municipal library concerning the artist Francisco de Goya, best known for his brutally frank etchings *The Disasters of War* (1810–1820). Surrounded by tumorlike wall accretions and nail-gunned mannequin heads, these drastic images deal, for Hirschhorn, in a condition of such intensity and turmoil that they offer a chance to *not* understand—their value lies precisely in resisting explanation and euphemism and "touching what is non-positive."[3]

1. "I want to be judged on what I do and that's only possible with works done with total, 100% energy." Thomas Hirschhorn, letter to Laurence and Hans Ulrich Obrist, 2000, reprinted in Benjamin H. D. Buchloh, Alison M. Gingeras, and Carlos Basualdo, *Thomas Hirschhorn* (London and New York: Phaidon, 2004), 136.
2. Okwui Enwezor, James Rondeau, and Hamza Walker, *Jumbo Spoons and Big Cake*, exhibition catalogue (Chicago: Art Institute of Chicago and Renaissance Society of the University of Chicago, 2000), 32.
3. Quoted in a press release for *Substitution 2*, a solo exhibition at Stephen Friedman Gallery, London, spring 2007.

This unforgiving work follows a whole series of recent "archaeologies" that have, on the one hand, excavated and examined the brutality and consumerism of our time and, on the other, championed artists of the past whose work is for Hirschhorn still acutely relevant to the politics of the present. The former tendency, to give just two examples, can be seen in *Cavemanman* (2002), a sprawling, shambolic network of cardboard caves, and *Superficial Engagement* (2006), a spectacular information-crammed labyrinth of slogans and tableaux concerning Iraq-war militarism and martyrdom, sadomasochism, and materialistic greed. The latter impulse perhaps found its fullest expression to date in *Musée Précaire* (2004). For this project, he built a temporary museum that was run by local residents in a Paris suburb. Having secured the collaboration of the city's Centre Georges Pompidou, the community venue hosted a series of eight exhibitions with important works by Hirschhorn's artistic heroes: Marcel Duchamp, Piet Mondrian, Kazimir Malevich, Andy Warhol, Salvador Dalí, Le Corbusier, Joseph Beuys, and Fernand Léger. (MA)

Born 1957, Bern, Switzerland
Lives and works in Paris, France

Thomas Hirschhorn graduated from the Schule für Gestaltung in Zürich in 1983. His work has been featured in solo exhibitions at venues such as Arndt & Partner, Berlin (2007, 2002); Stephen Friedman Gallery, London (2007, 2004, 2001); Galerie Chantal Crousel, Paris (2007, 2003); Alexanderplatz Station, Berlin (2006); Gladstone Gallery, New York (2006, 2002); Pinakothek der Moderne, Munich, and Institute of Contemporary Art, Boston (traveled to CCA Wattis Institute for Contemporary Arts, San Francisco) (all in 2005); Palais de Tokyo, Paris (2004); Musée National d'Art Moderne, Centre Georges Pompidou, Paris, and Kunsthaus Zürich (both in 2001); Art Institute of Chicago and Renaissance Society, University of Chicago (both in 2000, cats.); and Museum Ludwig, Cologne (1998). Hirschhorn's recent group exhibitions include *Airs de Paris*, Musée National d'Art Moderne, Centre Georges Pompidou, Paris (2007, cat.); Bienal de São Paulo, International Biennial of Contemporary Art of Seville, Spain, and *Heart of Darkness*, Walker Art Center, Minneapolis (all in 2006, cats.); *Universal Experience: Art, Life, and the Tourist's Eye*, Museum of Contemporary Art, Chicago (2005–2006, cat., traveled to Hayward Gallery, London, and Museo d'Arte Moderna e Contemporanea di Trento a Rovereto, Italy); *Monuments for the USA*, CCA Wattis Institute for Contemporary Arts, San Francisco (2005, cat.); *Common Wealth*, Tate Modern, London (2003, cat.); Documenta, Kassel (2002, cat.); *Unfinished History*, Walker Art Center, Minneapolis (1998–1999, cat., traveled to Museum of Contemporary Art, Chicago); and Skulptur Projekte Münster (1997, cat.).

Selected Bibliography

Buchloch, Benjamin H. D. "Cargo and Cult: The Displays of Thomas Hirschhorn." *Artforum* 40, no. 3 (November 2001): 109–15.
Curiger, Bice. *Short Guide into the Work of Thomas Hirschhorn*. New York: Gladstone Gallery, 2002.
Enwezor, Okwui, James Rondeau, and Hamza Walker. *Jumbo Spoons and Big Cake*. Exhibition catalogue. Chicago: Art Institute of Chicago and Renaissance Society of the University of Chicago, 2000.
"Thomas Hirschhorn." Special section. *Parkett*, no. 57 (1999): 112–48.
Wilson, Michael. "Caves of New York." *Artforum* 41, no. 6 (February 2003): 110–15.

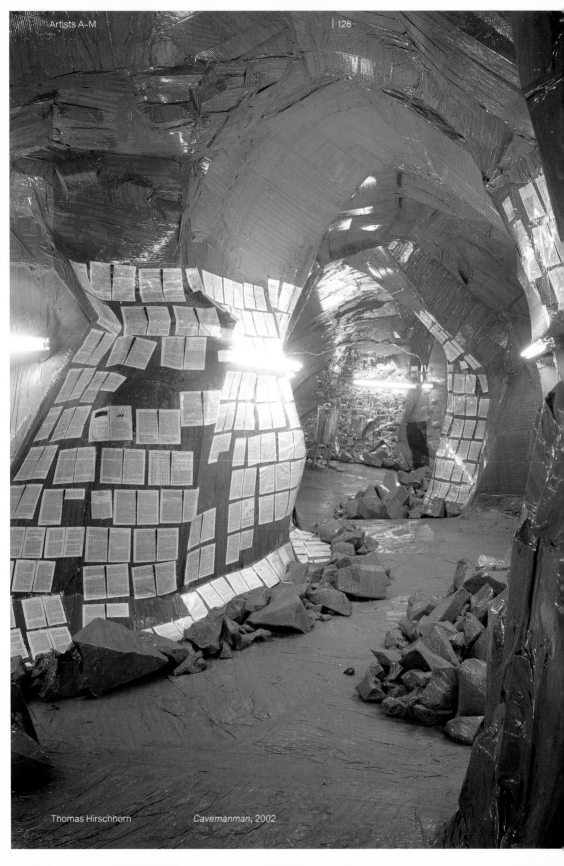

Thomas Hirschhorn *Cavemanman*, 2002

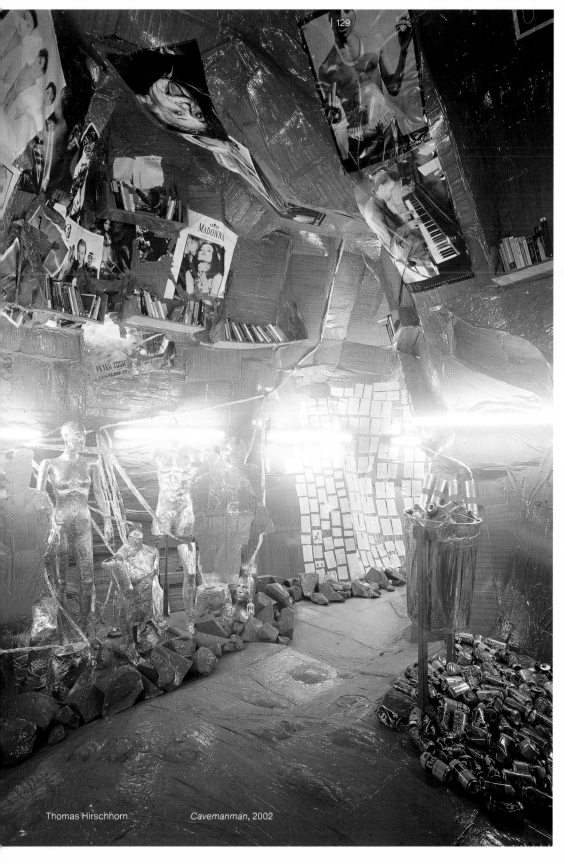

Thomas Hirschhorn *Cavemanman*, 2002

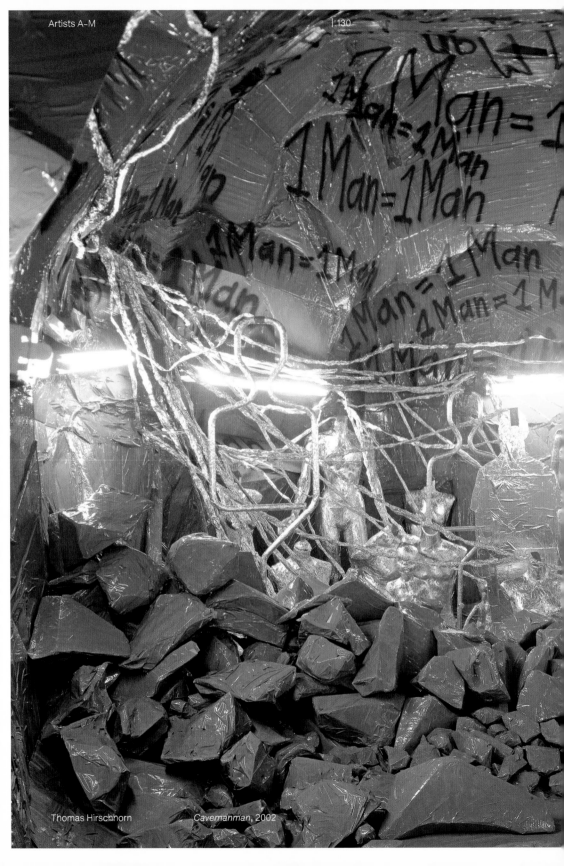

Thomas Hirschhorn *Cavemanman*, 2002

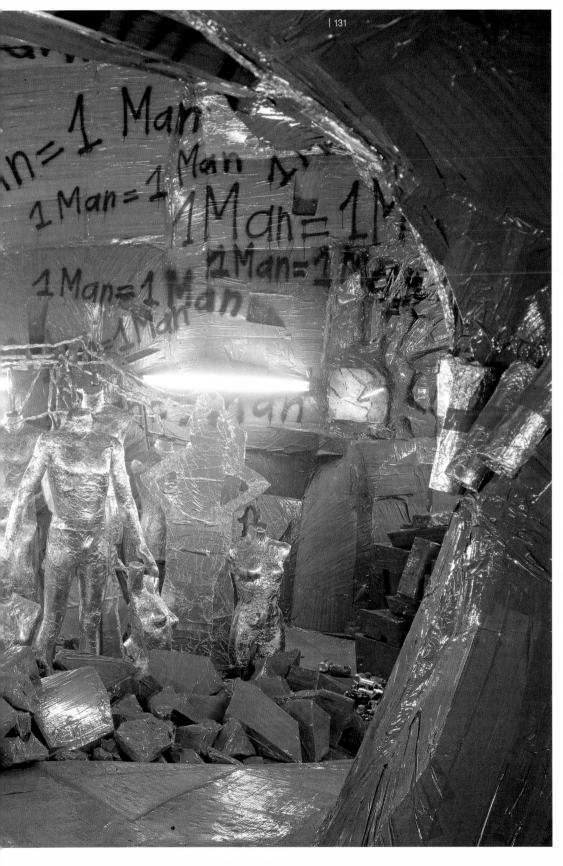

Richard Hughes

Civic pride appears to have gone awry in Richard Hughes' art, and once-fresh cultural forces have withered. His meticulously constructed sculptures are often cast or carved from resin to closely replicate items that might be found in a hovel of a bedsit or unceremoniously dumped by the side of the road. Objects such as a stained mattress (*The Big Sleep*, 2007) or a decrepit sofa (*After the Summer of Like*, 2005), for example, detail a squalor that disputes the typically pristine art gallery interiors in which they are exhibited. The clusters of cast psilocybin "magic" mushrooms that this forlorn furniture hosts might suggest that a lurid mental trip is the only deliverance available to their would-be owners. These trompe l'oeil sculptures can also act like bleak monuments to abused aspects of public space: in *Phantom Bouquet (Lights Out)* (2006), a vandalized lamppost becomes a pathetic vase, while the moldering planters of *Dead Headz* (2007) seem to have been neglected long ago, their blooms left to shrivel.

In addition to these sordid simulacra, Hughes creates arrangements of actual items, typically soft materials such as bags of garbage or soiled sleeping bags. Recalling the "trick" paintings of 16th-century artist Giuseppe Arcimboldo—in which fruit and vegetables might form the likeness of a face—Hughes' double-take installations appear to transform into recognizable images only when seen from a certain angle. For example, in *Crash My Party You Bastards* (2004), what at first seems to be a smashed-up living room gives rise to the face of a disheveled-looking woman, as a broken lamp resolves into eyes and brows, and a wrecked guitar takes the form of her nostrils. Apparently stuffed into a burnt-out trash can without a second thought, the dirty duvet of *Pffist* (2003)—like a face seen in the clouds—meanwhile forms a clenched fist.

The British West Midlands of Hughes' youth in the 1980s were a sprawl of urban neglect, blighted by ill-conceived and decaying postwar housing and sickened by the loss of traditional industries. A consideration of the

1. Often considered the archetypal Kitchen Sink drama, the film *Saturday Night and Sunday Morning* (1960) starred Albert Finney and was based on the 1958 novel of the same name by Alan Sillitoe.

legacy of degeneration and disaffection left by the failure of a once-bright vision of social modernity—and its manifestations through a wry, dispossessed poetics of municipal and domestic space—permeates the artist's work like a bad smell. Though the exploration of such themes harks back to the ripe tradition in UK cinema and theater of the so-called Kitchen Sink movement of the 1950s and 1960s, social commentary in Hughes' practice transcends national identities. The aforementioned magic mushrooms—whose sculpted forms also sprout from a crafted pile of fish-and-chip-shop chips (*Suburban Cowpat*, 2005)—constitute a veiled reference to the faded idealism of a generalized psychedelic moment. In *Studio 5 to 4* (2003), what looks like a mirror ball is actually made up of tiny photographic facets of the space in which it is exhibited, a stillborn, sparkleless club accessory whose title suggests it is a sorry surrogate for the similarly bankrupt disco fervor of the 1970s, as typified by the legendarily hedonistic nightclub Studio 54; here, it is less *Saturday Night Fever* and more *Saturday Night and Sunday Morning*.[1] (MA)

Born 1974, Birmingham, England
Lives and works in London, England

Richard Hughes graduated from Staffordshire University in 1995 with a BA and from Goldsmiths College, London, in 2003 with an MFA. His work has been featured in solo exhibitions at venues such as Michael Benevento, Los Angeles (2008); Anton Kern Gallery, New York (2007); Tate Britain, London (2006); Nils Staerk Contemporary Art, Copenhagen, and Modern Institute, Glasgow (both in 2005); The Showroom, London (2004, cat.); RomaRomaRoma, Rome (2003); and Turnpike Gallery, Manchester (1998). Hughes' recent group exhibitions include *Re-dis-play: Non-Art Collections from Artists and Curators*, Heidelberger Kunstverein (2007, cat.); *Strange, I've Seen That Face Before*, Städtisches Museum Abteiberg, Mönchengladbach, and *Beck's Futures*, Institute of Contemporary Arts, London (both in 2006, cats.); *British Art Show 6*, BALTIC Centre for Contemporary Art, Gateshead, England (2005–2006, cat., traveled to various venues in Manchester, Nottingham, and Bristol); Torino Triennale, Turin (cat.), and *Post Notes*, Institute of Contemporary Arts, London (traveled to Midway Contemporary Art, Minneapolis) (both in 2005); and *Granite*, Whitechapel Project Space, London (2004).

Selected Bibliography

Barrett, David. "Richard Hughes." *Art Monthly*, no. 281 (November 2004): 18–19.
Boase, Gair. "Richard Hughes." In Lizzie Carey-Thomas, Katharine Stout, and Rachel Tant, eds., *Keep on Onnin': Contemporary Art at Tate Britain*, 114–19. London: Tate Publishing, 2007.
Farquharson, Alex. "The Decay of Modernity, Melancholy Objects, and Shared Cultural Moments." *Frieze*, no. 95 (November–December 2005): 118.
Gingeras, Alison M. "First Takes." *Artforum* 43, no. 5 (January 2005): 157.
Ogg, Kristy. *The Shelf-life of Milk*. Exhibition catalogue. London: The Showroom, 2004.

Richard Hughes *Tomorrow Came*, 2007

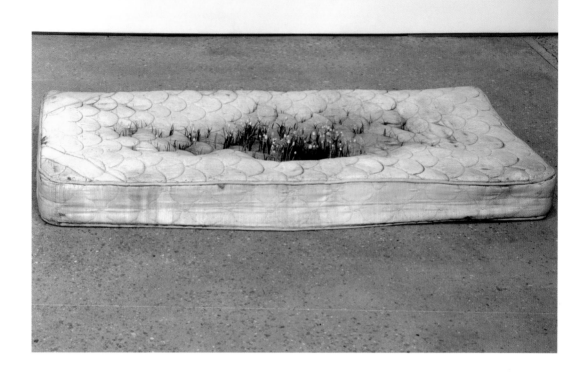

Richard Hughes *The Big Sleep*, 2007

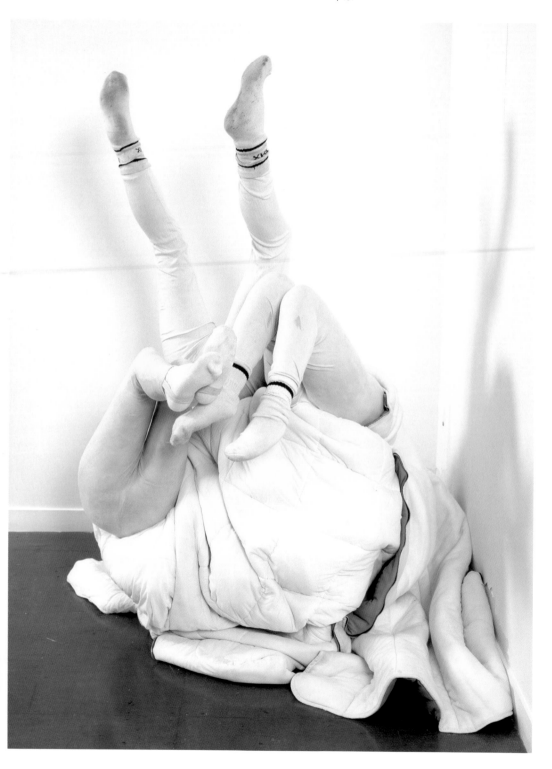

Richard Hughes *Love Seat*, 2005

Mike Kelley

In a career that spans three decades, Mike Kelley has produced work in nearly every imaginable medium. Generalizations can be made as to recurring themes in his work—such as repressed and recovered memory, notions of the sublime, abject and debased substances and activities, and ritualistic behaviors—as well as to his consistent embrace of provocation and perversion as the antitheses of primness, naïveté, and certainty. Yet, by "recycling motifs toward radically different purposes,"[1] as the artist describes it, Kelley overturns any single interpretation of either his work or his subject matter, intentionally producing a complex artistic topography that mirrors his creative motivation.

From the late 1970s into the 1980s, much of Kelley's work consisted of live performances that spectators perceived as "a high-energy 'succession of repressions and explosions.'"[2] Seminal events such as *Monkey's Island* (1982–1983), *The Sublime* (1983–1984), and *Plato's Cave, Rothko's Chapel, Lincoln's Profile* (1986) married text with image in a hybrid cacophony of activity referring to diverse philosophical and sociological sources. These works, along with his drawings and "craft" sculptures of the time, consistently employed the scatological to both inquisitive and darkly humorous ends.[3] By the mid-1990s, Kelley had begun an ongoing analysis of institutionalized education systems, based on his interest in "repressed memory syndrome," a psychological term used most commonly—and controversially—in connection with the recovery of repressed memories of childhood sexual abuse. A sculptural element from this project titled *Educational Complex* (1995), an architectural model from memory of the artist's past schools, formed the starting point for *Day Is Done* (2005), a massive installation consisting of video projections, photographs, drawings, sculptures, stage props, and sound. Here, the artist presented stylized re-creations of oddball, morbid, or ritualistic scenes, such as Halloween events, religious ceremonies, and costumed dance performances, that appeared in photographs in his collection of hundreds of high-school yearbooks.

1. Mike Kelley, e-mail message to the author, December 17, 2007.
2. John C. Welchman, "The Mike Kelleys," in John C. Welchman, Isabelle Graw, and Anthony Vidler, *Mike Kelley* (London and New York: Phaidon, 1999), 57.
3. For further discussion, see Elisabeth Sussman, ed., *Mike Kelley: Catholic Tastes*, exhibition catalogue (New York: Whitney Museum of American Art, 1993), 21.
4. This installation is related to an earlier one by Kelley, *Kandor-Con 2000*, originally presented as part of the exhibition *Zeitwenden* at the Kunstmuseum Bonn in 2000.

Kandors (2007) is the artist's most polished and fantastical realization of these ideas.[4] Stemming from Kelley's observation of a persistent lack of continuity in the depiction of Kandor in *Superman* comics, this installation reenvisions that fictive capital city through miniaturized Atlantis-like cityscapes. Covered by glass domes, these sculptural landscapes are bathed in the glow of luminescent lights and connected to other minimalist-inspired objects and architectural elements via respiratory tubing. Each of ten assemblages corresponds to a slightly ominous, tornado-like video projection on the wall. Sound (synthesized ambient and new-age music composed by the artist as well as "emotive" sounds), light, and motion envelop viewers of this spectacle. Here Kelley narrates a surrealistic topography through an all-encompassing sensory experience, suggesting through his numerous imaginative reinterpretations of a single motif the infinite variations of personal history. In this way, he is faithful to both the virtues and the shortcomings of memory. (HP)

Born 1954, Detroit, Michigan
Lives and works in Los Angeles, California

Mike Kelley graduated from the University of Michigan, Ann Arbor, in 1976 with a BFA and from the California Institute of the Arts, Valencia, in 1978 with an MFA. His work has been featured in solo exhibitions at venues such as Gagosian Gallery, London (cat.), and Wiels, Brussels (both in 2007); Jablonka Galerie, Berlin and Cologne (2007, 2001, cat., 1998, 1995, cat., 1991, 1989, cat.); Gagosian Gallery, New York (2006, cat.); Tate Liverpool and Museum Moderner Kunst Stiftung Ludwig, Vienna (both in 2004, cats.); Galleria Emi Fontana, Milan (2003, 2000); Patrick Painter Inc., Santa Monica, California (2002, 1999); Metro Pictures, New York (2002, 1999, 1995, 1990, 1988); Museu d'Art Contemporani de Barcelona, Rooseum Center for Contemporary Art, Malmö, Sweden, and Van Abbemuseum, Eindhoven (all in 1997, cats.); Whitney Museum of American Art, New York (1993, cat.); and Kunsthalle Basel, Institute of Contemporary Arts, London, and CAPC Musée d'Art Contemporain, Bordeaux (all in 1992, cats.). Kelley's recent group exhibitions include Skulptur Projekte Münster (2007, cat.); *Los Angeles, 1955–1985: The Birth of an Art Capital*, Musée National d'Art Moderne, Centre Georges Pompidou, Paris (2006, cat.); Whitney Biennial, Whitney Museum of American Art, New York (2002, 1995, 1993, 1991, 1989, 1987, 1985, cats.); Biennale d'Art Contemporain de Lyon, France (2001, cat.); *Out of Actions: Between Performance and the Object, 1949–1979,*

Museum of Contemporary Art, Los Angeles (1998, cat., traveled to MAK Galerie, Österreichisches Museum für Angewandte Kunst, Vienna, Museu d'Art Contemporani de Barcelona, Museum of Contemporary Art, Tokyo, and National Museum of Art, Osaka); Documenta, Kassel (1997, 1992, cats.); *Helter Skelter: L.A. Art in the 1990s*, Museum of Contemporary Art, Los Angeles (1992, cat.); Carnegie International (1991, cat.); *A Forest of Signs: Art in the Crisis of Representation*, Museum of Contemporary Art, Los Angeles (1989, cat.); and Venice Biennale (1988, cat.).

Selected Bibliography

"Mike Kelley." Special section. *Parkett*, no. 31 (1992): 64–99.
Sussman, Elisabeth, ed. *Mike Kelley: Catholic Tastes*. Exhibition catalogue. New York: Whitney Museum of American Art, 1993.
Welchman, John C. *Mike Kelley: Interviews, Conversations, and Chit-Chat (1986–2004)*. Zürich: JRP Ringier, 2005.
Welchman, John C., Isabelle Graw, and Anthony Vidler. *Mike Kelley*. London and New York: Phaidon, 1999.
Welchman, John C., and Mike Kelley. *Day Is Done*. Exhibition catalogue. New York: Gagosian Gallery; New Haven, CT: Yale University Press, 2007.

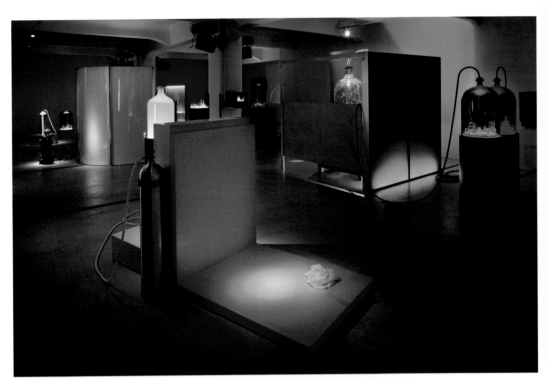

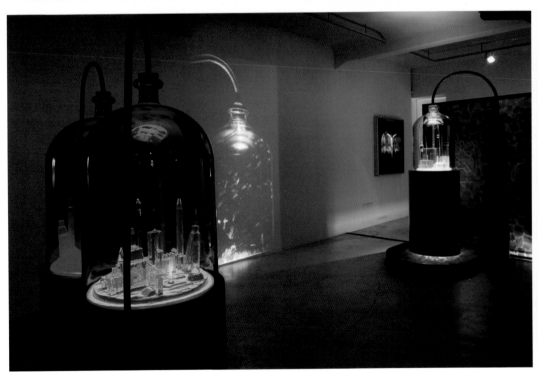

Mike Kelley

Kandors, 2007
Kandors, 2007

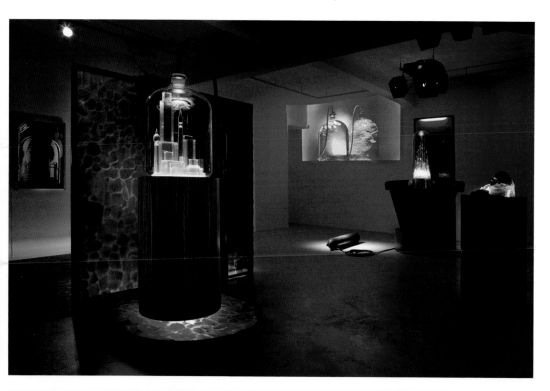

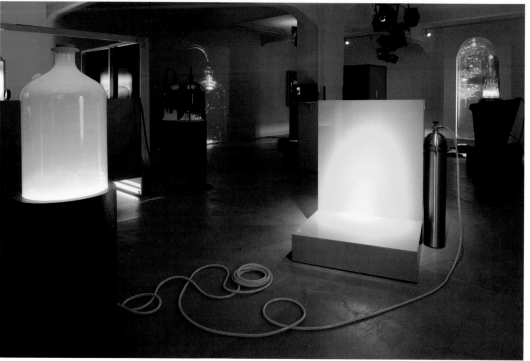

Mike Kelley *Kandors*, 2007
 Kandors, 2007

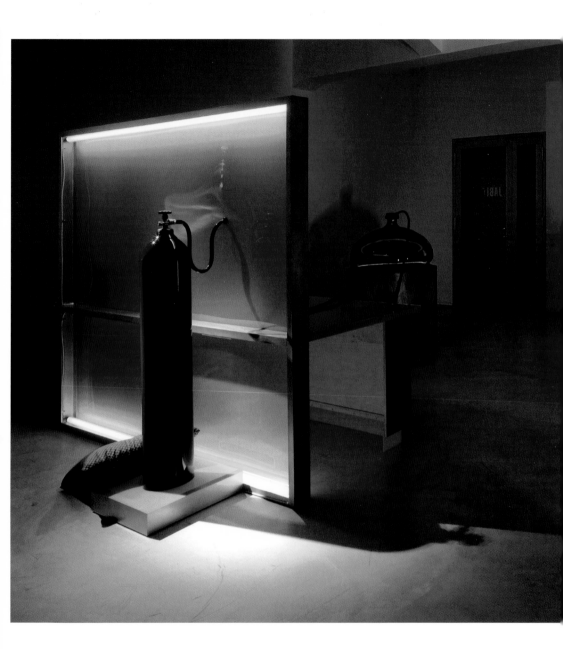

Mike Kelley *Kandors*, 2007

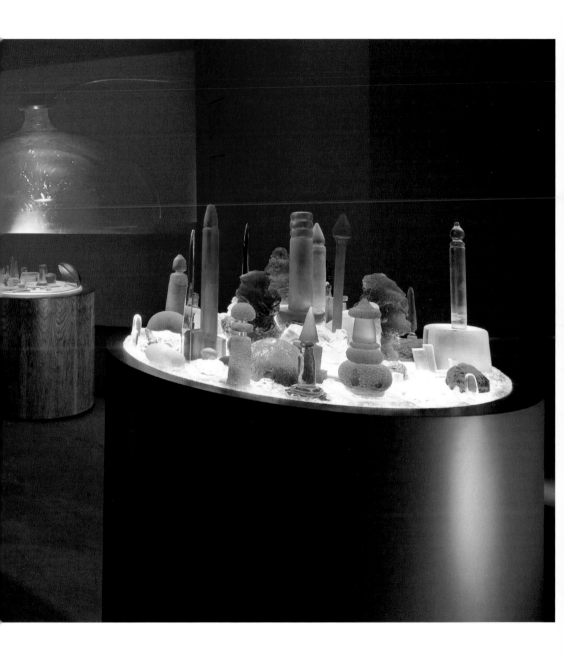

Friedrich Kunath

The centerpiece of a recent Friedrich Kunath exhibition in Los Angeles comprised a taxidermic bird—a crane—wearing men's shoes. It was posed as if it were walking across the gallery floor and looking back mournfully at the cartoonlike trail of shoe prints snaking behind it. Titled *I have always been here before*, Kunath's show was infused throughout with the sense of charmed awkwardness and tragicomedy that this bird's pathetic predicament invoked. High on a wall was a possible destination of the striding crane: a diminutive house with a Lilliputian ladder. Meanwhile, a painting nearby depicted a graphic of a giant straining in his efforts to push a suburban-style house out of view. Though this painting was not titled, the tone of Kunath's titles, when they do exist, and the phrases that often are spelled out in the work play a prominent role in a practice that has encompassed drawing and painting, video and photography, sculpture and books. For example, a 2002 film—part of a number of short videos that feature the artist repeatedly flummoxing passers-by by tripping over or falling out of trees—is titled *When Was the First Time You Realized the Next Time Would Be the Last Time?* In another work, the artist uses his arms and legs to spell out the letters of a similarly sorrow-ridden title, *Four Seasons of Loneliness* (2003), within a series of modestly scaled shots of landscapes. A further example: one of Kunath's paintings is made up of colored boxes, the type of geometry one might idly doodle when utterly bored. "I Waited for You but I Never Told You Where I Was" read the letters placed in each block, a lyric from a tear-jerking blues number, perhaps?

Flouting the bluntness of the slapstick of his earlier videos, Kunath's melancholy-prone work nevertheless possesses the gentlest of self-deprecating humor. What accumulates through its repeated sentiments of apparent failure and futility is, in part, a playful projection of an artist-persona that is a world-weary solipsist, a hopeless hero, and a lost soul. In this respect, Kunath demonstrates a clear fondness for the legacy of Bas Jan Ader, the Dutch conceptual artist with a similar propensity for falling over, bittersweet tragicomedy, and heartbreak. We could imagine

Ader's almost mythical fate (Ader and his boat were lost at sea in 1975 while on a voyage conceived as an artwork) as the undercurrent of two of Kunath's seemingly aleatory sculptures. The first (*Untitled*, 2003) creates the impression that a large, old-fashioned anchor is stuck fast in the gallery floor. The second (*Untitled*, 2005) consists of a clear acrylic box set on a Persian floor rug. Crammed inside the box is a canvas sailcloth, a small section of which bears the handwritten note, "I saved my breath for the sails." (MA)

Born 1974, Chemnitz, Germany
Lives and works in Cologne, Germany

Friedrich Kunath was awarded the Peter Mertes Stipend at the Bonner Kunstverein, Bonn, in 2001 (cat.) and the Jürgen Ponto-Stiftung Work Stipend in 2005. His work has been featured in solo exhibitions at venues such as BQ, Cologne (2007, 2004, cat., 2002, cat., 1998, cat.); Andrea Rosen Gallery, New York (2007, 2005); Blum & Poe, Los Angeles (2006, 2004); and Annet Gelink Gallery, Amsterdam (2003). Kunath's recent group exhibitions include *Panic Room: Works from the Dakis Joannou Collection*, Deste Foundation Centre for Contemporary Art, Athens, and *Learn to Read*, Tate Modern, London (both in 2007); *Fabriques du Sublime*, La Galerie, Centre d'Art Contemporain, Noisy-le-Sec, France, and *The Gravity in Art*, De Appel, Amsterdam (both in 2005); *Rhinegold: Art from Cologne*, Tate Liverpool, *Strawberry Fields*, La Colección Jumex and CANAIA, Mexico City (cat.), and *No One Else Can Make Me Feel the Colors That You Bring*, Temple Bar Gallery, Dublin (all in 2004); *Super-* *schloss*, Städtische Galerie, Wolfsburg (2002, cat.); and *Zero Gravity*, Kunstverein für die Rheinlande und Westfalen, Düsseldorf (2001, cat.).

Selected Bibliography

Blancsubé, Michel, Frédéric Bonnet, and Frank Leibovici. *Esquiador en el fondo de un pozo*, 124. Exhibition catalogue. Mexico City: La Colección Jumex, 2007.
Fox, Dan. "A Song in My Heart." *Frieze*, no. 79 (November–December 2003): 60–63.
Knight, Christopher. "Kunath Does Odd Work, But Well." *Los Angeles Times*, April 16, 2004.
Krassoievitch, Ivån. "Friedrich Kunath." In *Strawberry Fields*, 5–6. Exhibition catalogue. Mexico City: La Colección Jumex and CANAIA, 2004.
Uhr, Harald. *Peter Mertes Stipendium 2001: Thea Djordjadze/Friedrich Kunath*. Exhibition catalogue. Bonn: Bonner Kunstverein, 2001.

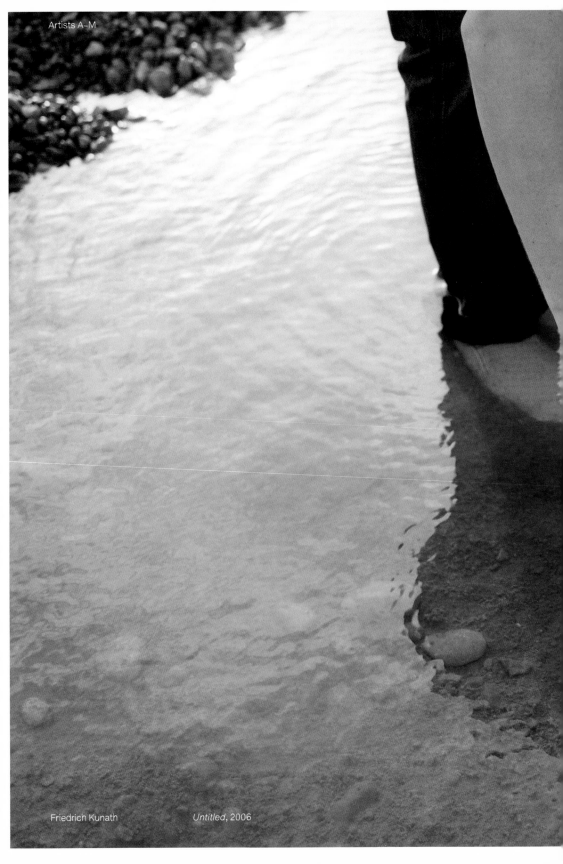

Friedrich Kunath *Untitled*, 2006

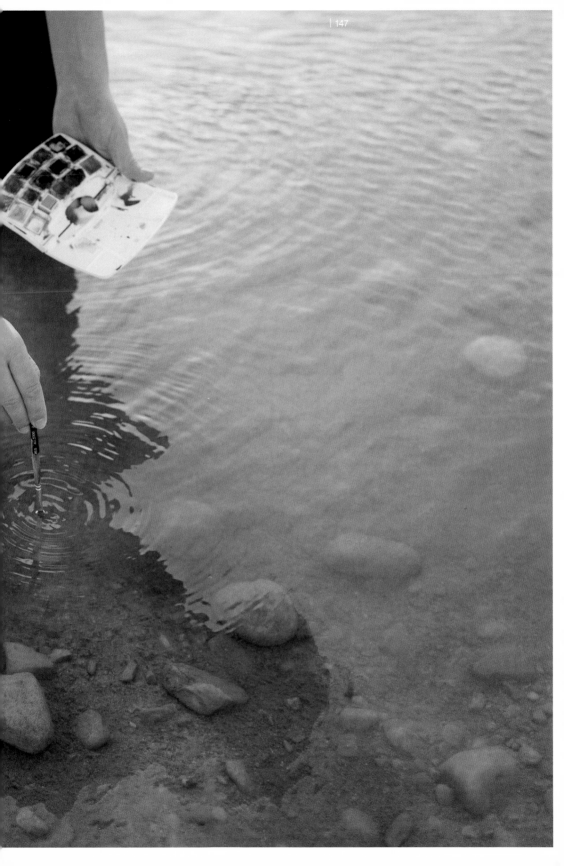

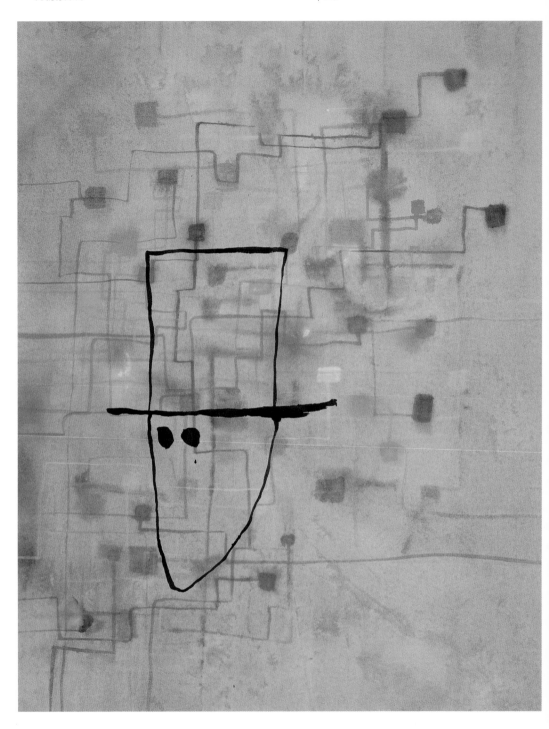

Friedrich Kunath *Untitled*, 2006

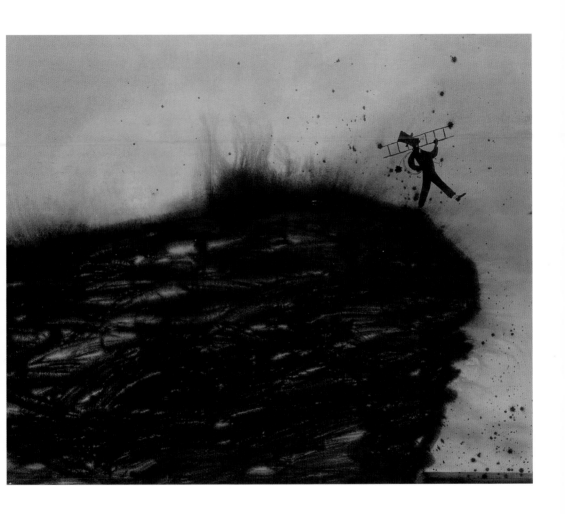

Friedrich Kunath *Untitled*, 2006

Maria Lassnig

Maria Lassnig has been exhibiting paintings and drawings since the late 1940s. She continues to build on an uncompromising body of work—"body" being a particularly relevant term—that, despite her having lived in New York from 1968 until she returned to her native Austria a decade later, has only recently been duly recognized outside of the German-speaking world. Lassnig considers all her paintings to be self-portraits, even those that appear not to depict her, or any human figures for that matter, and each derives from a process she terms "body awareness." If these works exceed the conventional sense of self-portraiture, then a more apt description of their analysis of corporeal presence might be that of merciless self-exposure.

Lassnig has no use for external, retinal, or anatomical views of her body, least of all photographic representations. "I want to be as independent as possible of machines and complicated tools," she has insisted. "Pencil and brush are primeval tools. Painting is a primeval art."[1] Instead, she bases her work on the often distressing internal sensations of inhabiting her own body, both physiologically and psychologically. Lassnig's human forms are often defective and supported by means of crutches. Their parts are frequently dysmorphic, tortured, or ungainly: "My view is not holistic," she has explained. "If I don't feel my feet, then I don't paint them."[2] For Lassnig, painting is a means to confront perceptions that are uncomfortable and embarrassing.

Du oder Ich (*You or Me*) (2005) shows the artist naked—and, as is typical of her recent work, isolated against a bare background—as she points one handgun to her temple and another out at the viewer. Such "drastic" paintings, as she has termed them, often place both the artist and those that behold her work in predicaments of unremitting intensity.[3] Lassnig's use of color also appears to inflict states of immediate anguish, stress, or

1. Quoted in Jurrie Poot, "The Inside Out," in Maria Lassnig, Rudolf Herman Fuchs, and Jurrie Poot, *Das Innere nach Aussen, Maria Lassnig: Bilder, Schilderijen, Paintings*, exhibition catalogue (Amsterdam: Stedelijk Museum, 1994), 39.
2. Quoted in Jörg Heiser, "Inside Out," *Frieze*, no. 103 (November–December 2006): 124.
3. Ibid., 120.
4. Quoted in Poot, "The Inside Out," 40.
5. See Donald Kuspit, "The Hospital of the Body," *Arts Magazine*, Summer 1990, 69–73.

exhaustion: "There are colors of pain and grief, nerve string colors, pressure and fullness colors ... crush and burn colors, death and decay colors, fear of cancer colors—these are the colors of reality."[4]

Art historian Donald Kuspit and others have suggested that Lassnig's harshly introspective practice might be understood as a response to the artist's childhood experiences attending a strict Ursuline convent school.[5] For Kuspit, Lassnig's immersion in an environment in which physical contact, sexuality, and bodily sensations were suppressed led her to use the act of painting as a surrogate way of confirming and enlivening the body through touch. At the very least, an oil on canvas such as *Kampfgeist I (Fighting Spirit I)* (2000) shows that her Catholic schooling has disgorged into paint in a direct way: a soccer player who is leaping to head a putty-like ball sports not only striped team socks but also a blue nun's habit with veil. Brutal football games are the subject of several of the artist's recent works, in which goalkeepers flailing in front of the net and players forcing each other off the ball or lurching with studded boots seem like episodes from a lawless match where winning carries an urgent moral imperative and losing has potentially mortal results. (MA)

Born 1919, Carinthia, Austria
Lives and works in Vienna, Austria

Maria Lassnig studied at the Universität für angewandte Kunst in Vienna from 1941 to 1944. Her work has been featured in solo exhibitions at venues such as Hauser & Wirth, Zürich (2007, 2004, cat., 2002); Friedrich Petzel Gallery, New York (2005, cat., 2002); culture2culture, Vienna (2005); Kunsthaus Zürich (2003, cat.); Museum Moderner Kunst Stiftung Ludwig, Vienna (1999, cat.); Kunsthalle Bern (1997, cat.); Musée National d'Art Moderne, Centre Georges Pompidou, Paris, and Städtisches Museum Schloss Morsbroich, Leverkusen, Germany (both in 1995, cats.); and Stedelijk Museum, Amsterdam (1994, cat.). Lassnig's recent group exhibitions include *Wack! Art and the Feminist Revolution*, Museum of Contemporary Art, Los Angeles (2007, cat.); *Into Me/Out of Me*, Kunst-Werke Institute for Contemporary Art, Berlin, and P.S. 1 Contemporary Art Center, Long Island City, New York (2006, cat.); *Eindhoven/Istanbul*, Van Abbemuseum, Eindhoven (2005); SITE Santa Fe International Biennial, Santa Fe, New Mexico (2004, cat.); Venice Biennale (2003, 1980, cats.); *EXPRESSIVE!* Fondation Beyeler, Riehen/Basel (2003, cat.); Documenta, Kassel (1997, 1982, cats.); and *Feminine-Masculine: The Sex of Art*, Musée National d'Art Moderne, Centre Georges Pompidou, Paris (1995, cat.).

Selected Bibliography

Cattelan, Maurizio, Massimiliano Gioni, and Ali Subtonik. "Maria Lassnig." In *Ice Cream: Contemporary Art in Culture*, 212–15. London and New York: Phaidon, 2007.
Drechsler, Wolfgang. *Maria Lassnig*. Exhibition catalogue. Vienna: Museum Moderner Kunst Stiftung Ludwig, 1999.
Heiser, Jörg. "Inside Out." *Frieze*, no. 103 (November–December 2006): 118–25.
Jones, Ronald. "Maria Lassnig." *Frieze*, no. 73 (March 2003): 98–99.
Kuspit, Donald. "The Hospital of the Body." *Arts Magazine*, Summer 1990, 69–73.

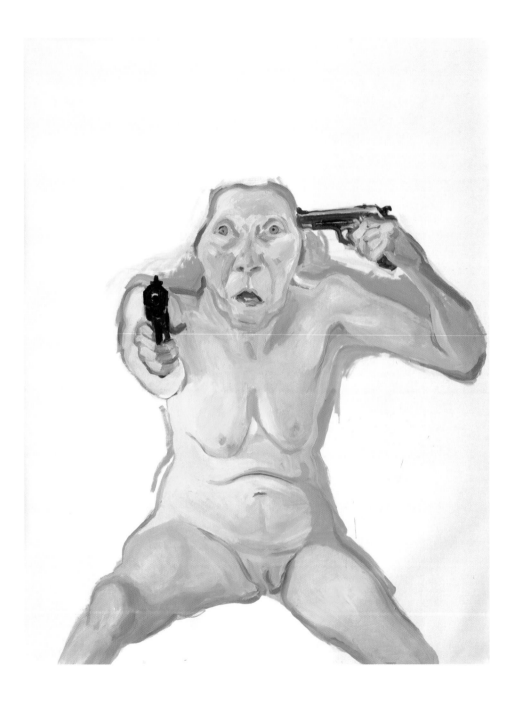

Maria Lassnig *Du oder Ich (You or Me)*, 2005

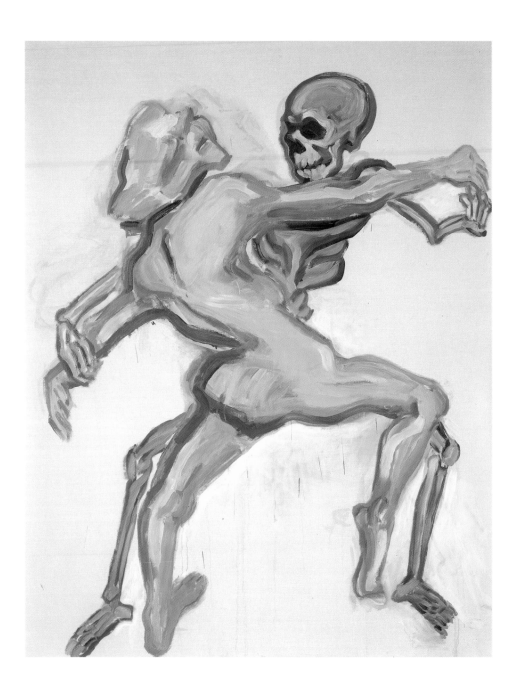

Maria Lassnig *Der Tod und das Mädchen (Death and the Girl)*, 1999

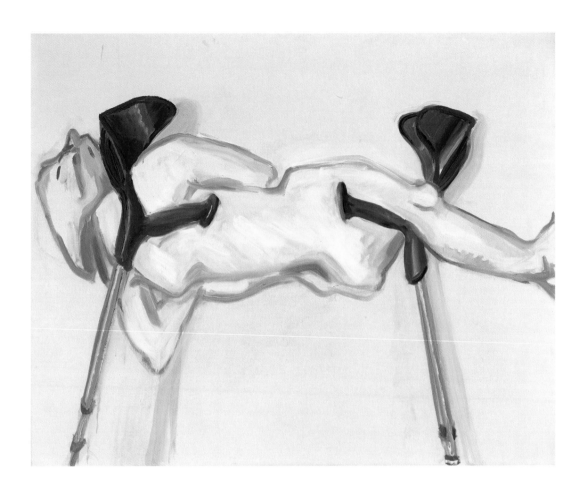

Maria Lassnig *Untitled (horizontally on two crutches)*, 2005

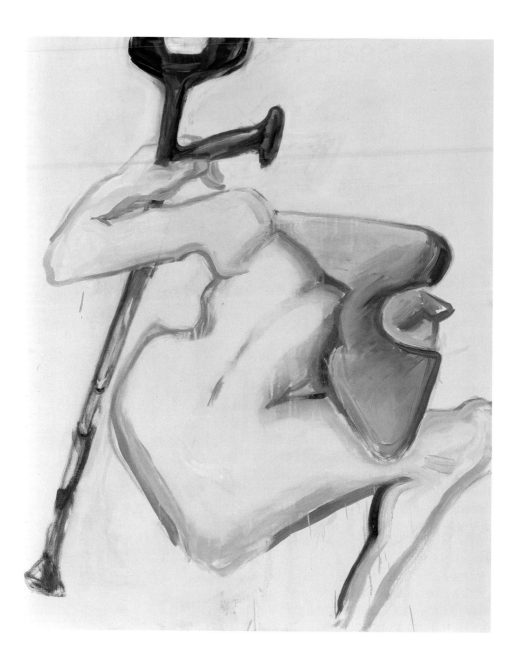

Maria Lassnig *Untitled (one crutch)*, 2005

Sharon Lockhart

Blending the rigorous aesthetic concerns of a formalist with an anthropologist's sensibility for community engagement and observation, Sharon Lockhart uses film and photography to create poignant, beautiful, and intimate portraits of her subjects. Expanding upon the legacy of experimental and structuralist cinema of the 1960s,[1] Lockhart carefully manipulates formal elements such as color, frame, sound, staging, and movement to establish visual and intuitive parameters that determine, like a metronome, the progression of the work and the pace at which it should be viewed. In an early but important work, *Goshogaoka* (1997), a 63-minute film of a girls' basketball team from Goshogaoka Middle School in Moriya, Japan, the artist creates this rhythm through careful audio and visual mechanisms. The events of the film take place in front of a single, static image of a wood basketball court flanked by a curtained stage. A combination of theatrical performance, highly choreographed practice drills, and imperfect human gestures ensues, accompanied by mesmerizing sounds of stomping and chanting. In addition to the film, Lockhart created a suite of photographs titled *Goshogaoka Girls Basketball Team*, which shows the girls in various staged poses, "frozen" in action as they imitate poses derived from sports photography. Since the making of this work, Lockhart has consistently explored in depth many of the elements it contains: portraiture, the relationship between photography and film, and the combination of fictive or choreographed performances with unscripted, intimate moments.

The film *Pine Flat* and the accompanying color photographs in *Pine Flat Portrait Studio* (both from 2005)[2] present a spare, meditative series of portraits of children the artist came to know during her nearly four-year stay in Pine Flat, California. *Pine Flat* is a two-part film focusing on children and adolescents interacting in the sublime landscape surrounding this small rural community. It is subdivided into twelve chapters: the first

1. For a discussion of avant-garde filmmaking in the 1960s, see Kerry Brougher et al., *Hall of Mirrors: Art and Film Since 1945*, exhibition catalogue (Los Angeles: Museum of Contemporary Art, 1996).
2. The complete work also includes three series of landscape photographs of Pine Flat taken in different seasons.
3. Linda Norden, "So Here's My Holiday," in *Sharon Lockhart: Pine Flat*, ed. John Alan Farmer and Charles Gute, exhibition catalogue (Milan: Charta, 2006), 129.

six depict individual children, and the second six show them in groups. Expanding on the durational temporality of *Goshogaoka*, *Pine Flat* requires of the beholder a slow and self-conscious reflection on the process of looking. The viewer consistently questions whether the children are truly engaged in their activities, pretending to engage in them, or simply following directives. In a sense, as one critic has noted, Lockhart "enables the children to play themselves."[3] Through pointed direction and choreography, she imbues the realism of her still portraits and moving images with elements of fiction and fantasy. The empathetic and at times melancholy gaze the artist directs at the children and adolescents in her work reveals individuals who have, at least for the camera, separated themselves from the outward pressures of society—whether of peers, adults, or culturally imposed expectations for how we choose to spend our time. Within Lockhart's precisely controlled environments, her subjects (and perhaps her viewers) can experience this elusive freedom. (HP)

Born 1964, Norwood, Massachusetts
Lives and works in Los Angeles, California

Sharon Lockhart graduated from the San Francisco Art Institute in 1991 with a BFA and from the Art Center College of Design, Pasadena, California, in 1993 with an MFA. Her work has been featured in solo exhibitions at venues such as the Arthur M. Sackler Museum, Harvard University, Cambridge, Massachusetts, and Walker Art Center, Minneapolis (both in 2006, cats.); Blum & Poe, Los Angeles (2006, 2003, 2001, 1998, cat., 1996); Gladstone Gallery, New York (2006, 2003, 2000); neugerriemschneider, Berlin (2006, 2004, 1999, 1996, 1994); Sala Rekalde, Bilbao (2005, cat.); Museum of Contemporary Art, Chicago, and Museum of Contemporary Art, San Diego (both in 2001, cats.); Museum Boijmans Van Beuningen, Rotterdam (2000, 1999, cat.); and Kunsthalle Zürich and Kunstmuseum Wolfsburg (both in 1999, cats.). Lockhart's group exhibitions include *Volksgarten: The Politics of Belonging*, Kunsthaus Graz, Austria, *Why Pictures Now: Photography, Film, Video Today*, Museum Moderner Kunst Stiftung Ludwig, Vienna (cat.), and *Hollywood Is a Verb*, Broad Art Foundation, Santa Monica, California (all in 2006); *Bidibidobidiboo*, Fondazione Sandretto Re Rebaudengo, Turin (2005, cat.); *Universal Experience: Art, Life, and the Tourist's Eye*, Museum of Contemporary Art, Chicago (2005–2006, cat., traveled to Hayward Gallery, London, and Museo d'Arte Moderna e Contemporanea di Trento a Rovereto, Italy);

Whitney Biennial, Whitney Museum of American Art, New York (2004, 2000, 1997, cats.); *Edén*, La Colección Jumex, Mexico City (2003); Biennale d'Art Contemporain de Lyon (2001, cat.); *Elysian Fields: A Proposal from the Purple Institute*, Musée National d'Art Moderne, Centre Georges Pompidou, Paris (2000, cat.); *Stills: Emerging Photography in the 1990s*, Walker Art Center, Minneapolis (1997); and *Hall of Mirrors: Art and Film Since 1945*, Museum of Contemporary Art, Los Angeles (1996, cat.).

Selected Bibliography

Farmer, John Alan, and Charles Gute, eds. *Pine Flat*. Exhibition catalogue. Milan: Charta, 2006.
Holte, Michael Ned. "The Observer." *Frieze*, no. 95 (November–December 2005): 98–103.
Lockhart, Sharon, Karel Schampers, Timothy Martin, and Ivone Margulies. *Sharon Lockhart: Teatro Amazonas*. Exhibition catalogue. Rotterdam: Museum Boijmans Van Beuningen, 1999.
Martínez, Chus, ed. *Sharon Lockhart: Pine Flat*. Exhibition catalogue. Frankfurt am Main: Revolver; Bilbao: Sala Rekalde, 2006.
Molon, Dominic, and Norman Bryson. *Sharon Lockhart*. Exhibition catalogue. Chicago: Museum of Contemporary Art; Ostfildern-Ruit, Germany: Hatje Cantz, 2001.

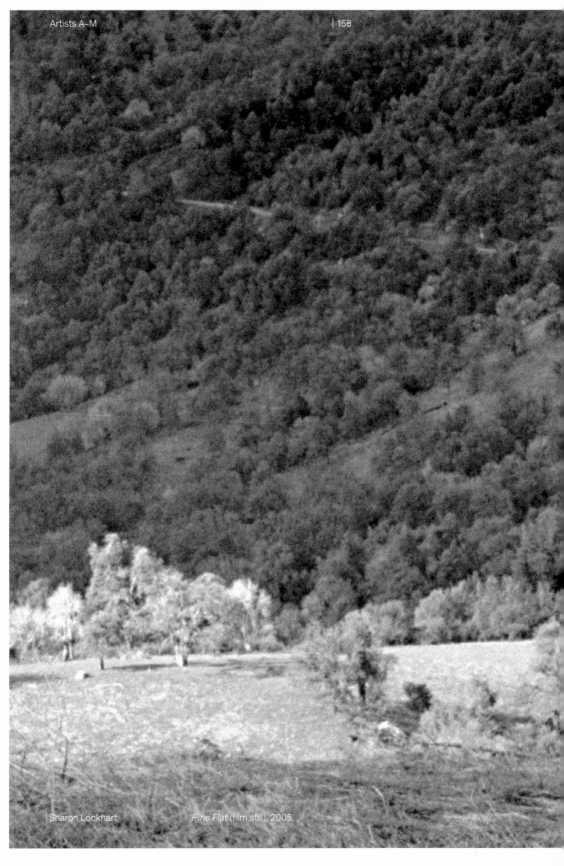

Sharon Lockhart *Pine Flat* (film still), 2005

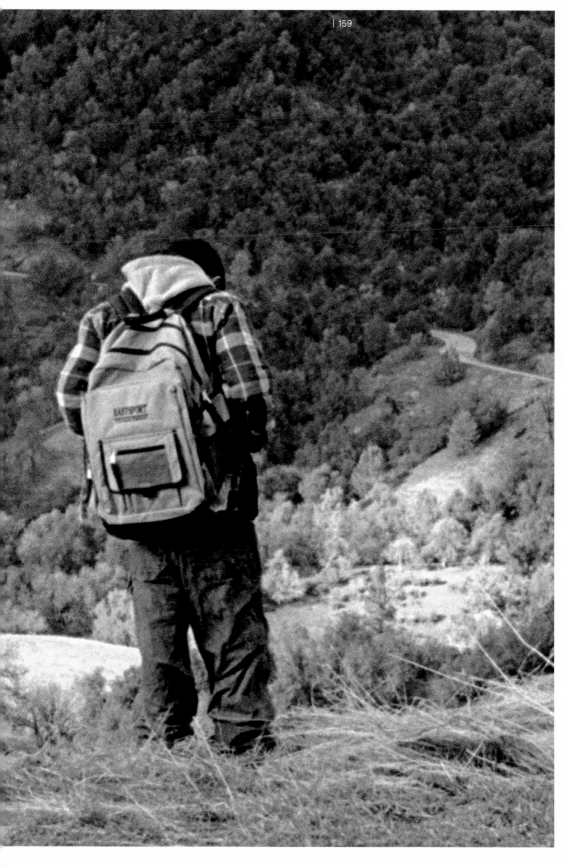

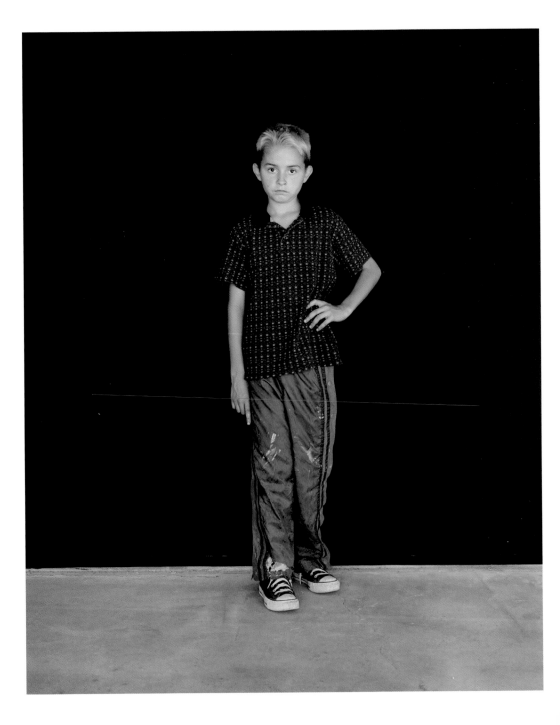

Sharon Lockhart *Pine Flat Portrait Studio, Meleah, Travis (Travis)*, 2005

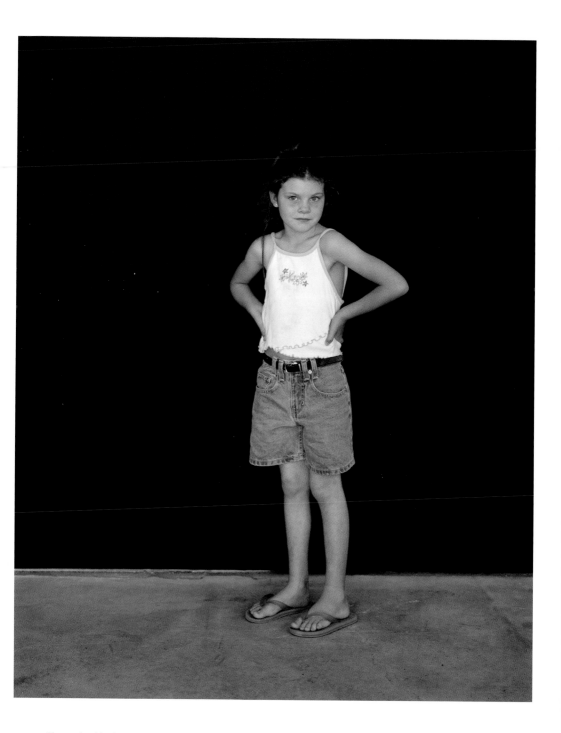

Sharon Lockhart *Pine Flat Portrait Studio, Meleah, Travis (Meleah)*, 2005

Mark Manders

Since 1986, Mark Manders has been engaged in an ongoing project he refers to as *Self-Portrait as a Building*, mapping his artistic persona through site-specific renegotiations of physical materials in space. Taking the shape of sculptures, installations, and drawings, these subtle rearrangements of existing and invented forms fuse specific and seemingly incongruous iconographic elements—including figures, animals, archaeological fragments, everyday objects, and architectural components—into a new visual language. The fragments of his *Self-Portrait as a Building* are alternately disconcerting and poetic, consisting of detailed floor plans, sculpted and found objects, and text, which together create a multidimensional conception of a single, evolving idea. A moment in the artist's childhood, at the age of eight, serves as a metaphorical anecdote for his desire to collect, transmit, and decipher an ongoing stream of information from his present, past, and future: "I was lying under a table and I had things in front of me that I made myself: a bowl made out of rope and two airplanes made out of matches and fabric. There was a beautiful light on these objects and they were just fantastic to me. Then I had a deep experience, I realized that I was the one that put these new objects in the world, and I was the only one that could do it in such a way."[1] Viewed in the context of what anthropologist Arjun Appadurai termed the "social life of things," whereby the circulation of inanimate objects through culture encodes them with residual layers of meaning,[2] Manders is both documenting and reinventing a highly personalized form of cultural history.

Within each object and from one installation to the next, Manders expresses the potential for symbiotic relationships between disconnected or opposing parts. Associations are implied by laying objects next to one another, affixing them together, connecting them with string, or sandwiching one object between two others. Central to this discourse is the relationship between presence and absence, wherein Manders himself is the fugitive specter. Other oppositional forces exist in his work: between language and form, a word and its meaning, a thought and its action, and interiority

1. Mark Manders, e-mail message to author, September 19, 2007.
2. Arjun Appadurai, "Introduction: Commodities and the Politics of Value," in *The Social Life of Things: Commodities in Cultural Perspective* (Cambridge, England: Cambridge University Press, 1986), 6.

and exteriority. A simple gesture can generate immeasurable psychological complexity. In its pursuit of a new sculptural landscape, Manders' work traverses a somber topography. The recurring prostrate animals, caves, dark spaces, anthropomorphic forms, robotic structures, and charcoal-black surfaces in his oeuvre flirt with menace and suggest an alternate universe in which paradox reigns over logic; here, oddly assembled fragments compose the circuits by which knowledge is communicated. This darkly melancholic quality is central to the meaning of Manders' work, providing an expression of interior psychological space and perhaps an indirect reflection of today's grim political environment. The artist proposes his own version of a hieroglyphic language in which words become symbols, time is measured in objects, and lived space is located somewhere between mind and matter. (HP)

Born 1968, Volkel, the Netherlands
Lives and works in Arnhem, the Netherlands,
and Ronse, Belgium

Mark Manders graduated from Hogeschool voor de Kunsten, Arnhem, the Netherlands, in 1992. His work has been featured in solo exhibitions at venues such as Kunstverein Hannover (cat.) and Tanya Bonakdar Gallery, New York (both in 2007); BALTIC Centre for Contemporary Art, Gateshead, England (2006, cat.); Irish Museum of Modern Art, Dublin (cat.), and Berkeley Art Museum, University of California (both in 2005); Zeno X Gallery, Antwerp (2004, 1997, cat., 1994, cat.); Art Institute of Chicago and Renaissance Society, University of Chicago (2003, cat.); Greene Naftali Gallery, New York (2002); Drawing Center, New York (cat.), and Stedelijk Museum, Amsterdam (both in 2000); Douglas Hyde Gallery, Dublin (1997, cat.); and Museum van Hedendaagse Kunst, Antwerp, and Van Abbemuseum, Eindhoven (both in 1994, cats.). Manders' recent group exhibitions include *The Fractured Figure: Works from the Dakis Joannou Collection*, Deste Foundation Centre for Contemporary Art, Athens, and Athens Biennial (both in 2007); *We Humans Are Free*, 21st Century Museum of Contemporary Art, Kanazawa, Japan, Berlin Biennial for Contemporary Art (cat.), and *An Image Bank for Everyday Revolutionary Life*, REDCAT, Los Angeles (all in 2006); *Trials and Terrors*, Museum of Contemporary Art, Chicago (2005); Manifesta:

European Biennial of Contemporary Art, San Sebastián, Spain (2004, cat.); *Contemporary Drawing: Eight Propositions*, Museum of Modern Art, New York, and Documenta, Kassel (both in 2002, cats.); and Venice Biennale (2001, cat.).

Selected Bibliography

Berg, Stephan, ed. *The Absence of Mark Manders*. Exhibition catalogue. Hannover: Kunstverein Hannover, 2007.
Kielmayer, Olivier. "Mark Manders: The Self as Grand Narrative." In *Sculptural Sphere*, edited by Rainald Schumacher, 97–102. Exhibition catalogue. Munich: Sammlung Goetz, 2004.
Manders, Mark, Marije Langelaar, and Laura Hoptman. *Singing Sailors*. Toronto: ROMA Publications and Art Gallery of York University, 2002.
Rondeau, James, ed. *Isolated Rooms*. Exhibition catalogue. Chicago: Art Institute of Chicago and the Renaissance Society at the University of Chicago, 2005.
Van de Sompel, Ronald, ed. *Mark Manders: Short Sad Thoughts*. Exhibition catalogue. Gateshead, England: ROMA Publications and BALTIC Centre for Contemporary Art, 2006.

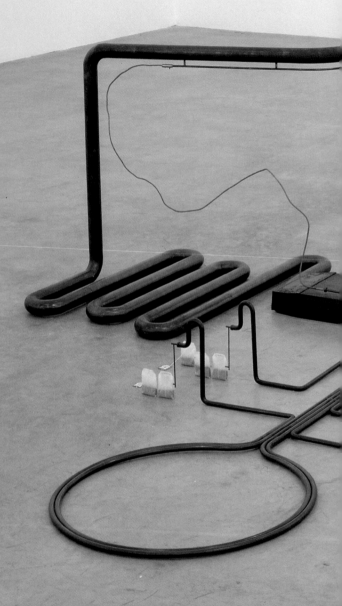

Mark Manders *Finished Sentence*, 1998–2006

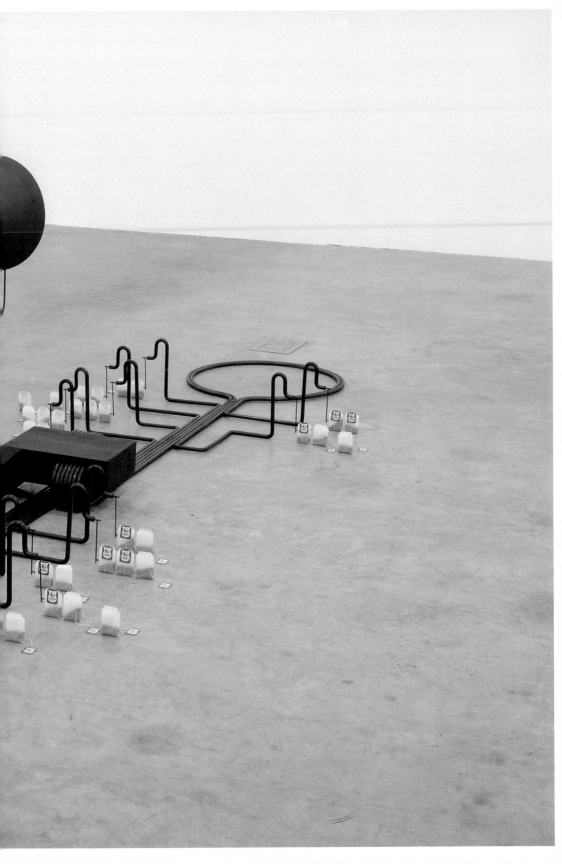

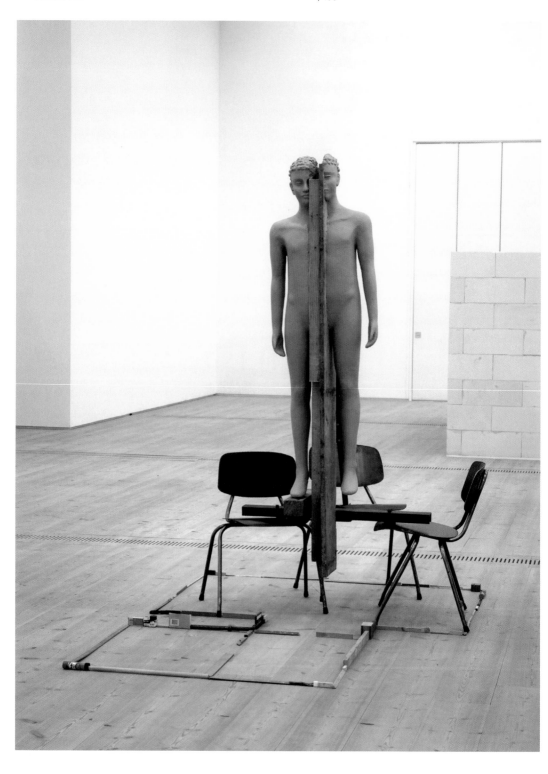

Mark Manders *Unfired Clay Figure*, 2005–2006

Mark Manders *A Place Where My Thoughts Are Frozen Together*, 2001

Barry McGee

Barry McGee's playfully anarchic multimedia installations blend the transgressive and antiauthoritarian impulses of graffiti with the considered techniques of a formal artistic practice. While he has said that the two are relatively separate—"I do indoor work and I do outdoor work"[1]—undeniably, McGee attempts to bridge the immense chasm between the spontaneous and uncontrolled atmosphere of street art and the mediated white cube of the gallery. Reflecting punk, outsider, folk, and other noninstitutionalized art forms, his multimedia environments combine detritus from urban culture with formal, traditional, or painterly elements, generating an ambivalent dialogue between the two spaces. Found, discarded, and recycled objects, overturned vehicles, motorized figures, audio components, and video monitors exist alongside portraits, text, assemblages of framed photographs and drawings, and geometrical sections of optical color-field "wallpaper." His installations also have a degree of humorous obstinacy: a recent exhibition included a sculpture of a hand clutching a bottle of spray paint and protruding from a leafy bush—comical graffiti camouflage—giving literal and metaphorical form to the artist's desire to see "the evidence of the human hand at a place, at a time, and then gone into memory."[2]

An empathy with youth culture and a desire to propagate an alternative discourse to that of commercial advertising are at the heart of McGee's work. "Disgusted by the culture of desire and consumption,"[3] as he describes it, McGee conceives of the inherently disruptive practice of graffiti—one that floods the landscape with (by definition) unsolicited, potentially disturbing marks—as a corrective to the corporate imbalance. For city governments, graffiti is vandalism. For others, namely those

1. Artist interviewed by Eungie Joo, in *Regards, Barry McGee*, exhibition catalogue (Minneapolis: Walker Art Center, 1998), no pagination.
2. Ibid.
3. Artist interviewed by Raphaela Platow, in *Barry McGee*, exhibition catalogue (Waltham, MA: Rose Art Museum of Brandeis University, 2004), no pagination.
4. Nayland Blake, "Barry McGee: Interview with Painter also Known as Twist," *Interview* 29, no. 2 (February 1999): 45.
5. Norman Mailer refers to de Kooning in regards to influences on graffiti when he writes, "If the family histories of the most messed-up families have all the garbage-can chaos of de Kooning's *Woman*, no wonder the subway writers prided themselves on style and éclat—'you got messed-up handwriting' being the final term of critical kill." From "The Faith of Graffiti," section 3, in *The Faith of Graffiti*, documented by Mervyn Kurlansky and Jon Naar, text by Norman Mailer (New York: Praeger, 1974), no pagination.
6. Willem de Kooning quoted in Mark Stevens and Annalyn Swan, *De Kooning: An American Master* (New York: A. A. Knopf, 2004), 571.

who engage in it, it is a form of expression, an identity, a community, and a release. McGee emerged as an important figure in the history of San Francisco Bay Area graffiti beginning in the 1980s under the tag name "Twist." His trademark images of morose, droopy, caricatured faces inspired by the transient and homeless people on the city streets, frequently combined with text, formed a poignant—if fleeting—commentary on the overlooked status of outsiders within a community. These characters appear throughout his installations in various forms, including drawings, photographs, and tags. The temporality of this visual language and the immediacy of its communication convey a history that is continually rewritten, erased, and written again. As McGee has commented, "I enjoy the feel of work on the street—it's like a glimpse or something that you'll just catch."[4] Willem de Kooning, an artist whose chaotic abstractions could by some stretch be compared to the uncontrolled gestures of graffiti,[5] once referred to the "slipping glimpse,"[6] an unquantifiable moment of inspiration that is briefly experienced and then incessantly pursued. The manifestation of this ephemeral and perpetually ungraspable sensation is present in McGee's working method as both a frustration and a sustaining momentum. His marks, both in the gallery and on the street, have a finite existence, part of the revolving door of time and memory. Amid the temporal cacophony of McGee's work, we find the messy evidence of life and the absurd pathos of human existence. (HP)

Born 1966, San Francisco, California
Lives and works in San Francisco

Barry McGee graduated from the San Francisco Art Institute in 1991 with a BFA. His work has been featured in solo exhibitions at venues such as BALTIC Centre for Contemporary Art, Gateshead, England (2008); REDCAT, Los Angeles, and Watari Museum of Contemporary Art, Tokyo (both in 2007); Stuart Shave/Modern Art, London (2005, 2002); Deitch Projects, New York (2005); Rose Art Museum of Brandeis University, Waltham, Massachusetts (2004, cat.); Gallery Paule Anglim, San Francisco (2004, 2002); Fondazione Prada, Milan (2002, cat.); UCLA Hammer Museum, Los Angeles (2000); and Walker Art Center, Minneapolis (1998; cat.). McGee's recent group exhibitions include *Art in America, Now*, Museum of Contemporary Art, Shanghai (2007, cat.); *Spank the Monkey*, BALTIC Centre for Contemporary Art, Gateshead, England (2006, cat.); *On Line*, Louisiana Museum for Moderne Kunst, Humlebaek, Denmark (2005); *Beautiful Losers: Contemporary Art and Street Culture*, Contemporary Arts Center, Cincinnati, and Yerba Buena Center for the Arts, San Francisco (2004–2005, cat., traveled to Orange County Museum of Art, Newport Beach, California); Liverpool Biennial, Tate Liverpool, and *Drawing*

Now: Eight Propositions, Museum of Modern Art, New York (both in 2002, cats.); *Un art populaire*, Fondation Cartier pour l'Art Contemporain, Paris (cat.), Venice Biennale (cat.), and *Holdfast: Barry McGee and Margaret Kilgallen*, Deste Foundation Centre for Contemporary Art, Athens (all in 2001); and *Indelible Market*, Institute of Contemporary Art, University of Pennsylvania, Philadelphia (2000, cat.).

Selected Bibliography

Celant, Germano. *Barry McGee*. Exhibition catalogue. Paris: Fondazione Prada, 2002.
Joo, Eungie. Interview. In *Barry McGee: Advanced Mature Work*. Exhibition brochure. Los Angeles: REDCAT, 2007.
————. "The New Folk." *Flash Art*, no. 224 (May–June 2002): 124–26.
Lack, Jessica. "Riot on an Empty Street." *I-D Magazine* (London), no. 258 (September 2005): 284–87.
Platow, Raphaela. *Barry McGee*. Exhibition catalogue. Waltham, MA: Rose Art Museum of Brandeis University, 2004.

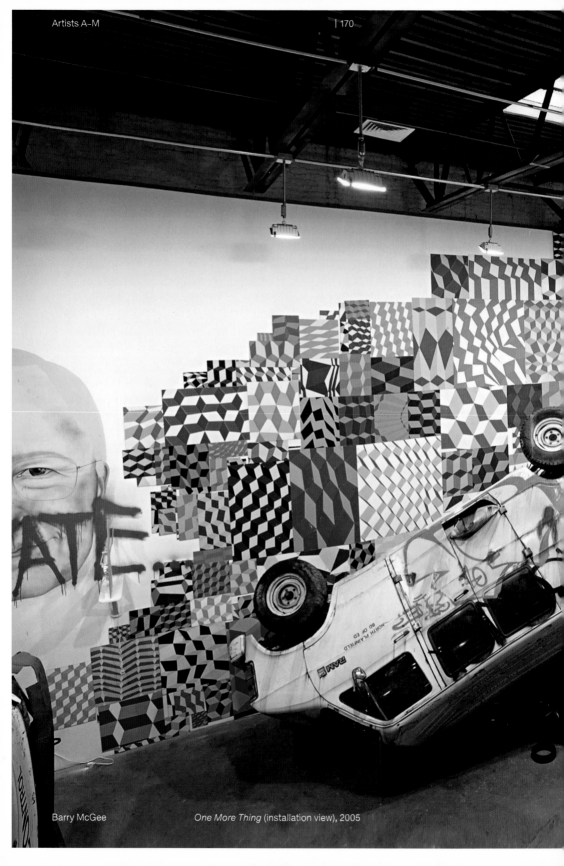

Barry McGee *One More Thing* (installation view), 2005

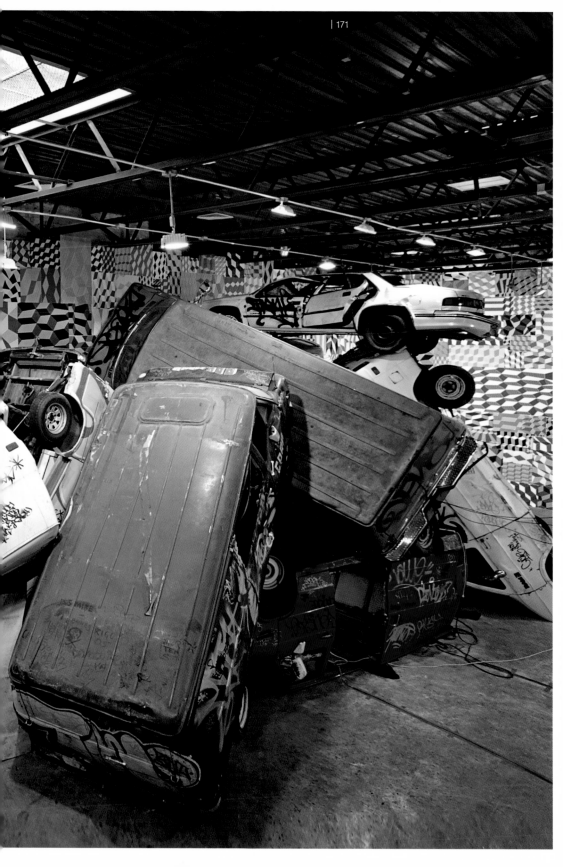

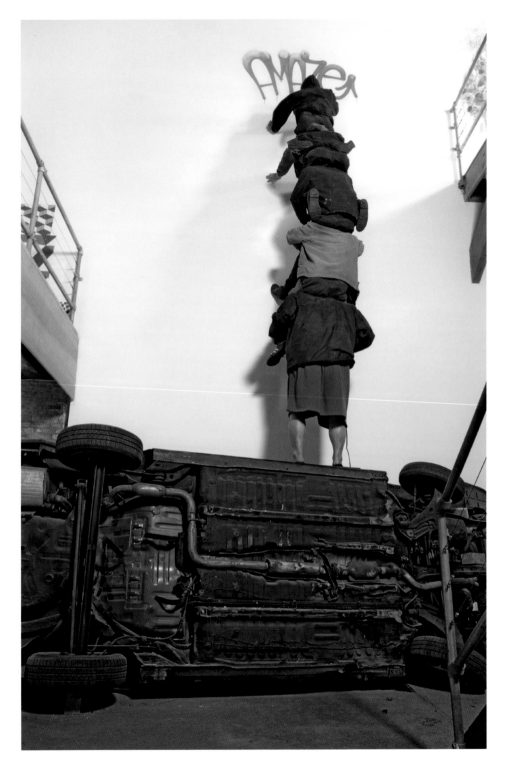

Barry McGee *One More Thing* (installation view), 2005

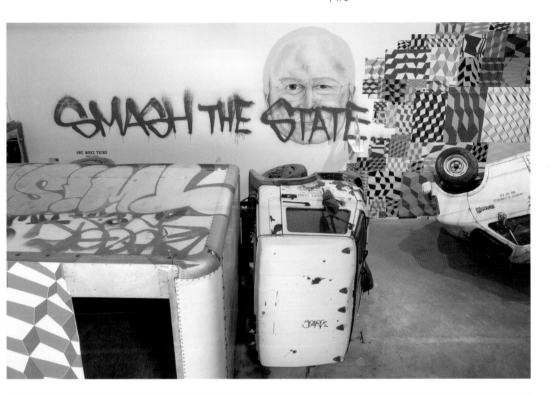

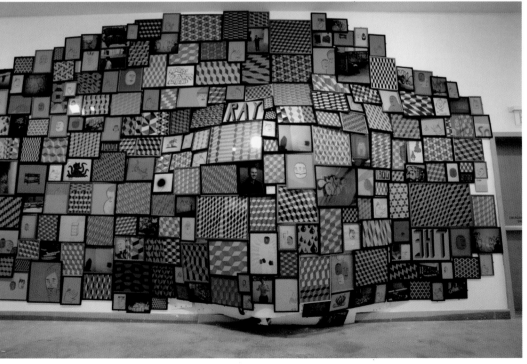

Barry McGee *One More Thing* (installation view), 2005
Advanced Mature Work (installation view), 2007

Mario Merz

The restless oeuvre of Mario Merz obstinately evades straightforward explication. Moreover, with its preponderance of spiral and vortex emblems and compulsive capacity for hoarding and material accumulation, it interrogates the very notion of "straight-ahead" progress, and with it, the value of modernity's ever onward march. In this respect, his art shares many of the preoccupations of so-called Arte Povera—literally "poor art"—a term coined to describe the work of Merz and a loose group of his contemporaries, including Giovanni Anselmo, Luciano Fabro, Jannis Kounellis, and Marisa Merz, the artist's partner, who also emerged in the milieu of the vibrant Italian art scene of the late 1960s.

Although the Arte Povera "movement" was never formalized, Merz's approach seems to encapsulate a core concern in its hostility to the technological, the rational, and the mass-produced—qualities enshrined by the post–World War II industrial boom, witnessed especially in his native Turin. (It is perhaps ironic, then, that the artist's foundation and archive, set up just before his death in 2003, now occupies a former factory of the Lancia car company.) Whether suggested by his sculptures' characteristic use of elementary, impoverished materials that invoke a scavenging, ritualized, and provisional form of art making or by the evocative and quasi-mythical beasts that often populate his paintings of the 1980s, Merz might be considered a "modern primitive."

His best-known devices are his multifarious igloo-shaped structures as well as his use of the theoretically infinite mathematical sequence known as the Fibonacci series (produced when two consecutive numbers are added together to generate the next: 1, 1, 2, 3, 5, 8, 13, and so on). The former are rudimentary domes made from all manner of often precariously conjoined materials—metal tubes, glass shards, mirrors, earth, stones, rubber, branches, sacking, lead, and the like—that appear to be basic forms of temporary human dwellings, "architecture without architects," recalling medieval Italian *trulli* shelters or prehistoric huts. The latter proliferation of numbers—which is manifested in natural processes and

structures such as shell and flower growth—was for Merz emblematic of the ebullience and accelerative harmonics of organic creation. Another essential element found throughout his work is neon light tubing, which he used frequently to illuminate and enumerate the numbers of the Fibonacci series, to lance canvases and objects, or to spell out slogans in an electrified form of the artist's handwriting.

Merz was a political firebrand throughout his life, inclined toward antifascism (he was imprisoned as a resistance activist in 1945) and poetic anarchism. His first igloo structure, *Giap's Igloo* of 1968, bears a gnomic statement attributed to the Vietcong general Vo Nguyen Giap ("If the enemy masses his forces he loses ground; if he scatters he loses strength"), while slogans from the student uprisings in Europe that same year, such as *Che fare?* (What is to be done?—itself paraphrasing Vladimir Lenin) and *Solitario solidale* (Solitary solidarity) are scripted in neon and set in wax or daubed on walls in several works. One of his last sculptures, *A Mallarmé* (2003), features a blue neon text borrowed from the French poet of the title—"Un coup de dés jamais n'abolira le hasard" (A throw of the dice will never abolish chance)—alongside piles of newspapers whose headlines announced the U.S.-led invasion of Iraq. (MA)

Born 1925, Milan, Italy
Died 2003, Turin, Italy

Mario Merz studied medicine at Turin University. Since the artist's death, his work has been featured in a solo exhibition at Sperone Westwater, New York (2007), and in group exhibitions such as *Arte Povera*, Kunstmuseum Liechtenstein, Vaduz (2007); *Sol LeWitt, Mario Merz*, Fondazione Merz, Turin (2006); and *The Last Picture Show: Artists Using Photography, 1960–1982*, Walker Art Center, Minneapolis (2004–2005, cat., traveled to UCLA Hammer Museum, Los Angeles, Museo de Arte Contemporánea de Vigo, Spain, Fotomuseum Winterthur, Switzerland, and Miami Art Central). During his lifetime, Merz's work was featured in solo exhibitions at venues such as Galleria Christian Stein, Milan (1999, 1996, 1994); Konrad Fischer Galerie, Düsseldorf (1998, 1995, 1991); Gladstone Gallery, New York (1994, 1990); Sperone Westwater, New York (1992); Castello di Rivoli Museo d'Arte Contemporanea, Turin (1990); and Solomon R. Guggenheim Museum, New York, and Museum of Contemporary Art, Los Angeles (both in 1989, cats.). Merz's group exhibitions include *Zero to Infinity: Arte Povera, 1962–1972*, Tate Modern, London, and Walker Art Center, Minneapolis (2001–2003, cat., traveled to Museum of Contemporary Art, Los Angeles, and Hirshhorn Museum and Sculpture Garden, Washington, DC); *Arte Italiana 1945–95*, Aichi Prefectural Museum of Art, Nagoya (1998, traveled to Museum of Contemporary Art, Tokyo, Yonoga City Museum of Art, Tottori, Japan, and Hiroshima City Museum of Contemporary Art); Venice Biennale (1997, 1993, cats.); *The Italian Metamorphosis, 1943–1968*, Solomon R. Guggenheim Museum, New York (1994, cat.); *Gravity and Grace*, Hayward Gallery, London (1993); and Documenta, Kassel (1992, cat.).

Selected Bibliography

Beccaria, Marcella, and Carolyn Christov-Bakargiev. *Mario Merz: The Monograph*. Turin: Fondazione Merz, 2005.
Boutoux, Thomas, ed. *Hans Ulrich Obrist: Interviews*. Vol. 1, 603–15. Florence: Fondazione Pitti Immagine; Milan: Charta, 2003.
Celant, Germano. *Mario Merz*. Exhibition catalogue. New York: Solomon R. Guggenheim Museum and Rizzoli, 1989.
———. "Sphere of Influence." *Artforum* 42, no. 5 (January 2004): 25–26.
Corà, Bruno, and Mary Jane Jacob. *Mario Merz at MOCA*. Exhibition catalogue. Milan: Fabbri Editori; Los Angeles: Museum of Contemporary Art, 1989.
"Mario Merz." Special section. *Parkett*, no. 15 (1987–88): 38–97.

Mario Merz *Cervo*, 1997

Mario Merz *Cervo* (detail), 1997

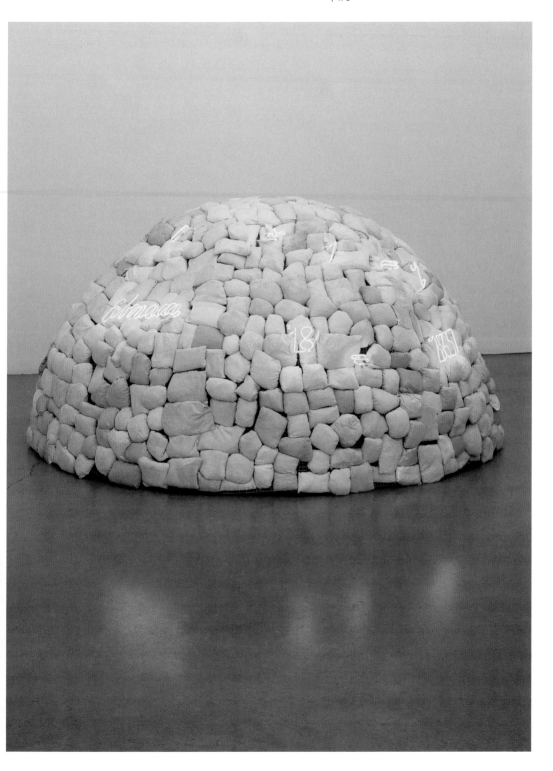

Mario Merz *Fibonacci Igloo*, 1972

Marisa Merz

Like the soft, amorphous residue of melted candle wax, able to be trans-formed into any number of shapes and molds, Marisa Merz's sculptures explore the malleable, phenomenological boundaries between form and formlessness and between interior and exterior states of being. For nearly forty years, Merz has created handmade sculptures, installations, drawings, and performances that quietly and intimately embrace the dichotomy between the mystical and tangible elements of our existence. Her literal use of substances such as wax, clay, salt, yarn, and various metals (copper, steel, aluminum, gold) as well as found objects such as twigs, furniture, knitting needles, and blankets places the notion of materiality at the center of her work. Many of these substances are organic in nature and can be characterized by their ability to oscillate between solid and fluid states, depending on temperature or hydration. In this way, they act as a metaphor for Merz's artistic investigation of various physical and psy-chological modes. From the late 1960s to the 1980s, her work frequently referred to the body, shelter, and the relationship of humankind to nature, themes that connected her work to the defining principles of Arte Povera (translated as "poor art"), a term that art critic Germano Celant coined to describe a tendency in late 1960s Italian art characterized by the use of humble materials and the crumbling of boundaries between art and life. Unlike the more overtly muscular art of many of her peers, Merz's works can be distinguished by the intimacy, ephemerality, and unpremeditated elegance with which they embody her ideas.

From 1965 to 1966, in the home in Turin that she shared with her husband, Mario Merz, the artist made *Untitled (Living Sculpture)*, a spectacular arrangement of twisting, tubular slabs of aluminum that hung from the ceiling, evocative of an underwater cornucopia of shiny mollusk shells and jellyfish tendrils. This "primordial entanglement," as Celant described it,[1] extended unevenly and somewhat aggressively into the viewer's space, generating a direct phenomenological experience. The radicality of Merz's sculptural practice becomes more clear when we compare her use of

1. Germano Celant, "Marisa's Swing," in *Marisa Merz*, exhibition catalogue (Paris: Éditions du Centre Pompidou, 1994), 241.

metal to that of her American counterparts. The work of Donald Judd in the 1960s and 1970s, for example, likewise necessitated a direct inter-action with its viewers, but with seductively polished, geometric, and perfectly formed steel and aluminum sculptures. Merz's *Untitled (Living Sculpture)* provides a formal and conceptual counterpoint with its ripped, cut, twisted, and chaotic forms.

More recently, Merz has produced an ongoing series of poignant, anti-monumental clay heads. These nontraditional busts are molded by the artist in soft clay and left to dry naturally; she then colors them with paint fixed in wax or sometimes even gold leaf. Deliberately sculpted with almost primitive, childlike gestures, the heads have features that range from gentle to blissful to pensive, always verging on the realm of abstrac-tion. *Tête rose* (1989) has two large, bulbous eyelids, seemingly closed, with a rectangular plinth for a nose and the faintest crescent of a line for a mouth. The head itself leans upward and tilts gently to one side, as if swaying to an internal chorus. The unseeing character of this head is consistent with the artist's ongoing desire to capture the invisible, interior world in physical form. Perhaps this sculpture can be connected to the title of an installation Merz presented in Rome in 1975: *Ad occhi chiusi gli occhi sono straordinarimente aperti* (The closed eyes are extraordinarily open). Shut your eyes, Merz tells us, and you will see. (HP)

Born 1931, Turin, Italy
Lives and works in Milan, Italy

Marisa Merz's work has been featured in solo exhibitions at venues such as Museo d'Arte Contemporanea Donnaregina, Naples (2007); Gladstone Gallery, New York (2006, 2004, 1994, cat.); Kunstmuseum Winterthur, Switzerland (2003, 1995, cat.); Galleria Christian Stein, Milan (1998, 1993); Stedelijk Museum, Amsterdam (1996); and Musée National d'Art Moderne, Centre Georges Pompidou, Paris (1994, cat.). Her recent group exhibitions include *Zero to Infinity: Arte Povera, 1962–1972*, Tate Modern, London, and Walker Art Center, Minneapolis (2001–2003, cat., traveled to Museum of Contemporary Art, Los Angeles, and Hirshhorn Museum and Sculpture Garden, Washington, DC); Venice Biennale (2001, 1988, 1980, cats.); *The Italian Metamorphosis, 1943–1968*, Solomon R. Guggenheim Museum, New York (1994, cat.); *Zeitlos*, Hamburger Bahnhof—Museum für Gegenwart, Berlin (1988, cat.); *Chambres d'Amis*, Stedelijk Museum voor Actuele Kunst, Gent (1986, cat.); *Spuren, Skulpturen und Monumente ihrer präzisen Reise*, Kunsthaus Zürich (1985, cat.); Documenta, Kassel (1982, cat.); and *Identité Italienne: l'art en Italie de 1959 à aujourd'hui*, Musée National d'Art Moderne, Centre Georges Pompidou, Paris (1981).

Selected Bibliography

Celant, Germano. "Marisa's Swing." *Artforum* 31, no. 10 (Summer 1992): 97–101.
Merz, Mario, Dieter Schwarz, and Tommaso Trini. *Marisa Merz*. Exhibition catalogue. Winterthur: Kunstmuseum Winterthur, 1995.
Merz, Marisa. *Marisa Merz*. Exhibition catalogue. Paris: Éditions du Centre Pompidou, 1994.
Panicelli, Ida. "Marisa Merz, Madre." *Artforum* 45, no. 10 (Summer 2007): 516.

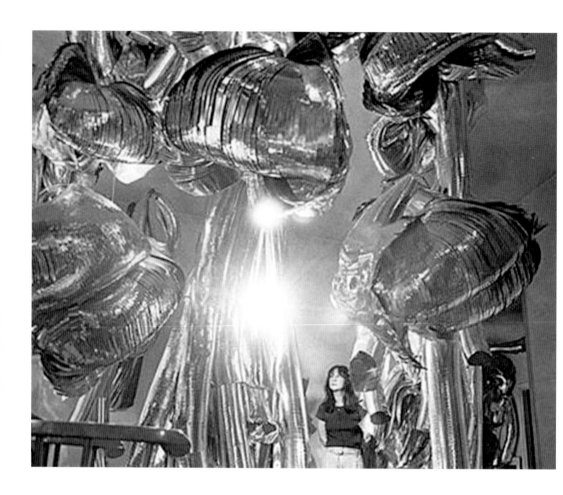

Marisa Merz *Untitled (Living Sculpture)*, 1966

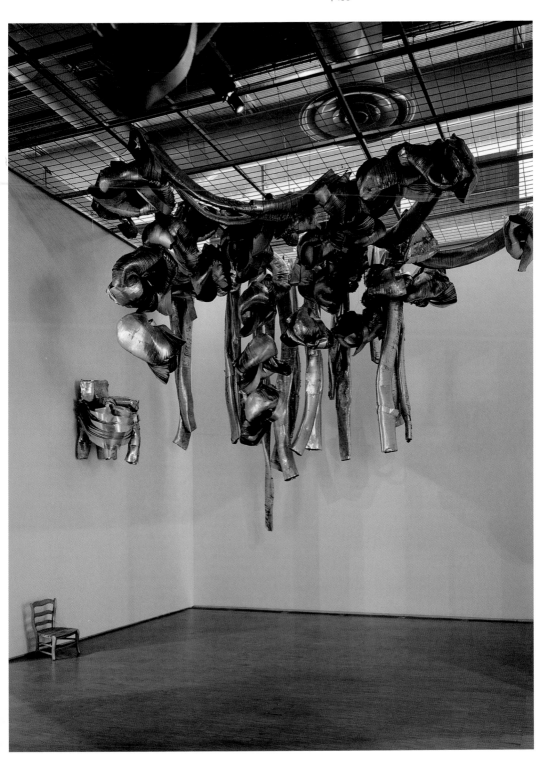

Marisa Merz *Untitled (Living Sculpture)*, 1966

Marisa Merz *Tête rose*, 1989

Marisa Merz *Tête et pièce de bois*, 1982

Blue Pavement

Andro Wekua

Sitting there in silence, he inhaled enough air for himself. He thought as he inhaled. To say it more precisely, every time he inhaled, he thought about how every inhale made his body heavier. He thought about how there was nothing that made you as heavy as air did.

Him, on the lawn, throwing out a photograph while holding it in memory. Noticing from afar how much time had passed. Although so much had changed, he was still saying it. Standing by the grave and climbing up the tree, saying: "Life's secret is the property of the dead." Not coming back down. Me leaving.

I forget where it was, at which corner or at which door. I only remember one side of the street.... Why am I nervous? Are you scared? What about the other side of the street? I can't remember the other side. It's hard to see past the rain to the other side. It's never ending, this side. It's not ending. This is the 11th circle already. Rain. The same side of the street. Exhaustion.

It was all gray with silver facades. It was the apartment where she lived. There were a lot of people and lots of different buildings. More tall ones and more short ones. The TVs were watching us. Minza and Nonha. I also split in two: I visited both places.

The one that stood on the other side of the street heard the sound of hurried steps on the blue pavement.

Sitting there with a frozen face, he stared at the recording on the monitor. The colors on the monitor fell on his face. Before leaving the room, he smiled.

Holiday Story

Haegue Yang

Script of the video essay *Holiday Story* (2007).

Resting.

Working.

Resting.
Working.

Resting?
Work!
Rest!
Have to work.
Working.
Work.
Work.
Work.
Work!
Working.

On holidays, the city falls to silence
 with a great population migration.
In the silence the city comes up clean,
 as if it has been washed.
The streets, once crowded with people,
 now reveal their bare surfaces.
One's field of vision is washed clean.
The mind still runs.
Silence.

One goes on a mission looking for a space
 called "holiday."
Perhaps the error is in thinking that
 holidays are time.

Because a holiday is a place where faith
 submerges ...
No, because faith gets buried under the
 marshland called holiday ...

Revolution does not know a holiday.
But, revolutions make national holidays.
Crises do not know rest.

The homeless do not know holidays either.
Crooks do not know holidays either.
I am not sure what holidays are either.

Holidays are a monster.
The thing is, people overlook that.
Also, my identity is ambiguous.
Holidays and my identity take after each
 other.
My identity?
Me.
Myself.
Living one's life for oneself?
Working?
For oneself?
Subjectivity?

Work!
Why?
What is it?
For oneself?
When one does not know oneself?

Labor.
Production.
Expression.
Not embarrassing?
It is embarrassing.
It is awful.
This is the space of holiday.

The sound of finishing up work.
The sound of pulling the shutter down.
The sound of packing up.
The sound of putting the package down.
The sound of unpacking.
The sound of opening a box.
The sounds of things do not stop.
It is the same; the world of things does
 not stop when the sound is there no more.
So pay attention to the moment when
 categories become meaningless!
Thinking about the moment when it seems
 as if nothing is happening.

Need a holiday.
Need a vacation.
That's right.

Streets are asleep.
Streets seem as if they are asleep.
The city is asleep.
One expects one will finally have time to
 sort out one's thoughts on a holiday or
 vacation.

One expects one could have a clear head on
 a holiday.
This is a likely thought coming out of a
 head that has spent many sleepless nights
 preparing for a holiday.
This holiday, one believes one will find
 the perfect moment to confess one's love.
This time, one believes there will be an
 opportunity to say what was unsaid
 before.
Or,
one believes one could finally explain,
 once and for all, that subject that was
 left hanging.
That is probably why you will lose that
 love over the holidays this time.
In the coming holiday
I swear you will say
there is no more love left between the two
 of you, that everything is over.
So on this holiday love, the love that
 supposedly does not exist any more, will
 continue; and no new love will begin
 either.
You spend this holiday waiting for the
 next holiday when you will confess the
 absence of love.

Since it's a holiday, it would be all right
 to spend time that way.
Since it's a suspended time.

One can be consoled even if one cannot see
 or think.
However, ultimately much happens in this
 space of suspended time.
Inside this time where nothing can be seen
 or heard,
inside this space, one gets totally
 intoxicated with holiday.

One spends this holiday waiting for the
 next holiday.
Holidays are the suspension of
 continuation.
Holidays are the continuation of delay.
Holidays are not time but space.
Much happens in this space called holiday.
Actually there is nothing that is
 suspended.
The space grows inside time.

Time folds.
Space is folded.

Dog Ears [1]

Matthew Monahan

Originally published in *Matthew Monahan: Five Years, Ten Years, Maybe Never,* exhibition catalogue (Los Angeles: Museum of Contemporary Art, 2007), 1–32 and 76–77.

When one entered the studio it was a good while before one's eyes adjusted to the curious light, and, as one began to see again, it seemed as if everything in that space ... impenetrable to the gaze, was slowly but surely moving in upon the middle. The darkness ... had gathered in the corners ... mountains of paper ... the paint pots gleaming carmine red, leaf green and lead white in the gloom ... the floor was covered with a largely hardened and encrusted deposit of droppings, mixed with coal dust ... in places resembling the flow of lava.

1. The dog ear is the first mark of the reader becoming a writer, if we allow this writer to be none other than a thief who hoards gems of language for his own use. The fold in the corner is a modest beginning, treating the text as paper and the book as sculpture. Can all these folds form a kind of figure, an origami image of its own? Or is it just a pack of barking dogs? Can anyone hear above these dog ears? There are seeing-eye dogs, muzzled pit bulls, far too many German shepherds, an English terrier, a few French poodles, and I, of course, am the underdog, the emerging artist, the runt of the pack. I have discerned in their barking rabble a pattern and story that I will choose to make my own, to lead these bloodhounds in search of a fugitive body escaped and still at large. No photos to confirm the capture, only the scent and the silly composite portraits of the sketch artist.

This ... was the true product of his continuing endeavours and the most palpable proof of his failure.[2] *I began to consider my mind's disorder a sacred thing.*[3] "To tidy up" would be to demolish an edifice full of prickly chestnuts that are spiky clubs, tinfoil that is hoarded silver, bricks that are coffins, cacti that are totem poles, and copper pennies that are shields.[4] Art ... reborn ... from amidst a general anarchy.[5]

I tried to answer you, to ask you: why all these faces, why such a blatant show of faces—but what came out was this rattling laughter, these gross, insistent gasps, hoarse, irrepressible....[6] *I laugh ... that my eyes persist in demanding objects that do not destroy them.*[7] *Bah! I'll make all the ugly faces I can!*[8]

He drew with vigorous abandon, frequently going through half a dozen of his willow-wood charcoal sticks in the shortest of time.[9] The simple contact of skin and paper ... emerges from a subterranean, muddled story—catastrophes, fusions, attempts that are no good[10] ... and that process of drawing and shading on the thick, leathery paper, as well as the concomitant business of constantly erasing what he had drawn with a woollen rag already heavy with charcoal, really amounted to nothing but a

2. W. G. Sebald, *The Emigrants* (1992), trans. Michael Hulse (New York: New Directions, 1997), 160–61.
3. Arthur Rimbaud, "A Season in Hell," reprinted in Rimbaud, *Complete Works*, trans. Paul Schmidt (New York: Perennial Classics, 2000), 234.
4. Walter Benjamin, quoted in Susan Buck-Morss, *The Dialectics of Seeing: Walter Benjamin and the Arcades Project* (Cambridge, MA: MIT Press, 1989), 263.
5. Simone Weil, "Beauty," in *Gravity and Grace* (1947), trans. Emma Crawford and Mario von der Ruhr (London: Routledge, 2002), 151.
6. Philippe Sollers, *Event*, trans. Bruce Benderson and Ursule Molinaro (New York: Red Dust, 1965), 33.
7. Georges Bataille, "The Practice of Joy before Death," reprinted in Bataille, *Visions of Excess: Selected Writings, 1927–1939* (Minneapolis: University of Minnesota Press, 1985), 239.
8. Rimbaud, "A Season in Hell," 227.
9. Sebald, *The Emigrants*, 161–62.
10. Sollers, *Event*, 71.

Studio, Los Angeles, 2006–2007

steady production of dust, which never ceased except at night.[11] He felt closer to dust, he said, than to light, air or water.[12] *I only find within my bones / A taste for eating earth and stones. / When I feed, I feed on air, / Rocks and coals and iron ore.*[13]

He himself once remarked, studying the gleam of graphite on the back of his hands, that in his dreams, both waking and by night, he had already crossed all the earth's deserts of sand and stone.[14]

Make the city swallow its dust! Turn gargoyles to rust![15]

And if he then decided that the portrait was done, not so much because he was convinced that it was finished as through sheer exhaustion, an onlooker might well feel that it had evolved from a long lineage of grey, ancestral faces, rendered unto ash but still there, as ghostly presences, on the harried paper.[16] *A face, thirsting to reach the surface, has left the depths of the abdomen, invaded the thoracic cavity.... Even the knees are trying to see. This is not a joke.... Such is my drawing, such it continues.*[17]

This shape is his *own* existence ... in all its stirrings and impulses:[18] the jungle physique of the barbarian and the over-soulful, over-wakeful, hecticly glittering eyes of the disciple of the Christian mysteries, extreme childish-ness and youthfulness and likewise extreme over-ripeness

11. Sebald, *The Emigrants*, 162.
12. Ibid., 161.
13. Rimbaud, "A Season in Hell," 235.
14. Sebald, *The Emigrants*, 164.
15. Rimbaud, "A Season in Hell," 235.
16. Sebald, *The Emigrants*, 162.
17. Henri Michaux, "Drawings with Commentary," reprinted in Michaux, *Darkness Moves: An Henri Michaux Anthology: 1927–1984*, ed. David Ball (Berkeley: University of California Press, 1994), 33.
18. G. W. F. Hegel, *Phenomenology of Spirit* (1807), trans. A. V. Miller (Oxford, England: Oxford University Press, 1977), 439.

and weariness of age ... [the] tenuousness of the spirit of late antiquity ... came together in a single person.[19] You've wavered between two systems ... between the meticulous phlegm and stern resolve of the old German masters and the dazzling ardor and happy abundance of the Italians. Your figure ... betrays the traces of this unfortunate vacillation.[20] *Although I possessed the capacity of bestowing animation, yet to prepare a frame for the reception of it, with all its intricacies of fibres, muscles, and veins, still remained a work of inconceivable difficulty and labour.... The materials at present within my command hardly appeared adequate to so arduous an undertaking.*[21] Everything is taken from the past. For the body and the soul ... we have ... household remedies and folk songs rearranged.[22] One day man was virulent, / he was nothing but electric nerves, / flames of a perpetually burning phosphorous, / but this passed into fable ... and the magic life of man fell, / man fell from his magnetic rock, / and inspiration which was the foundation / became chance, accident.[23] He who nowadays still ... lives for a time in metaphysics and art, has in any event gone back quite a distance and begins his race with other modern men under unfavorable circumstances: he appears to be at a disadvantage as regards both space and time.[24] The

19. Friedrich Nietzsche, *Human, All Too Human: A Book for Free Spirits* (1878), trans. R. J. Hollingdale (Cambridge, England: Cambridge University Press, 1986), 367.
20. Honoré de Balzac, *The Unknown Masterpiece* (1832), trans. Richard Howard (New York: New York Review Books, 2001), 12–13.
21. Mary Shelley, *Frankenstein* (1818; reprint, New York: Barnes & Noble Classics, 2003), 51.
22. Rimbaud, "A Season in Hell," 221.
23. Antonin Artaud, "Letter to Pierre Loeb" (1947), published in Artaud, *Selected Writings*, ed. Susan Sontag, trans. Helen Weaver (Berkeley: University of California Press, 1976), 517.
24. Nietzsche, *Human, All Too Human*, 128.

modern system makes it appear as though *everything* were explained.[25] Always this notion: suppose the Moderns were wrong? What if they had no talent?[26] Inside the museums, Infinity goes up on trial.[27] The works of the Muse now lack the power of the Spirit, for the Spirit has gained its certainty of itself from the crushing of gods and men.[28] In modernity the sacred has appeared, if at all, through the lens of vulnerability. Not in the emanation of pride and beauty, but as their shattering. Broken and mangled, isolated by its suffering, the sacred in our day pulsates, if at all, weakly.[29] Beauty ... has something powerless about it. For the terrifying digs in on the perimeter like the enemy in front of the walls of the beleaguered city and starves it out.[30] The statues are now only stones from which the living soul has flown ... our active enjoyment of them is therefore not an act of divine worship ... it is an external activity—the wiping-off of some drops of rain or specks of dust.[31] The visions have organized. But perhaps the most decisive are those that leave him no image, only the basic live trace of an erased adventure.... an endless museum of chatter molts into a dumb show.[32] *I imagine a set of distinct objects, pieces, sections of Babel, immersed in the confused murmur of tongues, walls penetrated or covered with viscous fury.... I see flashes of unities amidst occulted*

25. Ludwig Wittgenstein, *Tractatus Logico-Philosophicus* (1921), trans. C. K. Ogden (London: Routledge, 1990), 181.
26. Roland Barthes, "Soirées de Paris" (1979), in Barthes, *Incidents* (1987), trans. Richard Howard (Berkeley: University of California Press, 1992), 55.
27. Bob Dylan, "Visions of Johanna" (1966).
28. Hegel, *Phenomenology of Spirit*, 455.
29. Avital Ronell, *Stupidity* (Urbana: University of Illinois Press, 2002), 206.
30. Theodor Adorno, *Aesthetic Theory* (1970), trans. Robert Hullot-Kentor (Minneapolis: University of Minnesota Press, 1997), 51.
31. Hegel, *Phenomenology of Spirit*, 455.
32. Sollers, *Event*, 7.

multiplicities.[33] *For a long time ... it seems that I have had a dream that I am tumbling across the void and a crowd of idols made of wood, iron, gold and silver fall with me, follow me in my fall, pounding and shattering my head and loins.*[34] When the entire history of culture opens up before our gaze as a confusion of evil and noble, true and false conceptions, and at the sight of this surging of the waves we come to feel almost seasick, we are then able to grasp what comfort there lies in the idea of an *evolving god.*[35] In an unsuitable, indeed, hostile environment ... the world of the ancient gods would have had to die out, and it is precisely allegory that rescued it.[36] One ... erects an intricate scaffolding of the dead elements ... in order to ... possess an idea of them in our imagination.... it is the Spirit of the tragic Fate which gathers all those individual gods ... into one pantheon:[37] heads of the past, that *know* the night of life ... heads that have gone through something as serious as death and who could not save themselves, or else not very well ... heads profoundly hurt, that no longer trust anything, that remember[38] ... unknown soldier escaped from some war or other, ascetic body, reduced to few barbed wires[39] ... a genuine little man of earth ... unnoticed as ever somewhere far away the grinding of the wheels of history continues.[40]

How often, grim Caricature, must I / jingle my bells

33. Michel Serres, *Genesis* (1982), trans. Geneviève James and James Nielson (Ann Arbor: University of Michigan Press, 1995), 127.
34. Charles Baudelaire, quoted in Buck-Morss, *The Dialectics of Seeing*, 186.
35. Nietzsche, *Human, All Too Human*, 114.
36. Benjamin, quoted in Buck-Morss, *The Dialectics of Seeing*, 168.
37. Hegel, *Phenomenology of Spirit*, 455–56.
38. Michaux, "Ravaged People," in *Darkness Moves*, 261.
39. Michaux, "Drawings with Commentary," in *Darkness Moves*, 34.
40. J. M. Coetzee, *Life & Times of Michael K* (1983; reprint, New York: Viking Penguin, 1985), 161.

and kiss your bestial brow? / Until my aim is true— the circle squared— / how many arrows forfeit to the Void?[41]

Have I said it before? I am learning to see.... It still goes badly.[42] *Work while you can! A painter should philosophize only with a brush in his hand.*[43] *To some their idol will not be revealed, / and these doomed sculptors, branded with disgrace, / upbraid themselves and lacerate their breasts.*[44] *In order to glorify it, to embellish it, or in order to dismember it, to take it to the limit of what can be known about the body: I would go so far as to take bliss in a* disfiguration.[45] He grabowerates him and grabacks him to the ground; / He rads him and rabarts him to his drat; / He braddles him and lippucks him and prooks his bawdles; / He tackreds him and marmeens him / Mandles him rasp by rip and risp by rap. / And he deskinnibilizes him at the end.[46] *But now that I had finished, the beauty of the dream vanished, and breathless horror and disgust filled my heart.*[47] *I shuddered to see a face from the inside, but still I was much more afraid of the naked flayed head without a face.*[48] *Impossible to misidentify, was a darkness, a void, a tunnel that led all the way to my extinction.... I knew about the convex. But here was the concave.*[49] In a concave mirror, the image vanishes into infinity and appears again close before us. Just in this way, after self-consciousness

41. Baudelaire, *Les fleurs du mal* (1857), trans. Richard Howard (Boston: David R. Godine, 1982), 150.
42. Rainer Maria Rilke, *The Notebooks of Malte Laurids Brigge* (1910), trans. M. D. Herter Norton (New York: W. W. Norton, 1992), 15.
43. Balzac, *The Unknown Masterpiece*, 27.
44. Baudelaire, *Les fleurs du mal*, 150.
45. Barthes, *The Pleasure of the Text* (1973), trans. Richard Miller (New York: Noonday Press, 1975), 37.
46. Michaux, "The Big Fight," in *Darkness Moves*, 3.
47. Shelley, *Frankenstein*, 55.
48. Rilke, *The Notebooks of Malte Laurids Brigge*, 16.
49. Martin Amis, *Experience* (London: Vintage, 2001), 85.

has, so to speak, passed through infinity, the quality of grace will reappear; and this reborn quality will appear in the greatest purity, a purity that has either no consciousness or consciousness without limit: either the jointed doll or the god.[50] The artist, then, learns in his work that he did not produce a being *like himself*.... He could impart perfection to his work only by emptying himself of his particularity, depersonalizing himself and rising to the abstraction.[51] The picture hangs on the wall like a rifle or a hat ... travels from one exhibition to another. Works of art are shipped like coal from the Ruhr and logs from the Black Forest.[52] It is only through its darkness that this art can outmaneuver the demystified world and cancel the spell that this world casts by the overwhelming force of its appearance.[53] *I could only grasp a cluster of faces or masks / thrown down like rings of hollow gold / like scarecrow clothes, daughters of rabid autumn / shaking the stunted tree of the frightened races.*[54] If human beings have a destiny, it is rather to escape the face ... to become imperceptible, to become clandestine ... by strange true becomings that get past the wall and get out of the black holes, that ... elude the organization of the face—freckles dashing toward the horizon, hair carried off by the wind.[55] The inhabitant of the disordered face is not giving up.[56]

50. Heinrich von Kleist, "On the Marionette Theater" (1810), available at http://grace.evergreen.edu/~arunc/texts/literature/kleist/kleist.pdf.
51. Hegel, *Phenomenology of Spirit*, 429.
52. Martin Heidegger, "The Origin of the Work of Art" (1935–60), in *Poetry, Language, Thought*, trans. Albert Hofstadter (New York: Harper & Row, 1975), 19.
53. Adorno, *Aesthetic Theory*, 58.
54. Pablo Neruda, *The Heights of Macchu Picchu*, trans. Nathaniel Tarn (New York: Farrar, Straus & Giroux, 1966), 9.
55. Gilles Deleuze and Félix Guatarri, *A Thousand Plateaus: Capitalism & Schizophrenia* (1980), trans. Brian Massumi (Minneapolis: University of Minnesota Press, 1987), 171.
56. Michaux, "Ravaged People," in *Darkness Moves*, 261.

Shadowland

Richard Flood

Toussaint L'Ouverture, 1743–1803

A version of this essay was previously published in *Afterall*, no. 7 (2003), and adapted from its original publication in the exhibition catalogue *no place (like home)* (Minneapolis: Walker Art Center, 1997).

Cut a chrysalis open, and you will find a rotting caterpillar. What you will never find is that mythical creature, half caterpillar, half butterfly, a fit emblem for the human soul. For those whose cast of mind leads them to seek such emblems. No, the process of transformation consists almost entirely of decay.[1]

Art is not life, nor was it ever meant to be. Art is, at its most elevated, that triumph of the cognitive animal over banal necessity. History is not experience, nor a mirror of experience. History is, at its simplest, what has been remembered, or misremembered, for the record. Art and history are not congenial; they don't lie to each other, but they are incapable of telling the same truths. They can both approach the truth, caress it a bit, but truth is something other, something that is neither expressive nor linear. Art and truth are, however, sympathetically conjugal and dwell in the many-chambered cave of life and history. They merge and mingle in a whispering darkness where an occasional pulse of flame illumines that which we fear the most and that to which we aspire most dearly. It is a darkness inhabited by ghosts and infants, those who have passed over and those who have yet to bear witness or wear the stain of complicity. What light exists is provided by artists who, from the beginning, have transformed caves into civilizations.

THE DUCHESS: "I've done you so much harm in wishing to do you good."[2]

In 1823, a remarkable novel was published in France. Entitled *Ourika*, it purported to be the autobiographical account of a young Senegalese woman, who, as a child, was rescued from slavery and subsequently raised in the bosom of the French aristocracy. The book is brief; the prose, eloquently spare. While the first of the San Domingo slave uprisings in 1791 and the French Reign of Terror, which began in 1793, play crucial roles in the narrative, history is not really the issue. Rather, *Ourika* is concerned with a shadowland that eludes the map of history—a place where souls are doomed to wander in search of the history that has escaped them.

Ourika was the creation of Claire de Duras, an aristocrat and survivor of the French Revolution. Her book, which introduced the first Negro narrator in European literature, was an immediate best seller. As slavery did not

1. Pat Barker, *Regeneration* (New York: Penguin Books, 1993), 184.
2. Claire de Duras, *Ourika*, trans. John Fowles (New York: Modern Language Association, 1994), 46.
3. Ibid., 39.
4. C. L. R. James, *The Black Jacobins: Toussaint L'Ouverture and the San Domingo Revolution* (New York: Random House, 1963), 336.

become illegal in the French colonies until 1848, it was also a pioneering work of abolitionist literature—a moral fiction. Duras' heroine was based on fact, but the sensitivity of the author's characterization transcends the limitations of imaginative reportage. *Ourika* is one of those extraordinary novas that illuminate the landscape over which they burn and presage that which is to come.

The tender eloquence with which Duras tells Ourika's story is more than a graceful act of literary imposture; it is a transformative rite of identification. While it is also tempting to view *Ourika*, by extension, as a meditation on the status of women, that would be to miss the greater achievement. Duras was a presiding member of the French Enlightenment, authored novels, maintained a salon in the Tuileries Palace, and served as an intellectual mentor to one of the era's greatest diplomats, Vicomte Chateaubriand. With the exception of the novel's narrator, the women in *Ourika* are liberated. The great achievement of the novel is that it gives voice to something vast and unchartable. *Ourika* crystallizes the unthinkable awfulness of those cast into the shadowland—of those forced to follow a road map that leads inexorably to no place.

> What did it matter that I might now have been the black slave of some rich planter? Scorched by the sun, I should be laboring on someone else's land. But I would have a poor hut of my own to go to at day's end; a partner in my life, children of my own race who would call me their mother, who would kiss my face without disgust, who would rest their heads against my neck and sleep in my arms. I had done nothing—and yet here I was, condemned never to know the only feelings my heart was created for.[3]

THE GENERAL: "I am sending to France with all his family this man who is such a danger to San Domingo. The Government, Citizen Minister, must have him put in a very strong place situated in the center of France, so that he may never have any means of escaping and returning to San Domingo, where he has all the influence of the leader of a sect. If in three years this man were to reappear in San Domingo, perhaps he would destroy all that France had done there.... I entreat you, send me some troops. Without them I cannot undertake the disarming of the population, and without the disarming I am not master of this colony."[4] (General Leclerc, brother-in-law to Napoléon Bonaparte and commander of French forces in San Domingo)

In 1803, a scant few years after Ourika's fictional death, a real exile died at Fort-de-Joux, high in the Jura Mountains along the French-Swiss border.

The exile was Toussaint L'Ouverture, the Creole son of an African-born slave and the leader of what would, after his death, become the first successful slave rebellion in the New World. He was fifty-seven years old and a loyal son of France. He died believing in the Rights of Man promulgated by the Revolution and in the man who murdered him through aggressive neglect—Napoléon Bonaparte. Fort-de-Joux was L'Ouverture's shadowland. To the end, L'Ouverture believed that Bonaparte would negotiate in good faith, and as an equal, for the freedom of the slaves of San Domingo. Bonaparte, of course, had no intention of upsetting the machinery of slavery and simply sought to silence its most eloquent opponent. At Fort-de-Joux, shamed and separated from all he held dear, guilty of no crime that would warrant trial, L'Ouverture wrote from his heart to Bonaparte asking for release from the historical cul-de-sac to which he had been condemned:

> I have the misfortune to incur your anger; but as to fidelity and probity, I am strong in my conscience, and I dare to say with truth that among all the servants of the State none is more honest than I. I was one of your soldiers and the first servant of the Republic of San Domingo. I am to-day wretched, ruined, dishonored, a victim of my own services. Let your sensibility be touched at my position, you are too great in feeling and too just not to pronounce on my destiny.[5]

There was to be no justice for L'Ouverture. Perhaps, at the end, he took heart from the words he had pronounced to the captain of the boat sent to remove him from his Caribbean island to France: "In overthrowing me, you have cut down in San Domingo only the trunk of the tree of liberty. It will spring up again by the roots for they are numerous and deep."[6] The tragic irony of L'Ouverture's defeat was that the very citizens of France with whom he believed he shared a vision could not, by and large, accept the loss that honoring the vision would entail. It was, after all, the growing bourgeoisie who fostered and funded the French Revolution, and their continued welfare was deeply and profoundly interwoven with the slave trade. Even as the Revolution brewed in France, thirty to forty thousand slaves a year were still being fed into San Domingo to reap ever greater harvests in trade, harvests that spread the wealth not only in France but throughout Europe.

5. Ibid., 364.
6. Ibid., 334.
7. In Stephen E. Ambrose, *Undaunted Courage: Meriwether Lewis, Thomas Jefferson, and the Opening of the American West* (New York: Simon and Schuster, 1996), 35.
8. Duras, *Ourika*, 23.

Historical fact tells us that, in the twilight of the 18th century, there were half a million slaves on the island of San Domingo, the majority of whom were native Africans. The recent arrivals were often at odds with their Creole predecessors and both were at odds with the mulattos. Occupying neither world, the mulattos were subjected to the caprices of eugenic classification (there were 128 shades of color culminating in the *sang-mêlé*, who was composed of 127 parts white, 1 part black, and classified as black) and the whimsy of those who could offer or deny them freedom. It was a system that promoted self-loathing and hubris in equal portion. To be robbed of one's essential identity, and then blamed for the loss by the one who has robbed you, was perhaps the cruelest practice in a litany of atrocities enacted by the French overlords.

L'Ouverture sprang from the fatally abundant soil of San Domingo and formed an army that would, in his wake, topple the French rule and lead to the creation of Haiti, the first black state in the New World. L'Ouverture was, however, much more than a brilliant insurgent; he was a man of the Enlightenment, and he believed that he was fighting for the universal rights of man. Had he been less of a man, he might well have survived to realize half of his dream. As it was, that which made him great also destroyed him.

THE PRESIDENT: "The whole commerce between master and slave is a perpetual exercise of the most boisterous passions, the most unremitting despotism on the one part, and degrading submissions on the other."[7] (Thomas Jefferson, *Notes on the State of Virginia*)

One of the most chilling moments in *Ourika* comes when its narrator learns of the first massacre of the white planters by the San Domingo slaves and repudiates her own race, a race she knows nothing of. Later, at the height of the Terror, surrounded by her beleaguered white protectors, Ourika has a horrible epiphany that seals her fate as surely as L'Ouverture's idealism sealed his. "In any case," she reflects, "all the world was miserable, and I no longer felt alone. A view of life is like a motherland. It is a possession mutually shared. Those who uphold and defend it are like brothers. Sometimes I used to tell myself that, poor negress though I was, I still belonged with all the noblest of spirits, because of our shared longing for justice."[8] But, alas, Ourika had by then become a shadow and shadows cannot act; they are merely insubstantial echoes of that which they mimic.

Ourika, the metaphor, and L'Ouverture, the reality, are both seared by drawing too close to the tripartite flame of *liberté, égalité, fraternité*. Shaped by the pen and scarred by the brand, neither ever had the possibility of

escaping from the shadowland to see the fullness of themselves reflected in oneness with those whose reality they could only dream into being. The irony is that their dream had been construc ted by others less generous than themselves—others whose moral order depended on the extension of the promise and whose economic order necessitated the denial of the promise. The contradiction in it all is bluntly caught in Dr. Samuel Johnson's questioning taunt: "How is it that we hear the loudest yelps of liberty from the drivers of Negroes?"[9] The tragedy in it all is made devastatingly clear in the words of America's greatest advocate of the Enlightenment, Thomas Jefferson: "I tremble for my country when I reflect that God is just."[10] Jefferson (framer of the Declaration of Independence, American ambassador to the Court of Louis XVI, and third president of the United States) was, at the time of his death in 1826, one of the largest slaveholders in all of Virginia.

THE CURATE: "The procession went on, amid that mixture of rites that characterizes idolatry in all countries—half resplendent, half horrible— appealing to nature while they rebel against her—mingling flowers with blood, and casting alternatively a screaming infant, or a garland of roses, beneath the car of the idol."[11]

Two years before the death of Thomas Jefferson, Charles Robert Maturin, the Anglican curate of St. Peter's Church in Dublin, Ireland, died of an accidental dose of poison. He was forty-four years old and the author of the last epic Gothic novel, *Melmoth the Wanderer*. Maturin was Irish (and a nationalist) but came from a Protestant family that had fled France after the Edict of Nantes was reversed and persecution of the Protestants began once more. His novel is a giddy orchestration of ever-mounting horrors within a rat's nest of related stories, all of which are driven by the dementia induced by otherness. Woven through the novel are narrative strands dealing with Thomas Cromwell's subjugation of Ireland and the Roundhead confiscation of Irish-Catholic properties, the nightmares of Bedlam at the height of the English Restoration, and the persecution of Jews and dissidents by the Spanish Inquisition. Everything is overheated and very little is without historical precedent. Maturin had, for example, seen in his own lifetime the long-dormant Spanish Inquisition brought

9. Ambrose, *Undaunted Courage*, 449.
10. Ibid.
11. Charles Robert Maturin, *Melmoth the Wanderer* (Lincoln: University of Nebraska Press, 1961), 225.
12. Ibid., 123.
13. In Georges Bataille, *Erotism: Death and Sensuality*, trans. Mary Dalwood (San Francisco: City Lights Books, 1986), 194.
14. Ibid., 179.
15. Maturin, *Melmoth the Wanderer*, 15.

back to papacy-sanctioned life in 1778, and felt the sympathetic, anti-British shock waves that respirated through Ireland during the heady first year of the French Revolution.

While *Melmoth* seethes with all the height discordancy of the Gothic form, it has a noble gravity missing in other examples of the genre. Its protagonist, the Wanderer, is doomed to be an exile from all that he knows, and it is his exile that Maturin designates as the novel's greatest horror. Maturin was child of the Enlightenment, and while Gothic (in its antirational hysterical-ization of all incident) would seem, on the surface, to be an absolute contradiction to the goals of Enlightenment, it served Maturin's humanist concerns quite nicely. The unspeakable despair of a man who belongs nowhere, whose life is an endless search for a resting place, further led Maturin to write one of the century's great soliloquies of the dispossessed:

> The terror that I inspired I at last began to feel. I began to believe myself—I know not what, whatever they thought me. This is a dreadful state of mind, but one impossible to avoid. In some circumstances, where the whole world is against us, we begin to take its part against ourselves, to avoid the withering sensation of being alone on our own side.[12]

THE MARQUIS: "In Marseilles, he had himself whipped, but every couple of minutes he would dash to the mantelpiece and, with a knife, would inscribe on the chimney flue the number of lashes he had just received."[13] (Simone de Beauvoir, *Marquis de Sade*)

Not so curiously, one of Gothic fiction's most rational supporters was the Marquis de Sade (to admire him, wrote Georges Bataille, "is to diminish the force of his ideas").[14] For de Sade, who briefly profited from the Revolution when he was freed by the mob from the Bastille, the Gothic novel evidences "the inevitable fruits of the revolutionary shocks felt by all of Europe.... For those who know all the miseries with which scoundrels can oppress men, the novel became as difficult to write as it was monotonous to read.... It was necessary to call hell to the rescue ... and to find in the world of nightmare the history of man in this Iron Age."[15] While it would be difficult to advance de Sade as a model representative of the Enlightenment, he was certainly a recipient of its "fruits" and a disenfranchised member of its aristocratic originators. Certainly, in his sense of victimization and authorial role of victimizer, he understood the consummate perversity of master/slave relationships better than his more idealistic peers. Georges Bataille, in his essay "De Sade's Sovereign Man," quotes Clairwill, one of de Sade's most ticklish fictional inventions:

I'd like to find a crime that should have never-ending repercussions even when I have ceased to act, so that there would not be a single instant of my life when even if I were asleep I was not the cause of some disorder or another, and this disorder I should like to expand until it brought general corruption in its train or such a categorical disturbance that even beyond my life the effects would continue.[16]

Here, truly, is the demonic understanding of how the well of reason is poisoned and of the monstrous implications when others, namely "we," drink its putrescence. In his summation of de Sade's frightening contribution to Western thought, Bataille states it all quite clearly: "And if today the average man has a profound insight into what transgression means for him, de Sade was the one who made ready the path. Now the average man knows that he must become aware of things which repel him most violently—those things which repel us most violently are part of our own nature."[17]

THE POET: "Toussaint, the most unhappy man of men! Whether the whistling Rustic tend his plough Within thy hearing, or thy head be now Pillowed in some deep dungeon's earless den; —O miserable Chieftain! where and when Wilt thou find patience! Yet die not; do thou Wear rather in thy bonds a cheerful brow: Though fallen thyself, never to rise again, Live, and take comfort. Thou has left behind Powers that will work for thee; air, earth, and skies; There's not a breathing of the common wind That will forget thee; thou has great allies; Thy friends are exultations, agonies, And love, and man's unconquerable mind."[18] (William Wordsworth, "To Toussaint L'Ouverture")

William Wordsworth, the greatest of the English Romantic poets, died two years after the abolition of slavery in the French colonies and eleven years before the start of the American Civil War. By the time of his death, San Domingo had been the black republic of Haiti for forty-six years and Bonaparte had long been toppled and lay buried in indignity on Elba. Wordsworth's tribute to L'Ouverture is filled with eloquent promise and the implicit acknowledgment that what L'Ouverture fought to attain is within reach. It was not, nor is it today.

16. Bataille, *Erotism*, 174.
17. Ibid., 196.
18. In M. L. Rosenthal and J. J. M. Smith, *Exploring Poetry* (New York: Macmillan, 1955), 622.

Artistic responses to legacies born centuries ago and oceans away to parents we never knew continue unabated from the imagined Ourika. The legacies—colonialism, slavery, cultural and physical displacement—received some of their worst interpretations and the proposal of some of their most eloquent solutions in what Charles Dickens called "the best of times and the worst of times," the 18th century. The most fluorescent heritage of the age of Enlightenment—the Rights of Man—was forged by the French Revolution and put to savage use during the Reign of Terror. But, once the guillotine was stilled, nothing much seemed really changed. Instead of a Bourbon king, France raised a Corsican emperor.

Today, the progress toward a new age of *liberté, égalité, fraternité*—convulsive as it has been—still seems modest. L'Ouverture's tangled roots have put forth only the plainest of leaves, hardly the vibrant hybrid prophesied by the bloodied frenzy of cultivation. We have, as a civilization, washed up at no place in particular as the road to a true Enlightenment has proved more treacherous than ever anticipated. And, while art is far too fragile a creation to significantly alter the course of history, it can allow us, if only for a moment, to draw perilously close to an understanding of what history and life have done to those fellow pilgrims we share it with.

96 Sacraments

Paul Thek

"96 Sacraments" [Lufthansa notebook], c. 1975

ALI SUL MONDO

QUADERNO

96 Sacraments

1. To wake up. Praise the Lord.
2. To breathe. Praise the Lord. – the
3. To touch the earth. Praise the Lord.
4. To pee. Praise the Lord. To make a fire. Praise the Lord.
5. To wash. To comb your hair. Praise the Lord. Praise the Lord.
6. To prepare breakfast. Praise the Lord. To squeeze a lemon. Praise the Lord.
7. To eat breakfast. Praise the Lord. to take a pill.
8. To do the dishes to. Praise the Lord.
9. To clean up. Praise the Lord.
10. To write a letter. Praise the Lord
13. To mail a letter. Praise the Lord
11. To go out. Praise the Lord.
12. To see the sun. Praise the Lord.
14. To do the shopping.
15. To talk with some people.
16. To buy a paper.
17. To go come home.
18. To go to work.
19. To work.

20. To have lunch. Sing Praises!
21. To work in the afternoon. Praise the Lord.
22. To notice the light changing. Sing Praises.
23. To see a cat. Praise the Lord. Sing Praises.
24. To see a dog. Praise the Lord.
25. To stop for a rest. Praise the Lord.
26. To go home for dinner. Sing Praise!
27. To talk with a neighbor.
28. To talk with a neighbors child.
29. To kiss ~~someone~~ someone.
30. To eat dinner. Sing Praises!
31. To eat dinner with friends.
32. " " " " children.
33. " " " alone.
34. To have dinner with ~~someone~~ someone.
35. To think of love. Praise the Lord.
36. To think of hope. Praise the Lord.
37. To think. Praise the Lord.
38. To dream. Sing Praises!

39. To plan. Praise the Lord.
40. To write a poem. Praise the Lord
41. To read a poem. Praise the Lord
42. To forget bad things. Praise the Lord
43. To sing. Praise the Lord
44. To sing with someone. Praise the Lord.

45. To hold hands. Praise the Lord.
46. To hold anything. Praise the Lord.
47. To hug. Praise the Lord.

4

48. To get on a boat. Praise the Lord.
49. To go somewhere. Praise the Lord.
50. To eat a snack. Praise the Lord.
51. Not to eat a snack. Praise the Lord.
52. To give away some money.
 Praise the Lord.
53. To replace some technological
54. education with some spiritual
55. education.

56. To see an island.
57. To go swimming.
58. To see somebody worse off.
59. To see " better off.
60. To go swimming nude.
61. To make love in the day time.
62. " " " " nite
63. " " " with someone you know
64. " " " " " dont
65. To eat a peach
66. To comb your hair

To practice.
To be just.
To be a bit stronger than
 you were.
To understand a bit more.
To like the ups & downs of it.
To somewhere feel OK, in
spite of it all. To feel
good somewhere, knowing
all the "worst".

2º Avoiding being forced into
defiance, avoiding emotional
escalation, noticing more the
things of The Kingdom.

To seek the Lords opinion,
as, well, in our efforts,
whatever efforts.

To forget The Way.
To know The Devil, and his points.
Praise the Lord.

To find a way to grow
feathers. Praise the Lord.
To satisfy all hunger in the
world. Praise the Lord. To
avoid dominations and
dominatings. Praise the Lord.
To never stray? Praise the
Lord. To be innocent of
corruptions. Praise the
Lord.
To not think, Praise the
Lord, at least now and then.

To worship in anothers church,
in anothers way. Praise the Lord.

To fly away into the air, about as
high as a chicken cat, & then to
come back. Praise the Lord.
To be born. Praise the Lord.
To grow. Praise the Lord.
To die. Praise the Lord.

To wink. Praise the Lord!
To weep. Praise the Lord!
To appreciate cobwebs. Praise the Lord!
To have a toothache. Praise the Lord!
To be left alone. Praise the Lord.
To be afraid of the dark. Praise the Lord!
To be confused. Praise the Lord!
To be

The French are very revolution-
ary, but the Italians are
more graceful, if one had to
compare things, Praise the
Lord, excuse me for taking
the groups time.

PUMPKIN · PYRAMID

Just love what you're doing.

NEL TONDO: PARTICOLARE
DELLA CABINA DI COMANDO

icci PRODOTTI
IL DECOLLO DEL BOEING 707
INTERCONTINENTALE DELLA LUFTHANSA

Paul Thek 96 Sacraments

I Wish Your Wish

Rivane Neuenschwander

To make *I Wish Your Wish*, the Brazilian artist Rivane Neuenschwander asks people of different ages in different countries what they wish for; she then prints the wishes onto thousands of brightly colored ribbons, which are installed in the gallery. Visitors to the exhibition are invited to select from the wishes of others and leave behind a wish of their own.

I Wish Your Wish is inspired by the tradition of traveling to the Church of Nosso Senhor do Bonfim in São Salvador, Bahia, Brazil. Visitors to the church select a ribbon and tie it with three knots, making a wish with each knot. The ribbon is then tied to the visitor's wrist. According to tradition, wishes come true when the ribbon falls off the wrist.

I WISH I COULD GO BACK IN TIME I WISH THERE WAS NO RELIGION **A LIBERDADE DE NÃO SENTIR MEDO** DESIDERO CHE FINISCA IL DOLORE **I WISH TO FIND PLEASURE IN THINGS AS MUCH AS I USED TO AS A CHILD** JE DÉSIRE AVOIR MOINS PEUR DE LA VIE QUE DE LA MORT **I WISH I COULD BE FLYING WITHOUT STOPPING** I WISH I WAS SUPERMAN **DESEO NUNCA PERDER LA CAPACIDAD DE DESEO** I WISH TO KNOW WHAT I WILL BE WHEN I GROW UP **DES TRAVAUX QUI SOIENT COMME DES VOYAGES VERS DES PAYS LOINTAINS** EU DESEJO CALMA **I WISH THE WORLD WOULD BE WITHOUT CONFLICT** EU DESEJO IGUALDADE SOCIAL **I WISH FOR ETERNAL LOVE** JE DÉSIRE QUE LES DÉSIRS SE RÉALISENT **PEACE FOREVER IN LEBANON** I WISH MORNINGS WERE MORE PLEASANT **EU DESEJO O FIM DOS DESEJOS** JE VOUDRAIS RETROUVER L'AMOUR **SERENITY NOW INSANITY LATER** ICH WÜNSCHE DICH **EU DESEJO A FELICIDADE DO MEU FILHO THEO** DESEO QUE NO HAYA GRAVEDAD **I WISH I DIDN'T HAVE TO THINK** ICH WÜNSCHE MEINE ANGST VOR VERLUST ZU VERLIEREN **I WISH MONEY WOULDN'T PLAY SUCH AN IMPORTANT ROLE** I WISH A HOLIDAY IN LA PLAYA **DESIDERO TUTTA LA FELICITÀ DEL MONDO AI MIEI FIGLI** I WISH DEMOCRACY WAS REAL **JE DÉSIRE VIVRE AU BORD DE LA MER** I WISH TO GRADUATE **EU DESEJO MAIS HONESTIDADE DOS POLÍTICOS** I WISH FOR EXCITEMENT EVERY DAY OF MY LIFE **I WISH I COULD ACCEPT** ICH WÜNSCHE NIE WUNSCHLOS ZU SEIN **DESEJO A MORENA QUE ORGANIZA O BAGULHO** I WISH I COULD FIGURE OUT WHAT HAS TO BE DONE **I WISH I COULD SAY AN UNCONDITIONAL YES** JE DÉSIRE RETOURNER AU BRÉSIL **I WISH THAT THE WORLD WAS MY HOME** I WISH I HAD A BIG FLAT AND STUDIO IN THE CENTRE OF A BIG CITY **I WISH I HAD MORE TIME FOR MYSELF** ICH WÜNSCHE MIR MEHR ZEIT FÜR DICH **I WISH MY DESIRE** JE DÉSIRE NE PLUS AVOIR DE PATRIE **I WISH FOR PEACE WITHIN** EU DESEJO QUE PAREM DE MALTRATAR OS ANIMAIS **I WISH NOT TO BE BORED** I WISH THERE WAS NO STRESS IN MY LIFE **CURIOSITY SIMPLICITY TOLERANCE** I WISH TO HAVE A HEALTHY AND HAPPY CHILD **I WISH TO WISH THREE TIMES THE SAME WISH** I WISH I WAS DRINKING A MARGARITA IN MY FAVORITE BAR IN MEXICO **I WISH I COULD LIVE IN THE MOMENT AND FORGET THE PAST AND THE FUTURE** SAÚDE PROSPERIDADE E UM AMOR DE VERDADE **I WISH YOUR WISH** JE DEMANDE QUE RIEN DE MAL N'ARRIVE À MES ENFANTS **JE DÉSIRE MOURIR EN DORMANT** I HOPE TO GET A GOOD JOB **L'ÉPHÉMÈRE ILLUSION DE LA CHAIR FRAÎCHE** SEX FIVE TIMES A WEEK **TER UMA CASA COM JARDIM NA FRENTE** THE PEACE IN THE MIDDLE EAST **I WISH THAT I DID NOT HAVE TO WISH** I WISH TO BE ABSOLUTELY AND WHOLLY FREE **JE DÉSIRE CE QUI EST HORS DE MOI** I WISH I COULD CHANGE SOMETHING **I WISH FOR GOOD HEALTH** DESEO QUE ME QUIERAS COM PASIÓN **ICH WÜNSCHE MIR LOSLASSEN ZU KÖNNEN** ICH WÜNSCHE MIR

EIN VERDAMMT LANGES LEBEN **I WISH I COULD SLEEP FOREVER** J'AIMERAIS NE PLUS DÉPENDRE DES ANTI-DÉPRESSIFS **I WISH WISE AND HUMANITARIAN PEOPLE WERE CHOSEN AS LEADERS OF NATIONS** I WISH FOR LOVE **I WISH I WAS A ROCKSTAR** EU DESEJO-ME **QU'ELLE ME DISE QUE JE SUIS LA FEMME DE SA VIE** EU DESEJO QUE TODOS ESSES DESEJOS SE REALIZEM **I WISH I WOULD NEVER NEED ANYONE TO TAKE CARE OF ME IF SICK POOR OR MISERABLE** I WISH FOR GOD **EU DESEJO ME AMAR CADA VEZ MAIS** JE VEUX QUE M. RÉUSSISSE DANS SES ÉTUDES ET SA VIE **EU DESEJO VER O PALMEIRAS NA TERCEIRA DIVISÃO** JE DÉSIRE QUE LA JOIE DE VIVRE SOIS PLUS SIMPLE QUE J'IMAGINE **I WISH TO MAKE LIFE PROUD OF MY ACHIEVEMENTS** I WISH FOR NO MORE POLITICAL CRIMES IN LEBANON **MEU DESEJO É TER UM FILHO** JE VEUX DEUX MAISONS ET DEUX NATIONALITÉS **I WISH TO KNOW WHAT I WANT** QUERO QUE A OFICINA PROSPERE MUITO **I WISH I COULD GET RID OF GUILT** I WISH BEAUTY AND SEX **EU DESEJO ENCONTRAR ALGUÉM** EU DESEJO ANDAR DE TREM **I WISH I UNDERSTOOD VIDEO ART MORE** EU DESEJO QUE EU NÃO FIQUE CARECA **I WISH DIAMONDS** JE DÉSIRE QUE JE MARIERAI UN JOUR L'HOMME QUE J'AIME **JE DÉSIRE VOIR DE BEAUX SOURIRES** ICH WÜNSCHE MIR VIEL GESUNDHEIT VIEL GLÜCK UND VIEL ERFOLG **JE DÉSIRE BAISER** EU DESEJO UMA FEIJOADA **SABER O QUE FAZER COM MINHA ALMA** EU DESEJO NÃO BRIGAR COM NINGUÉM **I WISH TO FEAR NO ONE** I WISH MY DAYS HAD 30 HOURS **I WISH THAT I CAN HELP THE ONE I LOVE** I WISH I COULD SAY WHAT I FEEL **J'ESPÈRE RESTER LE PLUS LONGTEMPS POSSIBLE AVEC MA CHÉRIE** JE SOUHAITE RESPIRER **JE PRÉFÈRE MOURIR QUE SOUFFRIR** I WISH TO BE BORN AGAIN **EU DESEJO UM APARTAMENTO GRANDE** EU QUERO QUERER PARAR DE FUMAR **PERDER O MEDO DA PERDA** EU QUERO FICAR BOM **JE DÉSIRE AVOIR TOUT CE QUE JE DÉSIRE** JE VOUDRAIS QUE L'HOMME QUE J'AIME M'AIMASSE AUTANT EN RETOUR **I WISH YOU'LL ALWAYS BE THERE IN MY HEART** I WISH I COULD LOVE AND BE LOVED IN BIG CITIES **I WISH FOR YOU TO BE SAFE** JE DÉSIRE L'ART **QUERO PARAR DE CHEIRAR COCAÍNA** I WISH TO DIE FOR MY COUNTRY **I WISH TO BE A CINEMA ACTOR AND TO LIVE EVERY SINGLE EXCITING MOMENT IN IT** EU DESEJO O GÊNIO DA LÂMPADA **I WISH TO ACCEPT AND BE ACCEPTED** THAT ONE DAY I CAN RETURN EVERY SINGLE PENNY THAT MY DAD AND MOM GAVE ME **I WISH I COULD MAKE YOUR PAIN DISAPPEAR** I WISH I COULD RETURN TO PARIS AND FIND HIM **JE SOUHAITE QUE LES LOIS DEVIENNENT LA JUSTICE** J'ESPÈRE QUE CE JOUR ARRIVERA **I WISH I CAN** EU DESEJO PODER SER QUEM SOU SEM CAUSAR INVEJA **EU DESEJO CRIAR UMA OBRA PRIMA** JE DÉSIRE AVOIR MES PARENTS TOUTE MA VIE **I WISH TO LIVE A WONDERFUL AND PERFECT LIFE** EU QUERO UM EMPREGO **JE DÉSIRE QU'IL ME REVIENNE** YOU ARE MY WISH, BABY

EU DESEJO UNIR A ARTE COM A VIDA JE DÉSIRE QUE MA VIE CONTINUE TELLE QU'ELLE EST **I WISH I CAN LIVE ONE DAY WITH NO FEAR** I WISH TO BE IN "HEAVEN" **I REALLY WISH THAT I DON'T HAVE TO WISH** I WISH TO LIVE A HAPPY LIFE FREE FROM PAIN AND SADNESS **I WISH TO MY FAMILY HEALTH AND SUCCESS** I WISH NO ONE'S WISHES COME TRUE, THAT'S DEMOCRACY **I WISH I'LL TRAVEL TO FRANCE** I WISH I WAS HAVING SEX JUST NOW **DESEJO TER MAIS PACIÊNCIA** I WISH RELIGION WAS NOT AN ISSUE **ICH WÜNSCHE MIR IM GLÜCK ALT WERDEN ZU DÜRFEN** I WISH FOR PEACE IN THE MIDDLE EAST **I WISH TO HAVE A SISTER FOR M, HEALTHY AND HAPPY** I WISH TO DIE WITH NO REGRETS **JE DÉSIRE UN HOMME INCONNU ET QUE J'AIME ET QUI M'AIME** I WISH I COULD SEE DEAD PEOPLE **I WISH FOR A GREAT LIFE** I WISH ONE DAY TO BE A FATHER FOR ALL CHILDREN FROM NADA **I WISH THIS WISH WILL FIND YOUR WAY** I WISH YOU'LL ALWAYS REMEMBER **WHAT IS YOUR WISH?** **'CUZ I WISHED YOUR WISH** I DREAM TO ALWAYS DREAM **I WISH TO BE FORGOTTEN** PROTEJA-ME DO QUE EU DESEJO **I WISH FOR PEACE AND TO BE A FAMOUS SOCCER PLAYER** DESEJO ARMÁRIOS EMBUTIDOS **I WISH YOU HAD MY SMILE** I WISH I WERE TIME **EU DESEJO NÃO TOCAR A VIDA COM A PONTA DOS DEDOS** I WISH PEOPLE WOULD APPRECIATE THE GIFT OF LIFE **I WISH ALL MY DREAMS COME TRUE** I WISH FOR A LONG REASONABLE/FULFILLING LIFE AND NATURAL, PAINLESS DEATH TO ALL WHOM I LOVE **DESEJO SER SEMPRE DESEJADA** I WISH PROTECTION FOR THE WEAK, ANIMALS, PEOPLE, NATURE; AND THAT NO ONE SUFFERS ANYMORE **I WISH TO BE LOVED AND WANTED** I WISH I WON'T GET A RABBIT THIS TIME **NAM MYOHO RENGUE KYO** I WISH WISHES COME TRUE **I WISH TO GET MARRIED TO THE ONE I LOVE** I WISH YOU SERENITY **JE VEUX QUE MA FILLE M PUISSE TROUVER L'AMOUR ET L'HOMME DE SA VIE** DESEJO O TRICOLOR CAMPEÃO BRASILEIRO **JE DÉSIRE NE PAS ÊTRE MALADE** I WISH I COULD NEVER GAIN WEIGHT **JE DÉSIRE TOUT CE QUI EST DÉSIRABLE** JE DÉSIRE UN PAPA **I WISH BEIRUT REMAINS BEAUTIFUL** I WISH TO BE OPTIMISTIC **I WISH I COULD STOP SMOKING** I WISH TO BE SURE THAT WHAT I AM DOING IS GOOD **I WISH I COULD GIVE YOU EVERYTHING YOU ASK FOR** J'ESPÈRE QU'UN JOUR TOUT CHANGERA **I WISH SHE WAS FOR REAL** MENOS DESIGUALDADE NO MUNDO **J'ESPÈRE QUE LA MALADIE NE RENTRERA PAS À LA MAISON** JE DÉSIRE MOURIR APRÈS AVOIR ACCOMPLI MON RÊVE **JE DÉSIRE QUE TOUT CITOYEN LIBANAIS AIT LE CULTE DU RESPECT DE L'AUTRE** EU DESEJO O SILÊNCIO **DESEJO NÃO MORRER SOZINHA** I WISH PEACE FOR MY COUNTRY **I WISH TO WIN THE LOTTO** I WISH I COULD HAVE CHOSEN MY RELIGION **I WISH TO BE A FEMINIST** EU DESEJO TEMPO

Written by Max Andrews (MA) and Heather Pesanti (HP)

Matthew Monahan

At the root of Matthew Monahan's sculptures and drawings are perpetual physical attributes common to all humans: the face and the body itself. Whether speaking of a citizen of 1st-century Pompeii, a Han warrior, the person reading these words, or the person who wrote them—or of Monahan himself—the physiognomical and anatomical fundamentals of man remain more or less equal. "Nobody questions the 'meaning' of a face," the artist has said, yet "faces are inherently structural, inherently expressive and inherently traditional."[1] Correspondingly, Monahan employs the human body through its implication in the process of object making and self-recognition. He draws on our investment in the function and form of things we habitually have made to resemble ourselves—whether dolls and puppets, effigies and totems, statues and figurines, busts, masks, and other prostheses or those objects into which bodies may have transformed, such as relics, trophies, and mummies.

Composed and "decomposed" from a wide variety of materials, particularly carved floral foam and beeswax, the body as it emerges from Monahan's spontaneous sculptural process is rarely a discrete entity. Moreover, he has frequently installed individual pieces in dense clusters, lending gatherings of his works the heterogeneous appearance of a forgotten room in an eccentric museum of antiquities. Torsos, heads, and limbs are repeatedly broken or punctured as if the sculptures were made up of ransacked icons, and his charcoal drawings of faces are typically crumpled or torn into three dimensions. One ill-fitting element might be fused to another, causing us to ask: Has one civilization purloined the ruins of a former one? Or have the spoils of an exotic culture been repurposed? The plinths, pedestals, and vitrine structures that often integrate or encase these grotesque bodies are typically made from raw drywall, plate glass, or wood. These, too, are characteristically incomplete or smashed and further lend Monahan's work the dual sense that museological piety and violent iconoclasm have both been set loose.

1. Quoted in Kevin West, "Face Time," *W*, August 2007, 86.
2. Ibid.

"Take a sculpture and make one curve, you get Easter Island," the artist has said, evoking the famous monoliths of Rapa Nui. "You work on it and you get the Renaissance. Work more and you get Homer Simpson. I travel through all these time zones in the history of art."[2] As the latter quotation attests, though his work engages grand themes of life and death with sincerity and gravitas, it is immune neither to jest nor to contemporary influence. Among these influences could be counted a certain drift in postwar German art encompassing the sculptures of Thomas Schütte, Isa Genzken, and Monahan's onetime tutor Georg Herold, which similarly straddle an expressive vocabulary at once personal and universal. Monahan's raw craftsmanship and the perverse materiality of his work seem to align with such artists as well, distinctively estranging his practice from the more conceptual and "clean" tendencies in the art of his American peers. (MA)

Born 1972, Eureka, California
Lives and works in Los Angeles, California

Matthew Monahan graduated from Cooper Union School of Art, New York, in 1994 with a BFA and studied at De Ateliers, Amsterdam, from 1994 to 1996. His work has been featured in solo exhibitions at venues such as Anton Kern Gallery, New York (2005, 1997); Museum of Contemporary Art, Los Angeles (cat.), and Douglas Hyde Gallery, Dublin (both in 2007); Modern Art, London (2006); Galerie Fons Welters, Amsterdam (2005, 2002, 1998); Chinese European Art Center, Xiamen (2002); and Stedelijk Museum Bureau Amsterdam (2000). Monahan's recent group exhibitions include *Martian Museum of Terrestrial Art*, Barbican Art Gallery, London (2008, cat.); *USA Today*, Royal Academy of Arts, London (cat.), *Eden's Edge: Fifteen LA Artists*, UCLA Hammer Museum, Los Angeles (cat.), *Unmonumental: The Object in the 21st Century*, New Museum, New York (cat.), and *Hammer Contemporary Collection*, UCLA Hammer Museum, Los Angeles (all in 2007); Berlin Biennial for Contemporary Art, *Red Eye: L.A. Artists from the Rubell Family Collection*, Rubell Family Collection, Miami, and Whitney Biennial, Whitney Museum of American Art, New York (all in 2006, cats.); *MB: The Mary Blair Story (with My Barbarian)*, REDCAT, Los Angeles (2004); *11x Dutch Art*, National Center for Art, St. Petersburg (2001); *Exorcism/Aesthetic Terrorism*, Museum Boijmans Van Beuningen, Rotterdam (2000, cat.); and Liverpool Biennial, Tate Liverpool (cat.) and *Glad Ijs*, Stedelijk Museum, Amsterdam (both in 1999).

Selected Bibliography

Eleey, Peter. "Matthew Monahan." *Frieze*, no. 94 (October 2005): 214.
Gaines, Malik. "Under the Volcano: History and What We Make of It in the Work of Matthew Monahan." *Modern Painters*, October 2007, 76–83.
Griffin, Jonathan. "Matthew Monahan." *Frieze*, no. 110 (October 2007): 255.
Schambelan, Elizabeth. "Matthew Monahan." *Artforum* 44, no. 2 (October 2005): 264–65.
Wiseman, Ari. *Matthew Monahan*. Exhibition catalogue. Los Angeles: Museum of Contemporary Art, 2007.

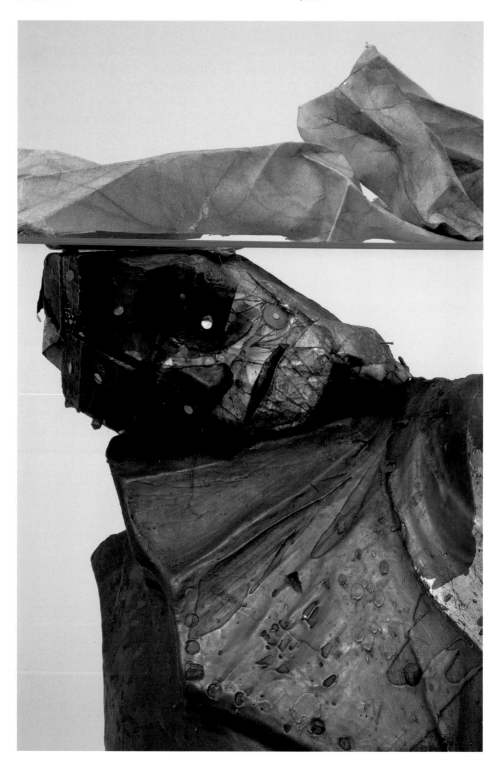

Matthew Monahan *Alchemy of Pain* (detail), 2006–2007

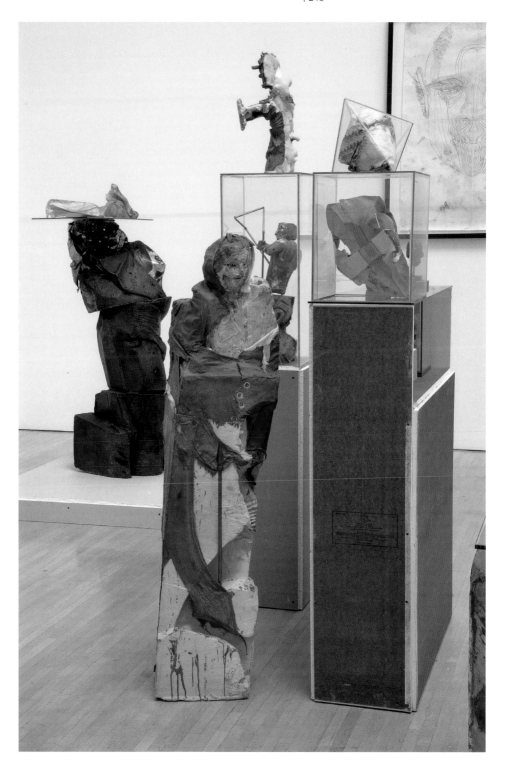

Matthew Monahan *Focus* exhibition (installation view), 2007

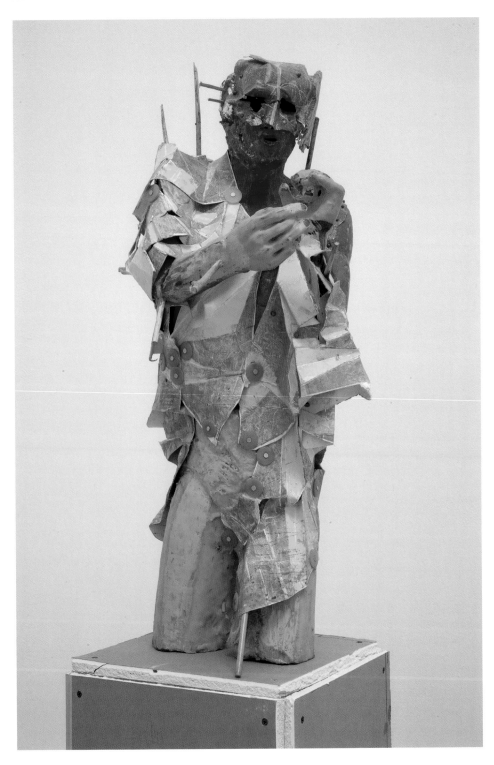

Matthew Monahan *Untitled*, 2006

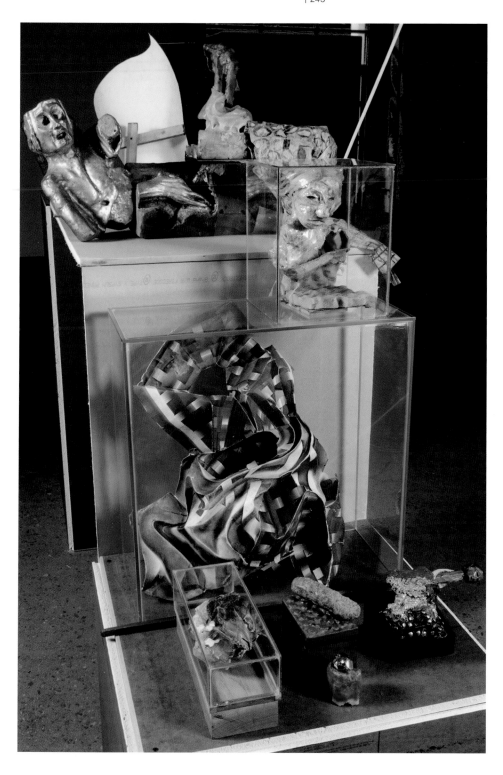

Matthew Monahan *Twilight of the Idiots*, 1994/2005

Rivane Neuenschwander

It is 2002: twenty-five metal buckets are hanging from cables from the ceiling in the entrance of the Museu de Arte da Pampulha, in Rivane Neuenschwander's home city of Belo Horizonte, Brazil. Water leaks from holes in their bases and is caught by an equal number of companion vessels on the floor. The final, and essential, element of *Chove Chuva (Rain Rains)* (2002) is a museum guard with a ladder who replenishes the water every few hours, thereby maintaining a continuous symphonic patter of drips. The museum building was once a former casino, opulently designed by the master architect Oscar Niemeyer, though in Neuenschwander's installation, it sounds as if we are huddled under a rickety corrugated roof as a tropical storm begins to fade.

Many of the refrains percolating through Neuenschwander's practice for the last decade were present in this enchanting centerpiece to her first solo exhibition in her native Brazil. Undoubtedly provoked by the idiosyncrasies of the space, such a large installation signaled, for many, a new trajectory for an artist who at the time was better known for the more modest scale of her works involving materials such as napkins, toothpicks, dust, spices, or paper fragments. Yet the precisely orchestrated, unforced economy of what she has termed "ethereal materialism" persisted. Ever present, for example, was a fascination with serendipity and the agency of living systems, so apparent in works such as *Carta Faminta (Starving Letters)* (2000). Here, garden snails gathered from a churchyard in Sweden were deployed to munch away at a series of rice-paper squares, producing archipelago-like silhouettes. Equally, the activation of sensory memory and the entrusting of the generosity of other people, as well as other nonhuman organisms, to spark a work to life would anticipate an emerging strand in her art making. Take a project such as *Ici là-bas aqui acolá* (2003), for example, which the artist conceived for an exhibition in Paris. She exhibited drawings made by friends and collaborators in Brazil that depicted their imagined impressions of a far distant yet familiar monument: the Eiffel Tower.

Likewise, for her contribution to the 2005 Venice Biennale, [...] (2004), she invited participation and public improvisation based on culturally embedded signs, in this case letters. (The reordering of syntax and alphabets is another touchstone in her work.) Typewriters were set up on colorful desks, and visitors were invited to type away on sheets of paper and then pin the results on the adjacent walls; each machine's letter keys, however, punched out only red and black full stops. In her first solo show in New York, in 2006, Neuenschwander exhibited more than one hundred examples of these donated type-drawings. Each recorded an attempt to make "sense" of a machine now robbed of its normative linguistic function. The video *Quarta-Feira de Cinzas/Epilogue* (2006) similarly stars points of color, yet as with Neuenschwander's previous lens-based collaborations with beetles (the 2001 photographic series *Pertence. Não pertence* [*Belongs. Does Not Belong*]) or fish (the 2002 video *Love Lettering*), it is once more an "alien" set of perceptions that enters into the process of composition: forest ants orchestrate what seems to us to be a festive parade of confetti dots among leaf litter, yet the significance of it for them remains unknowable. (MA)

Born 1967, Belo Horizonte, Brazil
Lives and works in Belo Horizonte

Rivane Neuenschwander graduated from Federal University of Minas Gerais, Belo Horizonte, in 1993 with a BFA and from the Royal College of Art, London, in 1998 with an MFA. Her work has been featured in solo exhibitions at venues such as Hirshhorn Museum and Sculpture Garden, Washington, DC, and Carnegie Museum of Art, Pittsburgh (both in 2007); Galeria Fortes Vilaça, São Paulo (2007, 2003); Tanya Bonakdar Gallery, New York (2006); Galerie Klosterfelde, Berlin (2005); Saint Louis Art Museum (2004); Walker Art Center, Minneapolis (cat.), and Museu de Arte da Pampulha, Belo Horizonte, Brazil (both in 2002); Stephen Friedman Gallery, London (2002, 1999, 1997); and Portikus, Frankfurt am Main (cat.), and Artpace, San Antonio, Texas (both in 2001). Neuenschwander's recent group exhibitions include *Comic Abstraction*, Museum of Modern Art, New York (cat.), and *Organizing Chaos*, P.S. 1 Contemporary Art Center, Long Island City, New York (both in 2007); *Tropicália: A Revolution in Brazilian Culture*, Museum of Contemporary Art, Chicago (2005–2006, cat., traveled to Barbican Art Gallery, London, and Bronx Museum of the Arts, New York); Bienal de la Habana, Cuba (2006, cat.); *Here Comes the Sun*, Magasin 3, Stockholm Konsthall (2005); *Happiness: A Survival Guide for Art and Life*, Mori Art Museum, Tokyo, and Venice Biennale (both in 2003, cats.); *The Eye of the Beholder*, Dundee Contemporary Arts, Scotland (2002); SITE Santa Fe International Biennial (1999, cat.); Bienal de São Paulo (1998, cat.); and Johannesburg Biennale and International Istanbul Biennial (both in 1997, cats.).

Selected Bibliography

Birnbaum, Daniel. "Feast for the Eyes: The Art of Rivane Neuenschwander." *Artforum* 41, no. 9 (May 2003): 142–46.
Birnbaum, Daniel, et al. *Rivane Neuenschwander: Ici là-bas aqui acolá.* Exhibition catalogue. São Paulo: Galeria Fortes Vilaça, 2005.
Hoffmann, Jens. *Powerful Circles: Rivane Neuenschwander.* New York: Americas Society, 2001.
———."Rivane Neuenschwander: Ethereal Materialism." *Flash Art*, no. 226 (October 2002): 90–92.
Ilesanmi, Olukemi. *To/From: Rivane Neuenschwander.* Exhibition catalogue. Minneapolis: Walker Art Center, 2002.

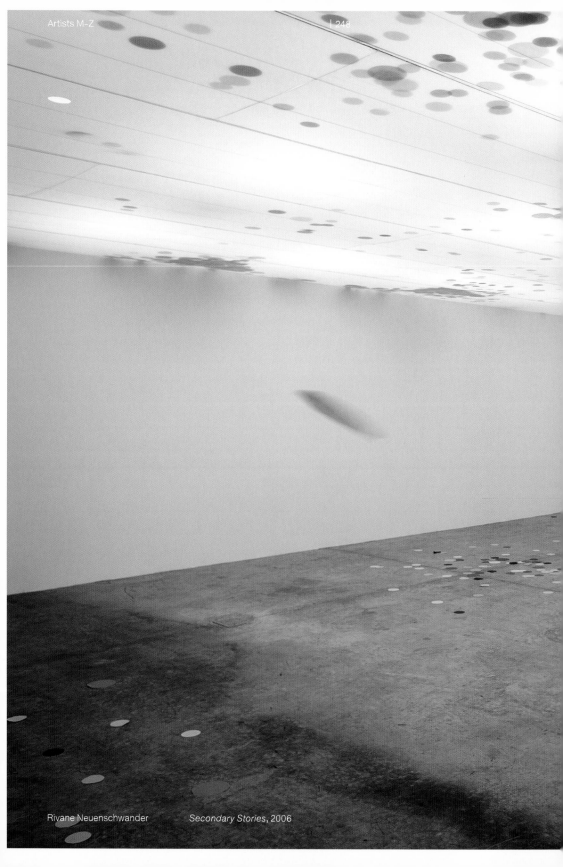

Rivane Neuenschwander *Secondary Stories*, 2006

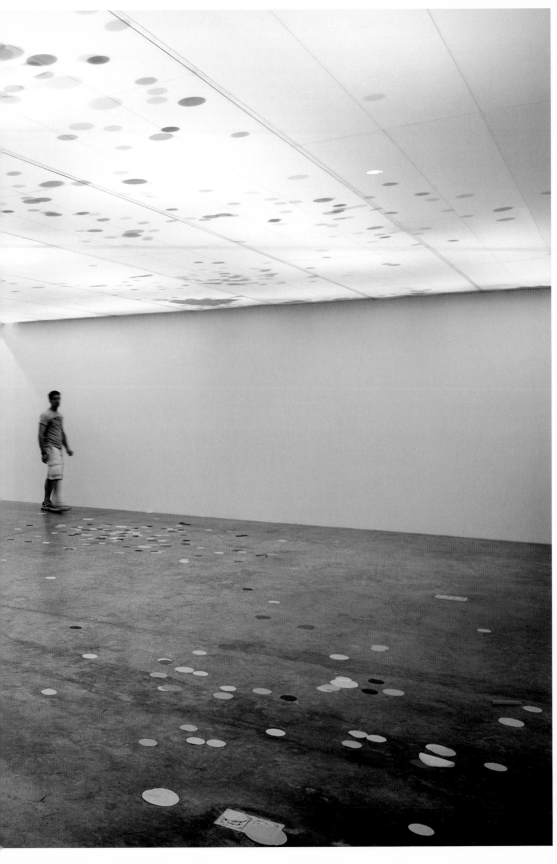

Rivane Neuenschwander *Quarta-Feira de Cinzas/Epilogue*, 2006

Noguchi Rika

In the introduction to his book *Kant and Duchamp*, the Belgian art theorist Thierry de Duve asks us to imagine ourselves as an alien anthropologist trying to understand what "art" means to Earth dwellers: "a word whose meaning escapes you and whose usage varies considerably among humans, but which, in all their societies, seems to refer to an activity that is either integrative or compensatory, lying midway between their myths and their sciences."[1] Noguchi Rika has been photographing our planet for more than a decade from this very position, halfway between myth and science. If she were testifying to de Duve's imagined extraterrestrial about the breadth and uniqueness of earthly terrains, she would simultaneously be providing it with tacit enlightenment about art, beauty, and aesthetics.

Seemingly made in response to a query about the cobalt color of the "blue marble" globe when seen from outer space, the series *Color of the Planet* (begun in 2004) required that Noguchi learn how to scuba dive. The resultant photographs—flooded with expanses of azure and ultramarine, emerald and virescent water—show the strange seabed formations known as the Yonaguni Monument, discovered as recently as 1985 off the coast of Yonaguni, Japan. Though some scientists argue that the sunken structures can be explained by curious natural erosion, others insist that they are the ruins of a previously unknown civilization. Noguchi often seeks such locations that speak of the limits of human knowledge and ambition. For her series *New Land* (1999–2000), the artist documented the construction of artificial islands off the coast of the Netherlands; the group of photographs known as *Rocket Hill* (begun in 2001) record the facilities and launch pad of the Tanegashima Space Center and its eponymous island setting.

Though some of her photographs have featured human beings as their principal subjects—for example, the Chinese swimmers in *About the World Below Zero* (2002), who frequently occupy the frame with all their fleshly physicality as they brave a frozen lake—more often than not, the human figure is remote, incidental, or entirely absent from her "fieldwork."

1. Thierry de Duve, *Kant after Duchamp* (Cambridge, MA: MIT Press, 1996), 3–4.

In the Desert (2006–2007), for example, is a series that is sparsely popu-lated by men tending to racing camels in the United Arab Emirates; fully cloaked to protect themselves from the dust and sunlight, these figures remain anonymous and featureless against both the grains of the sand and the grain of the photographic prints in which their images are now embedded.

Like Noguchi's descending scuba-diving self or the distant climbers ascending to the summit of Mount Fuji in her series *A Prime* (begun in 1997), her photographs seem to be suspended in a state of tranquil immersion, rapt with the possibility of experiencing and communicating perceptions too low or too high to be registered normally. Likewise, the series *The Sun* (begun in 2005) is an Earth-based exploration of a celestial body—our nearest and most familiar star—resulting from something that is beyond usual, or sensible, experience. Taken using the most primitive type of lenseless device for capturing images—a pinhole camera—the photographs show a sequence of bursting coronas and incandescent flare-ups, which resulted from shooting directly into the sun. (MA)

Born 1971, Saitama, Japan
Lives and works in Berlin, Germany

Noguchi Rika graduated from Nihon University College of Art, Tokyo, with a BFA in 1994. Her work has been featured in solo exhibitions at venues such as Gallery Koyanagi, Tokyo (2007, 2002, 1999); Mongin Art Center, Seoul, South Korea (2007); DAAD-Galerie, Deutscher Akademischer Austausch Dienst, Berlin (2006); D'Amelio Terras, New York (2005, 2003, 2001); Ikon Gallery, Birmingham, England, and Hara Museum of Contemporary Art, Tokyo (both in 2004, cat.); Galerie der Stadt Schwaz, Austria (2003); and Marugame Genichiro-Inokuma Museum of Contemporary Art, Kawaga, Japan (cat.), and Parco Gallery, Tokyo (both in 2001). Noguchi's recent group exhibitions include *Brave New Worlds*, Walker Art Center, Minneapolis (2007–2008, cat., traveled to La Colección Jumex, Mexico City); Sharjah Biennial, United Arab Emirates, and *The Door into Summer: The Age of Micropop*, Contemporary Art Gallery, Art Tower Mito, Japan (both in 2007, cats.); PhotoEspaña 2006—Naturaleza: Experiencia, Toledo (2006, cat.); *Moving Pictures*, Guggenheim Museum Bilbao (cat.), and *Time After Time: Asia and Our Moment*, Yerba Buena Center for the Arts, San Francisco (both in 2003); *Under Construc-tion: New Dimensions of Asian Art*, Tokyo Opera City Art Gallery and Japan Foundation Asia Center, Tokyo, and *Under Construction/Fantasia*, East Modern Art Centre, Beijing (both in 2002, cats.); *Facts of Life: Contemporary Japanese Art*,

Hayward Gallery, London, and *The Standard Exhibition*, Naoshima Contemporary Art Museum (now Benesse Art Site Noashima), Japan (both in 2001, cats.); and *Private Room II: Photographs by a New Generation of Women in Japan*, Contemporary Art Gallery, Art Tower Mito, Japan (1999, cat.).

Selected Bibliography

Chong, Doryun. "The Quiet Awe of Noguchi Rika." In *Brave New Worlds*, 166–73. Exhibition catalogue. Minneapolis: Walker Art Center, 2007.
Kamiya, Yukie. "Communicative Approach, from Asia." In *Under Construction: New Dimensions of Asian Art*, 119, 135–36. Exhibition catalogue. Tokyo: Japan Foundation Asia Center and Tokyo Opera City Art Gallery, 2002.
Matsui, Midori. "Noguchi Rika." In *The Age of Micropop: The New Generation of Japanese Artists*, ed. Midori Matsui, 41–45, 118–27. Exhibition catalogue. Tokyo: Parco Publishing, 2007.
Ozaki, Tetsuya. "Noguchi Rika." In *Vitamin Ph: New Perspectives in Photography*, 228–29. London and New York: Phaidon, 2006.
Watkins, Jonathan, and Atsuo Yasuda. *The Planet: Noguchi Rika*. Exhibition catalogue. Tokyo: Hara Museum of Contemporary Art; Birmingham, England: Ikon Gallery, 2004.

Noguchi Rika left to right, top to bottom: *The Sun #1*, 2005; *#12*, *#10*, *#13*, *#5*, *#14*, 2006

Noguchi Rika left to right, top to bottom: *The Sun #9*, *#3*, *#17*, *#4* *#2*, *#11*, 2006

The Sun #15, 2006

Manfred Pernice

Manfred Pernice recycles humble construction materials from the built environment, such as particleboard, concrete, steel, and cardboard, reconfiguring them into open-ended sculptural propositions. His objects and installations—as well as his accompanying drawings and models—suggest unique architectonic forms while retaining traces of their past lives. These forms pointedly disarm the viewer: his cylindrical sculptures or self-described "cans"[1] and rough-edged movable containers, for example, evoke abstracted interpretations of furniture or buildings stripped of their function and reduced to a point of near illegibility. Presented in relation to one another, in the context of larger installations, these works form an uncertain sculptural syntax made of fragmented words and phrases rather than complete sentences. One is reminded of Jorge Luis Borges' fictional Tlönic language devoid of nouns, in which objects can be described only in accretions and combinations of modified verbs.[2] But unlike Borges' imaginary temporal (and nonspatial) world, Pernice's oeuvre is concerned entirely with space as manifested in the overlapping realms of landscape, architecture, and the infrastructure underlying the built environment. Conceptually, his objects refer to neutral, commodified, and often overlooked sites from our man-made surroundings: spaces through which people pass (hallways, stairways, walkways), containers for moving things (ships, boxes), and places for pause or transition (benches). His works frequently begin with the geography and history of a particular place. For example, Pernice used a local butcher shop in Milwaukee, Wisconsin, whose owners came from Wehen, Germany—the same city where the artist spent his childhood—as the basis for a sculptural installation that referred to symbolic elements from both cities while remaining essentially abstract in its sculptural premise.[3] This site-specificity is inspirational and conceptual rather than physical or literal, as multiple manifestations of a work or exhibition could exist in different places in

1. Christiane Schneider, "Manfred Pernice: Conversions," in Rainald Schumacher, ed., *Sculpture Sphere*, exhibition catalogue (Munich: Sammlung Goetz, 2004), 122.
2. Jorge Luis Borges, "Tlön, Uqbar, Tertius Orbis," in *Labyrinths: Selected Stories and Other Writings*, ed. Donald A. Yates and James E. Irby (New York: New Directions, 1964), 3–18.
3. See Brigitte Kölle, "Between," in *Infrastructure*, exhibition catalogue (Cologne: Walther König, 2003), 21.
4. Quoted in ibid., 22.
5. Schneider, "Manfred Pernice: Conversions," 121.
6. Quoted in John Elderfield, *Kurt Schwitters* (New York: Thames and Hudson, 1985), 49.

modified form. According to the artist, "the story could also be told some-where else, but it would then have to be told differently."[4] A sense of incompletion permeates all of Pernice's work, reinforcing, as one critic has noted, "the recognition that provisional insights and statements are all that can be expected."[5] This is Pernice's own "uncertainty principle."

Pernice's installation *Commerzbank* (2004) featured low, benchlike objects interspersed with found materials, figurative elements, and a video. The exhibition paid homage to the early 20th-century German artist Kurt Schwitters and his seminal Merz movement, begun in 1919 and continuing until his death in 1948. Named after Schwitters' "Commerzbank" collage, the movement proposed a democracy of materials and concept through the use of found and discarded everyday materials to create collages and assemblages. This "all-over" approach to spatial construction, agglom-eration of parts, and use of humble materials—manifested most completely in Schwitters' massive *Merzbau* architectural construction, built first in Hannover and subsequently destroyed in the war—preceded and fore-shadowed contemporary installation practices, including that of Pernice. As Schwitters wrote, "I realized that all values only exist in relationship to each other and that restriction to a single material is one-sided and small-minded."[6] Pernice's practice exists in this space between resolution and clarity, where meaning comes from the perpetual accumulation and renegotiation of ideas and materials, and the only certain concepts are those that remain unresolved. (HP)

Born 1963, Hildesheim, Germany
Lives and works in Berlin, Germany

Manfred Pernice studied art in Braunschweig between 1984 and 1987, as well as at the Universität der Künste, Berlin, then known as Hochschule der Künste, in 1993. His work has been featured in solo exhibitions at venues such as Anton Kern Gallery, New York (2008, 2004, 2001, 1998); Museum Ludwig, Cologne (2007); Galerie Mai 36, Zürich (2007, 2002); Galerie Neu, Berlin (2004, 2002, 2000, 1998, 1995); Regen Projects, Los Angeles (2002); Hamburger Bahnhof—Museum für Gegenwart, Berlin, Witte de With Center for Contemporary Art, Rotterdam, Portikus, Frankfurt am Main, and Kunsthalle Zürich (all in 2000); and Musée d'Art Moderne de la Ville de Paris (1998, cat.). Pernice's recent group exhibitions include *Unmonumental: The Object in the 21st Century*, New Museum, New York, and Skulptur Projekte Münster (both in 2007, cats.); International Biennial of Contemporary Art of Seville, Spain (2006, cat.); Venice Biennale (2003, 2001, cats.); Documenta, Kassel (2002, cat.); Manifesta: European Biennial of Contemporary Art, Ljubljana (2000, cat.); *German Open*, Kunst-museum Wolfsburg (1999, cat.); Berlin Biennial for Contemporary Art (1998, cat.); and Biennale d'Art Contemporain de Lyon (1997, cat.).

Selected Bibliography

Bell, Kirsty. "The Salvage City." *Art Review*, July–August 2004, 62–66.
Burgi, Bernhard, ed. *Manfred Pernice*. Exhibition catalogue. Zürich: Kunsthalle Zürich, 2000.
Dziewior, Yilmaz. "Openings: Manfred Pernice." *Artforum* 37, no. 8 (April 1999): 112–13.
"Manfred Pernice." Special section. *Afterall*, no. 11 (2005): 81–96.
Vorwoert, Jan. "Pre-fabs Sprout." *Frieze*, no. 69 (September 2002): 94–97.

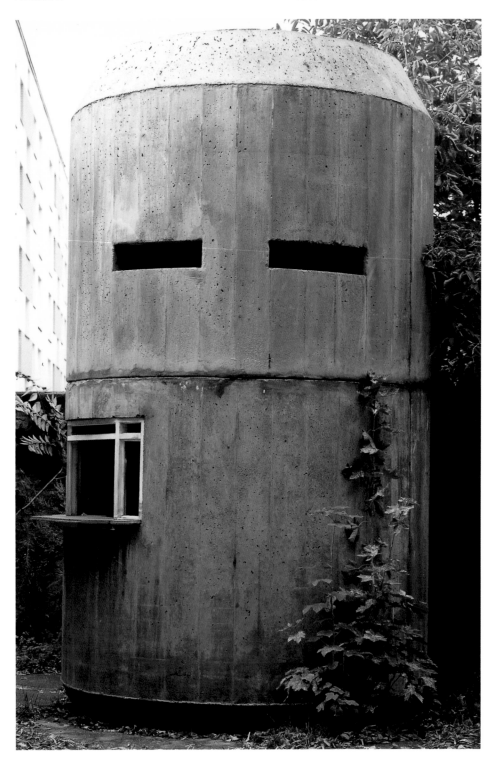

Manfred Pernice *Parkdose*, 2000/2001

Manfred Pernice Untitled, 2008
Fritz Heckert-tub, 2005

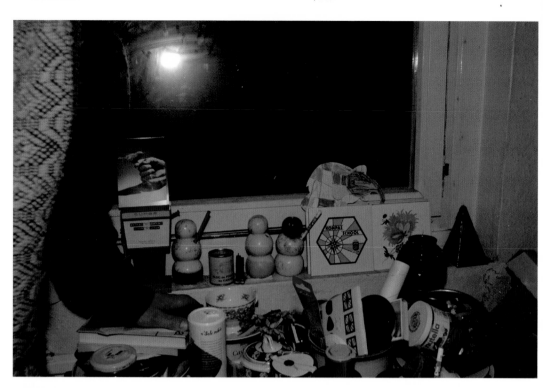

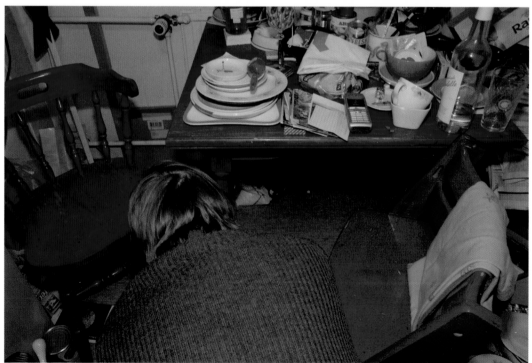

Manfred Pernice Untitled, 2008
 Untitled, 2008

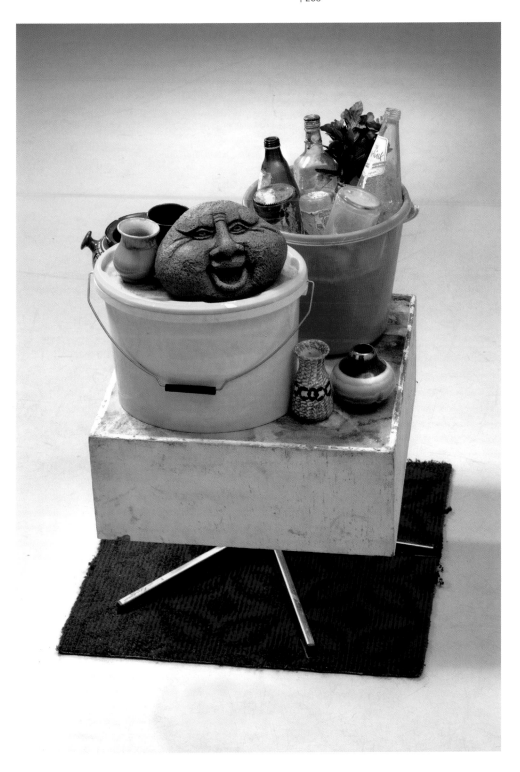

Manfred Pernice *jubiläum*, 2005

Susan Philipsz

At the heart of Susan Philipsz's ephemeral installations lie the infinite possibilities of sound to sculpt both the physical experience of space and the intangible recollections of our memories. While she has also made films, her primary mode of production consists of recording her own voice singing a cappella renditions of appropriated music, in tones that subtly reflect her Scottish roots, and then projecting these in particular locations. On a corporeal level, these works imperceptibly transform viewers' understanding of the architectural structures around them and magnify their perception of the passage of time. Her corpus of music, while always consisting of preexisting songs or "covers," spans a range of sources, including traditional folk songs, dirges, ballads, theme songs from films, iconic pop music, and nationalistic anthems. The artist's voice is delicate and imperfect, in some instances resonating with clear accuracy and at other times gently warbling in tone, the result being closer to that of a promising amateur singer rather than the polished or perhaps even overly synthesized recordings of a professional. As with so much performance and street art in the 1970s and 1980s, Philipsz's work eschews physical traces of her presence in the world. Through their ephemerality, as well as their subtle flaws and unpredictability, her installations suggest a counterpoint to the increasingly slick and commercialized world of today's creative production. Her solitary voice, performing historical songs often chosen by the artist for their tragic, romantic, or melancholy lyrics, "appears not only as a dreamlike recollection of the past, but also like a poignant expression of survival."[1]

The matchmaking of a particular song to a location alters and complicates the cultural meaning ascribed to both. In *The Lost Reflection* (2007), Philipsz's project for the Skulptur Projekte Münster that year, the artist chose to site her work in the underpass beneath a bridge over a lake. She installed recordings of a Jacques Offenbach barcarole so that the two voices—both of them belonging to Philipsz—seem to be calling out to

1. Carolyn Christov-Bakargiev, *Susan Philipsz 03.1*, exhibition brochure (San Antonio, TX: Artpace, 2006).
2 Quoted in Pernille Albrethsen and Jacob Fabricius, "Stay with Me, Malmö Konsthall," in *Susan Philipsz: Stay with Me*, exhibition catalogue (Malmö, Sweden: Malmö Konsthall, 2005), 15.

each other from either side of the bridge. For the artist, in this moment the "contrast between the intimacy of the voice and the immensity of the space might conjure notions of feeling exposed."[2] The piece stopped bikers and walkers along the passageway, who, in a communal experience catalyzed by Philipsz's haunting voice, gathered in a circle to listen. Shortly thereafter, everyone dispersed and the sidewalk was empty, the moment, like the work itself, lost to time.

In 2002, for her sound installation *Wild Is the Wind*, Philipsz sited her version of the eponymous love song in Comb of the Winds, a romantic inlet and tourist destination on the coast of San Sebastián, Spain. The song itself has an iconic history (including covers by Nina Simone and David Bowie) made more complex by Philipsz's poignant rendition. As the well-known lyrics go, "Like the leaf clings to the tree/Oh, my darling, cling to me/For we're like creatures of the wind, and wild is the wind." The notion of clinging is an apt metaphor for Philipsz's work, as her songs affix themselves to the peripheries of thought, coloring memories of place and time with their melancholic harmonies. (HP)

Born 1965, Glasgow, Scotland
Lives and works in Berlin, Germany

Susan Philipsz graduated from Duncan of Jordanstone College of Art and Design, Dundee, Scotland, with a BFA in 1993 and from University of Ulster, Belfast, with an MFA in 1994. Her work has been featured in solo exhibitions at venues such as Tanya Bonakdar Gallery, New York (2008); Galerie Isabella Bortolozzi, Berlin (2008, 2006); Mizuma Art Gallery, Tokyo, and Centro Galego de Arte Contemporánea, Santiago de Compostela, Spain (both in 2007); Büro Friedrich, Berlin (2006, 2005); Malmö Konsthall, Sweden (2005, cat.); Kunstverein Arnsberg, Germany (2004, cat.); Ellen de Bruijne Projects, Amsterdam (2004, 2002); and Temple Bar Gallery and Studios, Dublin (2002). Philipsz's recent group exhibitions include Skulptur Projekte Münster (cat.), Busan Biennale, South Korea (cat.), and *The Sound of Things: Unmonumental Audio*, New Museum, New York (all in 2007); Berlin Biennial for Contemporary Art, and *ARS 06: Sense of the Real*, Museum of Contemporary Art Kiasma, Helsinki (both in 2006, cats.); Guangzhou Triennial, China, and Torino Triennale, Turin (both in 2005, cats.); and *Susan*

Philipsz, Paul Pfeiffer, Brian Fridge, Artpace, San Antonio, Texas, and Tate Triennial, Tate Britain, London (both in 2003, cats.).

Selected Bibliography

Aguirre, Peio. "When the Body Speaks." *A Prior*, no. 16 (February 2008): 127–58.
Christov-Bakargiev, Carolyn. "Susan Philipsz." In *Cream 3*, 288–91. London and New York: Phaidon, 2003.
Christov-Bakargiev, Carolyn, Francis McKee, Jacob Fabricius, Will Bradley, and Andrew Renton. *Susan Philipsz: Stay with Me*. Exhibition catalogue. Malmö, Sweden: Malmö Konsthall, 2005.
Mac Giolla Léith, Caoimhín. "Susan Philipsz." In *The Glen Dimplex Artist Awards Exhibition 2001*, 21–25. Exhibition catalogue. Dublin: Irish Museum of Modern Art, 2001.
Segade, Manuel. *Susan Philipsz*. Exhibition catalogue. Santiago de Compostela, Spain: Centro Galego de Arte Contemporánea, 2007.

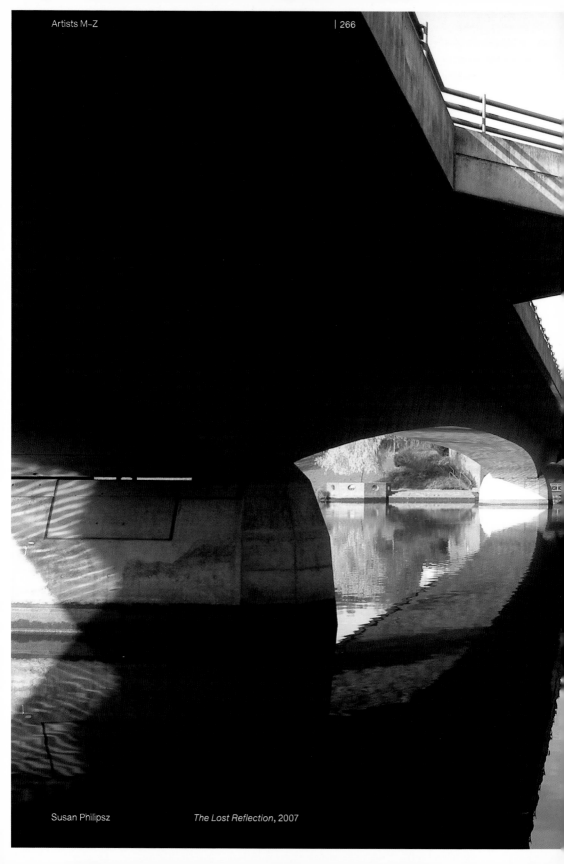

Susan Philipsz *The Lost Reflection*, 2007

Susan Philipsz

Susan Philipsz in the recording studio for *The Lost Reflection*, Berlin, April 2007

Susan Philipsz *The Dead*, 2000

Wilhelm Sasnal

Working primarily as a painter and filmmaker, Wilhelm Sasnal brings to his art an underlying skepticism about the authenticity of visual culture and the process of seeing. The doubt with which he approaches pictorial signs and markers reflects in part his upbringing in communist Poland during the 1970s and the subsequent turbulence surrounding its transformation to capitalism in the 1990s, as well as a less quantifiable relationship to the country's postwar uncertainty in regard to history and memory.[1] It also seems to indicate an awareness—and wariness—of the cultural biases of visual language, a characteristic not surprising for someone whose direct life experience consists of multiple geographies and ideologies. As a result, the artist employs a deliberate heterogeneity of styles (from graphic to abstract and expressive to minimalist), sources (including photographs, the Internet, television, magazines, comic books, and other media), and subject matter (such as portraits, landscapes, architecture, cartoons, and everyday objects). "I don't care about consistency much," the artist has said. "Rules can just drag you towards boredom."[2]

Sasnal is also a formalist, interested in the substance of paint and the results of its variable physical applications. By exaggerating his brushstrokes and manipulating the medium's texture or transparency through drips, smears, and heavily coated or unpainted sections of the canvas, for example, he exploits the material qualities of paint to powerful effect. Compositionally, he frequently uses the pictorial frame to depict snapshotlike close-ups or fragments of his subject matter, dislocating and decontextualizing the imagery such that it becomes decorative, unrecognizable, or symbolically suggestive of something else. In *R. Smithson* (2002), Sasnal portrays a lushly painted black-and-white photo fragment of the artist Robert Smithson's lanky legs slung over an easy chair, while in *Section through the Ground with Potatoes* (2006), he renders vegetables and dirt in an ethereal, beautiful, and rhythmically divided (one-third, two-thirds) composition in lavender and black.

1. See Carina Plath, "Mościce," in Ulrich Loock, Carina Plath, and Beatrix Ruf, *Wilhelm Sasnal: Night Day Night*, exhibition catalogue (Ostfildern-Ruit, Germany: Hatje Cantz, 2003), 9–16.
2. Quoted in Martin Coomer, "Not Being Boring: Wilhelm Sasnal," *Art Review* (London), no. 4 (October 2006): 36.

Likewise, Sasnal's 16mm films and occasional videos incorporate both realism and abstraction to disconcerting ends. *Untitled (Touch Me)* (2004) features grainy footage of a moving landscape accompanied by a mesmerizing synthetic sound track (by the American postpunk band Suicide) while a squidlike ink wash oozes slowly and hypnotically down the frame. Music is an important component of this abstraction, an element that compounds the experience through the interaction of image and sound. In *The Ranch* (2007), various genres of music (church choir, heavy metal, jazz, symphonic, and reggae, for example) alternate over twelve short segments (including shots of a working ranch, a women's softball game, and a strange threesome walking through a cemetery), which were filmed while the artist was traveling around Texas during his three-month residency in Marfa. Often—as when an upbeat and slightly jarring jazz-ska sound track is overlaid with footage of calves being castrated—these pairings form challenging, incongruous, or synchronic juxtapositions that reflect the artist's highly personalized vision of history and place. Disarmingly inconclusive and unbound by culture-specific rules or logic, Sasnal's oeuvre—with its alteration and reinterpretation of imagery and deceptively simple manipulation of media—offers glimpses of a poetic, unfamiliar language that challenges the viewer to question the transient nature of visual perception. (HP)

Born 1972, Tarnów, Poland
Lives and works in Tarnów

Wilhelm Sasnal studied at the Polytechnic in Kraków from 1992 to 1994 and at the Academy of Fine Arts in Kraków from 1994 to 1999. His work has been featured in solo exhibitions at venues such as Zacheta National Gallery of Art, Warsaw (cat.), and Johnen Galerie, Berlin (both in 2007); Anton Kern Gallery, New York (2007, 2005, 2003); Van Abbemuseum, Eindhoven (cat.), and Frankfurter Kunstverein, Frankfurt am Main (both in 2006); Sadie Coles HQ, London (2006, 2003); Foksal Gallery Foundation, Warsaw (2006, 2002, 2001); Berkeley Art Museum, University of California (2005); Camden Arts Centre, London (cat.), and Hauser & Wirth, Zürich (both in 2004); and Kunsthalle Zürich (cat.) and Museum van Hedendaagse Kunst, Antwerp (both in 2003). Sasnal's recent group exhibitions include *The Painting of Modern Life*, Hayward Gallery, London, and *Airs de Paris*, Musée National d'Art Moderne, Centre Georges Pompidou, Paris (both in 2007, cats.); *The Vincent 2006*, Stedelijk Museum, Amsterdam, and *Infinite Painting: Contemporary Painting and Global Realism*, Villa Manin Centro d'Arte Contemporanea, Codroipo, Italy (both in 2006, cats.); Prague Biennale (2005, cat.); Bienal de São Paulo (2004, cat.); Gwangju Biennale, South Korea (cat.), *Urgent Painting*, Musée d'Art Moderne de la Ville de Paris (cat.), and *A Need for Realism: Solitude in Ujazdowski*, Centre for Contemporary Art, Ujazdowski Castle, Warsaw (all in 2002); and Tirana Biennial, Albania (2001, cat.).

Selected Bibliography

Bellini, Andrea. "There Are No Rules: An Interview with Wilhelm Sasnal." *Flash Art*, no. 243 (July–September 2005): 88–90.
Kantor, Jordan. "The Tuymans Effect." *Artforum* 43, no. 3 (November 2004): 164–71.
Landesman, Mark. "For Your Pleasure." *Frieze*, no. 75, (May 2003): 80–83.
Loock, Ulrich, Carina Plath, and Beatrix Ruf. *Wilhelm Sasnal: Night Day Night*. Exhibition catalogue. Ostfildern-Ruit, Germany: Hatje Cantz, 2003.
Neuenschwander, Simone. "Wilhelm Sasnal: New Ruins." *Flash Art*, no. 243 (July–September 2005): 84–87.
"Wilhelm Sasnal." Special section. *Parkett*, no. 70 (May 2004): 58–95.

Wilhelm Sasnal *Untitled*, 2007

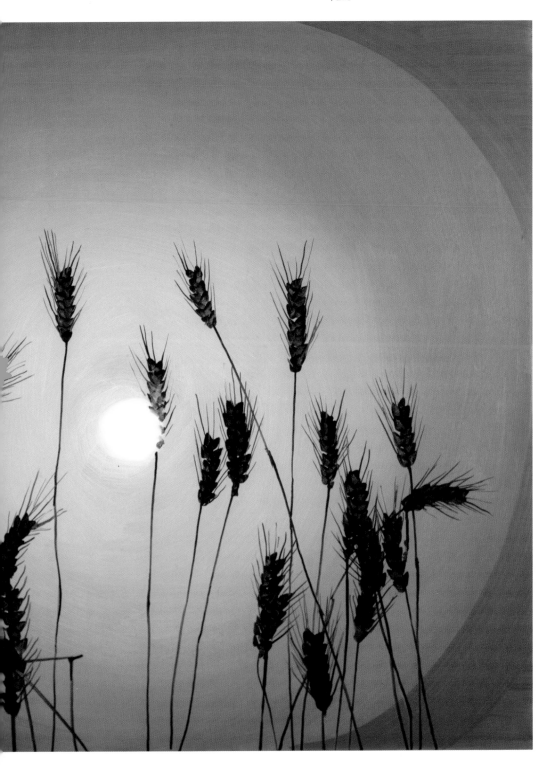

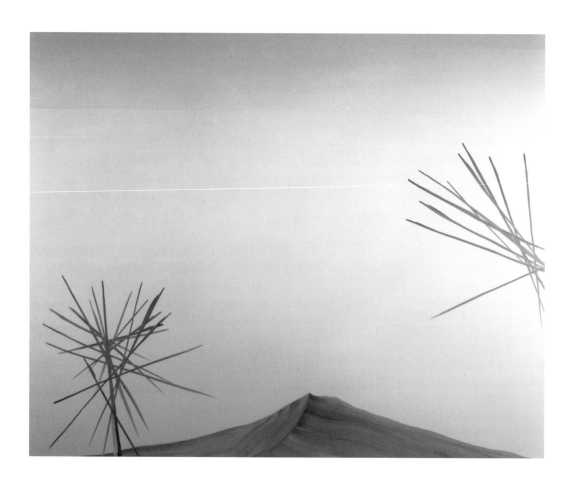

Wilhelm Sasnal *Untitled*, 2006

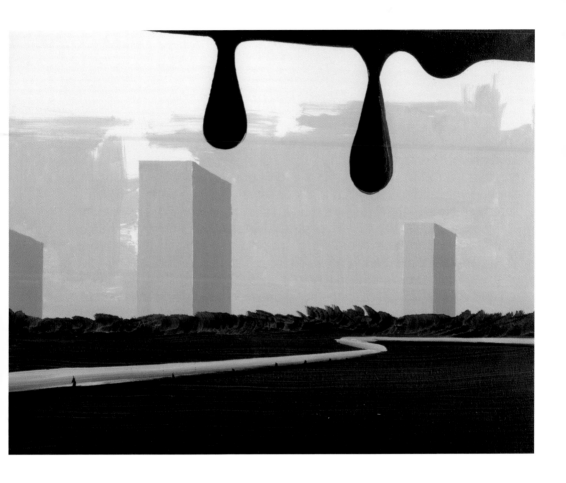

Wilhelm Sasnal *Untitled*, 2007

Thomas Schütte

Though predicated on the interpretation and articulation of history, memory, and death, Thomas Schütte's work will gravely disappoint anyone searching for the grandiose and heroic. His deliberately unrealized proposals for monuments and memorials and his unnervingly beautiful and grotesque interpretations of the figure are marked by ambivalence, skepticism, and conjecture. In this way, his conceptual alignment is commensurate more with Samuel Beckett's itinerant protagonist Molloy than with any bronze-cast general atop a rearing horse. In his architectural models, figurative-inspired sculptures, and works on paper, Schütte examines and critiques a series of interrelated relationships—between history and the present, public and private space, objects and their surroundings, and the spectator and the artwork. A contrarian by nature, Schütte puts forth and then subverts ideas, combining language, imagery, and context in ways that are consistently unfamiliar to the viewer. As the artist has said, "I think I'm in opposition to anything you can mention, even if I know it's wrong."[1] His approach then might best be described as an ongoing, antithetical series of propositions rather than a set of material concerns.

Since the beginning of his career, Schütte has consistently explored formal issues of scale, color, and dimensionality as well as philosophical concerns, including memorialization and the metaphorical "death" of the artist (see, for example, *Mein Grab* [My grave] from 1981, a painting on paper and an architectural model of the artist's own tombstone). By the mid-1980s, his two- and three-dimensional objects and installations—in manifestations ranging "from sublimation [to] pure functionality"[2]—increasingly came to reflect the debates in post-cold-war Germany centering on nationalism, culture, civic values, and the nature of memorials and commemorative public sculpture. In 1987, for the Skulptur Projekte Münster, Schütte conceived of *Kirschensäule* (Cherry column), a sandstone plinth crowned by two bulbous red cherries made of enameled aluminum that parodied the

1. Artist interviewed by James Lingwood in Julian Heynen, James Lingwood, and Angela Vettese, *Thomas Schütte* (London and New York: Phaidon, 1998), 32.
2. Lynne Cooke, "Tradutore, traditore," in Lynne Cooke, ed., *Thomas Schütte: Scenewright, Gloria in Memoria, In Medias Res*, exhibition catalogue (New York: Dia Art Foundation; Düsseldorf: Richter Verlag, 2002), 44.
3. For further discussion, see Angela Vettese, "Focus: Kirschensäule," in Heynen, Lingwood, and Vettese, *Thomas Schütte*, 118–27.

architecture of the city while attempting to formulate a less grandiose style of contemporary public sculpture.[3] Twenty years later, he again responded to this plaza with *Modell für ein Museum* (Model for a museum) (2007), a glass-enclosed construction surrounding an existing fountain that reformulated his extended commentary on institutional structures.

In addition to creating architectural maquettes and site-specific installations, Schütte has consistently explored the role of the human subject, along with its limits and possibilities, through his nontraditional and expressive brand of figuration. Perhaps the best-known examples of his imaginative reinterpretation of the figure are his *Grosse Geister* (Big spirits), amorphous, twisting, ghostlike characters cast in aluminum, bronze, or steel. From these evolved the *Zombies*, fragmented sculptural piles of appendages, torsos, and heads taken from the *Grosse Geister* forms. Here, metaphorical images of the spirits have decayed into shards of their former selves, caught between life and death. Related to his *Torsos* of 2005 and the *Bronzefrauen* (Bronze women) of 2006, all heavily indebted to classical sculpture, these partially figurative bundles could perhaps be read as the artist's tragicomic interpretation of the human condition. Though crumbled to the ground in seemingly inert ruins, Schütte's *Zombies* maintain the possibility that something new might emerge from their transformed remains. (HP)

Born 1954, Oldenburg, Germany
Lives and works in Düsseldorf, Germany

Thomas Schütte studied at the Kunstakademie Düsseldorf from 1973 to 1981. His work has been featured in solo exhibitions at venues such as Henry Moore Institute, Leeds (2007); Galerie Nelson-Freeman, Paris (2007, 2004, 2002, 1996); Frith Street Gallery, London (2007, 2002); Konrad Fischer Galerie, Düsseldorf (2006, 2001, 1997); Museu de Arte Contemporânea de Serralves, Porto, Portugal (2005); Marian Goodman Gallery, New York (2005, 2003, 1999, 1997, 1996); Kunstmuseum Winterthur, Switzerland (2003–2004, traveled to Musée de Grenoble, France, and Kunstsammlung Nordrhein-Westfalen, Düsseldorf); Galerie Rüdiger Schöttle, Munich (2003); Stedelijk Museum, Amsterdam (2000); Dia Center for the Arts, New York (1999, 1998, cat.); and Whitechapel Art Gallery, London (1998). Schütte's recent group exhibitions include *Come, Come, Come into My World*, Ellipse Foundation Art Centre, Alcoitão, Portugal (2007); Berlin Biennial for Contemporary Art and *The 80s: A Topology*, Museu de Arte Contemporânea de Serralves, Porto, Portugal (both in 2006, cats.); *RAF: Regarding Terror*, Kunst-Werke Institute for Contemporary Art, Berlin (cat.), and *L'humanité mise à nu et l'art en frac même*, Casino Luxembourg (both in 2005); *Reanimation*, Kunstmuseum Thun, Switzerland, and *ArchiSculpture*, Fondation Beyeler, Riehen/Basel (both in 2004, cats.); *The Dark, Update #4*, Kunstmuseum Wolfsburg (2001); *Figurare*, Castello di Rivara, Italy (2000); Documenta, Kassel (1997, 1992, 1987, cats.); Skulptur Projekte Münster (1997, 1987, cats.); *Distemper: Dissonant Themes in the Art of the 90s*, Hirshhorn Museum and Sculpture Garden, Washington, DC (1996, cat.); and *Architecture(s)*, Musée d'Art Contemporain, Bordeaux (1995).

Selected Bibliography

Cooke, Lynne, ed. *Thomas Schütte: Scenewright, Gloria in Memoria, In Medias Res*. Exhibition catalogue. New York: Dia Art Foundation; Düsseldorf: Richter Verlag, 2002.
Heiser, Jörg. "Heroes and Villains." *Frieze*, no. 89 (March 2005): 98–103.
Heynen, Julian, James Lingwood, and Angela Vettese. *Thomas Schütte*. London and New York: Phaidon, 1998.
"Thomas Schütte." Special section. *Parkett*, no. 47 (1996): 96–140.
Thomas Schütte. With an essay by Douglas Fogle. Stockholm: Jarla Partilager, 2006.
Winzen, Matthias. *Thomas Schütte. Zeichnungen/Drawings*. Cologne: Snoeck Verlagsgesellschaft, 2006.

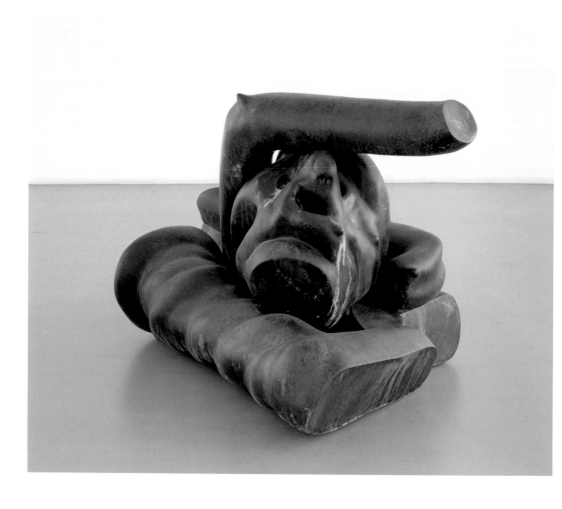

Thomas Schütte *Zombie V*, 2007

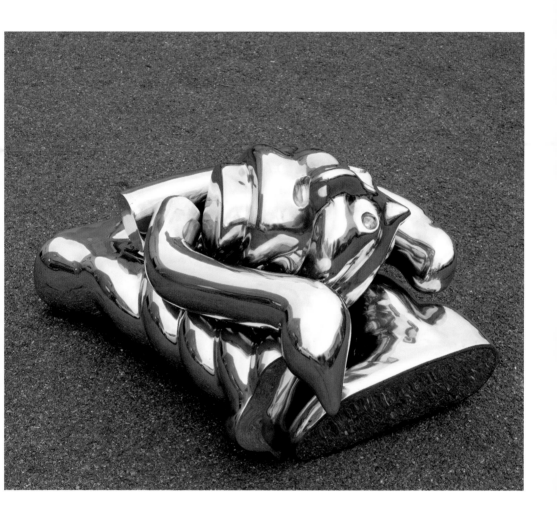

Thomas Schütte *Zombie VI*, 2007

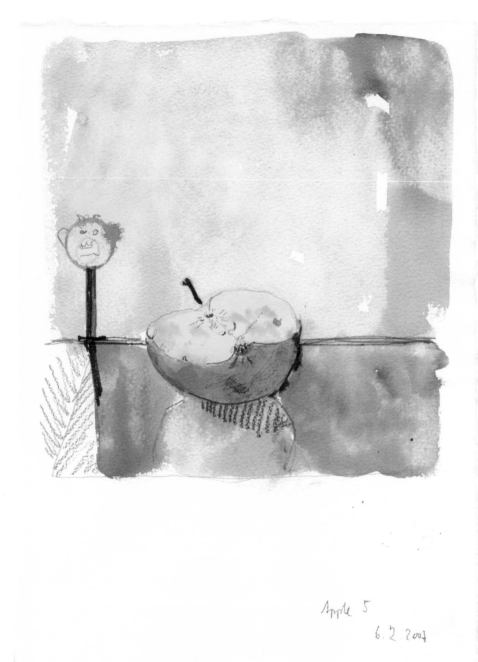

Thomas Schütte *Apple 5*, 2007

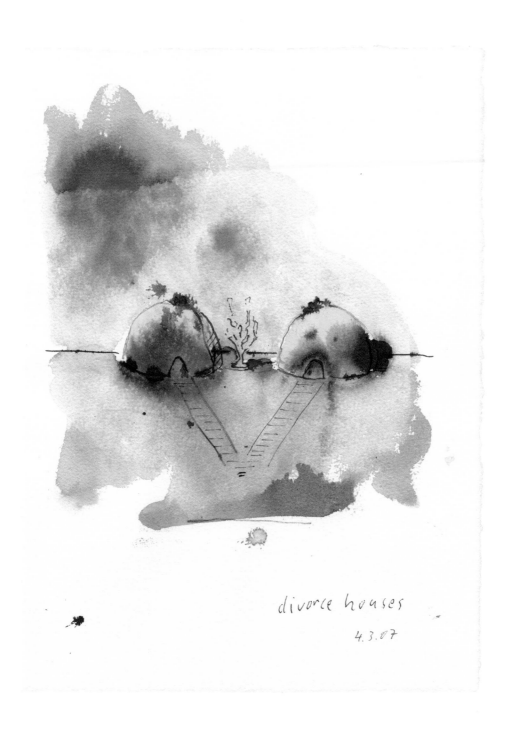

Thomas Schütte *divorce houses*, 2007

Ranjani Shettar

What is modern, what is traditional, and what is natural are among the questions at stake in Ranjani Shettar's intricate sculptures, installations, and prints. With a precisely tuned sense of the symbolic and sacred potential in both organic and man-made materials, Shettar makes art that functions within a broad dynamic of metaphysics and an aesthetics of beauty. It draws inspiration from beliefs embedded in Indian culture and traditions, and entreats physical objects to be interlocutors with spiritual and intangible dimensions, a feature common to many religious and magical rites. Yet the substances the artist has employed are rarely emotive or precious. She has incorporated coconut fibers, resin, mud, cotton, plastic, terra-cotta, wax, twine, and metal in her work. Indeed, the verb *incorporate*, meaning literally to form into a body, is particularly apposite in describing what were among Shettar's first exhibited objects, her *Homes* (2000–2002). She intended these pod- or cocoon-like rudimentary forms to serve as alluring lodgings for divine bodies, boldly giving form to the artist's wish that a devotional presence might be persuaded to take physical form and settle there.

There is an acknowledged resonance in Shettar's art with the high-tech economic growth that has taken place in recent years in her home city of Bangalore—a trajectory that has shadowed the artist's own emergence on the international art scene since 2000. Expanding on its prowess in electronics manufacturing, the city is today a leading force in the burgeoning IT and Internet sector. In light of Shettar's engagement with spiritual connectedness and highly skilled craft, the global networks and dexterous labor of new technology offer a more secular paradigm for considering the consciousness of her art and all that she invests in it.

Her work often demands a sensory and emotive response, and it frequently presents us with joyous compositions that appear to conflate biomorphic forms and scales—whether clusters of algae, the skeins of the nervous system, latticework corals, flower garlands, honeycombs, or fruiting bodies. The title of the room-filling *Vasanta* (2005) means "spring" or

"transition" in the Kannada language of southern India, and the sap-green and yellow tones of the sculpture's filigree of dyed thread and nodes of beeswax globs complement this evocation of abundant seasonal life. The "networked" structure appears to unfurl in a vortex between the gallery floor and the ceiling. This enveloping work was recently presented in a group exhibition entitled *Freeing the Line* (2006), whose context suggested that Shettar's hanging weblike pieces—such as *Hoomalae* (Gods rained flowers) of 2005—could be seen as delicate drawings without paper. While such a context enmeshed Shettar's organic forms with a rejection of the essentialist, geometrical conception of space that has often been the dominant model in Western modernist abstract art and design, it equally drew it closer to what might been termed the "alternative modernisms" of pioneering women artists such as Marisa Merz, Eva Hesse, Lygia Clark, and Gego who came to prominence in the 1960s. (MA)

Born 1977, Bangalore, India
Lives and works in Bangalore

Ranjani Shettar graduated from the College of Fine Arts, Karnataka Chitrakala Parishath, Bangalore, in 1998 with a BFA and in 2000 with an MFA. Her work has been featured in solo exhibitions at venues such as Institute of Contemporary Art, Boston (2008); Talwar Gallery, New Delhi (2007, cat.); Artpace, San Antonio, Texas (cat.), and Talwar Gallery, New York (both in 2006); University Gallery, Fine Arts Center, University of Massachusetts, Amherst (2005, cat.); Gallery Sumukha, Bangalore (2003); and Synergy Art Foundation, Bangalore (2000). Shettar's recent group exhibitions include Biennale d'Art Contemporain de Lyon and Sharjah Biennial, United Arab Emirates (both in 2007, cats.); *Freeing the Line*, Marian Goodman Gallery, New York, and Biennale of Sydney (both in 2006, cats.); *J'en rêve (Dream On)*, Fondation Cartier pour l'Art Contemporain, Paris (cat.), *Landscape Confection*, Wexner Center for the Arts, Ohio State University, Columbus (cat.), and *Out There*, Sainsbury Centre for Visual Arts, Norwich (all in 2005); KHOJ International Artists' Association, New Delhi (2004); and *How Latitudes Become Forms: Art in a Global Age*, Walker Art Center, Minneapolis (2003, cat.).

Selected Bibliography

Altaf, Sasha. "Ranjani Shettar." In *Transition and Transformation: A. Balasubramaniam and Ranjani Shettar*, 9–15. Exhibition catalogue. Amherst: University of Massachusetts, 2005.
De Zegher, Catherine. In *Freeing the Line*, 59–68. Exhibition catalogue. New York: Marian Goodman Gallery, 2006.
Fogle, Douglas. "Ranjani K. Shettar." In *How Latitudes Become Forms: Art in a Global Age*, 232–35. Exhibition catalogue. Minneapolis: Walker Art Center, 2003.
Talwar, Deepak. "Ranjani Shettar." In *(desi)re*, 25–30. Exhibition catalogue. New York: Talwar Gallery, 2005.
Vergne, Philippe. "Ranjani Shettar." In *Ninth Lyon Biennial—00s: The History of a Decade That Has Not Yet Been Named*, ed. Stéphanie Moisdon and Hans Ulrich Obrist, English ed., 259–60. Exhibition catalogue. Zürich: JRP Ringier, 2007.

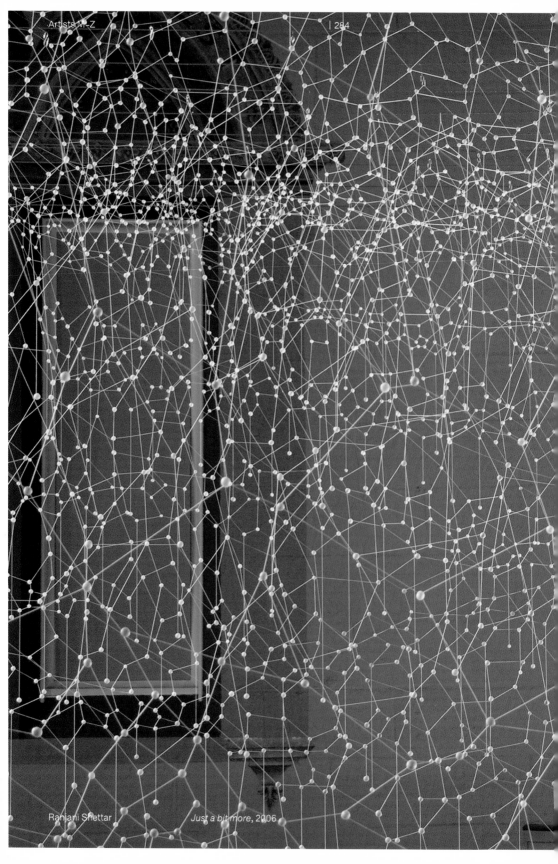

Ranjani Shettar *Just a bit more*, 2006

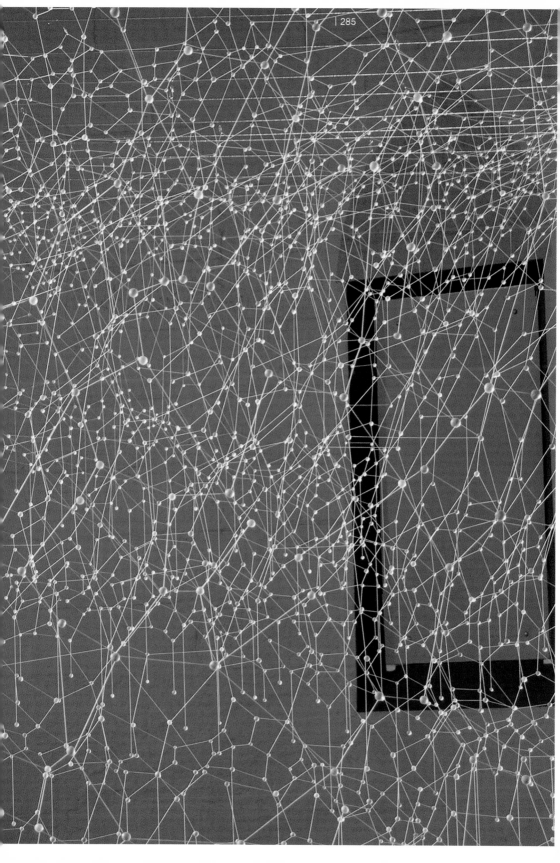

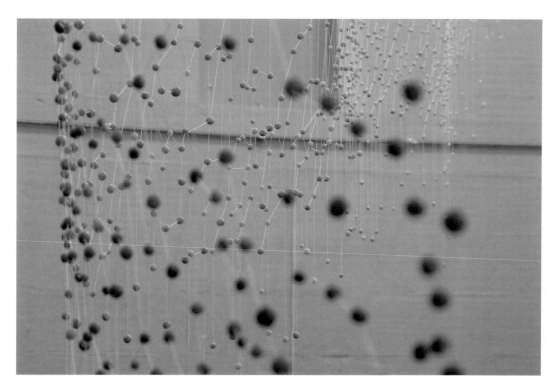

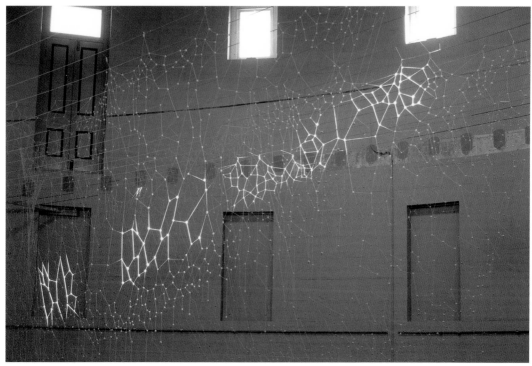

Ranjani Shettar

Just a bit more, 2006
Just a bit more, 2006

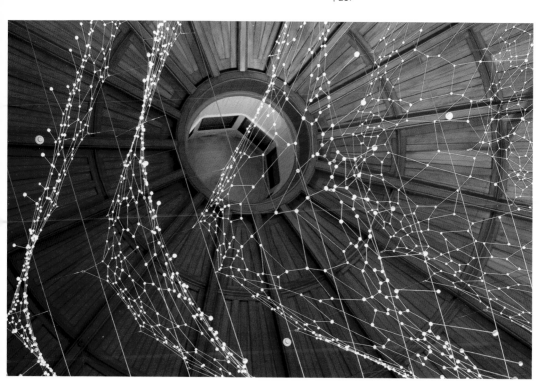

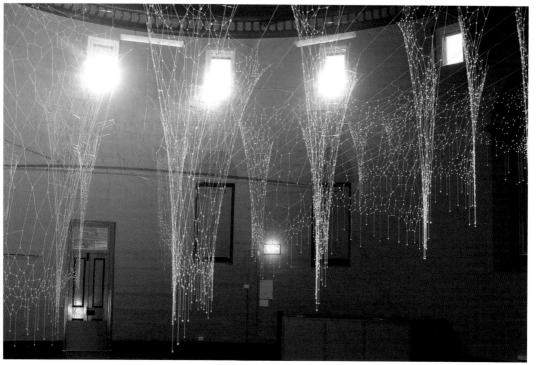

Ranjani Shettar *Just a bit more*, 2006
 Just a bit more, 2006

David Shrigley

With a deliberately naive style and an intellectually dark sense of humor verging on the absurd, David Shrigley makes drawings, paintings, sculptures, and photographs that collectively illustrate a scathing commentary on the various artistic, social, and political states of humanity. In the early 1990s, he worked primarily as a cartoonist for newspapers and publications in the United Kingdom; he has also been a practicing musician. Both activities require a flexibility and succinctness with language as well as an affinity for the written word, and these qualities carry over into his approach as a visual artist. Almost without exception, his works are hilarious, cynical, and sharply intelligent, covering a broad range of topics, including music, art, politics, health care, religion, sexuality, and life and death. When exhibited in an installation or displayed together in one of the artist's books, they form a nonnarrative, fragmentary language of their own that parallels the circuitous paths of modern communication.

Frequently, Shrigley's vignettes speculate as to the hopeless role of an artist in society or, more broadly, the potential futility of human existence. In a 1994 ink-on-paper drawing captioned "Artists talk about their work," a figurehead with scrappy hair and one blackened eye divulges, in stunted prose: "I go around bars at the weekends and deliberately get into fights and get my head kicked in while a friend of mine videos it."[1] In other instances, Shrigley's method of satire descends into the grotesque, as with *Five Years of Toenail Clippings* (2002), whose title describes it exactly; this project was based on the artist's interest in thinking about "how much of oneself is cut off or falls off (nails, hair, skin, teeth)."[2] Yet, beyond its face value, the work poses metaphorical questions regarding identity, body image, and transformation through the loss or shedding of physical parts. Beneath the flamboyant irony and self-deprecating humor lies an undercurrent of vulnerability that lends many of Shrigley's illustrations and objects a bracing poignancy and reveals intimate notions of individual and collective identities. As the artist has said, "There is a fine

1. As it appears in *David Shrigley: Everything Must Have a Name*, ed. David Bellingham, exhibition catalogue (Malmö, Sweden: Malmö Konsthall, 2007), 2.
2. Artist interviewed by Jacob Fabricius, "Jacob F. Interviews Shrig," in *David Shrigley: Everything Must Have a Name*, 12.
3. Ibid., 10.

line between being a nobody and a somebody. It's perhaps more about self-perception than anything else."[3]

In *I Stand Alone*, an alternately tender and boorish illustration from 1993, a crudely drawn figure, appearing much like a macabre cartoon snowman with a mop-top hairdo, stands looking off the page while a voice bubble extending from his mouth contains an image of a devil with an excessively large penis. Above the main figure are the words "I stand alone, because my words are unacceptable to others," a simple statement suggesting that the individual who speaks what he is truly thinking will unavoidably look strange to others. Much like the embarrassing cousin at a family gathering who evokes both empathy and disgust, here, Shrigley comments with equal amounts of self-aware sarcasm and existential pathos on the inevitable solitariness of each person's existence. In works that never cease to amuse, and often end up doing much more, Shrigley explores the never-ending possibilities for embarrassment, failure, and perhaps even revelation in the daily events of our life. (HP)

Born 1968, Macclesfield, England
Lives and works in Glasgow, Scotland

David Shrigley graduated from the Glasgow School of Art in 1991 with a BFA. His work has been featured in solo exhibitions at venues such as BQ, Cologne (2008, 2005, cat., 2003, cat.); Anton Kern Gallery, New York (2008, 2005, 2002); Stephen Friedman Gallery, London (2007, 2004, 2001); Malmö Konsthall, Sweden, and Aspen Art Museum, Colorado (both in 2007); Galleri Nicolai Wallner, Copenhagen (2007, 2005, 2003, 1998); Dundee Contemporary Arts, Scotland (2006); Yvon Lambert, Paris (2006, 2004, 2000); Galerie Francesca Pia, Bern (2004); Kunsthaus Zürich (2003, cat.); and Camden Arts Centre, London (cat., traveled to Mappin Art Gallery, Sheffield, England), Musée d'Art Moderne et Contemporain, Geneva, and UCLA Hammer Museum, Los Angeles (all in 2002). Shrigley's recent group exhibitions include *Laughing in a Foreign Language*, Hayward Gallery, London (2008, cat.); *Momentary Momentum*, Parasol Unit Foundation for Contemporary Art, London (2007, cat.); *The Compulsive Line: Etching 1900 to Now*, Museum of Modern Art, New York (2006); *Situation Comedy: Humor in Recent Art*, Contemporary Museum, Honolulu (2005–2007, cat., traveled to Chicago Cultural Center, Winnipeg Art Gallery, Manitoba, Canada, MacKenzie Art Gallery, Regina, Saskatchewan, Canada, and Salina Art Center, Kansas); *State of Play*, Serpentine Gallery, London (cat.), and *Emotion Eins*, Frankfurter Kunstverein, Frankfurt am Main, and Ursula Blickle Foundation, Kraichtal, Germany (both in 2004); *Splat, Boom, Pow! The Influence of Cartoons in Contemporary Art*, Contemporary Arts Museum, Houston (2003–2004, cat., traveled to Institute of Contemporary Art, Boston, and Wexner Center for the Arts, Ohio State University, Columbus); and *British Art Show 5*, organized by Hayward Gallery, London (2000, cat., traveled to various venues in Edinburgh, Scotland, Southampton, England, Cardiff, Wales, and Birmingham, England).

Selected Bibliography

Bellingham, David, ed. *David Shrigley: Everything Must Have a Name*. Exhibition catalogue. Malmö, Sweden: Malmö Konsthall, 2007.
Brown, Katrina. "Who Is He Who Did This? Is He Still Here?" In *David Shrigley*, 67–68. Burgos, Spain: Centro de Arte Caja de Burgos, 2007.
Harrod, Horatia. "Oddly Drawn Boy." *Sunday Telegraph, Seven Magazine*, August 26, 2007.
Searle, Adrian. "Crude Awakenings." *Guardian*, November 21, 2006.
Shrigley, David. *The Book of Shrigley*. Edited by Mel Gooding and Julian Rothenstein. London: Redstone Press, 2005.

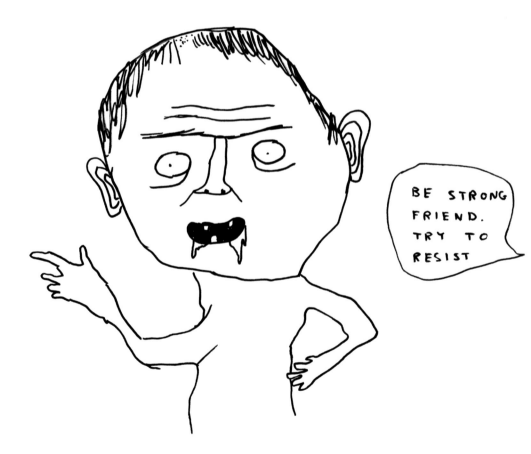

David Shrigley *Untitled*, 2007

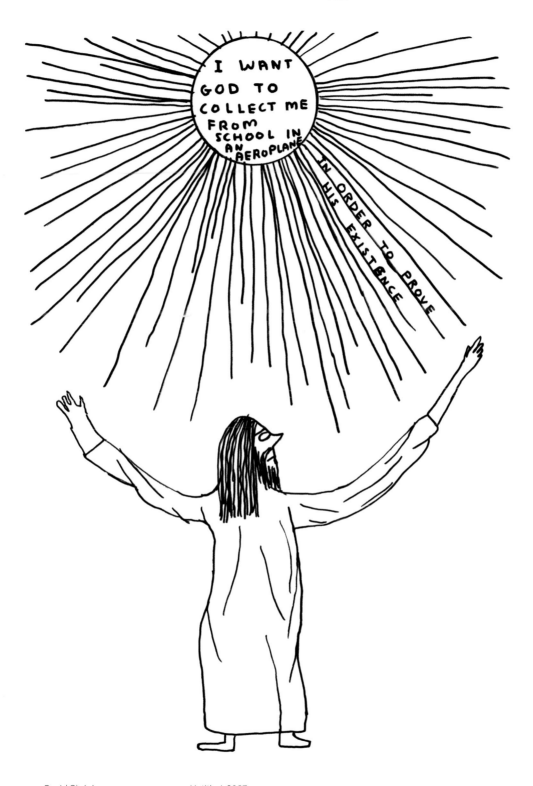

David Shrigley *Untitled*, 2007

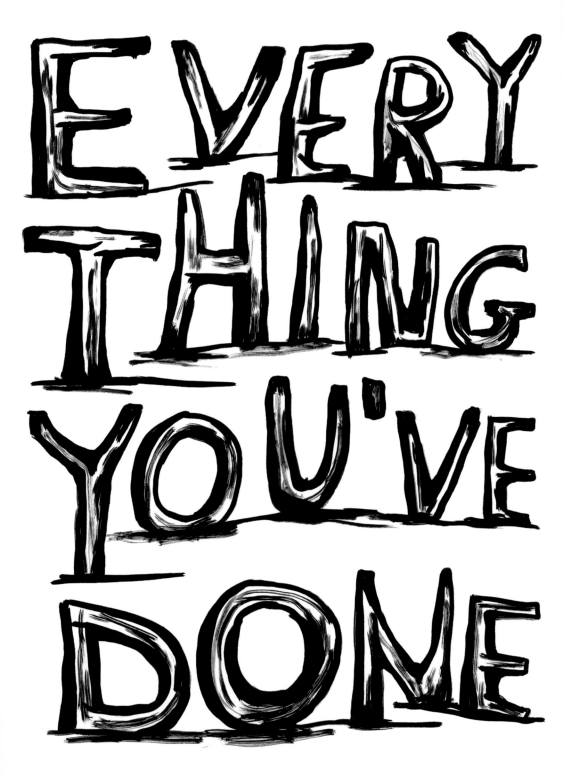

David Shrigley *Untitled*, 2007

David Shrigley *I'm Dead*, 2007

Paul Sietsema

Commensurate with contemporary art's increasingly polyvalent practices, Paul Sietsema is a sculptor of space whose "objects" are meditations on the ambiguity of vision and perception. He works primarily in film and sculpture—though he also makes collages, drawings, photographs, and books—and his oeuvre fluctuates between three-dimensional objects and flat, moving images, and between history and the present, ambitiously suggesting "space as a portal to the fourth dimension."[1] While his techniques and processes vary from one project to the next, on more than one occasion he has meticulously reconstructed specific objects or environments—such as an 18th-century rococo salon or the 1960s apartment of a famous art critic—and then documented and investigated these handmade assemblages (and the spaces they occupy) using 16mm film. Influenced by the formal concerns of 1960s structuralist filmmaking, the artist consistently engages with cinematic and sculptural conventions, exploring various combinations of form, texture, color, space, and movement. His subject matter spans a geographic and temporal range, referencing modernist visual, filmic, and decorative arts history, the production and consumption of images in contemporary society, and the cultural construction of perception. Yet in his work, historical content becomes recontextualized and flattened, presenting a kaleidoscope of fragmentary images in a "collapsed space."[2]

His most recent project, *Figure 3* (2008), takes as its subject rare images of indigenous ethnographic objects found in various locations, including the South Pacific region of Oceania prior to European colonization, and organizes them loosely around the notion of a burial site. Evoking the custom in ancient Egypt of placing mummified bodies in their tombs with accoutrements for the afterlife, Sietsema describes the conception of the grouping of objects in the film as having belonged to a metaphorical

1. Artist interviewed by Giovanni Intra, in "Paul Sietsema: Empire," *Flash Art*, no. 228 (January–February 2003), 83.
2. Paul Sietsema, *Construction of Vision/Constructie van het zien*, exhibition catalogue (Arnhem: Sonsbeek 0 and Regen Projects, 2001), no pagination.
3. Artist in conversation with the author, November 14, 2007.
4. Paul Sietsema, e-mail messages to the author, January 9 and January 10, 2008.
5. In the exhibition *Paul Sietsema: Empire* at the Whitney Museum of American Art in 2002, the artist exhibited the film alongside related ephemera, including sculptures, notebooks, drawings, and objects.

"individual" who has been "clothed in parts of history" that have been timelessly decontextualized and can be experienced in a purely phenomenological manner.[3] Here, Sietsema has reimagined the objects as "sites," where "various formalized ideas intersect ... at the hand of material processes,"[4] manipulating the materials to explore their aesthetic and conceptual possibilities and subsequently filming them. For the artist, building these sculptural investigations has less to do with artifice than with his desire to immerse himself, through the act of making, in the very ideas of cultural production and consumption that his work interrogates, as well as to sever the objects from their historical obligations.

Empire (2002), a 24-minute film whose title refers both to Andy Warhol's film of the same name and London's famous theater, consists of six segments featuring reconstructed architectural, geometric, decorative, and organic forms.[5] The longest segment entails an orange-hued cinematic analysis of a model, made by the artist, of art critic Clement Greenberg's apartment as depicted in a 1964 *Vogue* magazine photograph. Conceptually, the work suggests a spatial exploration of historical and modernist avant-garde principles. Formally, the images—poetic, enigmatic, beautiful, and perplexing—present an open-ended and expansive visual language, one in which images are words and sentences are formed in the mind's eye. In his work, Sietsema brings both the artist and the viewer toward an ambiguous visual space full of unresolved potential. (HP)

Born 1968, Los Angeles, California
Lives and works in Los Angeles

Paul Sietsema graduated from the University of California, Berkeley, in 1992 with a BA and the University of California, Los Angeles, in 1999 with an MFA. His work has been featured in solo exhibitions at venues such as De Appel, Amsterdam (cat.), and San Francisco Museum of Modern Art (both in 2008); Whitney Museum of American Art, New York (2003, cat.); Regen Projects, Los Angeles (2002); and Brent Petersen Gallery, Los Angeles (1998). Sietsema's recent group exhibitions include Berlin Biennial for Contemporary Art (2008, cat.); Moscow Biennale of Contemporary Art (cat.), *Fast Forward: Contemporary Collections for the Dallas Museum of Art*, Dallas Museum of Art (cat.), and *Live/Work: Performance into Drawing*, Museum of Modern Art, New York (all in 2007); *Le Mouvement des Images,* Musée National d'Art Moderne, Centre Georges Pompidou, Paris (2006, cat.); *Ecstasy: In and About Altered States*, Museum of Contemporary Art, Los Angeles (2005, cat.); *Uncertain States of America: American Art in the Third Millennium*, Astrup Fearnley Museet for Moderne Kunst, Oslo

(2005–2008, cat., traveled to Musée d'Art Moderne de la Ville de Paris, Center for Curatorial Studies, Bard College, Annandale-on-Hudson, New York, Serpentine Gallery, London, Reykjavik Art Museum, Iceland, Herning Kunstmuseum, Denmark, Centre for Contemporary Art, Ujozdowski Castle, Warsaw, Musée de Sérignan, France, Galerie Rudolfinum, Prague, and Songzhuan Art Centre, Beijing); and *Sonsbeek 9: Locus/Focus*, Arnhem (2001, cat.).

Selected Bibliography

Hainley, Bruce. "Openings: Paul Sietsema." *Artforum* 37, no. 6 (February 1999): 86–87.
Iles, Chrissie. *Paul Sietsema: Empire*. Exhibition catalogue. New York: Whitney Museum of American Art, 2003.
Intra, Giovanni. "Paul Sietsema: Empire." *Flash Art*, no. 228 (January–February 2003): 82–83.
Sutton, Gloria. "Paul Sietsema." In *Ice Cream: Contemporary Art in Culture*, 348–51. London and New York: Phaidon, 2007.

Paul Sietsema *Figure 3* (film still), 2008

Paul Sietsema *The Copyist*, 2005

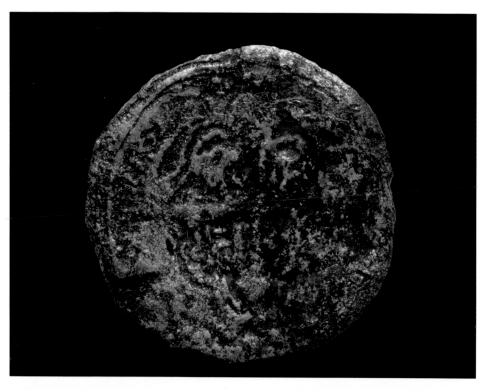

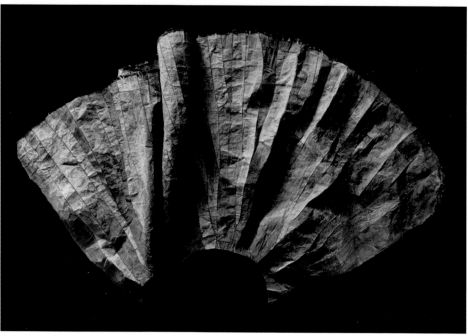

Paul Sietsema *Figure 3* (film still), 2008
Figure 3 (film still), 2008

Rudolf Stingel

In the modestly sized grayscale painting *Untitled (Birthday)* (2006), Rudolf Stingel portrays himself with photographic precision as he celebrates the coming of his fiftieth year. Yet, and despite having a martini in one hand and a cigarette in the other, this is clearly not an anniversary that filled the artist with merriment; his dour expression alone might extinguish the candles that overload his cake. For an artist more renowned for cavalierly dazzling canvases and riotously garish carpet installations, *Untitled (Birthday)* and several other similarly melancholic paintings executed in the last few years seem to indicate a more introspective, or at least less exuberantly colorful, direction for his twenty-year career. Indeed, Stingel has described his recent self-portraits as being "very different from everything that I have done before.... I just want to go back to a more psychological platform," he has added, "reconnecting because of my age and everything to my origins, somehow. It also seemed to me to be the bravest thing I could do."[1]

However, to cast Stingel's newly brooding photorealist paintings as entirely straight-faced, or his earlier work as overwhelmingly self-assured, would be to overestimate the apparent schism. Throughout his career—from his New York debut in which he simply fitted a gallery with an excoriatingly orange carpet to the gold-on-gold or red-on-red brocaded surfaces he has often employed on canvases or walls—Stingel's art has maintained a wry attitude whereby the stunning visual effects often seem uncomfortable with the casually "vulgar" ease with which they wield their seductive powers. The visual sorcery typical of his paintings from the late 1980s, for example—sumptuous polychromatic panels that might be taken for luxurious crushed velvet—were deliberately shown to be merely the result of a banal procedure, as the artist produced what was effectively a "make your own Stingel" guide (*Instructions*, 1989), suggesting, too, that he could disavow having to make them. Likewise, in the "hall of mirrors" evoked by his tinfoil-coated foam-panel installations, which become incised and graffitied by exhibition visitors, grand illusion is necessarily defiled.

1. Stingel interviewed by Victoria Miguel, quoted in http://www.rbge.org.uk/the-gardens/edinburgh/inverleith-house/archive/rudolf-stingel.

Slumped wearily against the pillows on a hotel bed, staring into the distance, the brooding Stingel of the movie-screen-size canvas *Untitled (after Sam)* (2005) is painted in seeming utter flatness, both emotionally and technically—as if he can no longer tolerate his own work's impressive tricks, yet cannily carrying off a further triumph of execution in any case.

The three-panel *Untitled* (2007) is a partial copy of a self-portrait triptych by the English painter Francis Bacon, who died in 1992 and was best known for his burdened, psychologically exorcising portraits in which the human body frequently appears caged or damaged. Stingel has edited out the figures that would have occupied the flanking panels in the original, leaving a lone central Bacon in the midst of a stagelike structure so characteristic of his paintings. Rendered in washed-out shades of gray, Bacon's borrowed presence appears ghostly, as if floating out from a poor reproduction in a black-and-white art history book or summoned in a séance as an agent of unquestionably frank emotional credentials. (MA)

Born 1956, Merano, Italy
Lives and works in New York, New York

Rudolf Stingel's work has been featured in solo exhibitions at venues such as Sadie Coles HQ, London (2007, 2004); Museum of Contemporary Art, Chicago (2007, cat., traveled to Whitney Museum of American Art, New York); Paula Cooper Gallery, New York (2005, 2002, 2000, 1999, 1997, 1994); Walker Art Center, Minneapolis, and Grand Central Station Terminal, New York (both in 2004); Galleria Massimo De Carlo, Milan (2004, 1999, 1997, 1992); Museum für Moderne Kunst, Frankfurt am Main (2004); Museo d'Arte Moderna e Contemporanea di Trento a Rovereto, Italy (2001, cat.); Margo Leavin Gallery, Los Angeles (2000, 1998, 1996); and Kunsthalle Zürich (1995, cat.). His recent group exhibitions include *Infinite Painting: Contemporary Painting and Global Realism*, Villa Manin Centro d'Art Contemporanea, Codroipo, Italy (cat.), Whitney Biennial, Whitney Museum of American Art, New York (cat.), and *Figures in the Field: Figurative Sculpture and Abstract Painting from Chicago Collections*, Museum of Contemporary Art, Chicago (all in 2006); *Universal Experience: Art, Life, and the Tourist's Eye*, Museum of Contemporary Art, Chicago (2005–2006, cat., traveled to Hayward Gallery, London, and Museo d'Arte Moderna e Contemporanea di Trento a Rovereto, Italy); Venice Biennale (2003, cat.); *Painting at the Edge of the World*, Walker Art Center, Minneapolis (2001, cat.); *Examining Pictures: Exhibiting Paintings*, Whitechapel Art Gallery, London (1999–2000, cat., traveled to Museum of Contemporary Art, Chicago, and UCLA Hammer Museum, Los Angeles); SITE Santa Fe International Biennial (1997, cat.); and *Painting: The Extended Field*, Magasin 3, Stockholm Konsthall, and Rooseum Center for Contemporary Art, Malmö, Sweden (1996, cat.).

Selected Bibliography

Bonami, Francesco, Chrissie Iles, and Reiner Zettl. *Rudolf Stingel: Paintings, 1987–2007.* Exhibition catalogue. Chicago: Museum of Contemporary Art; New Haven, CT: Yale University Press, 2007.
Feldman, Hannah. "Rudolf Stingel." *Artforum* 45, no. 8 (April 2007): 260–64.
Princenthal, Nancy. "Stingel's Eclectic Playlist." *Art in America* 95, no. 8 (September 2007): 126–31.
Rabinowtiz, Cay Sophie. "1000 Words: Rudolf Stingel." *Artforum* 43, no. 9 (May 2005): 220–21.
"Rudolf Stingel." Special section. *Parkett*, no. 77 (September 2006): 102–39.

Rudolf Stingel *Untitled*, 2007

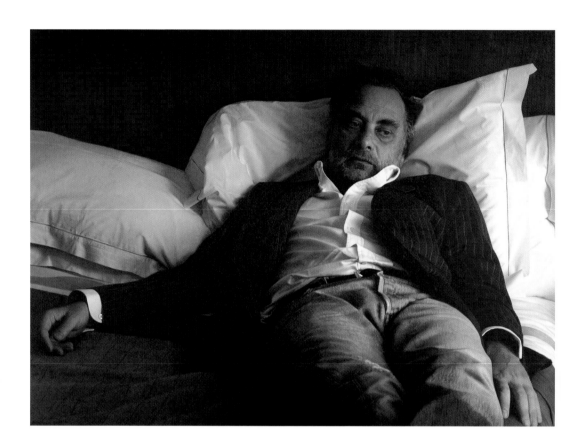

Rudolf Stingel *Untitled (after Sam)*, 2005–2006

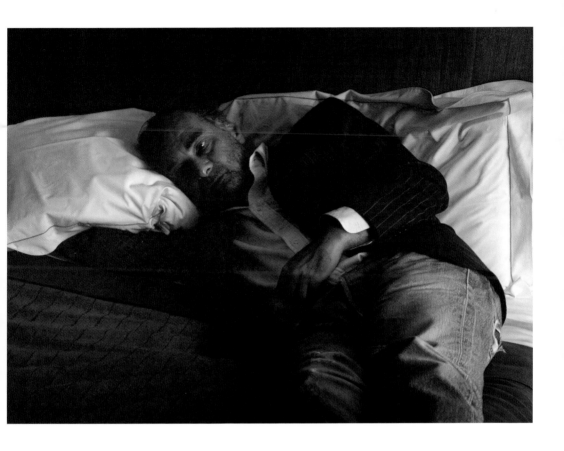

Rudolf Stingel *Untitled (after Sam)*, 2006

Katja Strunz

In her sculptural installations and works on paper, Katja Strunz transforms found and humble materials such as scrap metal, wood, and old pages or photographs from books into playful, fantastical, and slightly ominous landscapes that imbue the gallery space with historical memory. In some cases, Strunz paints her objects in flat monochrome colors or black and white. In others, she displays them in raw form, as can be seen in her oxidized metal pieces, which the artist on occasion purposely left outside to obtain a coarse patina, fusing their bold physical presence with allusions to the past via aged surfaces and historically evocative shapes. Placed in seemingly random arrangements around a room, her objects paradoxically communicate both delicacy and aggression and posit an intuitive and abstract language whereby the various forms—in a single work, within an installation, or on paper—create constellations whose parts are in direct communication with one another. In *whose garden was this* (2006), irregularly shaped cubes and folded, sharp-edge sculptures emerge from the walls and crevices while metal ashtrays on wiry posts evoke soldiers clustered in a small army on the floor. Triangular wall sculptures, crimped like fans, reappear consistently throughout her work, a symbolic element in her visual language that she manipulates to radically different effect within the bounds of three-dimensional space. Made up of creases, diagonals, and angles, of divergent shapes, textures, and sizes, and placed alone or in various grouped arrangements, these winged objects poetically evoke moths bound to the wall, suggesting metaphorical depictions of "movement arrested in flight."[1]

Mining the evolutionary chronology of modernist art history, her work frequently wears its historical precedents on its sleeve, paying homage to the past as a footnote to the present. Conceptually, Strunz's oeuvre is perhaps most closely aligned with Robert Smithson's iconic theories on entropy, in which erosion is a metaphor for the slippage and mirroring of

1. Suzanne Hudson, "Katja Strunz: A Second Present of the Past," in Suzanne Hudson and Lutz Niethammer, *Katja Strunz* (London: Koenig Books, 2007), 13.
2. Smithson developed now-canonical theories on erosion and entropy in his works and writings. See various essays by the artist in *The Writings of Robert Smithson*, ed. Nancy Holt (New York: New York University Press, 1979).
3. Jorge Luis Borges, "In Praise of Darkness," in *In Praise of Darkness*, trans. Norman Thomas di Giovanni (New York: E. P. Dutton, 1974), 125.

time and history (or perhaps, simply, the erasure of memory).[2] In an early work from 1997, Strunz attempted to "realize a transformation" of one of Smithson's three-dimensional mirrored-steel constructions of the mid-1960s, conceiving of the process as a gesture toward recovering the past while acknowledging its inevitable blind spots. The artist describes her work in terms of "aftermath" and the manner in which time's passing changes the way we view an artwork and its significance. For Strunz, aftermath connotes a gradual blindness to the artist's vision, but also the discovery of increasingly new associations and meanings. As Jorge Luis Borges wrote in a poem about the onset of his physical blindness, "from south and east and west and north/roads coming together have led me/ to my secret center."[3] In the tradition of both Borges and Smithson, Strunz's work suggests a dual metaphor of blindness encompassing both the negative connotation of lost vision and a potentially new way of seeing, whereby the center of the work shifts with the ever-expanding body of temporal history it accrues. (HP)

Born 1970, Ottweiler, Germany
Lives and works in Berlin, Germany

Katja Strunz studied at Johannes Gutenberg Universität, Mainz, and Staatliche Akademie der Bildenden Künste, Karlsruhe, from 1989 to 1998. Her work has been featured in solo exhibitions at venues such as the Modern Institute, Glasgow (2007, 2003, 2001); Galerie Almine Rech, Paris, and Artpace, San Antonio, Texas (both in 2007); Museum Haus Esters, Krefeld, Germany (2006); Gavin Brown's enterprise, New York (2006, 2001); and Galerie Giti Nourbakhsch, Berlin (2002, 2000). Strunz's recent group exhibitions include *Winter Palace*, De Ateliers, Amsterdam, and *Delusive Orders*, Muzeum Sztuki, Łódź, Poland (both in 2007); *Strange I've Seen That Face Before*, Städtisches Museum Abteiberg, Mönchengladbach (cat.), and *Art Scope 2005/2006—Interface Complex*, Hara Museum of Contemporary Art, Tokyo (both in 2006); *Ars Viva 04/05—Zeit*, Kunsthalle Mannheim (2004–2005, cat., traveled to Kunstverein für die Rheinlande und Westfalen, Düsseldorf, and Zacheta National Gallery of Art, Warsaw); *Formalismus. Moderne Kunst, heute*, Kunstverein, Hamburg (cat.), and *It's All an Illusion:*

A Sculpture Project, Migros Museum für Gegenwartskunst, Zürich (both in 2004); and *Land, Land!* Kunsthalle Basel, and *The Daimler Chrysler Collection*, ZKM/Zentrum für Kunst und Medientechnologie, Karlsruhe (both in 2003).

Selected Bibliography

Buhr, Elke. "Arts Blooming in Berlin." *Modern Painters*, March 2006, 93–97.
Eichler, Dominic. "Something Old, Something New." *Frieze*, no. 74 (April 2003): 84–85.
Hudson, Suzanne. "Openings: Katja Strunz." *Artforum* 44, no. 8 (April 2006): 234–35.
Hudson, Suzanne, and Lutz Niethammer. *Katja Strunz*. London: Koenig Books, 2007.
Mac Giolla Léith, Caoimhín. "Katja Strunz." In *Formalismus. Moderne Kunst, heute*, 185–91. Exhibition catalogue. Hamburg: Kunstverein, 2004.
Nymphius, Friederike. "Katja Strunz." In *Minimalism and After II*, 44–45. Exhibition catalogue. Berlin: Daimler Chrysler Collection, 2003.

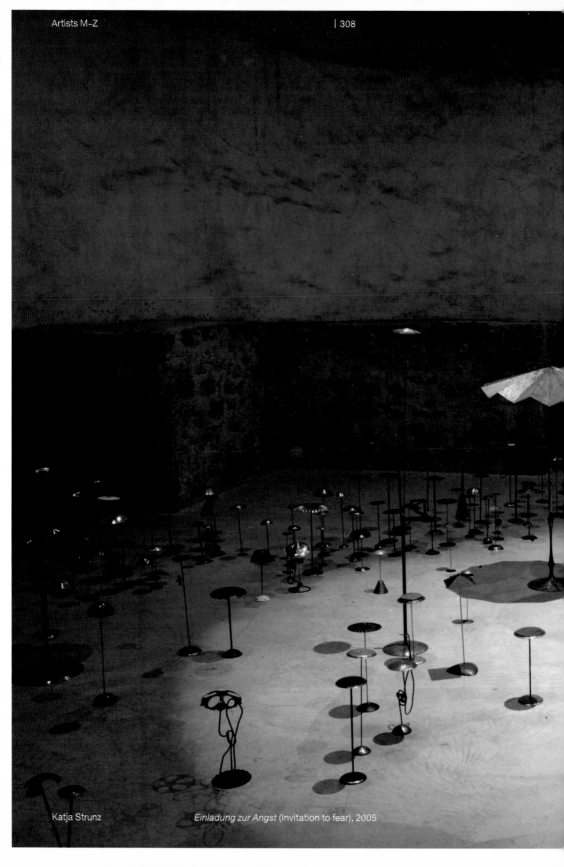

Katja Strunz *Einladung zur Angst* (Invitation to fear), 2005

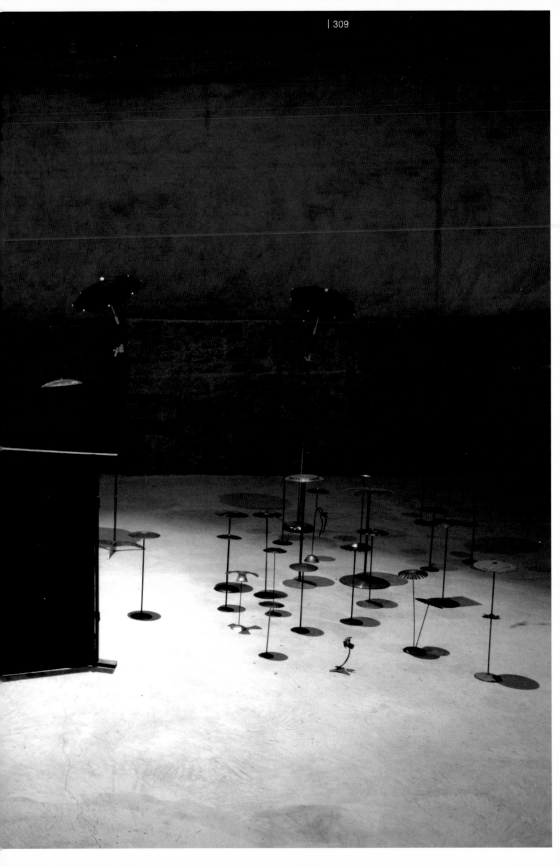

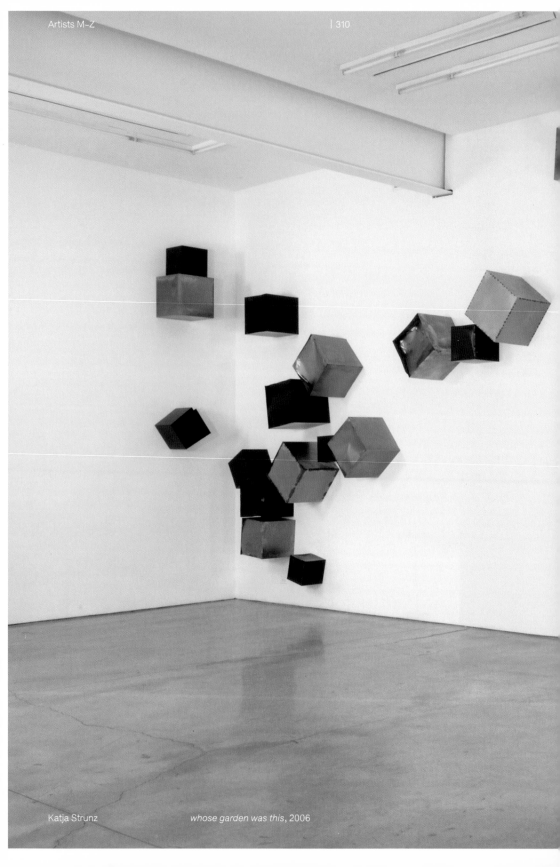

Katja Strunz *whose garden was this*, 2006

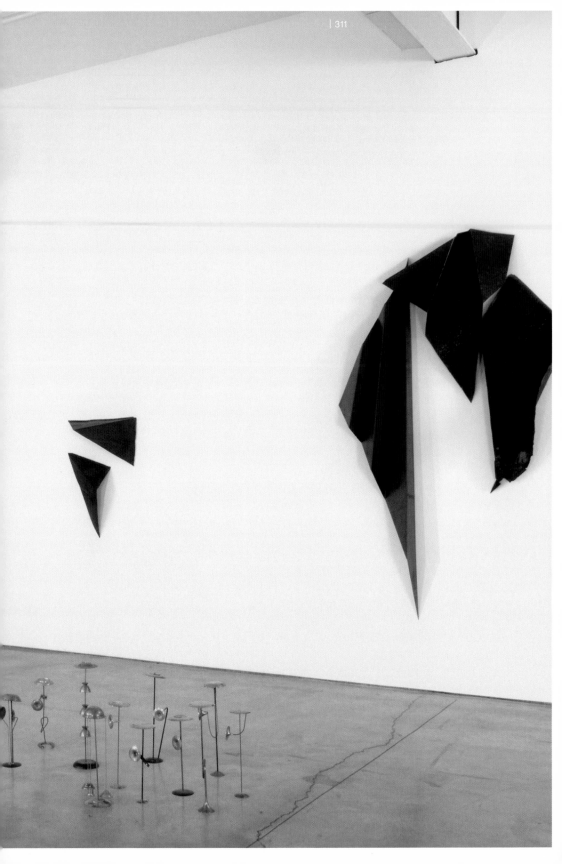

Paul Thek

Our desire to experience one of Paul Thek's massive installations, or "processions,"[1] is inevitably a futile one. These chaotic, highly symbolic works—environments constructed of quotidian materials such as daily newspapers, crates, branches, sand, inexpensive cloth, and cast-wax objects—existed for a moment and then disappeared. Like so much performance, Land, conceptual, and other impermanent art forms of the 1960s and 1970s, they survive only in photographs. Such flux and ephemerality were essential to Thek's approach, one which postulated a contrarian position to the cool, polished forms of Minimalism, the commercial focus of Pop art, and the bright, primary, or monochrome canvases of abstractionists of the era. An American expatriate living in Europe, Thek created works that reflect a nomadic journey (both physically and allegorically) through Western culture, religion, and sexuality, combining disparate elements into complex, theatrical, and often fleeting installations, paintings, and sculptures. Thek's need to convey his inner psychological conflicts—a deep ambivalence toward Catholicism, his repressed homosexuality, and despair over the war in Vietnam—became manifest in his art.

Though he started out as a painter, in the early 1960s Thek first earned recognition for his Technological Reliquaries, glossy wax models of raw meat in elegant, minimalist Plexiglas cases. These grotesque slabs of bloody flesh presented as sculpture and displayed within rectangular shapes referencing Donald Judd's pristine industrial sculptures and Andy Warhol's kitschy Brillo Boxes were Thek's subversive argument to his counterparts in America. In the late 1960s and into the 1970s, concurrent with the rise of installation as an art form, Thek began to create intricate and visually lush installations—calling them "processions" to indicate their intimate relationship with the passage of time—in which he juxtaposed numerous references to Western culture and religion: the Bible, Jungian psychology, Italian Catholic processions, the art of Frank Stella and

1. Ann Wilson discusses the artist's use of the term "processions" in the introduction to her essay "Voices from the Era," in *Paul Thek: The Wonderful World That Almost Was*, ed. Louise Neri and Barbera van Kooij, exhibition catalogue (Rotterdam: Witte de With Center for Contemporary Art, 1995), 57.
2. See Richard Flood, "Paul Thek: Real Misunderstanding," in *Paul Thek: The Wonderful World That Almost Was*, 104–12.

Jasper Johns, icons of various saints, and so on.[2] Often engulfing entire rooms, these immersive environments sought to capture and combine ordinary ephemera from the surrounding world and transform them into chaotic and emotionally wrought scenes. Alongside installation work, painting remained a consistent component in Thek's art making, presenting a more contained format in which he used newspaper as the background for witty, semiabstract, and oddly beautiful compositions. These were often simple and brightly colored—ranging from abstract to figurative to text-based—and always highly evocative. Thek also left behind an abundance of notebooks filled with his personal writings. At one point he mused, "I seem to teeter on the brink of 'enlightenment,' yet my energies [are] sapped at the root by my awareness of serving 2 masters, with the traditional results, alienation from EVERYTHING, like a bad dream." In the context of the rest of his work, these alternately lucid, poetic, and manic scribblings compose, with cruel irony, a portrait of an individual whose contradictory views on religion, sexuality, and identity informed some of the most poignant, innovative, and heterogeneous artistic forms of his time, even as they posed an insurmountable burden to his very existence. (HP)

Born 1933, Brooklyn, New York
Died 1988, New York, New York

Paul Thek studied at the Art Students League in New York and Pratt Institute in Brooklyn in 1950, as well as at the Cooper Union School of Art in New York between 1951 and 1954. Since his death, his work has been featured in solo exhibitions at venues such as ZKM/Zentrum für Kunst und Medientechnologie, Karlsruhe (2007–2008, cat.); Alexander and Bonin, New York (2007); and Mai 36 Galerie, Zürich (2007, 1993, cat.); Kunstmuseum Luzern, Switzerland (2005); Camden Arts Centre, London (1999–2000, cat., traveled to Douglas Hyde Gallery, Dublin, Newlyn Art Gallery, Cornwall, and Mai 36 Galerie, Zürich); Arts Club of Chicago (1998, cat.); and Witte de With Center for Contemporary Art, Rotterdam (1995–1996, cat., traveled to Neue Nationalgalerie, Berlin, Fundació Antoni Tàpies, Barcelona, Kunsthalle Zürich, Migros Museum für Gegenwartskunst, Zürich, and MAC, Galeries Contemporaines des Musées de Marseille). In addition to being featured in the 1967 Carnegie International (cat.), Thek's work has been included in group exhibitions such as The Eighth Square: Gender, Life, and Desire in the Visual Arts since 1960, Museum Ludwig, Cologne (2006, cat.); Painting at the Edge of the World, Walker Art Center, Minneapolis (2001,

cat.); Bienal de São Paulo (1985, cat.); Venice Biennale (1980, 1976, cats.); and Documenta, Kassel (1972, 1968, cats.).

Selected Bibliography

Delehanty, Suzanne. Paul Thek/Processions: The Tower of Babel, Uncle Tom's Cabin, Bandwagon, The Burning Bridge, Bo Jangles, Jack Lantern, Paul Thek, Zhivago. Exhibition catalogue. Philadelphia: University of Pennsylvania Press, 1977.
Flood, Richard. "Paul Thek. Real Misunderstanding." Artforum 20, no. 2 (October 1981): 48–53.
Head, Tim, Caoimhín Mac Giolla Léith, and Simon Morissey. Paul Thek. Exhibition catalogue. London: Camden Arts Centre, 1999.
Morgan, Stuart. "The Man Who Couldn't Get Up." Frieze, no. 24 (September–October 1995): 47–51.
Neri, Louise, and Barbera van Kooij, eds. Paul Thek: The Wonderful World That Almost Was. Exhibition catalogue. Rotterdam: Witte de With Center for Contemporary Art, 1995.
Swenson, G. R. "Beneath the Skin." Interview. Art News 65, no. 2 (April 1966): 66–67.

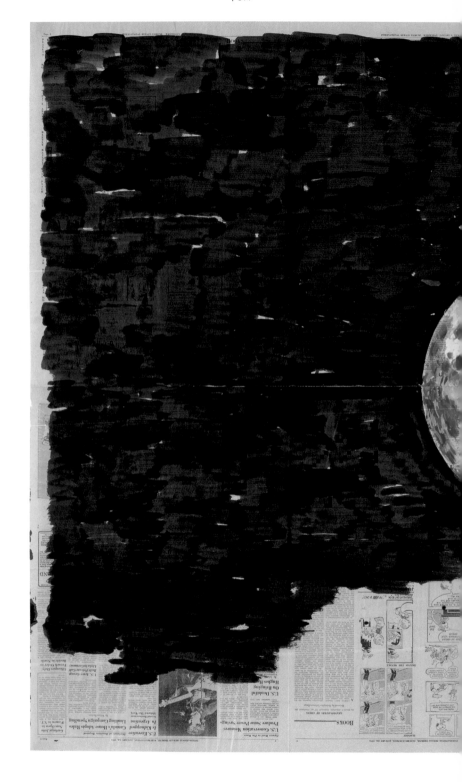

Paul Thek *Untitled (Earth Drawing I)*, c. 1974

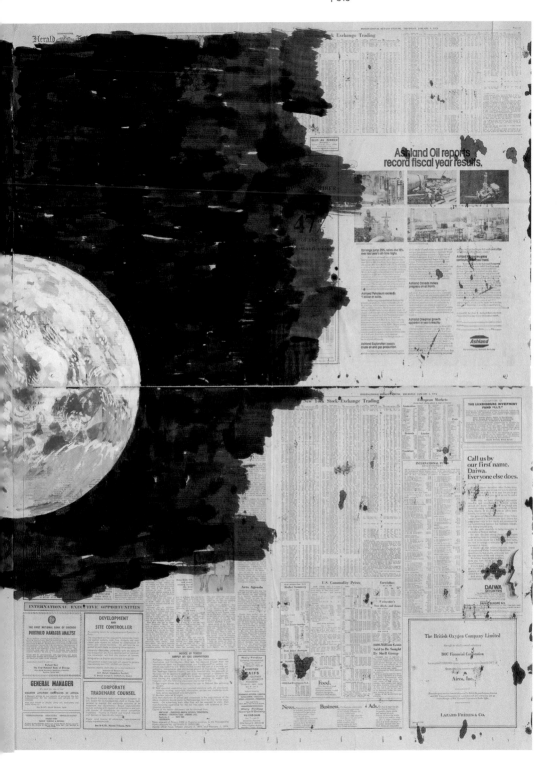

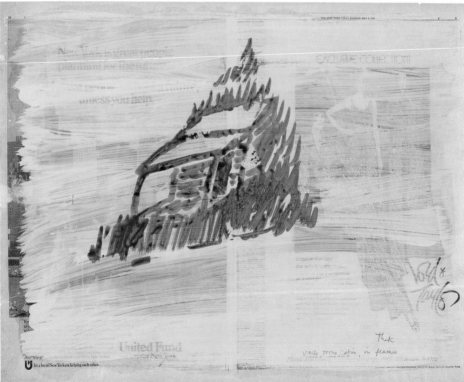

Paul Thek

2 Birds, 1975
Uncle Tom's Cabin in Flames, 1975

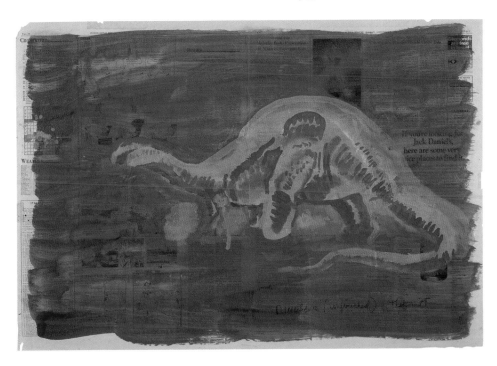

Paul Thek

Dinosaur (Unfinished), 1975
Man by Red Sea, Contemplating, 1975

Wolfgang Tillmans

As Wolfgang Tillmans was coming into his own in the early 1990s, the discourse around photography was typically dominated by issues of scale and effects. The vast, panoramic vistas of Andreas Gursky's work, for example, had a powerful, authoritative, and glossy presence. By contrast, Tillmans made a self-conscious decision in 1992 to "avoid the language of importance,"[1] as he has put it, and it is a liminal, ephemeral, and transitory sensibility that has characterized his use of photography ever since.

Though his works are too intimate to be classified as documentary per se, they have functioned from the outset as contingent documents of the artist's social milieu and physical surroundings. Whether creating portraits of friends and lovers or records of antiwar marches and techno-music subculture—subjects that appear throughout his asynchronous work—the photographer is emphatically a participant in a lived experience, rather than simply a witness to it. The same can be said equally of his still lifes or even his blushing abstract photographs, made without the use of a camera, which nevertheless convey an interpersonal intensity. Tillmans' oeuvre has accumulated into several overlapping bodies of work that constitute a reservoir of thousands of judiciously considered and strikingly immediate pictures. As the title of a 2003 exhibition by the artist declared: "If one thing matters, everything matters." Whether depicting a rat disappearing down a drain, a sock drying on a radiator, a lightning strike, an armpit, a bunch of keys, or a seated friend, a Tillmans image seems to selectively expose irresistible photographic truths about its subject with refinement and precision.

The critical nature of Tillmans' "being-in-the-world with others"[2] is also manifest in his role in editing and orchestrating his images for exhibitions or the pages of magazines and books. The artist typically installs his

1. "Avoiding what I call a language of importance was a key choice I took in 1992, feeling that I wanted to use the gallery space as a laboratory in which I can put my pictures and see how they react to being with each other, being in public, as well as being just naked sheets of paper." Wolfgang Tillmans quoted in Julie Ault, "The Subject Is Exhibition," in Julie Ault et al., *Wolfgang Tillmans*, exhibition catalogue (Los Angeles: UCLA Hammer Museum; Chicago: Museum of Contemporary Art, in association with Yale University Press, 2006), 126.
2. Daniel Birnbaum, "A New Visual Register for Our Perceptual Apparatus," in Ault et al., *Wolfgang Tillmans*, 24.
3. Quoted in "How Else Can We See Past the Fiction of Certainty," interview by Gil Bank, *Influence*, no. 2 (2004): 117.

works in clusters, couplets, or grids and sometimes singly, recalling a teenager's bedroom wall or a workplace pinboard, perhaps. From postcard-size to human proportions, his communities of images always populate an exhibition wall or tabletop in a way that suggests a set of relationships or a public conversation. Photographs are sometimes framed to take on a sculptural presence, but more often than not, the mode of presentation is, as the subjects of his picture taking can often be, too, somewhat naked and vulnerable—unprotected inkjet printouts that hang straightforwardly from pins and binder clips or that are affixed with tape. "I see an unframed photograph as an object of great beauty in its purity as a thin sheet of paper," the artist has said, "but I'm also resisting the statement that one image or object is more important than others.... The totality will always reflect more of what I think than any single picture can, but the single picture functions as the definitive version of the subject for me here and now."[3] (MA)

Born 1968, Remscheid, Germany
Lives and works in London, England, and Berlin, Germany

Wolfgang Tillmans studied at Bournemouth and Poole College, Academy of Art and Design, Bournemouth, England, from 1990 to 1992. His work has been featured in solo exhibitions at venues such as Hamburger Bahnhof—Museum für Gegenwart, Berlin (2008, cat.); Andrea Rosen Gallery, New York (2007, 2003, 2002, 2001, 1999, 1998, 1996, 1994); Galerie Daniel Buchholz, Cologne (2007, 2003, 2001, 1999, 1997, 1996, 1994, 1993); Museum of Contemporary Art, Chicago (2007–2008, cat., traveled to UCLA Hammer Museum, Los Angeles, Hirshhorn Museum and Sculpture Garden, Washington, DC, and Museo Tamayo Art Contemporáneo, Mexico City); P.S. 1 Contemporary Art Center, Long Island City, New York (2006, cat.); Maureen Paley/Interim Art, London (2005, 2002, 1999, 1995, 1993); Regen Projects, Los Angeles (2004, 2002, 1999, 1995); Tokyo Opera City Art Gallery (2004, cat.); and Tate Britain, London, and Louisiana Museum for Moderne Kunst, Humlebaek, Denmark (both in 2003, cats.). Tillmans' recent group exhibitions include What Does the Jellyfish Want? Museum Ludwig, Cologne (2007, cat.); The Secret Public: The Last Days of the British Underground, 1978–1988, Kunstverein München, Munich (2006–2007, traveled to Institute of Contemporary Arts, London); Surprise Surprise, Institute of Contemporary Arts, London (2006, cat.); Covering the Real, Kunstmuseum Basel (cat.), and Extreme Abstraction, Albright-Knox Art Gallery, Buffalo, New York (both in 2005); The Flower as Image, Louisiana Museum for Moderne Kunst, Humlebaek, Denmark (2004, cat., traveled to Fondation Beyeler, Riehen/Basel); Encounters

in the 21st Century, 21st Century Museum of Contemporary Art, Kanazawa, Japan (2004); Painting Pictures: Painting and Media in the Digital Age, Kunstmuseum Wolfsburg (2003, cat.); Uniforms, Order and Disorder, Stazione Leopolda, Florence (2001, cat., traveled to P.S. 1 Contemporary Art Center, Long Island City, New York); Présumés innocents, CAPC Musée d'Art Contemporain, Bordeaux (cat.), Apocalypse: Beauty and Horror in Contemporary Art, Royal Academy of Arts, London (cat.), and Turner Prize 2000, Tate Britain, London (all in 2000); and Berlin Biennial for Contemporary Art (1998).

Selected Bibliography

Ault, Julie. "The Subject Is Exhibition." In Julie Ault, Daniel Birnbaum, Russell Ferguson, Dominic Molon, Lane Relyea, and Mark Wigley, Wolfgang Tillmans, 119–37. Exhibition catalogue. Los Angeles: UCLA Hammer Museum; Chicago: Museum of Contemporary Art, in association with Yale University Press, 2006.
Gopnik, Blake. "Tillmans's Touch." Washington Post, May 13, 2007.
Myers, Holly. "After Arbus." LA Weekly, October 18, 2006.
Shimizu, Minoru. "Wolfgang Tillmans: The Art of Equivalence." In Wolfgang Tillmans: Truth Study Center, ed. Wolfgang Tillmans. Cologne: Taschen, 2005.
Tillmans, Wolfgang, and Hans Ulrich Obrist. The Conversation Series: 6. Cologne: Walther Koenig, 2007.

Wolfgang Tillmans *paper drop (Berlin)*, 2007

Wolfgang Tillmans *flower*, 2006

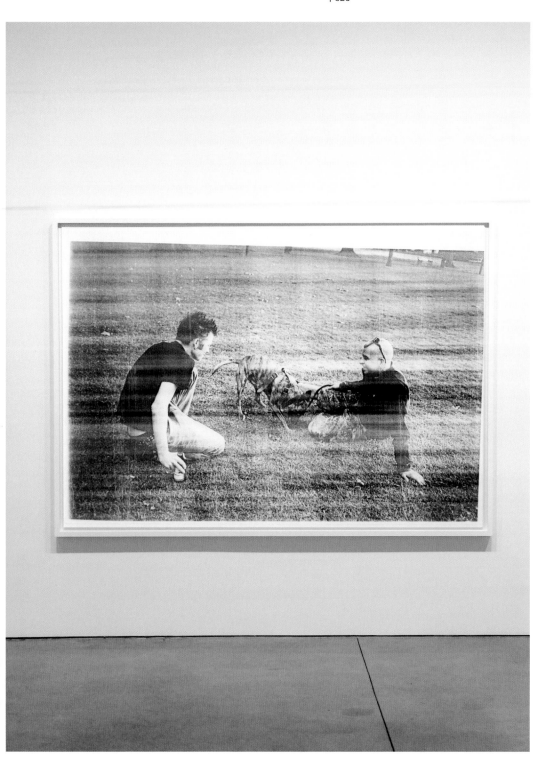

Wolfgang Tillmans *Victoria Park*, 2007

Rosemarie Trockel

With both sincerity and humorous irony, Rosemarie Trockel interrogates the inherent contradictions in our systemic cultural tropes relating to gender, domesticity, the body, and humanity's relationship to the animal kingdom. Characterized by an eclectic range of media and techniques, including ceramics, knitted-wool "paintings" and clothing, films and videos, sculptural objects, photographs, and collages, her work insists upon open-ended readings, proposing strategies that encourage loose and even incongruous associations rather than steadfast conclusions. Dualities between the authentic and the reproduced, commercial and handmade, organic and synthetic, and traditional and decorative arts appear consistently throughout her oeuvre, bringing to mind, as one critic suggested, Bertold Brecht's theory that "freedom will be acquired through the principle of contradiction."[1] Trockel frequently alludes to domestication, as can be seen in her ceramics, clothing, kitchen iconography, and houses for domesticated animals, suggesting an ambivalent relationship to the perception of "feminine myths" as well as an active resistance to the traditionally male German art world from which she emerged. The ambiguousness of her stance with regard to these oppositions becomes central to the meaning of the work. As the artist has said, "One is never on firm ground."[2]

Trockel has used knitting and textiles as an integral part of her practice since the 1980s. In her alternately abstract, symbolic, and representational wool "paintings," objects, and installations, she weaves together elements of both the mechanical and the handmade. These works, in a decontextualization of cultural iconography, frequently feature symbolic patterns relating to political or commercial systems—such as the swastika, hammer and sickle, and Playboy Bunny—knit into unassuming canvases in repeating motifs. Through their strange combinations of processes and techniques and their dislocation of familiar markers of visual language, they evoke simultaneous notions of warmth and discomfort in the viewer.

1. Lynne Cooke, "In Medias Res," in *Rosemarie Trockel*, exhibition catalogue (Munich: Sammlung Goetz, 2002), 23. Trockel has engaged the writings of Bertold Brecht in her work, as in her video *Manu's Spleen 4* (2002).
2. Trockel to Lynne Cooke in ibid.
3. *Rosemarie Trockel: Country Life, New Ceramics, and Pottery,* presented at Gladstone Gallery, New York.

A 2006 exhibition of Trockel's work in New York featured platinum-plated ceramic wall reliefs and floor pieces, demonstrating her increasing focus on the medium in recent years.[3] The spectacular wall grates, cast from old wooden planks, evoked bronze Renaissance chapel doors or the gates to a medieval prison, while the misshapen, squat, and rough-walled floor objects suggested collapsed pots or metallic mounds of animal dung. Continuing her existential and, at times, ironic investigation of the relationship between humans and animals, Trockel cast the ceramic floor mounds from slabs of raw meat. In its dialectical juxtaposition of polished and rough forms, the installation spoke ambivalently about the sphere of domesticity while the artist's nontraditional combinations of styles and materials opened up eccentric and imaginative possibilities for sculpture. In such forms, she unseats conventional imagery from established meaning. Known visual symbols are made unfamiliar, while the disconcerting, grotesque sculptural topography reiterates Trockel's embrace of an uncanny world. (HP)

Born 1952, Schwerte, Germany
Lives and works in Cologne, Germany

Rosemarie Trockel studied painting at the Werkkunstschule of Cologne from 1974 to 1978. Her work has been featured in solo exhibitions at venues such as Galerie Crone, Berlin, and Donald Young Gallery, Chicago (both in 2008); Monika Sprüth/Philomene Magers, London (2007); Gladstone Gallery, New York (2006, 2001, 1997, 1994, 1988); Museum Ludwig, Cologne (2005, cat., traveled to Museo Nazionale delle Arti del XXI Secolo, Rome); Monika Sprüth/Philomene Magers, Cologne (2004, 1997, 1994, 1992, 1986, 1984, 1983); Museum für Moderne Kunst, Frankfurt am Main (2003); Dia Center for the Arts, New York (2002, cat.); Moderna Museet, Stockholm (2001, cat.); Musée National d'Art Moderne, Centre Georges Pompidou, Paris (2000, cat.); and Donald Young Gallery, Seattle, and Whitechapel Art Gallery, London (both in 1998). Trockel's recent group exhibitions include Biennale d'Art Contemporain de Lyon (2007, cat.); The 80s: A Topology, Museu de Arte Contemporânea de Serralves, Porto, Portugal (2006, cat.); 40yearsvideoart.de: Part 1, ZKM/ Zentrum für Kunst und Medientechnologie, Karlsruhe, and K21, Düsseldorf (2006, cat.); Flashback: Revisiting the Art of the 80s, Kunstmuseum Basel (cat.), and Spinning the Web: The eBay Connection, Museum für Moderne Kunst, Frankfurt am Main (both in

2005); Venice Biennale, and Face to Face to Cyberspace, Fondation Beyeler, Riehen/Basel (both in 1999, cats.); International Istanbul Biennial (1999, 1995, cats.); Documenta, Kassel (1997, cat.); Manifesta: European Biennial of Contemporary Art, Rotterdam, and Biennale of Sydney (both in 1996, cats.); Bienal de São Paulo (1994, cat.); Allegories of Modernism: Contemporary Drawing, Museum of Modern Art, New York (1992, cat.); and Carnegie International, Carnegie Museum of Art, Pittsburgh (1988, cat.).

Selected Bibliography

Eiblmayr, Silvia, Barbara Engelbach, Brigid Doherty, and Gregory Williams. Rosemarie Trockel: Post-Menopause. Exhibition catalogue. Cologne: Museum Ludwig and Walther Koenig, 2006.
Graw, Isabelle. "Rosemarie Trockel Talks to Isabelle Graw." Interview. Artforum 61, no. 7 (March 2003): 224–25.
Heiser, Jörg. "The Seeming and the Meaning." Frieze, no. 93 (September 2005): 109–15.
"Rosemarie Trockel." Special section. Afterall, no. 8 (November 2003): 61–86.
"Rosemarie Trockel." Special section. Parkett, no. 33 (1992): 30–77.

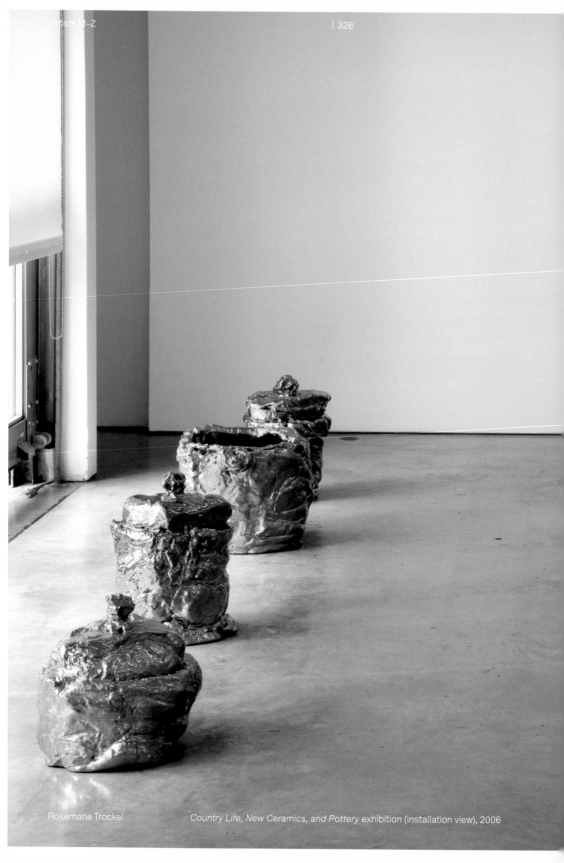

Rosemarie Trockel *Country Life, New Ceramics, and Pottery* exhibition (installation view), 2006

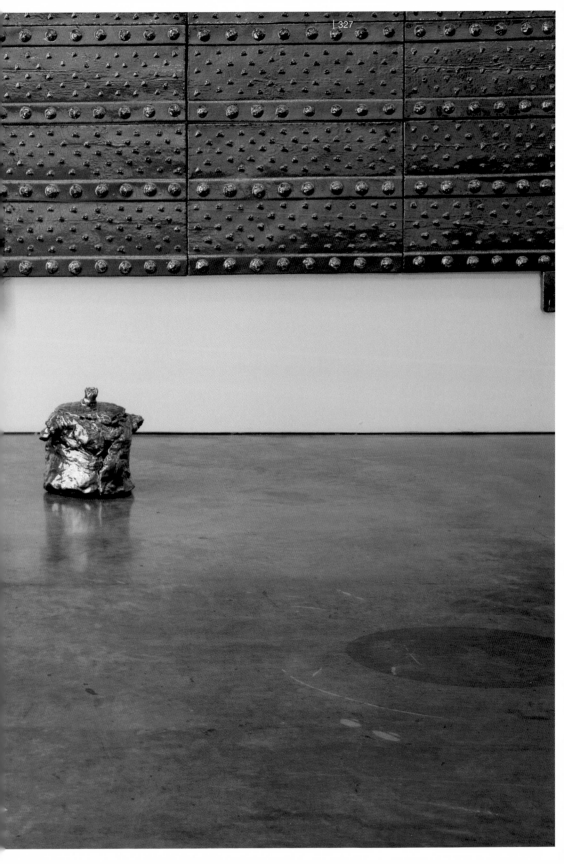

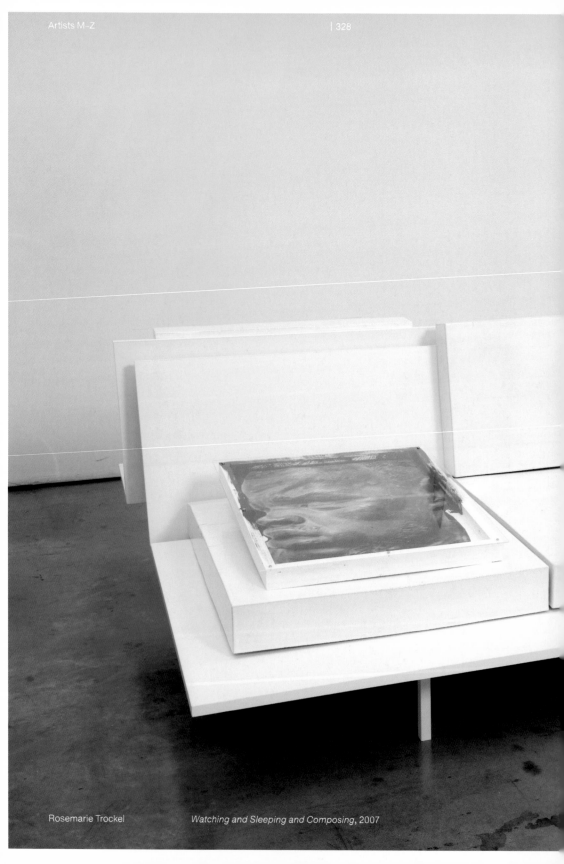

Rosemarie Trockel *Watching and Sleeping and Composing*, 2007

Apichatpong Weerasethakul

Apichatpong Weerasethakul is the foremost independent experimental filmmaker to have emerged from Thailand. The four major features he has directed to date, beginning in 2000, dovetail with a series of shorter single-screen works and multiscreen video installations, each made with collaborators from his production company Kick the Machine, formed in Bangkok in 1999. Weerasethakul's beguiling films draw on Thai society's deep-rooted reverence for the realm of the supernatural, Buddhist themes of previous and future incarnations, and popular soap operas. Time is frequently rendered fluid and layered, and apparently ordinary episodes slide into slumberous "Once upon a time …" folktales in which the light and the jungle often become protagonists in themselves.

Blissfully Yours (2002) follows Min and his girlfriend, Roong, as they while away a lazy, hazy, and hot afternoon in the forest and try to soothe his skin condition. Min is a Burmese immigrant, and as the director has explained, the film provides "an overdose of happiness" in which he chose to "focus on mundane and futile activities, which in themselves carry an underlying political message."[1] Weerasethakul's work is often haunted by mirroring, splitting, and doubling both structurally (the credits of *Blissfully Yours* occur halfway through) and through rhymed images and transformations. Steeped in an anxiously sensual and foreboding portrayal of the jungle, his breakthrough film *Tropical Malady* (2004) also follows two lovers, here a farmer and a soldier, yet it is cleft by the apparent vanishing of one of them midway through the story, the inference being that he has been magicked into a tiger. In Weerasethakul's world, linear narrative is usurped by ambience, and his characteristic use of extended takes and sumptuous tracking shots also suggests a meditative approach to cinematic consciousness. According to Weerasethakul, his films "encourage the idea of self-awareness.... [They] always encourage

1. Filmmaker's note on *Blissfully Yours*, http://www.kickthemachine.com works/blissfully_yours_note .html.
2. Weerasethakul interviewed by Michael Guillén, "Thai Cinema—*The Evening Class* Interview with Apichatpong Weerasethakul," http://theeveningclass.blogspot.com, entry of April 13, 2007.
3. Filmmaker's note from 2005 on *Syndromes and a Century*, http://www.kickthemachine.com/works/ Syndromes.html.
4. Weerasethakul interviewed by Tony Rayns, "Memories, Mysteries," July 2006, http://www .kickthemachine.com/works/Synd_interview.html.

the audience to explore the movie but also themselves ... you're not lost in the stream of narrative, you're aware of sitting and watching and your environment."[2]

Syndromes and a Century (2006) is similarly formed from two distinct halves. It turns on a doubled interview scene between a male doctor and a female doctor, the first of which is set in a sun-dappled country hospital, the second in a fluorescent-lit city clinic. As we encounter, among others, a singing dentist, a monk who dreams of chickens, prosthetic legs, and magnificent orchids, scenes play out through paralleled correspondences and visual doppelgängers as "time is collapsed to mimic a pattern of remembering."[3] *Syndromes and a Century* is based loosely on the director's parents' recollections of their experiences before they met, and it conjures an intensely personal spell of truth and fiction. "The pleasure," for Weerasethakul, "is not in remembering exactly but in recapturing the *feeling* of the memory and in blending that with the present."[4] The four-screen installation *Unknown Forces* (2007) functions as an indirect account of Thailand's shifting demographics and work practices. Consisting mostly of a static shot of the back of a sun-baked pickup truck as it carries a group of nomadic laborers, it gives voice to a "voiceless" workforce through storytelling, humor, and dance. (MA)

Born 1970, Bangkok, Thailand
Lives and works in Bangkok

Apichatpong Weerasethakul graduated from Khon Kaen University, Thailand, in 1994 with a BA and from the School of the Art Institute of Chicago in 1997 with an MFA. His work has been featured in solo exhibitions at venues such as SCAI The Bathhouse, Tokyo (2008), and REDCAT, Los Angeles (2007). Weerasethakul's recent group exhibitions include *Discovering the Other*, National Palace Museum, Taipei (cat.), and *Space for Your Future: Recombining the DNA of Art and Design*, Museum of Contemporary Art, Tokyo (both in 2007); Liverpool Biennial, Tate Liverpool (cat.), *Grey Flags*, Sculpture Center, Long Island City, New York (cat.), and Curtas Vila do Conde International Film Festival, Portugal (all in 2006); Taipei Biennial, Biennale de l'Image en Mouvement, Geneva, and Torino Triennale, Turin (all in 2005, cats.); SENI Singapore, *Slow Rushes: Takes on the Documentary Sensibility in Moving Images from around Asia and the Pacific*, Contemporary Art Centre, Vilnius, Lithuania, Busan Biennale, South Korea, and *Videotraffic*, Artsonje Center, Seoul (all in 2004, cats.); *Under Construction: New Dimensions of Asian Art*, Tokyo Opera City Art Gallery (2003); and International Istanbul Biennial (2001, cat.).

Selected Bibliography

Dargis, Monohla. "The Fabulist Who Confounded Cannes." *New York Times*, June 26, 2005.
Quandt, James. "Exquisite Corpus: The Films of Apichatpong Weerasethakul." *Artforum* 63, no. 9 (May 2005): 226–31.
Rebhandl, Bert. "Ghost World." *Frieze*, no. 103 (November–December 2006): 150–55.
Rithedee, Kong. "Jungle Fever." *Film Comment*, May–June 2005, 44–47.
Wong, Martin. "Unseen Force/Original Syndrome." *Giant Robot*, no. 48 (May 2007): 40–45.

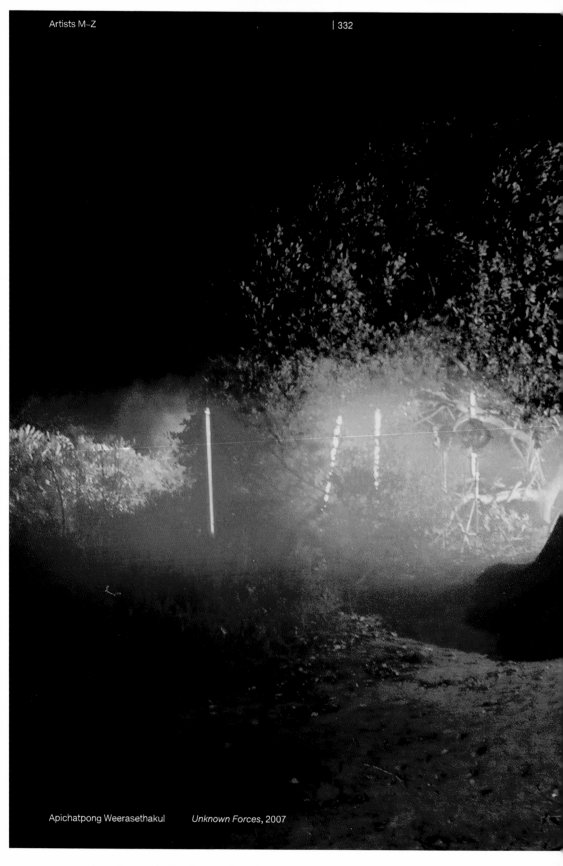

Apichatpong Weerasethakul *Unknown Forces*, 2007

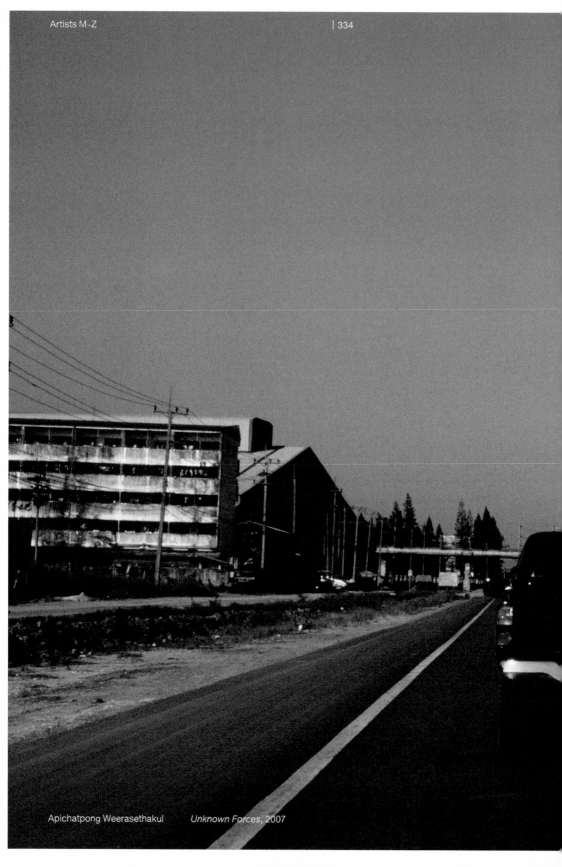

Apichatpong Weerasethakul *Unknown Forces*, 2007

Andro Wekua

Figuring out the work of Andro Wekua is like mining a narrow, compressed seam of some precious artistic mineral. His paintings, drawings, prints, collages, films, and imposing sculptural tableaux are encountered in a thin layer that lies between sedimented fact and autobiography on the one side and myth and theatrics on the other. Moreover, it seems as if our excavations take place largely in the dark. Wekua casts a pervasive mood of crepuscular seclusion in his two-dimensional work, which consists of claustrophobic accumulations of fragmentary photographs, geometries, chromatics, and texts. But the obscurity is also accompanied by the willful denial of vision, which is a leitmotif of the uncanny life-size cast figures that populate his art and a catalyst for our own disorientation as we feel our way around his cavernous use of symbols and associations.

In *What Is Your Name My Child* (2004), this lack of sight affects the cast-wax figure of a schoolboy, dressed in a prim uniform of gray shorts, shirt, tie, and black lace-up shoes, who is placed high on a black-glazed ceramic pedestal. He stands rigidly to attention, as if being chastised, his hands blackened, perhaps singed, and his eyes smothered with paste. In other portentous scenes, it is female figures that have been brutalized, having apparently had their eyes put out with hot pokers, as in, for example, *Do You Want to Play with Me?* (2005) or having been tortured and beheaded, as in *Boy Oh Boy* (2006). In a work such as *Wave Face* (2005), meanwhile, blindness appears in the disguise of a theatrical mask that is held and contemplated by the mannequin-woman who sits poised atop a magisterial purple-tiled thronelike platform.

Much has been made of the role that the artist's personal and family history has played in his artwork, of the way he was forced to cut short his childhood to flee the violence of the war-torn former Georgian Soviet Socialist Republic. Yet Wekua pointedly resists exoticizing narratives of loss, trauma, turmoil, and displacement. Memory—whether triggered by the artist's mise-en-scènes, passages of his own prose, his evocative titles, or glimpses of a bedroom, a seaside house, and the like from his 2005 film

1. Quoted in Samantha Conti, "Out of the Past...," *W*, November 2006, 359.

Neighbour's Yard—is instead assumed to be no more authentic, or no less artificial, than, for example, the clippings from vintage magazines and silver-screen-star portraits that wend their way into his collages or the classical or Freudian symbolism that his emotionally demanding work might animate. As the artist has commented, speaking of his hometown of Sukhumi, "Sometimes I think I don't really want to go back there, because I don't want to destroy the images that I have in my head. I have all I want to have."[1] (MA)

Born 1977, Sukhumi, Georgia
Lives and works in Zürich, Switzerland

Andro Wekua graduated from the National Art School in Sukhumi in 1991. Following postgraduate work in the fine arts program at the Gogebashvili Institute, Tbilisi, Georgia, from 1993 to 1994, Wekua graduated from the Visual Art School, Basel, Switzerland, in 1999. His work has been featured in solo exhibitions at venues such as Gladstone Gallery, New York (2008, cat., 2006, cat.); Museum Boijmans Van Beuningen, Rotterdam (2007, cat.); Galerie Peter Kilchmann, Zürich (2007, 2005); Kunstmuseum Winterthur, Switzerland (2006, cat.); Bonner Kunstverein, Bonn, and Rubell Art Collection, Miami (both in 2005); and Neue Kunst Halle St. Gallen, Switzerland (2004, cat.). Wekua's recent group exhibitions include *Fractured Figure: Works from the Dakis Joannou Collection*, Deste Foundation Centre for Contemporary Art, Athens, and *Like Color in Pictures*, Aspen Art Museum, Colorado (both in 2007, cats.); *Printemps de Septembre*, Festival of Contemporary Images, Toulouse, France (cat.), *Let's Stay Alive till Monday*, Children National Gallery, Tbilisi, Georgia, *Painting Architecture*, Camden Arts Center, London (cat.), *Infinite Painting: Contemporary Painting and Global Realism*, Villa Manin Centro d'Arte Contemporanea, Codroipo, Italy (cat.), Berlin Biennial for Contemporary Art (cat.), *Acquisitions Récentes*, Musée National d'Art, Centre Georges Pompidou, Paris, and *Neuerwerbsausstellung der Grafischen Sammlung*, Kunsthaus Zürich (all in 2006); and Prague Biennale (2005, cat.).

Selected Bibliography

Baumann, Daniel. "Andro Wekua: Being at One with One's Self." *Flash Art*, no. 254 (May–June 2007): 106–7.
Cattelan, Maurizio. "Shadows on the Façade: An Interview with Andro Wekua." *Flash Art*, no. 254 (May–June 2007): 108–10.
Jetzer, Gianni. "Archaeology as Biographical Clue." In *That Would Have Been Wonderful*, 76–79. Exhibition catalogue. Zürich: Edition Patrick Frey, 2005.
Schwarz, Dieter, and Rein Wolfs. *If There Ever Was One*. Exhibition catalogue. Zürich: JRP Ringier, 2006.
Subotnik, Ali. "Back to Life." *Parkett*, no. 77 (2006): 186.
Zolghadr, Tirdad. "Notes on Andro Wekua." *Parkett*, no. 78 (2006): 6–17.

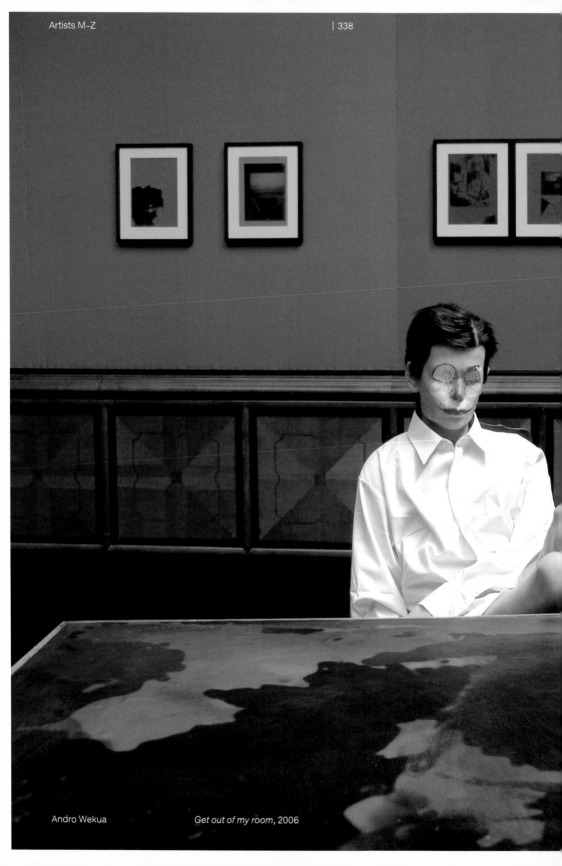

Andro Wekua *Get out of my room*, 2006

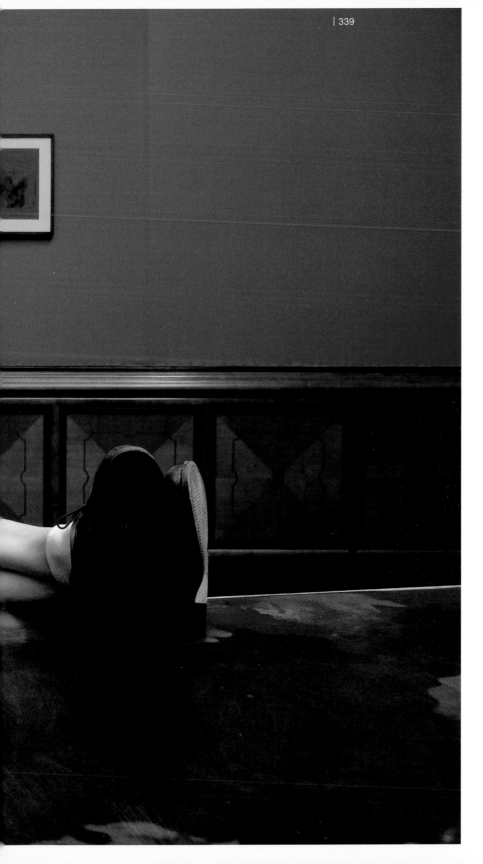

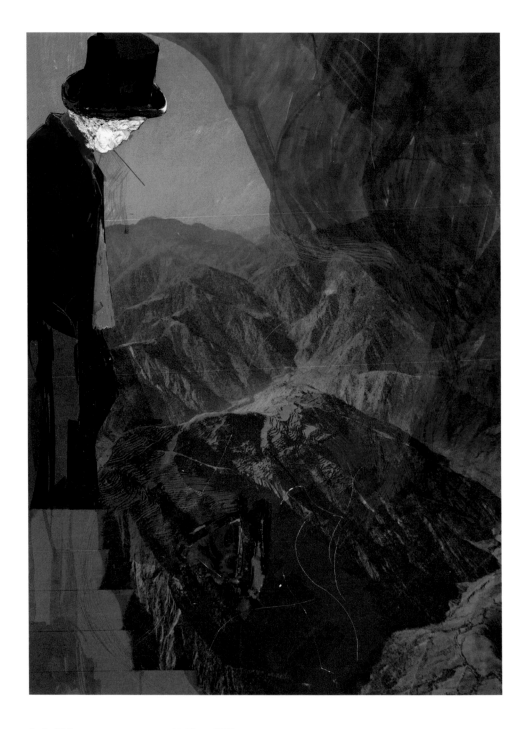

Andro Wekua *My Place*, 2006

Andro Wekua *Without Mirror*, 2005

Richard Wright

With an acute understanding of form, architecture, and color, Richard Wright paints ephemeral wall drawings that call attention to overlooked parts of the built environment while subtly altering the viewer's experience of space. He developed his brand of site-specific art making in the early 1990s, when, after twelve years of painting primarily figurative images on canvas, he destroyed all of his works created prior to 1990 and began to paint increasingly abstract, nonnarrative imagery directly onto the wall. This change in method reflected a parallel shift from figurative to conceptual work in Glasgow's vibrant painting scene of which he was an influential member.[1]

Although Wright also makes works on paper, his primary modus operandi consists of installations or interventions, which he often places in the unconventional or marginalized spaces of a site, such as ceilings, cornices, windowpanes, or the edges of a wall. Each of his wall drawings is unique, reflecting the artist's response to a particular place. They are also, in theory, temporary by nature, as he requires that each of these be painted over at the end of the exhibition.[2] Using simply a brush and paint—primarily gouache, but also tempera, oil, enamel, and even gold leaf—Wright creates his wall drawings on-site in a time-consuming and laborious process. The results are improvisational yet precise paintings with designs ranging from organic, tattoolike forms to geometric line drawings to cosmological sunbursts or constellations. Wright's works play with perspective and optical effects, reminiscent of quieter versions of Bridget Riley's bold Op Art paintings, evoking (seen or imagined) fluctuations of color, shadow, and light. Unlike Riley or the virtuoso of conceptual wall drawings, Sol LeWitt, both of whom conceived their work but preferred to have others execute it, Wright generally paints with his own hand. Perhaps more like the delicate and unquantifiable pencil-on-gesso grid paintings of Agnes Martin, Wright's wall drawings have a mechanically precise appearance from a

1. For more about he Glasgow scene, see Kari J. Brandtzæg, *Glasgow: A Presentation of the Art Scene in the 90s* (Oslo: For Art/The Institute for Research within International Contemporary Art, 1997), 37–40.
2. The exception to this rule is when a wall drawing is acquired into a collection. Although these are also site-specific works, they can remain in perpetuity in that physical space.
3. Quoted in Brian Sholis, "Richard Wright," in *Vitamin D: New Perspectives in Drawing*, ed. Reena Jana (London and New York: Phaidon, 2005), 326.
4. Referring to *Sodium & Asphalt*, exhibition cocurated by the Museo Tamayo Arte Contemporáneo and the British Council; venues included Museo Tamayo Arte Contemporáneo, Mexico City, and Museo de Arte Contemporáneo de Monterrey.

distance, the result of their seemingly perfect arrangement of lines, curves, and forms; upon closer inspection, however, they reveal slight irregularities that divulge the works' innately handmade qualities.

Wright operates in an "expanded field" between painting, architecture, and ornamentation. His installations are subtly antiauthoritarian in their restrained disruption of institutional space and in the contradiction that exists between the laborious process of their creation and their inevitable disappearance—as he has said of his work, "the most important thing … is that it is destroyed."[3] As part of a group exhibition in Mexico City in 2004, Wright renegotiated contested outdoor spaces by installing abstract silkscreen prints of his design on the walls of various buildings, pasting them over preexisting torn posters and graffiti tags.[4] Like the advertisements and paint marks around them, his prints eventually succumbed to the urban evolutionary life cycle, disappearing beneath layers of paper or paint, or simply being rubbed off. Wright's transient practice asserts the importance of erasure as a natural part of creativity and the possibility for quiet marks on a wall to change our perception of everything around them. (HP)

Born 1960, London, England
Lives and works in Glasgow, Scotland

Richard Wright graduated from the Edinburgh College of Art, Scotland, in 1982 with a BFA and from the Glasgow School of Art in 1995 with an MFA. His work has been featured in solo exhibitions at venues such as Modern Institute, Glasgow (2008, 2003); Museum of Contemporary Art, San Diego (2007); BQ, Cologne (2006, 2003, cat., 1999, cat.); Le Domaine de Kerguéhennec, Bignan, France, and Gagosian Gallery (uptown), New York (both in 2005); Dundee Contemporary Arts, Scotland (2004, cat.); Kunstverein für die Rheinlande und Westfalen, Düsseldorf (cat.), and Gagosian Gallery, London (both in 2002); Tate Liverpool and Kunsthalle Bern (both in 2001); and Gagosian Gallery, New York (2000). Wright's recent group exhibitions include *Jardins Publics*, Edinburgh International Festival (2007); *Strange I've Seen That Face Before*, Städtisches Museum Abteiberg, Mönchengladbach (cat.), and *The Subversive Charm of the Bourgeoisie*, Van Abbemuseum, Eindhoven (both in 2006); *Supernova*, organized by the British Council (2005–2007, cat., traveled to Bunkier Sztuki, Kraków; Kunstihoone, Tallinn, Estonia; Contemporary Art Centre, Vilnius, Lithuania; City Gallery, Prague; Jan Koniarek Gallery, Trnava, Slovakia; Gliptoteka, Zagreb, Croatia; Multimedia Center, Split, Croatia; and Nicosia Municipal Arts Centre, Cyprus); *Killing*

Time and Listening between the Lines, La Colección Jumex, Mexico City (2003); *Drawing Now: Eight Propositions*, Museum of Modern Art, New York (2002, cat.); *Here + Now, Scottish Art 1990–2001*, Dundee Contemporary Arts, Scotland, and *Painting at the Edge of the World*, Walker Art Center, Minneapolis (both in 2001, cats.); *Intelligence: New British Art 2000*, Tate Britain, London (2000, cat.); *Selections: Winter 1999*, Drawing Center, New York (1999); and Manifesta: European Biennial of Contemporary Art, Luxembourg (1998, cat.).

Selected Bibliography

Brown, Katrina M., ed. *Richard Wright*. Exhibition catalogue. Dundee: Dundee Contemporary Arts, 2006.
Farquharson, Alex. "Back to the Wall." *Frieze*, no. 58 (April 2001): 80–83.
Kersting, Rita, and Anette Freudenberger, eds. *Richard Wright*. Exhibition catalogue. Düsseldorf: Kunstverein für die Rheinlande und Westfalen, 2002.
"Richard Wright." Special section. *Afterall*, no. 7 (2003): 18–39.
Sholis, Brian. "Richard Wright." In *Vitamin D: New Perspectives in Drawing*, edited by Reena Jana, 326–29. London and New York: Phaidon, 2005.

Richard Wright No Title, 2006

Richard Wright No Title, 2006

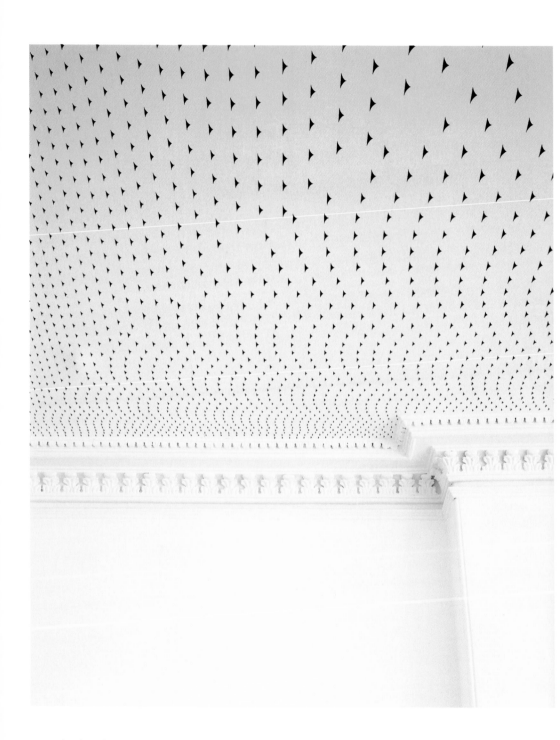

Richard Wright No Title, 2007

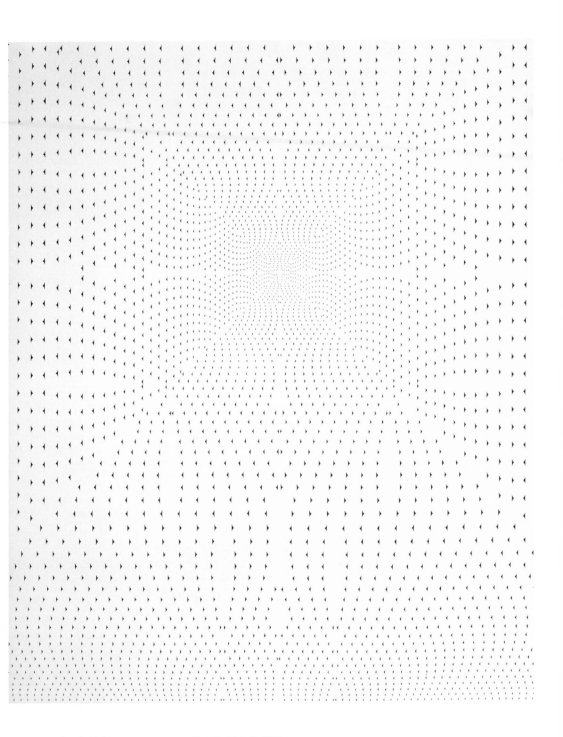

Richard Wright No Title (detail), 2007

Haegue Yang

Haegue Yang's restless video-essays *Restrained Courage* and *Unfolding Places* (both from 2004) each are made up of almost twenty minutes of apparently insignificant moments from days and nights spent in Amsterdam, London, Berlin, and the artist's city of birth, Seoul, South Korea. Cars thunder underneath a bridge, the sun emerges from behind a wharf building, passengers drift across a station concourse, a tree is reflected in a window. The voice-overs that accompany the handheld footage were scripted by Yang yet are read by actors, and as they repeatedly express sentiments of awkward dislocation and a frustration in relating with others, they bring a vulnerable and confessional inflection to the stream of images. Brightly colored, geometric origami constructions appear strewn across puddles in *Unfolding Places*. They also featured as elements of *Sadong 30* (2006), a project in Inch'ŏn, South Korea, in which Yang transformed the interior and courtyard of a decrepit house with fragile interventions of sculpture and light. Origami constructions carry a metaphorical burden in her work, and the artist has spoken of the contrast between the learned behavior of paper folding and the "nonfolding" method that she aspires to, which for her is a constant attempt to "unlearn" standardized habits. Consequently, beginning in the late 1990s, as her work became known to a wider public, Yang has continued to resist a defining medium, engaging instead with a range of means, including wall drawing, books, sculpture, installation, moving image, and photography.

The oblique self-analysis that Yang uses as both strategy and substance in her "placeless" art is symptomatic of someone who has lived for many years outside of her country of origin and whose life and work entail the high-mobility and in-transit condition common to many contemporary artists operating internationally. This acute sense of provisional belonging—being at home in what is foreign and feeling foreign in what is home—lends Yang's work a hair-trigger sensitivity for the inflections of quotidian experience. The photographic series *Social Conditions of the Sitting Table* (2001), for example, inventories the practice in Korea of putting low tables outside the front door of some homes—something that

doubtless seemed unremarkable to her within the culture. Yet her eulogy to these ostensibly banal tables—vestiges from traditional house design wherein a raised threshold would have allowed visitors to be received without being formally welcomed into the home—highlights the tenacity of socially meaningful objects that have persisted despite modernization and the loss of original context.

Storage Piece (2004) is a succinct and humorous anomaly among Yang's narratives of belonging, cultural baggage, and emancipation. Finding herself without a place to store several of her works, which were due to be returned from various exhibitions around the world, and simultaneously preparing for a new exhibition in London, she neutralized the two predicaments by creating a third. What emerged was a new sculpture made of the diverted "homeless" artworks, which sat unseen and mothballed in their protective bubble wrap or packed in crates strapped to wooden pallets. (MA)

Born 1971, Seoul, South Korea
Lives and works in Frankfurt am Main and Berlin,
Germany, and Seoul

Haegue Yang graduated from the Fine Arts College at Seoul National University in 1994 with a BFA and the Städelschule, Frankfurt am Main, in 1999 with an MA. Her work has been featured in solo exhibitions at venues such as Cubitt, London (2008); Dépendance, Brussels (2007, 2004); Galerie Barbara Wien, Berlin (2007, 2004, 2000); Basis voor Actuele Kunst, Utrecht (2006, cat.); and Hessisches Landesmuseum, Darmstadt (2004). Additionally, she completed a site-specific installation, *Sadong 30*, in Inch'ŏn, South Korea (2006, cat.). Yang's recent group exhibitions include *Brave New Worlds*, Walker Art Center, Minneapolis, *Tomorrow*, Artsonje Center and Kumho Museum, Seoul, Prague Biennale, and *Made in Germany*, Kestnergesell-schaft, Hannover (all in 2007, cats.); *"If I Can't Dance, I Don't Want to Be Part of Your Revolution": Edition 2—Feminist Legacies and Potentials in Contemporary Art Practice*, De Appel, Amsterdam (2006–2007, cat., traveled to Museum van Hedendaagse Kunst, Antwerp); Bienal de São Paolo (2006, cat.); Busan Biennale, South Korea (2004, cat.); and Manifesta: European Biennial of Contemporary Art, Frankfurt am Main, and Gwangju Biennale, South Korea (both in 2002, cats.).

Selected Bibliography

Birnbaum, Daniel. "First Take: Daniel Birnbaum on Haegue Yang." *Artforum* 41, no. 5 (January 2003): 123.
Chong, Doryun. "Territory of a Poet-Activist: Haegue Yang." In *Brave New Worlds*, 218–24. Exhibition catalogue. Minneapolis: Walker Art Center, 2007.
Larsen, Lars Bang. "Community Work: Space and Event in the Art of Haegue Yang." In *Community of Absence*, 29–34. Exhibition catalogue. Utrecht: Basis voor Actuele Kunst, 2007.
Pethick, Emily. "FOCUS: Fog Machines, Scent Dispensers and Origami; Sci-fi Tower Blocks and Urban Detritus." *Frieze*, no. 103 (November 2006): 144.
Voltz, Aurélie. "Haegue Yang: Remote Room." *Flash Art*, no. 255 (July–September 2007): 129.

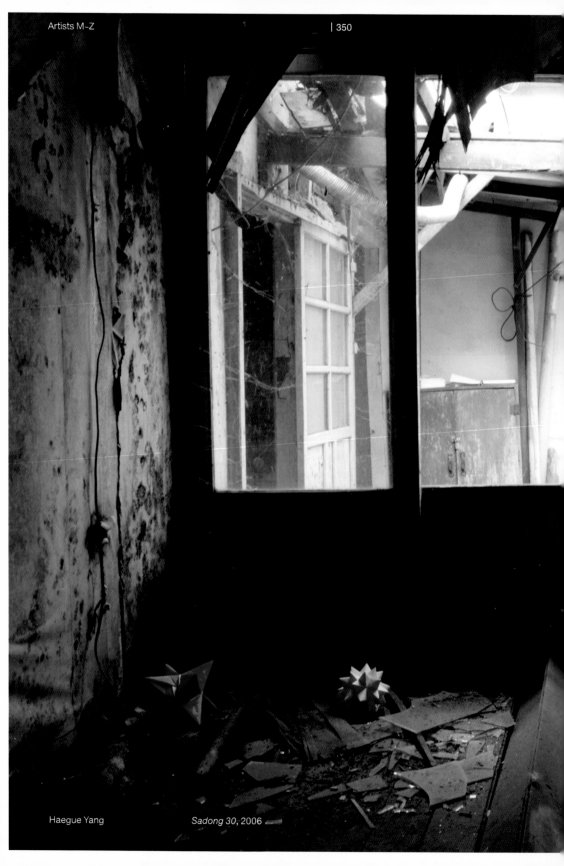

Haegue Yang *Sadong 30*, 2006

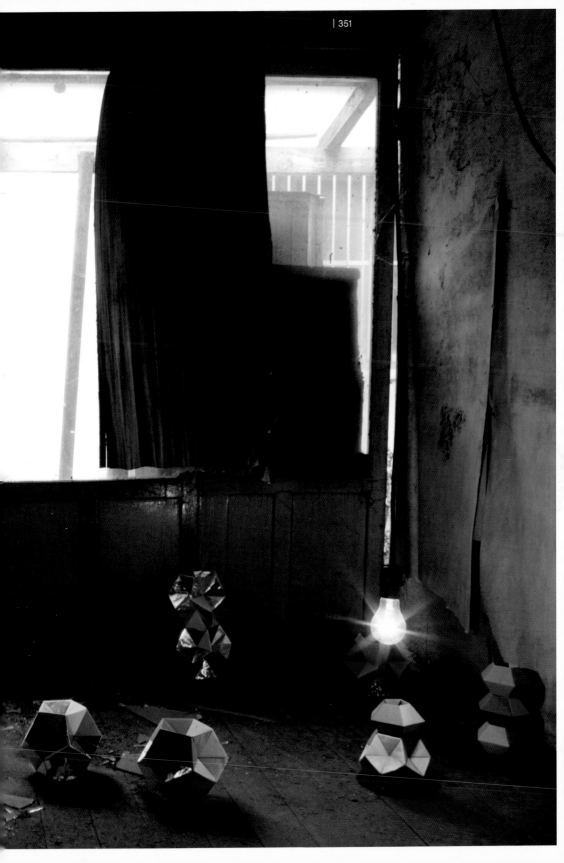

Haegue Yang *Sadong 30*, 2006

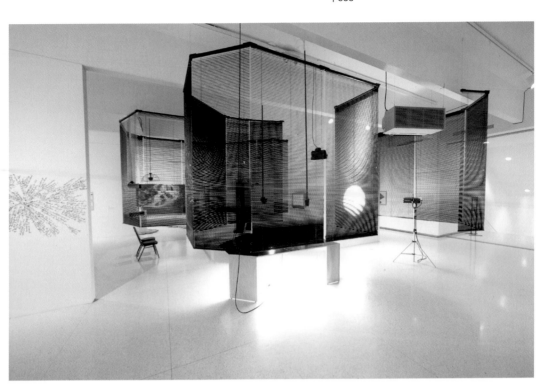

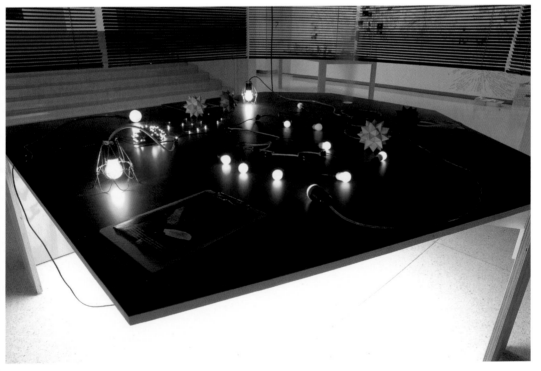

Haegue Yang *Blind Room*, 2006/2007
 Blind Room, 2006/2007

The Great Game to Come: An Introduction to a New Form of Being

Chus Martínez

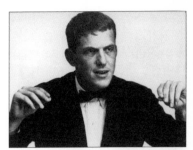

Jørgen Leth, *The Perfect Human*, 1967

I.

A tuxedo-clad man in his thirties, or perhaps even younger, is sitting in a chair and looking straight at us. He rubs the polished wooden surface of a pipe on his face, leaning forward so that for a short while he comes closer to us. He sits straight again, gaining distance from the camera lens. He turns in his chair, showing us his right profile, and plays with the pipe for a few seconds before putting it to his lips and expertly packing it with tobacco. He turns in his chair again so that we see him now in left profile and lights the tobacco with a match, puffing slowly and rhythmically at the pipe. Suddenly a melody can be heard. The pastoral sound of an oboe instills the almost anthropological imagery we have seen thus far with mood. A woman comes into view. She stares at us as if she were looking in a mirror. She holds her hair, plays a little with the idea of tying it up in back, and then tilts her head so she can see if this is what she wants. She lets her hair fall from her hands. It is beautiful and dark, long and silken. The man fastens his belt, the woman retouches her makeup. A male voice-over intones, with a Scandinavian accent: "Here is the human. Here is the human. Here is the perfect human."

The Perfect Human (Det perfekte menneske) was filmed in 1967 by the Danish filmmaker Jørgen Leth. During its twelve minutes' duration, the film shows a man and a woman enacting the perfect human. The perfect man and the perfect woman find themselves in an empty room brightly lit by sunlight. Dressed in the simple sophistication of good taste, both are the lone inhabitants of an endless new world; self-contained and self-controlled, far away from the ever-evolving political realities, they concentrate solely on themselves. They move in the room, skipping and jumping, reveling in the absolute stability of their situation. "We will see the perfect human functioning"—that voice again—but what are they thinking? How can the world emerge from such an airtight space?

And yet, existential possibilities abound. The perfect human is a self-proclaimed metroman: he is "cooked,"[1] cultivated, and follows the usual itineraries of the civilized condition. He knows and loves the codes, and at the same time they bore him. The perfect human is not the average man; he is not at the mercy of the world's every destructive whim or the

1. The term "cooked" here refers to the dichotomy established by the French cultural anthropologist Claude Lévi-Strauss. Lévi-Strauss postulates that the raw/cooked axis is characteristic of all human culture, with elements falling along the "raw" side of the axis being those of "natural" origin, and those falling on the "cooked" side being of "cultural" origin, that is, products of human creation.
2. Alexander Trocchi, Cain's Book (London: John Calder Publishers, 1963), 11.
3. Hans-Jørgen Nielsen, Nye Sprog Nye Verdener—udvalgte artikler om kunst og kultur (Copenhagen: Gyldendal, 2006), 36 (translation mine).
4. Félix Guattari, The Three Ecologies, trans. Ian Pindar and Paul Sutton (London: Athlone Press, 2000), 50.

nonviolent social control of media. This individual knows about the unseen pressures of market forces, the ideology of unrestricted competition, the plunder of natural resources, the widespread poverty and malnutrition of one-third of the world's population, the exploitation of low-income laborers and other vulnerable groups, and on and on. But in an effort to singularize his existence, he has returned to a state of saturated unconsciousness, eerily silent and with an acute sense of attitude. Perception turns inward and registers intactness: "For the attitude born of this sense of inviolability some Americans have used the word 'cool.'"[2] Attitude is a rhetorical form because, unlike personality, attitudes conform to experience. About the same time the movie was made, a contemporary of Leth's, the writer Hans-Jørgen Nielsen, observed that "there are no value systems, but there are points of value that connect one situation to the next, from one attitude to the next."[3] But how do all these points of importance connect?

This fantasy of the self as inviolable should not be mistaken for misanthropy. The empty room in which the perfect human lives and moves is his privileged antechamber; from here, life can be rehearsed and analyzed. He takes this room to be an antidote to the media-manufactured apparatuses that produce subjectivity. However, the room is a phantom, and so is the perfect human. In his book *The Three Ecologies*, the French philosopher Félix Guattari describes the situation: "Capitalist power has become delocalized and deterritorialized, both in extension, by extending its influence over the whole social, economic and cultural life of the planet, and in 'intension', by infiltrating the most unconscious subjective strata. In doing this it is no longer possible to claim to be opposed to 'capitalist' power only from the outside, through trade unions and traditional politics. It is equally imperative to confront capitalism's effects in the domain of mental ecology in everyday life: individual, domestic, material, neighbourly, creative or one's personal ethics."[4] The perfect human created his phantom space as a result of an endangered life. Unable to step into the public domain and search for a consensus, he decided to retrieve and cultivate a singular production of existence. The perfect human is in a state of diastolic closure, a state of necessary inhibition in order to get in touch with himself again.

One distinction is very important to make: the perfect human is a trope that stands for the private intellectual, a cultivated person for whom it has become impossible to act in the public domain. He is in his bright, private room, not addressing an audience in an auditorium, not glad-handing voters in the street or presiding over an intellectual discourse before the community. He cannot participate in the real, because he does not accept

the premises of societal consensus; but in his mind, he rehearses the public domain, he is preoccupied with it all the time. He has no public life, not yet. He is like a promise of hope set aside, a form of being that the future may require. It is a question, if one bothers to pose it at all, of finding a new criterion of relevance to invent a new contract of citizenship: how to become a voice in the public realm, how to become a public intellectual. It may require the activation of many other isolated singularities, the recovery of many micropolitical and microsocial formations, "working for humanity and not simply for a permanent re-equilibration of the capitalist semiotic Universe."[5]

II.

In a text that is halfway between reproach and straight, factual account, the Argentine artist and writer Luís Felipe Noé outlines in a few pages the life and work of the legendary Alberto Greco, one of the most influential artists in Buenos Aires in the 1960s. The text was written on the occasion of a commemorative exhibition at Galería Carmen Waugh in 1970, five years after the artist's death. Greco committed suicide in Barcelona in 1965, but before doing so, he wrote the word "FIN" (the end) on his left hand and took note of the details of his death agony on the label of an inkbottle. Apparently, Greco had previously announced, on a number of occasions, his desire to make death his masterwork. Perhaps the most appropriate reference here would be a survey carried out in 1960 in which leading members of the artistic community in Buenos Aires were asked about their projects for the coming year. Greco's reply was unambiguous: "to commit suicide." No one knows what caused him to undertake such an ambitious project, but his declaration leaves no doubt as to the impor-tance he attached to it, not only within the inescapable dialectic between life and death but also in the context of his artistic practice. Like many of his contemporaries, Greco was perfectly aware of the postmedia condi-tion of contemporary art. If modernity had striven to define and proclaim that which is specific to the medium par excellence, namely, painting, that same endeavor had opened the doors to the negation of what is essential and the adoption of all that is general—of that which belongs not only to art but also to the larger sphere of life. The metaphor of an indivisible unity in any given medium, intrinsic to and constituent of a unique experience that is impossible to capture through any other medium, had been called into question as never before in history.

5. Ibid., 51.
6. Ernesto Laclau, *Emancipation(s)* (London: Verso, 1996), 6.

Greco could therefore posit his suicide as a legitimate artistic act that should not be considered merely as a personal act of despair. At the same time, it was a demonstration of the ongoing power of this metaphor, of its echo—the strength of historical tradition in and on the artist's premeditated, instigative act. Any gesture or theory that points to the existence of a protected "interior" state alien to an "exterior" one is a metaphysical fiction. Whether we are referring to the "interior" of a work of art as opposed to its context or a vital moment of lived experience as opposed to its repetition in memory or in signs, the distinction is a fallacy in either sense. The idea of that which is authentically intrinsic does not hold true. Greco's suicide takes this suspicion to new extremes. Nothing seems more one's own than one's death; the identity principle seems to be proven in this terminal moment of experience, which is nontransferable and incommunicable. Greco performed his death as a representational act, not one to be followed by others. Since nothing is identical to itself and all interiority is constructed from exteriority, this death, contextualized within the corpus of the artist's mythic career, became an act of subversive appropriation designed to implode the theory of the specificity of artistic media.

Greco faced the greatest problem of the perfect human, namely, how to challenge the fiction of the empty room in which the perfect human lives and moves, by identifying principles on which a new contract with equals can be made. Greco, like the perfect human, does not believe in participation. Or, more accurately, he believes that participation is another phantom, an illusion mobilized by market forces and encouraging a perverse sort of regressive adulthood. The matter is especially complicated because the terms of the invitation to participate are not acceptable. Participation is a ceremony, a therapy to ease the apprehensions of ordinary existence by modeling it through myths and narratives. Of course, we can forever buy into the fiction that we are playing and interacting with those around us; however, there are no easy ways out here: "Emancipation," wrote the theorist Ernesto Laclau, "means *at one and the same time* radical foundation and radical exclusion; that is, it postulates, at the same time, both a ground of the social and its impossibility."[6] To leave that bright, empty room in order to continue playing the game of consensus and participation without announcing the necessity, at the least, of a radical reform in the social contract (since the allure of revolution seems vain and destructive) would be like reading the "Modest Proposal" of Jonathan Swift literally, as an invitation to ease the economic troubles of Ireland by selling children born into poverty as food for the rich. Understanding has a transformative effect. The socialist leader Rosa Luxemburg believed that "freedom is freedom for those who think differently," the emphasis of which the French

philosopher Alain Badiou provocatively shifted into "freedom is freedom only for those who really think."[7] Art can do both; it can stop before real thinking begins, but it can also continue a little bit beyond.

Performance art explores first and foremost the nature, conditions, and limits of the agreements made between the performer and the audience. To apply for one's own suicide—which Greco literally did to earn himself a travel grant to Paris—is a little like participating in a live television broadcast, a promise that could be fulfilled in real time. In live TV, real time has been agreed upon. The assumption is that what we are about to see is "for real" whereas, in fact, everything is prestructured, packaged, and edited. Only when something highly unexpected happens does the audience recall the terms of the agreement, believing that the shock is scripted. In January 1972, Chris Burden broke one of these agreements by hijacking a TV station. He was invited to participate in a local TV program, and after some back-and-forth about the best way for him to contribute, he agreed on an interview format. As he described it:

> I arrived at the station with my own video crew so that I could have my own tape. While the taping was in progress, I requested that the show be transmitted live. Since the station was not broadcasting at the time, they complied. In the course of the interview, Phyllis [Lutjeans] asked me to talk about some of the pieces I had thought of doing. I demonstrated a T.V. Hijack. Holding a knife at her throat, I threatened her life if the station stopped live transmission. I told her that I had planned to make her perform obscene acts. At the end of the recording, I asked for the tape of the show. I unwound the reel and destroyed the show by dousing the tape with acetone. The station manager was irate, and I offered him my tape which included the show and its destruction, but he refused.[8]

Fiction, reality, and the agreement on what constitutes reality get confused here. Watching Burden's action on live TV, one does not know if it is staged, if they all agreed on it beforehand. You cannot believe it is true when Burden puts the knife to the throat of the interviewer. Nobody can be sure about the terms of the contract anymore. You cannot participate if you don't know if there were previous agreements, because then you may look like a fool, taking part in a fake reality, a fake drama, or a fake joy.

7. See Alain Badiou, *Logiques des mondes: L'être et l'événement, 2* (Paris: Éditions du Seuil, 2006).
8. *Chris Burden: Beyond the Limits*, ed. Peter Noever (Vienna: Museum für angewandte Kunst; Ostfildern-Ruit, Germany: Cantz, 1996), 132.

III.

Like Greco, the perfect human can help us rethink the paradoxes in the terms of the contract that social parties establish, of which art is also a part. Greco, the self-proclaimed perfect arrogant man, was one of those who believed in the radical power of words. Therefore, he was also fascinated by what could not be said, and he staged an act that forces us to wish that common words would take on new meaning. By doing what he said he would do, he touched upon questions of agency and, why not, participation. The very moment he enumerated his own death among other projects for the coming year, he established a contract with his audience. In this, he was a genius and an idiot at the same time, because he fulfilled the conditions of the contract—he did what he said he would do—but he also broke it, since art operates by moving the mind without taking lives.

Truth should not be misconstrued as a matter of any genuine correspondence between beliefs and the actual state of affairs, but rather should be understood as a trope. Truth is a construction, an architecture made by a mobile army of ironies, metaphors, metonymies, and anthropomorphisms that shape our views of the world. A trope is a figure of speech, an attitude of language. It is not suited for formulating a systematic proposal, but it provides a vocabulary for conveying the mental images that may activate the desire for change.

In order to avoid the dangers of the contractual gap, Leth's perfect human simply went home and suspended action. The inviolable man has radical and continuous doubts about the language he uses to justify his actions and his beliefs: the very words he employs to praise his partner and his friends, to pour contempt on his enemies, to describe his long-term projects and hopes. But he is also a man impressed by other vocabularies, by the possibility of playing them off one another rather than being seduced by the logical flow of arguments. His method is one of redescription, not inference. He is fascinated by the opportunity to make sense of one's world, of one's own terms. This suggests a means for empowering that which is being redescribed, and also suggests that thoughts and subjects can be explicated in a manner that corresponds more closely with reality. The new, if such a thing exists, does not result from unveiling the real or from substituting a powerless world for a utopia machine. On the contrary, it results from exploring the perfect human's skill at producing surprising gestalt switches by making smooth, rapid transitions from one terminology to another. Actually, the perfect human has dropped the idea of getting at the truth, preferring instead to make things new at the

end of this laborious process of redescription. In his exile from the world, he is considering the world from scratch, rehearsing the conditions. This moment of isolation and privacy is the necessary condition for a future reengagement with public life. This is his possibility for becoming public again, for shifting the terms of how he acts in the world. He is aware that we need to invent a new form of being, and that cannot be done without great effort.

Why Do We Have Time to Think about Our Bodies?

Mark Manders

Originally published in Stephan Berg, ed., *The Absence of Mark Manders*,
exhibition catalogue (Hannover: Kunstverein Hannover, 2007), 176–77.

Time keeps dragging me away from the sound I love.

I guess you can say without fear of contradiction that animals have a different perception of time than humans. Time as we know it arose with the birth of thought, and of course this new perception of time only really took hold at the point when language emerged. Thinking takes time. When the first anthropoid stood erect and picked up a stone to throw at an enemy, man took his first cautious step out of the here and now. The idea that, after its brief flight through the air, the stone

could knock out the enemy can be seen as the moment when awareness of the future was born. In throwing the stone, man was in a sense catapulting himself out of the realm of birds, animals, and plants. Unlike when sleeping, mating, eating or building a nest, a crucial split occurred inside the thrower's head a fraction of a second before the stone was thrown. One part controlled the body and was anchored in the present, just as it had always been, but the other small part unfurled out of the present to a moment just beyond the present, to a possible future event in the world—the stone striking the enemy's head.

This must have started with a single individual, and if you pursue the idea further, the repetition of the throw, which was triggered by the success of the first one, opened the door to thinking as we know it—it staked out the beginnings of a big new area of memory. We acquired a consciousness in which, for example, there was time to think about our bodies, and this led to the separation of body and mind, which to some is actually painful.

Something really did change inside this proverbial anthropoid's head. Thinking cannot extend the moment of consciousness, so part of our consciousness was now preoccupied with thinking, with other matters that are not really anchored in the present. So man's consciousness of the present was split up into three areas rather than one: it was henceforth in competition with the future and the past, with ideas conveyed in language.

This evolutionary process was continually spurred on by the expansion of language, and it created a new perception of time which was embedded in actual time. This thinking is fertile soil for melancholy, as well as for melancholic wonderment. We can now wonder at the ingeniousness of plants—the way they raise up their leaves to catch refreshing drops of rain and

guide them down to their roots, and the fact that they have decided not to move around but to live in the same place all the time, which means they do not need to be able to see. Plus the fact that they have arranged for their fruits to be dispersed by animals or the wind. Plants have organized their existence so ingeniously that they do not even have to wake up.

Things that cannot wake up can never be jealous, either. We have created a huge area of desires that we can communicate, and as a result we can evolve at lightning speed, above all by making things. Ultimately, computers are ingenious in much the same way as plants are. They cannot really reproduce, of course, and no computer has ever woken up, but there is so much that they can do. As an artist I want to make something that is just as beautiful as a plant, or a computer. In my case it is a fictitious person in the form of a large building.

Visual art—except for the last few years—has constantly been preoccupied with the static. The static image is poetically related to our perception and our thinking, which take place in time. We want all these images to be anchored in a large, simultaneous, static present (or this is what we have more or less agreed on among ourselves), despite our awareness of their chronological evolution.

In that sense, of course, photography is an interesting, lucid new medium, which has recently been used as a metaphor by some who actually dispute our chronological perception of time: to them, each moment is its own universe and everything is simultaneous, so that even the green coffee cup remains intact after it has been smashed to pieces. It strikes me as an absurd theory. Just put a scratch on an LP and you will know for sure that something has changed in the world.

The Famous Last Words

Paul Sietsema

Text from *The Famous Last Words*, a poster produced in 2005. Reprinted with permission of the artist.

Time takes on different dimensions when measured by the sun, birds, and the appetite, rather than hacked into seconds and hours, as it was in my first days here. I had suspected it was the lack of timepieces, or, perhaps, the fact that every moment was lived, felt, and registered in an environment totally new to me, where, by necessity, I had to keep alert to avoid being struck by a falling coconut, cutting my feet on the many reefs here, making a wrong step. Whatever the cause, although I was never bored for a fraction of a second, every day felt so rich and long that a week became like several

months, and proceeded this way until, in the end, in the moments leading up to the final transformation, any sense of what I had come to know as time was lost completely.

And now everything is motionless, in complete silence. Not a sound from sky or earth. Gone is the soft touch of cool grass along my naked back. Gone the sun, once viewed through closed eyelids, the sweet smell of rich soil and vegetation, gone the sparkle of myriad crystal points of the morning's rain like so many stars in the canopy's underworld of shadows. How I longed for the feeling of fresh blood streaming through my body and the damp jungle air that had once filled my lungs.

In the beginning everything had seemed clearer; I had known it was one thing to dream of it and another to do it. I was making an attempt at it. Returning to nature. I crushed my watch between two stones and let my hair and beard grow wild. Climbed the palms for food. Cut all the chains that bound me to the rest of the world. I tried to enter this wilderness empty-handed and barefoot, as a man at one with nature.

Today I would have been condemned for such an existence; my hair hung down to my shoulders and my beard was so long that my mustache could be seen from behind. I ran away from bureaucracy, technology, and the grip of twentieth-century civilization. My only garment, if any at all, was a flowery loincloth, and my home was of plaited yellow bamboo. I drew no salary, for I had no expenses; my world was free for birds and beasts and barefoot men to help themselves to what they needed, one day at a time.

This experience was indeed a kind of waking dream, a trip deep into an utterly different existence. But a trip without drugs. For this journey was carefully planned and a solid reality.

It is, I am sad to say, quite impossible to reproduce the entire manuscript of this journey, which directly and simultaneously translated the subject, the rhythms, the forms, the chaos, as well as the inner defenses and their devastation; I found myself in difficulties, confronted by a typographical wall. Everything had to be written, for unfortunately there was no other form with which to capture the unexplainable experiences contained herein. And then written again, for the original text, more tangible than legible, more drawn than written, would not, in any case, be clear to

anyone except those skilled in the decipherment of mysterious forms. What remains are the few words found here, the result of so many written while the transformation was at its height, and before my ability to record was lost forever.

In the beginning, the modesty and simplicity of my thoughts proliferated, all complexity and useless meanderings being absorbed by the matted bamboo walls that housed my new existence. The attractive plaiting became ever more engaging as the fresh bamboo aged and an increasing number of bars and panels turned golden yellow and intermingled with the green ones, like a live tapestry. At the same time and in the same way, the basketwork of the green palm roof began to flame into reddish brown. The patterns and figures in the plaiting of my new walls had, surprisingly, taught me the enjoyment found in the escape from the instability and complexity of natural beauty, its capriciousness, the constant manifestation of its rain cloud of knowable things, and was, in retrospect, the beginning of my newfound devotion to the regularity of the world of inert, crystalline, geometric forms.

As I had heard, the previous inhabitants of this island, this island on which I started out as but a tourist, were not able to trust entirely to visual impression the means of becoming familiar with a space extended before them and so were dependent upon the assurances of their sense of touch. Tormented by the dangers and entangled inter-relationships and flux of the phenomena of the outer world, these inhabitants were dominated by an immense need for tranquility. They did not project themselves into the pictorial world of natural beauty that lay before them, but rather were drawn to the possibility of taking individual things out of this externalized world, out of its arbitrariness and seeming fortuitousness, of eternalizing them by approximation to abstract forms, and in this manner, of finding a point of tranquility, a refuge from appearances.

I thought, staring at those plaited walls, in hours just before sleep, sensing the early nuances of some kind of psychic shift, that perhaps it was not a distance in time that makes our consciousnesses seemingly different in makeup but a distance in space, and more presently, something inherent to this island and its desolation. The fear of extended space that habitation and intellectual reflection were supposed to eliminate seemed to be finding footholds in my consciousness in the same way that the tendrils

of the jungle's flora continued to reestablish their hold on the structure of my bamboo enclosure.

And just as the previous inhabitants of this island, its natives, I found myself longing to be delivered from my individual being; I found, as they had, that I was safe as long as I was absorbed into an external object, an external form, and could feel, as it were, my individuality flow into fixed boundaries in contrast to the boundless differentiation of my consciousness. And they found, as I ultimately did, that in this self-objectification lies a self-alienation. This affirmation of our individual need for perimeter represents, simultaneously, a curtailment of its illimitable potentialities and a negation of its un-unifiable differentiations. In this identification I am not the real I, but am inwardly liberated from the latter; I am apart from contemplation of the form (a statue, a rock); I am only this ideal, this contemplating I. In this sense I am lost, to the contemplation of the form.

This impulse, which the previous inhabitants were given to as well and was probably the cause of their disappearance, lies at the heart of the most profound understanding of the perceiving consciousness. For here the last trace of connection with and dependence on life has been effaced; here the highest absolute form, the purest abstraction has been achieved; here is law, here is necessity, while everywhere else the caprice of the organic prevails.

It is here that this story truly begins; it is where I, your narrator, come into existence in the form I take now, for at this point during my stay on the island, a threshold was reached and a flash of sorts appeared, unexpectedly, in my mind, forming a new thought pattern, simultaneously blinding me to my previous ways and delivering to me a new and wondrous vision.

And what I learned, as well as they, and will never forget, in fact cannot forget for reasons to be made clear, was that by deliberately contemplating a form, and simultaneously visualizing that form, we conjure in our minds a pattern that is in tune with a larger and more expansive external field and which can, in time, be brought to reverberate with this field and thus coincidentally describe and eventually contain our own forms, our own existences. This reverberation is brought about partially by concentrating on the visualized image and its deeper meanings with sufficient mental tension, which holds in place a seemingly endless expanse of

symbolic patterning that is capable not only of allowing our body, our form to absorb this energy field as it is absorbed by it, but also to commune with others who have entered the field throughout a continuum of cyclically shaped time. It is in this way that I first absorbed the energy of the previous inhabitants of this island and understood that I was becoming one with them.

Eventually, as my unintended internal resistances began to diminish, I found myself giving up the laborious efforts to manipulate the myriad mental elements that make up this energy field into some kind of meaningful combination, and a new and defining principle took over. Acting simultaneously on all of these elements, it combined them in a pattern, which was of unforeseen harmony, great simplicity, and considerable beauty, of a new kind.

This new energy field, the first time I experienced it, was projected above the plane of the jungle floor and through the reverberations of its crystalline form shifted the dirt, mulch, and plants into various two-dimensional representations of its own manifold structure; snowflake-like patterns of great beauty, a plane of compromised geometric multiplicity. This entire system, I noticed, shifted itself constantly, tuning itself to the mental field so as to maximize the amplification of the reverberation. I suppose what I didn't expect in the beginning, and what seems should have been so clear now, was that this field would eventually have the same effect on myself, on my own physical configuration.

My new form is strange, even savage, but it is not difficult to maintain. If looking at me you may first perceive larger fragments, leftover from earlier attempts at building a structure. Some of these fragments are lopsided, others show a kind of complicated symmetry. Some are loosely put together and will disintegrate further, others are more closely knit and will have stable form. During this eternity of random motion, what used to be my consciousness is located elsewhere, and worry not, dear reader, will not interfere.

Loose Associations Lecture

Ryan Gander

Originally published in Ryan Gander and Stuart Bailey, *Appendix* (Amsterdam: Artimo, 2003). Reprinted with permission of the artist.

Hello, I'm Ryan. Erm ... all these things are linked somehow, but at times the associations may be a bit loose.

‡ These are called desire lines. At least, that's what spatial designers and town planners call them. This first photo was taken in Kassel in Germany ... I'm talking about the lines on the ground here. When spatial designers plan pavements, there are always bits of waste ground left between them and when they don't design them properly you get these desire lines that have been worn away by people who cut across the middle. They're always on the most direct route people want to take, which is why they're called desire lines. ‡ This is another one, taken in Poland. It's Paulina Olowska's photograph, so I have to thank her for letting me use it. It's a particularly beautiful example because it's a really badly designed space. You can see that there are actually two lines, which cross each other in the middle of this pre-planned square.

‡ There's a university in Buffalo, in New York State. The campus there was relocated twenty years ago, so the architect could completely redesign it. He built the entire site but didn't put any paths in ... he just left it as gravel. ‡ There's very heavy snowfall in New York State in winter, and as the campus began to be used students began to navigate around the campus, leaving paths in the snow, so if there were a lot of people walking on the path, it would end up very wide, and the ones that weren't used so much were narrower. The architect then sent a helicopter up to make an aerial photograph of the campus, then plotted all these desire lines on a map and built the paths in the same positions with the same widths as the desire lines. It's an example of perfect planning of public space.

‡ This is the Royal Northern General Hospital in Sheffield. About fifteen years ago almost every hospital in Britain had these lines. ‡ They're called trauma lines, found particularly in accident and emergency clinics. The reason they're called trauma lines is because when people are under a lot of stress—say if your son has been in a car accident or something—you can't remember directions very well, but you CAN remember a colour to follow, so if you had to go to x-ray you'd follow yellow. This is one of only a few hospitals left in Britain with the system. Most have been phased out and replaced by overhead sign systems. ‡ This leafy jungle vine line is to direct the public to the children's casualty unit.

‡ That's the Barbican Centre in north London, made by Chamberlain, Powell and Bon. Building was started on it in, I think, 1955, and it took thirty years to complete. It covers a massive thirty-five-acre site. ‡ The site was completely flattened during the bombings of World War Two. Because it was built over such a long period of time, it wasn't planned and built as a whole but in separate staggered phases. It contains a theatre, an arts centre, shops, a library, schools —in fact, if you were to live there, there's actually no reason to ever leave. You might have heard of the Barbican because of the fact that it was supposed to be a very civically minded modernist utopian sort of housing project. Due to the fact that it was built in phases, though, it became a bit like a maze, being very difficult to find your way around.

‡ This is a picture of my Auntie Deva. Her name is spelt D-E-V-A, which is the Roman name for Chester, a city in the northwest of England which was one of three major roman fortifications. Chester was called Deva, York was called Yorvic and London was called Londinium. Auntie Deva has a saying about the Barbican: 'Once seen entering never seen again.' There's a sort of link there because the word Barbican etymologically comes from the word barricade and, in turn, fortress, and, in turn, fortification or a similar sort of defensive structure, which is quite a contradiction to the initial modernist principles on which the Barbican was supposedly based.

‡ These are navigation lines, similar to those trauma lines in the hospital, which help the public find their way around the Barbican. ‡ They don't work in terms of colour coding, as all the lines are yellow, but every so often signs are painted along the line. ‡ This sign is for the Barbican arts centre, and ‡ this one for St. Paul's underground station.

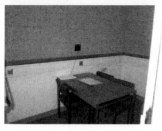

‡ This is a passivity line. It's not so easy to distinguish, but it's here ... you see, it runs horizontally at waist height around the walls of the room. They're usually found in police interview rooms, because sometimes people get restless or violent when they're being interviewed. ‡ The line has been designed by psychologists and employed by the police. If there is a horizontal line running around a room, psychologically we feel that we should be below it or at the same height as it, which means we are less likely to wander around and more likely to sit down and stay seated, to remain passive.

‡ I'm fascinated by these types of spaces ... interview rooms and conference rooms, like the one we're in here today. This lecture theatre shares the same generic identity. We could easily be in any other conference space in the world. ‡ This is mostly to do with the furniture, of course. It's always utilitarian, always easily stackable, moveable, storable, and easily cleaned. There are two classics for the masses that I want to acknowledge here. In Britain, at least, one of these two can be found in every village hall, community centre, school or library. This chair is the Robin Day Polypropylene from 1962 and the other is the Arne Jacobsen Series 7 model 3107, from about 1955. ‡ I took this picture at the London Design Museum where they exhibit them side by side. There have been 14 million of these Robin Days made, and that's excluding all the fakes of which I imagine there could easily be twice as many.

‡ This is at the V&A, the Victoria and Albert museum in London. In the exhibition it was pointed out that this chair was a copy. The text next to it explains its faults—that the plywood is too thick, that the waist is too narrow, that the original didn't have a handle cut in the back and that the fittings are not the same. It seems that the V&A are very good at buying or acquiring fakes of things ‡ because they have dedicated a room to all the bad decisions they've made over the years. Room 46 is devoted to their fakes and forgeries. ‡

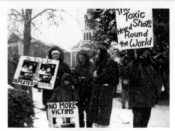

‡ That's Homer Simpson sitting on a chair backwards in what is known as the Classic Pose, which can be traced back to the Arne Jacobsen Series 7 model 3107, because it has a narrow waistline that accommodates the sitter's legs on either side. This association, then, has shifted from the form of a piece of furniture to the form of a human body. ‡ This is Christine Keeler who was a model and sex symbol of the sixties and seventies. This photograph was taken for the publicity for a film that was about to be made, but, in the end, never completed. The story I heard was that the film company gave her a contract which she signed without reading properly, which had a clause in it stating she had to be naked for the photo shoot. The very generous and understanding photographer employed the Classic Pose, so that she would still be naked, fulfilling the contract without showing her bits. ‡ You might also remember Leroy from 'Fame' or the girl in 'Flashdance'— both sat on chairs back to front on stage and danced around them.

‡ That's Alan Ginsberg in the back-ground, and someone yesterday said that the other guy is Andy Warhol in disguise but I'm not sure about that. Anyway, it's Bob Dylan from 1965, holding up the text from his list-song 'Subterranean Homesick Blues'. ‡ It's one of the earliest examples of a music video, ‡ and the reason it seems more like an MTV clip than other examples of music with visuals made around that time is probably due to the fact that it was actually the title sequence for a documentary called 'Don't Look Back' by D.A. Pennebaker, who followed Bob Dylan on a UK Tour.

‡ The form of articulation of someone holding a sign must come from political demonstration or activism. As the voice has limited volume, holding a sign of what you want to say can speak effectively louder and clearer. ‡ This is a work by the British artist Gillian Wearing from 1995 called 'Signs that Say What You Want Them to Say, Not What Other People Want Them to Say'. Basically, it's a series of photographs of people holding signs of their innermost fears, secrets or desires. And this is ... well, I can't show you the video of it because its impossible to get hold of ... a television commercial that was made for Volkswagen a short while after Gillian Wearing first exhibited her 'Signs'. ‡ This is a still from the commercial that involved these two guys holding signs of their desires and thoughts. I believe Gillian Wearing made attempts to take legal action against the makers of the advert for copyright infringement, which was unsuccessful because there were so many other examples of this form of articulation through history.

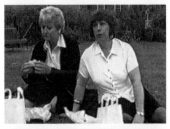

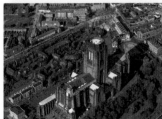

Over-dubbing children's voices onto films of adults is another over-used device. ‡ These videos are another work of art made by Gillian Wearing called 'Ten to Sixteen' from 1997. The art collector Charles Saatchi bought the work, shortly, after which this television advert for Sky Digital appeared on the British TV stations ITV and Channel 4. It turns out that the ad agency responsible for the Sky Digital advert was none other than Saatchi & Saatchi advertising. I understand Gillian Wearing went about taking legal action again, and failed again. She should probably just learn to share.

The next thing is also related to sharing or appropriating ideas. ‡ This is the Nat West Tower—or Tower 42 as it is often known—in Central London, just north of the river. It's the headquarters for Nat West Bank, and, after it was built in 1980, the tallest building in London for ten years. ‡ This is a plan of it, and this is the bank's logo ‡—I don't think I need to point out the resemblance.
‡ This is an e-mail I wrote to the guy who manages the building. It seems incredible to me that an architect can build a building from a simple logo that was made by a graphic designer eight years earlier. Buildings are quite complicated things, right? You have to fit lifts in and ventilation tunnels and make the best use of space—it's not an easy task, so he must have really liked that logo.

‡ This is an aerial photograph of the area—that's the Nat West tower there on the middle left. It's not the only example of something that can be distinguished from a bird's eye view. ‡ Churches and cathedrals throughout time have been built on the form of the crucifix. You can imagine God looking down from above, to see where all his followers are.

‡ These are from an atlas of Belgium. On the opposite page to the regular schematic maps are aerial photographs of the same areas, the main difference being these large green blank areas on the aerial versions. ‡ This one covers a military base, and this one covers the Royal Palace in Brussels—it's censorship on a grand scale. I wonder if the airspace is restricted as well and I also wonder if it would be possible to request a green blotch over your own house, which could also be considered private property.

From a tool that diverts attention, to a tool that directs attention ... British blue plaques. ‡ They're all over the country, but mostly in London, put up by the National Tourist Board on the front of significant historical figures' places of residence to keep the tourists happy. For example, there's one on a semi-detached house on a dual carriageway on the way into Liverpool, which is where John Lennon grew up. This is the plaque for a Serbian Historian, which was allegedly taken down ‡ after it was discovered that he hadn't lived in London for the required amount of years to qualify for one. This seems a little strange considering that here ‡ on Baker Street there's a plaque for Sherlock Holmes, who wasn't a real person, merely a fictional character of Sir Arthur Conan Doyle, so by rights he shouldn't have a plaque either. This is the house on Baker Street where he lived, or rather, where he didn't live.

Alpha	A	.-	Mike	M	--	1	.----
Bravo	B	-...	November	N	-.	2	..---
Charlie	C	-.-.	Oscar	O	---	3	...--
Delta	D	-..	Papa	P	.--.	4-
Echo	E	.	Quebec	Q	--.-	5
Foxtrot	F	..-.	Romeo	R	.-.	6	-....
Golf	G	--.	Sierra	S	...	7	--...
Hotel	H	Tango	T	-	8	---..
India	I	..	Uniform	U	..-	9	----.
Juliet	J	.---	Victor	V	...-	0	-----
Kilo	K	-.-	Whiskey	W	.--		
Lima	L	.-..	X-ray	X	-..-		

Here's another Great British detective, ‡ called Inspector Morse. That's Inspector Morse and ‡ that's John Thaw the actor, who died recently. You can tell them apart by their different suits. The series was written by Colin Dexter and went on for years with a huge following—it became a British institution. Morse code is mixed into the music just before the opening titles scroll down. ‡ The composer of the theme, Barrington Pheloung, actually weaves the names of each programme's killer into the theme tune of each episode. There are plenty of examples of Morse code weaved into music—from Kate Bush to Kraftwerk—but this example seems particularly notable as the music has to be adapted for every new episode. ‡

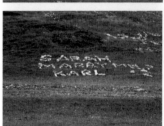

‡ This is my Grandfather. During the war he was in the RAF as a radio operator on a Blenheim bomber, so he's fluent in Morse code. He's not so keen on Inspector Morse, but my Grandmother is a big fan, so he insists on telling her at the beginning of every episode who the killer is. The Morse code is still in his blood, so he has an amateur radio set in the small spare box room of his house, which he uses to communicate with people all over the world. One of his objectives is to communicate with people in places he has never been able to reach before—also the main principle of a competition called 'The Worked All Britain Awards'. ‡ This is based on official Ordnance Survey map grid squares. Each OS grid is split into ten sub-grids and each of these is given a number. When he makes contact with a new person he logs their call sign and coordinates in a special book ‡ and colours in the square on his map.

The communicating couple also send each other what is called a QSL card, ‡ which is a receipt confirming the contact. The irony here is that it's possible for him to talk to anyone anywhere in the world for free, but then has to pay the postage of a card to confirm it. I don't know what QSL stands for, but there are codes like '73s', which I believe means 'Love to the wife'. It's one of the standard number abbreviations used in Morse code. Most QSL cards are home-made by the radio operators themselves, so of course they're extremely beautiful. ‡ This guy has two identities, so he just ticks a box when he decides who he wants to be. ‡ And this one's been made on a typewriter, creating a primitive ASCII typeface. Anyway, the point is to collect all the squares then send off your QSL cards to a governing body to receive a certificate or reward of some kind. It's incredibly difficult to collect all the squares, because some are on top of mountains, in water, or on marshland. The real fanatics make battery-powered mobile radio sets and mount them on boats or the backs of bikes to enable their friends to work the certain squares they're missing.

‡ This place on the same map is called Llandudno, a small seaside town on the north coast of North Wales. ‡ The bay and pier are positioned between two large rocks that jut out into the sea. The one to the east is called the Little Orme and the one to the west is called the Great Orme. There's a cable car from the town to the Great Orme that goes over the top of a small fossil quarry. Up there a small phenomenon is taking place—a sort of geological graffiti made with rocks. Not many people actually go right up there, but you can see the messages really well from the cable car. ‡ This one says 'Sarah marry me? Karl'.

Here's another graffiti. ‡ This is all over Amsterdam ... you've probably seen it around. I'm interested in it because it's the epitome of a 'complete concept'. It justifies itself every time I see it, and also distinguishes itself from all the other graffiti tags in the city. No other can compete with this. I liked it so much I hunted out the guy that did it by putting adverts in the search column of newspapers so that I could work on a project with him. You see the tag again, ‡ and again ‡ and again ‡ and again ... and the word always directs you to the next time you'll see it.

‡ This one's from Scotland, on the street in Glasgow. It's another self-referential graffiti tag, and again a kind of full circle concept. It's also spelt wrong. There are some words that do that to your brain—when spelt wrong they seem camouflaged. With some words I just read over the mistakes, like 'desert' and 'dessert'.

‡ This is a book by Marshall McLuhan and Quentin Fiore, 'The Medium is the Message'. Well, that's how you'd all probably say it if you didn't know better, and that's how I've only ever heard it referred to. ‡ The real title is 'The Medium is the MASSage'. If you search for it on Internet bookshops, those shops that haven't imported the information of their stock using barcodes or ISBN numbers, but have manually typed in the information about the stock, almost always call this book 'The Medium is the MESSage'. It's as if it now has two names. This is the fourth time I've done this lecture this week, and every day I've told a different story as to why this book has two names and every night I've had my head bitten off by people telling me that the information I gave was untrue. I'll just say that it's possible that it was a typesetting error by the printers in Luton on the cover of the first British edition, but it's also plausible that it was a deliberate play on the idea that the title would be mistaken for an already-existing saying, or that the title refers to the massaging effect of television culture—seemingly rich while actually dulling the senses.

ABCDEFG
HIJKLMNOPQRS
TUVWXYZ

├ HIGH BARNET

├ TOTTERIDGE

├ WOODSIDE PARK

HILL
ST

├ WEST FINCHLEY

├ Totteridge
& Whetstone

├ Woodside Park

├ West Finchley

├ Finchley Central

‡ This is Edward Johnston's Underground Railway Sans typeface from 1918, made specifically for the London underground tube map radically redesigned by Harry Beck. In 1962, the London underground railway company controversially decommissioned Beck, and a company manager who was not trained as a designer decided he could do a better job. The result was basically Harry Beck's map with less bendy bits, but the other significant difference between the two was the shift from the station names being in capitals ‡ to lower case, ‡ with capitals retained only for significant junctions where lines crossed. Around the same time there was a general shift from capitals to mixed case in Britain: motorway signs changed in 1959, London bus blinds in 1961, and British Rail station signs in 1962.

‡ This is the most viewed page on the Internet. The generics. That's the first television test screen ‡ from 1934, made five years before the first television was introduced. And that's the Sony test screen. ‡ This one's my favourite because it gives you all its possibilities—every colour that it could possibly offer in its most pure form, but no content. It's actually giving you everything and nothing at the same time.

‡ This is blue-wall fly-posting paper produced for billboards and outdoor street hoardings. The back of the paper is sprayed with a blue ink wash to insure when it is posted on top of another poster, the image beneath doesn't show through. I'm interested in it because of the way each poster negates the poster and, in turn, the event beneath it. Sometimes in London I see a wall of posters glued on top of one another almost an inch thick. ‡ They are like a chronology of the city; a history of urban narratives. Yves Klein Blue.

purple magazine

‡ This is a work by Liam Gillick called 'Inside now, we walked into a room with coca cola coloured walls' from 1998. It's taken from a passage from his book 'The Big Conference Centre'. The daubs are where he attempted to recreate the colour of Coca Cola. Gillick Brown. ‡ This is Bill Drummond's International Grey. There's a different grey in every tin.

And this is now—the websites from 'purple' magazine ‡ and the jan van eyck academie in maastricht ‡ without any capital letters. The Jan van Eyck has a design department with an impressive reputation, so it's odd that they can't be bothered to hold down the shift key. Apart from general laziness, the origin of this trend has to be the Internet. The internet is not case-specific, so you can type in a domain name in capitals or lower case and it makes no difference ... you still end up at the same website.

There's Prince, with a microphone shaped like a gun. ‡ And that's Prince as well. ‡ He changed his name to, erm, this ... which, well, which you can't actually pronounce. And he sent the media this symbol as a character to be incorporated into the most commonly used typefaces so that the press would still write about him. Obviously nobody could be bothered with the trouble of installing the character, so they ended up just writing 'The Artist Formerly Known as Prince', and it was all a bit pointless in the end. Serves him right. ‡ This is the 'point d'ironie', made by the French writer and theorist Alcanter de Brahm at the end of the nineteenth century; its purpose being, when placed at the front of a sentence, to warn the reader that the following passage is about to be ironic, or, if at the end of a sentence, that the previous passage was ironic. It's a bit like Spanish, where an upside-down question mark is used at the beginning of a sentence as well as the right way round at the end. Of course it makes a lot of difference where you put a punctuation, question or exclamation mark. In the case of the point d'ironie, it was never recorded exactly how it was to be used, so we just have to guess.

‡ And that's the American verbal version of the point d'ironie in 'Wayne's World' ... Not! It's perhaps significant that in America irony needs to be so clearly flagged in speech. As there's no obvious written equivalent of 'Not!', it seems there might be a need for the point d'ironie after all, but it's a bit of a paradox: if the word 'Not!' is used after an ironical passage then the passage is no longer really ironical anyway. ‡ I don't really know anything about this sign, except that I guess it's another Americanism, something to do with heavy metal, and maybe a sign for the devil. ‡ Everyone knows this one however. The history of shaking hands when meeting someone is a gesture to show that you come in peace. It is from the days when gentlemen with qualms would duel with either fencing swords or small hand-held muskets. Offering your right hand is to show that you don't hold or conceal a weapon.

There's another proud gesture. ‡ The 'V' sign originated during the battles between England and France in the seventeenth century. The French used crossbows—a mechanical form of the bow and arrow, which were pulled, loaded, locked and then fired with a trigger, whilst the English used very powerful manual longbows, ‡ which had to be fired with their forefingers. ‡ The French were very intimidated by the power of the longbow archers, because the arrows could by fired from a greater distance away. If they captured an English archer, rather than kill him they would just cut off the two forefingers on his right hand and release him, knowing that he wouldn't be able to fire any more arrows. So at the beginning of a battle the English archers would come from their position in the line up behind the men at arms, around the flanks and would taunt the French with a 'V' sign, showing their two fingers were still intact and that they were able to fire arrows and kill them.

The link here is maybe not the clearest but it's to do with the word 'archer'. I'll come to it in a moment. ‡ This is the Centre for Knowledge on the Caledonian Road in Islington, North London. It's a society for students of The Knowledge, where apprentices gather to learn the geography of London whilst studying and taking exams to be a Hackney Carriage taxi driver. These mopeds here in front belong to people studying The Knowledge. They spend three years riding around the city on these with maps and test books on a Perspex clipboard, learning how to navigate. It's just like a degree course. Every few weeks they have to go to a police station to be tested on a route between two points. They're probably the most knowledgeable taxi drivers in the world. ‡ This is from a video of an interview I made a few months ago at this place, with some of the students reading out directions.

The police issue reference points for the taxi drivers to learn, like a route from one place to another. ‡ This is Jeffrey Archer, who was both a Conservative member of parliament and a bad novelist. He was sent to prison for lying under oath about an incident involving a prostitute and a brown paper envelope containing £2000. This is ironic because he wrote a book that I think was also made as a play, called 'The Accused', the storyline of which was almost identical to this particular part of his life, so it didn't take a Holmes or Morse to work out what had been going on. The police set a new point for the apprentices of The Knowledge to learn the day Jeffrey Archer was sent down for perjury, from the Red Lion ‡ on Archer Street to Belmarsh Prison. ‡

'Kids' was probably one of the most controversial films of the nineties. ‡ Larry Clark and Harmony Korine made it. Apparently, Larry Clark came across Harmony Korine asleep on a bench in Central Park with a script in his hand, so he took it and started reading it and, err, yeah, anyway, I don't know if that's true. It doesn't matter, but the two-significant things about the clip are firstly the vernacular language, which was quite incomprehensible, and the low-slung trousers. ‡ The history of wearing low-slung trousers can be traced back to American gang culture. It works as a signifier of respect to other gang members in prison. When you go to prison you have the belt from your trousers and the laces from your shoes taken away so that you can't use them to hang yourself, meaning that your pants fall down and the tongues in your trainers stick out. ‡ An association could also maybe be formed between the baggy clothing and the one-size-fits-all clothing that prisoners are given.

‡ And that clip was from 'Boyz 'n' the Hood' from the eighties. The subcultural vernacular speech or slang heard in 'Kids' is even more extreme here, to the point at which it is considered an independent language, 'Ebonics': 'Ebony' as in black and 'Phonics' as in sound. ‡ There are schools in California now where children can study and be examined in Ebonics, so it has officially been recognised as a language in America. I'm not sure, but I think the reason it is considered a language rather than a dialect is because the difference is not only in terms of vocabulary but also in terms of sentence structure. I would say 'I am', in French it would be 'Je suis', and in Ebonics 'I be'.

Apple Fritter	Bitter
Apple Tart	Fart
Apples and Pears	Stairs
Archer	2000
Are you George?	Are you sure?
Aris	Arse
Aristotle	Bottle
Army & Navy	gravy
Army and Navy	Gravy
Artful Dodger	Lodger
Arthur Bliss	Piss
Arthur Scargill	Gargle (drink)

An Elvish typeface: Tengwar Cursive by Harri Perälä

-She's an Elf.
-He's fading.

‡ Cockney rhyming slang is, however, definitely a dialect rather than a language. To be a true cockney you have to have been born within the sound of the Bow Bells from a Church in the East End of London. The system is formulated mostly on the idea of rhyming, although there are a few exceptions that are formulated on the idea of loose associations. 'Archer' now means 'two thousand', for example, because of the incident I mentioned before involving the money, the brown paper bag and the prostitute. You see 'Aris', here ... that means 'Arse', because 'Aris' is short for 'Aristotle', which rhymes with bottle, which is short for 'bottle and glass', which is rhyming slang for 'ass'. I told you the associations were loose ... ‡ This is a record produced by the BBC in the seventies as a teaching aid to help children identify accents and dialects from different regions of the country. These things are also used by actors as tools to help mimic accents. The Cockney example on it is particularly interesting because it's not only a documentation of the dialect, but also of social change—the kinds of words that were being used. It's a real time capsule. The origins of Cockney come from the barrow boys on the East End markets of London, so in a sense it's English codified for a particular profession, used so that market traders could communicate with each other in private, without the customers understanding what they were talking about.

‡ Elvish is the language of the elves, of course ... both spoken and written, with a selection of typefaces. ‡ It comes from J.R.R. Tolkien's 'Lord of the Rings', and looks incredibly similar to forms of shorthand or speedwriting. ‡ She's an elf, and she's speaking Elvish, which sounds a bit like Welsh really. ‡ That's Elvish writing. Tolkien studied at Oxford University—I think it was St John's College. In Oxford and Cambridge there are weird societies and fraternities that you can join, which always seem a little sinister—clever rich people sitting around in a castle drinking wine. Anyway, at Oxford there's an Elvish Society, where the members sit around, eat dinner together and speak Elvish, discussing the works of Tolkien.

```
ƛ  ʎ  ʏ  ʊ  ɾ  ɪ  ƪ
a  b  ch  D  e  gh  H

ʔ  ɳ  ʅ  ʂ  ɲ  ʌ  ʒ
I  j  l  m  n  ng  o

ʒ  ʃ  ʔ  ʑ  ʁ  ʘ
p  q  Q  r  S  t  tlh

ʎ  ɥ  ʃ  ʑ  ʼ
u  v  w  y  '

—  ʃ  ⟨  ⟨  ʃ  ʃ  ⋈
0  1  2  3  4  5  6

ʃ  ⋈  ↑
7  8  9
```

```
# verb prefixes
bI=    you (n/o)
bo=    you (pl)-him/her/it/them
cha=   you (pl)-us
cho=   you-me
Da=    you-him/her/it/them
DI=    we-them
Du=    he/she/it-you
qho=   imp: you-us, you (pl)-us
HI=    imp: you-me, you (pl)-me
jI=    I (n/o)
ju=    you-us
lI=    he/she/it-you (pl), they-you (pl)
lu=    they-him/her/it
ma=    we (n/o)
mu=    he/she/it-me, they-me
nI=    they-you
nu=    he/she/it-us, they-us
pe=    imp: you (pl) (n/o)
pI=    we-you
qa=    I-you
re=    we-you (pl)
Sa=    I-you (pl)
So=    you (pl) (n/o)
tI=    imp: you-them, you (pl)-them
tu=    you (pl)-me
vI=    I-him/her/it/them
wI=    we-him/her/it
```

I find it fascinating that every year so many languages pass into extinction—like native Australian aboriginal languages from settling tribes—that have never been recorded, while people make so much effort to keep alive languages rooted in fiction. ‡ This is Klingon, devised by the American linguist Dr Marc Okrand in 1992 for Paramount pictures. Klingons are those people with the ripples on their forehead in Star Trek. This is the alphabet, then, and this is part of the dictionary. Apparently, Klingon is the fastest growing language in the universe. Thank you, and good afternoon.

Esoteric, useless, dumb, opportunistic ...

Paul Chan in Conversation with Eungie Joo

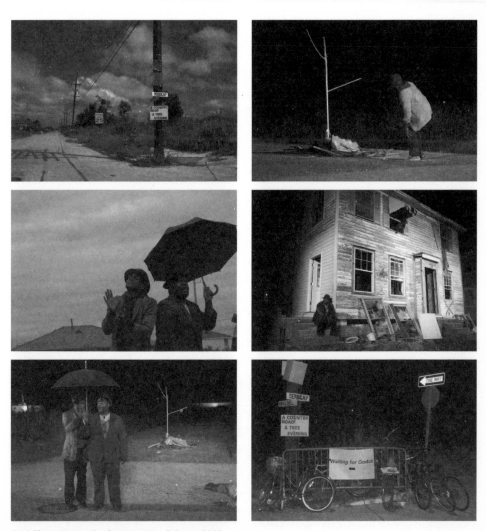

Paul Chan, *Waiting for Godot in New Orleans*, 2007

Paul Chan participated in the last *Carnegie International* with *Happiness (finally) after 35,000 Years of Civilization—after Henry Darger and Charles Fourier* (2000–2003), an animation-based video installation that expounds upon societal regulations of desire. Over the past several years, Chan's remarkable passion for philosophy, art, participation, and struggles for freedom has greatly influenced my own thinking as a curator and fellow citizen. Following the completion of his ambitious teaching, organizing, and theater project *Waiting for Godot in New Orleans*,[1] Chan and I discussed the project at his studio in New York. The following is an excerpt of our conversation that day. —EJ

Eungie Joo: Okay, do we start at the beginning or the end? It's up to you—or the middle? How did you come to work on a project in New Orleans?

Paul Chan: It started with one trip. I was invited to New Orleans by Tulane University in November 2006 to speak, and in the process of speaking, I got a chance to visit with people I'd worked with before and to visit a city I'd never seen. It was through that one trip that I realized perhaps I could do more than a lecture and a couple studio visits—that something else could happen.

EJ: Why *Waiting for Godot*?

PC: First, it was visual. The landscapes I saw in New Orleans on my first trip—the empty lots, the debris, the magnificent trees, all echoed in form if not in spirit every production of *Godot* I had ever seen. Then there were the people. Everyone in New Orleans knows what it means to wait. *Godot* is not abstract or speculative; it is simply the stale air everyone breathes in this void of a place. And when *Godot* premiered in Paris in 1953, Beckett, you have to imagine, was thinking about what was happening outside the theater as well as what was happening onstage—that the outsideness of what was happening in Paris after World War II had something to do with how you visualized, how you contextualized what was happening inside the theater. And in a way, I felt the same way about seeing New Orleans. That in a strange way, there was no inside or outside anymore. It was just all there, as bare as life, and so why not use it? Why not show it for what it is? Which is a desolate landscape in which people wait for something to

1. *Waiting for Godot in New Orleans* is a project by Paul Chan, coproduced by Creative Time and the Classical Theatre of Harlem. The production was directed by Christopher McElroen, featuring Wendell Pierce and J. Kyle Manzay, in collaboration with New Orleans partners: University of New Orleans, Xavier University, Dillard University, NOCCA High School, Lusher High School, Frederick Douglass High School, John McDonough High School, Students at the Center, Neighborhood Story Project, The Porch, and Renaissance Project.

come and in fact it doesn't come, or perhaps it will, someday ... as long as they don't kill themselves, or kill each other.

EJ: Had you seen the Classical Theatre of Harlem's 2006 production of *Waiting for Godot*? Did you know about it?

PC: I missed it. And it was in the back of my mind when I came back from New Orleans. They were one of the first groups I contacted, thinking that perhaps I could get their advice. And so I called them in January [2007] and scheduled a meeting with Christopher McElroen, one of the founders of the Classical Theatre. He directed their production of *Waiting for Godot*, in which Gogo and Didi, the main characters, are waiting on a rooftop and the stage is flooded with water. That was definitely a direct assault—making a connection between Katrina and the play. And so I met Chris and talked to him about it, never thinking that they would have the time or energy, or frankly even the interest, to do it. But he really liked the idea, and so we started working together on it.

EJ: And the idea of doing *Godot* on the streets of the city—is it related to the history of how the play had been presented at San Quentin penitentiary or how it was staged by Susan Sontag in Sarajevo in 1993?

PC: Those events were only in the cards after the fact. And they came like a gift. The more I thought about what I wanted to do in New Orleans, the more I started researching the play. I had known about Sontag's production. I knew a little about the San Quentin workshops. I found out when I was in New Orleans that the Free Southern Theater, a local theater company that worked with the SNCC [Student Nonviolent Coordinating Committee] in the South during the civil rights movement, did a version of *Godot*, not only in Mississippi but in New Orleans as well. And so all these examples of Beckett's work popping up in unorthodox theatrical venues came up, and it just seemed appropriate and necessary to position Beckett's work, especially *Godot*, within a nontheatrical milieu. Almost returning it to its roots, as far as I'm concerned. The longing for the new is a reminder of what is worth renewing. That's certainly what I had envisioned it doing. That somehow the play—its form, its composition, its language—is so specific that it has the ability to speak in its silences in a kind of present tense that few plays, few art forms can. It's one of the most present plays out there. It's present because it gives enough silences, enough empty spaces to be filled with time. Present time. Which is not really time at all, but something else entirely.

EJ: I remember, when we spoke early on about the idea, that you were considering whether it was a plausible idea to pursue a theater production as your project. I am curious about your initial hesitations about the project.

PC: I think the hesitation came from having been on the ground in New Orleans, having seen essentially a hallucination of what the play is supposed to be. It was at that point that I realized the play wasn't the thing. Maybe there's another way to get to this. It would have been easy and unfortunate if *Waiting for Godot* had been done in New Orleans in a conventional theater. It would have been easy and unfortunate if I had done something there that did not push the limit of not only its form but also its place. It would have been easy and unfortunate if I had presumed that art, contemporary or modern or whatever, had the ability today to be more than simply appeasement or compromise.

EJ: Whose appeasement?

PC: Everyone's. [*both laugh*] Everyone feels good. Everyone feels that art, as a historical bookmark for an ideality of something, could, in and of itself, be the symbol that it longs to be. Which is to say, something exchangeable for all. And so the task then was to treat it like something else. And because I was working with Creative Time, a public art group, I had the luxury and challenge and obstacle of imagining it not as a project, but as a campaign.

EJ: As a campaign?

PC: I think part of the hesitation I had earlier on was not about whether the play would be any good, but rather what else could be done, what else should be done in order for it to fully inhabit what it is.

EJ: I do recall discussing something about whether it would be esoteric to just go down there and produce the play.

PC: Esoteric, useless, dumb, opportunistic ...

EJ: Opportunistic and cynical.

PC: But that diminishes the true question of what the problem is. The real problem is whether the form of things and the presence of people can compose a new relationship and distance to each other that can increase the weight and tension of both. In the case of *Godot*, the question was to

organize it in a way that honors and expands its capacity as a play to do something more than being a play. Beckett's plays aren't really plays, they are really something else. I don't know what they are sometimes. The challenge was to capture and honor that sort of "What the fuck is this?" response. That was what I was asking. And what it ended up being was essentially a campaign. The play becomes the organizing principle by which disparate elements come together in such a way that a public is formed and not simply assumed. Because no one wants Beckett, you know what I mean? It's pure hubris to think that people wanted it, but it's not pure hubris to think that it's possible to come together in a different way using a different set of "metrics," to use this sort of 21st-century military term. What I also realized, or what I also believe in, is that the price of coming together is always the price of coming together around something foreign, something alien. And this was the perfect opportunity to see if this was true, if my belief was true. And there's nothing more alien than Beckett, nothing more alien than Beckett in the terrain of New Orleans.

EJ: At what point did you decide that you had to move down there? And at what point did you know that the Classical Theatre would coproduce the play? I think all these things are relevant. To use the play as the organizing principle, certain things had to be taken care of. If you actually had to direct to play, that would have become the task itself—you would have run out of time for the larger project. At what point did this kind of come together so that you could approach this as a project of moving down there and teaching and experimenting with what it meant to organize a group around the production?

PC: I knew right away in January 2007 about moving down there and teaching. That was what I was asking really—whether this was a good idea. I always knew the play was a good idea. Let's be cruel about it, or egotistical. The idea was a solid one.

EJ: Interesting in and of itself.

PC: Yes, but I knew that a good solid idea is already a kind of failure, because the better an idea is, the more it fixes the shape of its form. A bad idea at least doesn't know what it wants to be, so there is still room, still life. So the question is, can this good idea turn into a really bad idea and in the process reorient the way we organize life around this thing? I realized this very early on. So the task was set: organize a life, a city, an ephemeral presence around something alien and something that no one wants.

EJ: And so for you, then, what was the goal?

PC: My goal was to lose. I told Creative Time that. I told them that if we were going to do this right, we had to be willing to lose. Big. And that means everything: money, time, resources. Even a sense of what it means to be who we are. When I was working with folks in New Orleans, like the artist Willie Birch, he told me that one of the ways you hold ground with the young kids who are becoming drug dealers in his neighborhood, about the only way you can reach them is not to condescend, not to show them the right way, but to show them you're willing to risk more than they are. And so if you're willing to clean up the street during a hail of gunfire, the sense of risk becomes a form of transmission. I thought that was a very good way of imagining what it means to work on any number of levels. But certainly, that was one of the things that was implicit before and explicit during the project—that we had to risk more than people expected. Chris and I constantly said the play itself was the smallest component and our biggest headache. The biggest headache we had was organizing the city in all its disparate elements during the nine months we were there researching and meeting and the four months of organizing and teaching. By the time the play came up, we were okay. If we didn't have the play, it would have been okay. The project wouldn't have been what it was on a national, or even international, level, but locally, we were doing fine, because we had, through this obscure, alien thing called Beckett, reached parts of the streets of New Orleans that people didn't think were reachable.

EJ: What do you mean by reach them? What did you do?

PC: We began by going to meetings, and we'd just hang out. We started slowly gathering people in—from four colleges, two high schools, two elementary schools, ten community groups, from all different wards. People who had no reason or belief in the need to talk to each other. And here comes Classical Theatre of Harlem and me, not knowing any better, being young and stupid and saying, "Oh, we'll work with you, we don't care." That's how it started. And so our "coalition of the willing" started in March and ended in December. But it wasn't until the first performance that people realized who we were working with. We didn't come to New Orleans saying we're going to bring everyone together. We only brought people together at the end. And this was strategic.

EJ: You mean you worked with each group separately?

PC: Right, you work on their terrain, on their time.

EJ: And what did you do with these groups?

PC: At the University of New Orleans I taught once a week for the entire fall semester, a contemporary art history class, because that is what they wanted. At Xavier University I taught once a week, running a workshop on practical skills for the arts, which is what they wanted me to teach. The poet Kalamu ya Salaam works at a recovery high school, and I worked with his students Thursday nights, watching movies and talking about video production. The Porch, which is a community arts collective in the 7th Ward, held theater workshops. At John McDonough High School, I gave artist lectures. Same thing at Lusher High School, Louisiana Art-works, Catholic and Protestant churches, anywhere that wanted me to come in and talk about art. I hustled up microphones for video groups, sat on panels, commiserated, challenged, whatever. And just kept doing that, week in and week out. You know, in a way, the person who mastered this kind of work was Karl Rove.

EJ: Your hero! [*laughs*]

PC: No, not a hero, but certainly a model and an image of what Hegel would call the cunning of reason. Rove revolutionized organizing for the Republican Party by reimagining the borders that separate and connect the disparate if not outright antagonistic elements of his own party. He then redefined the shape of his party by reshaping what it meant to be a Republican, building what amounts to a decadelong campaign, a domes-tic coalition of the willing. He built a coalition that fundamentally worked in solidarity by sharpening difference, inside itself and outside itself. And I think he did it by understanding that each of the tense elements in his coalition already possessed not only its own identity and history but also its own terrain and sense of time. And the task then was to organize within their sense of terrain and time. It was by understanding as intimately as possible their sense of terrain and time that Rove was able to become the invisible mediator between the elements. Writers as different as Karl Marx, Maurice Blanchot, and Jean-Luc Nancy have asked how communities come together in a form that grants them the force of sovereignty without sacrificing their histories and contradictions as human beings. I think Rove actually provides a discursive model of how it can be done.

EJ: Let me ask you about Beckett. As you said, in *Waiting for Godot*, Beckett is thinking about what's happening outside the theater. In thinking

about *Waiting for Godot* for New Orleans or for this time period, how does Beckett fit into your thinking?

PC: Above all else, he believed in form, realizing that if you have the right form, it expands above and beyond itself and does things that are both unpredictable and provocative. And that is much more useful than anything that calls itself useful.

EJ: That reminds me of an earlier conversation about urgency and political engagement.

PC: Yeah, your question about what it means to be a person who makes artwork and is also engaged. But you also must realize that John Currin is just as engaged as I am, that escape is another form of engagement. And that you can read the room temperature of the times and have a connection to that sense of urgency as much from engagement as from escape. To me it's no different. They're both illusional, because the debt is infinite. We can't pay it off on our own. It's not up to us on our own.

EJ: But it's the nature of the connection. Yes, everybody who is a social being deals with society in one way or another, that's fine. But I do think that turning on your skill of analysis when many people do not—when you're not required to—to turn that on and to speak, to act, to facilitate the speaking of others or their actions, this is a different kind of engagement.[2] We've had many cynical conversations together, but based somewhere in the belief that actions can have a repercussion. This is a different kind of engagement.

PC: I don't disagree, but does it get you any closer to what you think you are after? This is the question.

EJ: That's a good question, but I often wonder, with this idea of engaging with politics, or political or social issues, however we define them, if that's the line of reasoning of an optimist.

PC: Or a libertine.

EJ: Maybe, but I actually think that it's an optimistic attitude. It's not a pessimistic line of reasoning.

2. See for example, Chan's *Untitled* Video on Lynne Stewart and Her Conviction, the Law, and Poetry (2006). This video is downloadable at http://nationalphilistine.com/lynne/index.html.

PC: The emotion that accompanies these words "optimism" and "pessimism"—that's really alien to me. It is, in fact, irrelevant to me. It's about freedom above all else.

EJ: I don't think the way you offer criticism is meant to stop the thinking. To me, it's meant to push the thinking, to make things a little harder.

PC: But is it optimism that drives that, or is it knowing that the freedom we imagine isn't in fact free?

EJ: Or that we can't even imagine freedom?

PC: The thing we have isn't what it is, that's simply a given. And so now what do you do? I think the models out there of doing are unsatisfying. They're unfree, all of them. None of them are free. Maybe I haven't read enough, maybe I haven't experienced enough. I'm sure that's probably it, but everything seems like a consolidation of power, left and right, so none of them feel free. So what is possible given that there's no right way? None. No right way.

144 Freedoms

Mario Merz

Text in the order of the Fibonacci series composed by Mario Merz in the 1970s and 1980s. Originally published in *Mario Merz*, exhibition catalogue, Kunsthaus Zürich (Frankfurt am Main: Verlag Sauerländer, 1985). Translated by Meg Shore.

1 Freedom to read in prison
1 Freedom to draw
2 Freedom to leave
3 Freedom to give something to someone
5 Freedom to arbitrarily enter into a political conversation
8 Freedom to endure a declaration of hostility
13 Freedom to bear the burden of patience
21 Freedom to have three contrasting ideas
34 Freedom to become the accused without being so
55 Freedom not to believe oneself to be a prisoner of the economy
89 Freedom not to be a moralizer under adverse conditions
144 Freedom not to believe in a generalization

BIOGRAPHY AS SUSTENANCE (space and freedom in natural progression).

1 Libertà di lettura in una prigione
1 Libertà di disegnare
2 Libertà di partire
3 Libertà di regalare una cosa a qualcuno
5 Libertà di entrare arbitrariamente in una conversazione politica
8 Libertà di soffrire una dichiarazione di ostilità
13 Libertà di sostenere il peso della pazienza
21 Libertà di avere tre idée contrastanti
34 Libertà di rendersi imputato senza esserlo
55 Liberta di non credersi prigioniero dell'economia
89 Libertà di non essere moralizzatore in condizioni avverse
144 Libertà di non credere a una generalizzazione

BIOGRAFIA COME SOSTENTAMENTO (spazio e libertà in progressione naturale).

Checklist

As of April 1, 2008

Doug Aitken
Migration: 365 Hotel Rooms, 2008
4-projection outdoor video installation
dimensions variable
Courtesy of 303 Gallery, New York; Galerie Eva Presenhuber, Zürich; Victoria Miro Gallery, London; and Regen Projects, Los Angeles

Kai Althoff
Untitled, 2007
fiberglass, steel, acrylic, electric motor, colored and clear epoxy resin, carpet, doll, steel grids, rug, lamp, suit, fabric, paint, vase, and scissors
dimensions variable
François Pinault Collection, Paris

Mark Bradford
Across 110th Street, 2008
mixed-media collage on canvas
102 x 144 in.
(259.1 x 365.8 cm)
Courtesy of the artist and Sikkema Jenkins & Co., New York

Mark Bradford
Help Us, 2008
white stone
approx. 20 x 77 1/2 ft.
(6.1 x 23.6 m)
Courtesy of the artist and Sikkema Jenkins & Co., New York

Mark Bradford
A Thousand Daddies, 2008
mixed-media collage on paper
132 x 280 in.
(335.3 x 711.2 cm)
Courtesy of the artist and Sikkema Jenkins & Co., New York

Mark Bradford
A Truly Rich Man Is One Whose Children Run Into His Arms When His Hands Are Empty, 2008
mixed-media collage on canvas
102 x 144 in.
(259.1 x 365.8 cm)
Courtesy of the artist and Sikkema Jenkins & Co., New York

Cao Fei
Whose Utopia, 2006–2007
video; color, sound
20 min.
Courtesy of the artist and Lombard-Freid Projects, New York

Vija Celmins
Night Sky #17, 2000–2001
oil on linen mounted on wood
31 x 38 in.
(78.7 x 96.5 cm)
Modern Art Museum of Fort Worth, Gift of The Burnett Foundation

Vija Celmins
Night Sky #16, 2000–2001
oil on linen mounted on wood panel
31 x 38 in.
(78.7 x 96.5 cm)
The Art Supporting Foundation to the San Francisco Museum of Modern Art

Vija Celmins
Night Sky #14, 1996–1997
oil on linen mounted on wood panel
19 1/2 x 22 1/2 in.
(49.5 x 57.2 cm)
Rachofsky Collection, Dallas

Vija Celmins
Night Sky #12, 1995–1996
oil on canvas mounted on panel
31 x 37 1/2 in.
(78.7 x 95.3 cm)
Carnegie Museum of Art, Pittsburgh, The Henry L. Hillman Fund

Vija Celmins
Night Sky #10, 1994–1995
oil on canvas
31 x 37 1/2 in.
(78.7 x 95.3 cm)
Courtesy of the artist, New York

Vija Celmins
Night Sky #6, 1993
oil on linen mounted on wood
19 1/8 x 22 3/8 x 1 3/16 in.
(48.6 x 56.8 x 3 cm)
Walker Art Center, Minneapolis, Purchased with the aid of funds from Harriet and Edson W. Spencer and the T. B. Walker Acquisition Fund, 1995

Vija Celmins
Night Sky #2, 1991
oil on canvas mounted on aluminum
18 x 21 1/2 in.
(45.7 x 54.6 cm)
The Art Institute of Chicago, Ada S. Garrett Fund, 1995.240

Vija Celmins
Night Sky #1, 1990–1991
oil on canvas mounted on wood panel
18 3/8 x 22 1/8 in.
(46.7 x 56.2 cm)
Collection of Wade and Angela Thompson, New York

Vija Celmins
Untitled (Comet), 1988
oil on canvas
15 3/4 x 18 1/2 in.
(40 x 47 cm)
National Gallery of Art, Washington, Gift of Edward R. Broida
2005.142.13

Phil Collins
untitled, 2008
single-channel video projection; color, sound
dimensions variable
Courtesy of the artist; Tanya Bonakdar Gallery, New York; Kerlin Gallery, Dublin; and Victoria Miro Gallery, London.
Commissioned by 2008 *Carnegie International*, Carnegie Museum of Art, Pittsburgh

Bruce Conner
Angel, 1975
gelatin silver print photogram
85 x 39 in.
(215.9 x 99.1 cm)
Walker Art Center, Minneapolis, Butler Family Fund, 1989

Bruce Conner
Angel, 1975
gelatin silver print photogram
85 x 39 in.
(215.9 x 99.1 cm)
University of California, Berkeley Art Museum and Pacific Film Archive, partial gift of Richard Lorenz

Bruce Conner
Angel Light, 1975
gelatin silver print
photogram
86 ½ x 40 x 2 ¾ in.
(219.7 x 101.6 x 7 cm)
Collection of Shirley
and Ross Davis,
San Francisco

Bruce Conner
Blessing Angel, 1975
gelatin silver print
photogram
85 x 39 in.
(215.9 x 99.1 cm)
Collection of Ann Hatch,
San Francisco

Bruce Conner
Butterfly Angel, 1975
gelatin silver print
photogram
85 x 39 in.
(215.9 x 99.1 cm)
Collection di Rosa
Preserve, Napa, CA

Bruce Conner
Kiss Angel, 1975
gelatin silver print
photogram
96 x 40 in.
(243.8 x 101.6 cm)
Carnegie Museum of Art,
Pittsburgh, The Henry L.
Hillman Fund

Bruce Conner
Night Angel, 1975
gelatin silver print
photogram
85 x 39 in.
(215.9 x 99.1 cm)
Walker Art Center,
Minneapolis, Butler
Family Fund, 1989

Bruce Conner
Untitled, 1975
gelatin silver print
photogram
96 ½ x 40 ⅜ x 3 in.
(245.1 x 102.6 x 7.6 cm)
de Saisset Museum,
Santa Clara, CA, Gift of
Bruce Conner, 6.1.1989

Bruce Conner
Untitled (Angel), 1975
gelatin silver print
photogram
96 ½ x 40 ⅜ x 3 in.
(245.1 x 102.6 x 7.6 cm)
de Saisset Museum,
Santa Clara, CA, Gift of
Bruce Conner, 6.2.1989

Bruce Conner
Enfolding Angel, 1974
gelatin silver print
photogram
36 x 33 x 3 in.
(91.4 x 83.8 x 7.6 cm)
Collection of Henry S.
Rosenthal, San Francisco

Bruce Conner
*Sound of Two Hand
Angel*, 1974
gelatin silver print
photogram
89 x 38 ³/₁₆ x 2 ¾ in.
(226.1 x 97 x 7 cm)
framed
Collection of Tim Savinar
and Patricia Unterman,
San Francisco

Bruce Conner
Teardrop Angel, 1974
gelatin silver print
photogram
52 x 34 in.
(132.1 x 86.4 cm)
Collection di Rosa
Preserve, Napa, CA

Peter Fischli and
David Weiss
Cupboard, 2008
carved polyurethane and
paint
82 ¹¹/₁₆ x 43 ⁵/₁₆ x 35 ⁷/₁₆ in.
(210 x 110 x 90 cm)
Courtesy of the artists;
Galerie Eva Presenhuber,
Zürich; Matthew Marks
Gallery, New York;
and Monika Sprüth/
Philomene Magers,
Munich/Cologne/London

Peter Fischli and
David Weiss
Untitled, 2005
105 carved and painted
polyurethane objects
dimensions variable
Private foundation, Oslo,
c/o Peder Lund
Courtesy of Galerie Eva
Presenhuber, Zürich

Peter Fischli and
David Weiss
An Unsettled Work,
1987–2004
slide show on hard disk
25 min.
Sammlung Thomas
and Christina Bechtler,
Switzerland
Courtesy of Galerie Eva
Presenhuber, Zürich;
Monika Sprüth/Philomene
Magers, Munich/Cologne/
London; and Matthew
Marks Gallery, New York

Ryan Gander
*He walked ahead, leading
her through a blizzard of
characters*, 2008
a 3000-word text written
by the ghostwriter Davis
Allsop, screen-printed
directly onto the gallery,
wall, which immediately
afterward is replastered
dimensions variable
Courtesy of Tanya
Bonakdar Gallery, New
York; Annet Gelink
Gallery, Amsterdam; and
STORE Gallery, London

Ryan Gander
*Man on a bridge—(A
study of David Lange)*,
2008
16mm film transferred to
HD video projection;
color, sound
duration variable
Courtesy of Tanya
Bonakdar Gallery,
New York; Annet Gelink
Gallery, Amsterdam; and
STORE Gallery, London

Ryan Gander
*A sheet of paper on
which I was about to
draw, as it slipped from
my table and fell to the
floor*, 2008
100 15-cm crystal balls
dimensions variable
Courtesy of Tanya
Bonakdar Gallery,
New York; Annet Gelink
Gallery, Amsterdam; and
STORE Gallery, London

Daniel Guzmán
Fuck you too, 2007, from
the series *La búsqueda
del ombligo* (The search
of the navel), 2005–2007
ink on paper on wood
panel
82 ¹¹/₁₆ x 70 ⅞ x 1 ⅜ in.
(210 x 180 x 3.5 cm)
Carnegie Museum of Art,
Pittsburgh

Daniel Guzmán
Jealous Guy, 2007, from
the series *La búsqueda
del ombligo* (The search
of the navel), 2005–2007
ink on paper on wood
panel
82 ¹¹/₁₆ x 70 ⅞ x 1 ⅜ in.
(210 x 180 x 3.5 cm)
Collection of César
Cervantes, México

Daniel Guzmán
Tristessa, 2007, from the
series *La búsqueda del
ombligo* (The search of
the navel), 2005–2007
ink on paper on wood
panel
82 ¹¹/₁₆ x 70 ⅞ x 1 ⅜ in.
(210 x 180 x 3.5 cm)
Private collection,
Cologne

Daniel Guzmán
El cobrador de impuestos
(The tax collector), 2006,
from the series *La
búsqueda del ombligo*
(The search of the navel),
2005–2007
ink on paper on wood
panel
82 ¹¹/₁₆ x 70 ⅞ x 1 ⅜ in.
(210 x 180 x 3.5 cm)
Collection of Charlotte
and Bill Ford, Greenwich,
Connecticut

Daniel Guzmán
Negro (Black), 2006, from
the series *La búsqueda
del ombligo* (The search
of the navel), 2005–2007
ink on paper on wood
panel
82 ¹¹/₁₆ x 70 ⅞ x 1 ⅜ in.
(210 x 180 x 3.5 cm)
Private collection, Cologne

Daniel Guzmán
Batalla (Battle), 2005,
from the series *La
búsqueda del ombligo*
(The search of the navel),
2005–2007
ink on paper on wood
panel
82 ¹¹/₁₆ x 70 ⁷/₈ x 1 ³/₈ in.
(210 x 180 x 3.5 cm)
La Colección Jumex,
Mexico City

Thomas Hirschhorn
Cavemanman, 2002
wood, cardboard, tape,
aluminum foil, books,
posters, videos of
Lascaux 2, dolls, cans,
shelves, and fluorescent
light fixtures
dimensions variable
Courtesy of the artist
and Gladstone Gallery,
New York

Richard Hughes
The Big Sleep, 2007
jesmonite, pigment,
acrylic paint, modeling
putty, and plastic
9 ¹/₂ x 75 x 35 ⁷/₈ in.
(24.1 x 190.5 x 91.1 cm)
Ovitz Family Collection,
Los Angeles
Courtesy of Anton Kern
Gallery, New York, and
The Modern Institute/
Toby Webster Ltd.,
Glasgow

Mike Kelley
Kandor 20, 2007
mixed media with video
projection
1 plinth with bottle:
57 ¹/₁₆ x diam. 38 in.
(144.9 x diam. 96.5 cm)
1 plinth with city:
37 ⁵/₈ x diam. 37 ¹³/₁₆ in.
(95.6 x diam. 96 cm)
Plexi sculpture:
80 ¹/₂ x 96 x 60 ¹/₈ in.
(204.5 x 243.8 x 152.7 cm)
Courtesy of Jablonka
Galerie, Cologne/Berlin

Mike Kelley
Kandor 17, 2007
mixed media with video
projection
overall:
128 ³/₈ x 97 ⁵/₈ x 80 ¹¹/₁₆ in.
(326.1 x 248 x 205 cm)
Glenstone Museum
Foundation, Potomac,
MD

Mike Kelley
Kandor 15, 2007
mixed media with video
projection
overall:
95 ¹/₂ x 123 ³/₁₆ x 86 ³/₈ in.
(242.6 x 312.9 x 219.4 cm)
Private collection, Cologne
Courtesy of Jablonka
Galerie, Cologne/Berlin

Mike Kelley
Kandor 13, 2007
mixed media with video
projection
base with tank:
87 ³/₁₆ x 47 ⁷/₁₆ x 24 ¹³/₁₆ in.
(221.5 x 120.5 x 63 cm)
Plexi wall unit:
95 ¹/₂ x 95 ¹¹/₁₆ x 99 ³/₁₆ in.
(242.6 x 243.1 x 251.9 cm)
Courtesy of Jablonka
Galerie, Cologne/Berlin

Mike Kelley
Kandor 6, 2007
mixed media with video
projection
sculpture:
58 ¹¹/₁₆ x 100 x 51 ³/₄ in.
(149.1 x 254 x 131.4 cm)
bottle/plinth:
74 x diam. 23 in.
(188 x diam. 48.4 cm)
The Jill and Peter Kraus
Collection, New York

Mike Kelley
Kandor 4, 2007
mixed media with video
projection
part 1 with bottle:
63 ³/₈ x 127 ³/₁₆ x 96 ¹/₁₆ in.
(161 x 323.1 x 244 cm)
part 2 with cities:
57 ¹/₁₆ x 104 ⁵/₁₆ x 37 in.
(144.9 x 265 x 94 cm)
Courtesy of Jablonka
Galerie, Cologne/Berlin

Mike Kelley
Kandor 1, 2007
mixed media
overall:
145 ¹/₄ x 115 ³/₈ x 95 ¹/₂ in.
(368.9 x 293.1 x 242.6 cm)
Private collection
Courtesy of Jablonka
Galerie, Cologne/Berlin

Friedrich Kunath
Ariel, 2008
gouache, acrylic, and
varnish on canvas
40 ¹/₄ x 52 ³/₄ in.
(102.2 x 134 cm)
Courtesy of Blum & Poe,
Los Angeles; BQ,
Cologne; and Andrea
Rosen Gallery, New York

Friedrich Kunath
Bureau of sad endings,
2008
gouache on canvas
33 ³/₈ x 25 ¹/₂ in.
(84.8 x 64.8 cm)
Courtesy of Blum & Poe,
Los Angeles; BQ,
Cologne; and Andrea
Rosen Gallery, New York

Friedrich Kunath
Defectus, 2008
gouache on canvas
23 ⁹/₁₆ x 31 ⁷/₁₆ in.
(59.6 x 79.9 cm)
Courtesy of Blum & Poe,
Los Angeles; BQ,
Cologne; and Andrea
Rosen Gallery, New York

Friedrich Kunath
Dimension Z, 2008
gouache, graphite,
and varnish on canvas
23 ⁵/₈ x 33 ¹/₂ in.
(60 x 85.1 cm)
Collection of Yvonne
Quirmbach, and Jörn
Bötnagel, Cologne

Friedrich Kunath
Peregrinus, 2008
gouache, acrylic, and
varnish on canvas
52 ¹¹/₁₆ x 70 ⁷/₈ in.
(133.8 x 180 cm)
Courtesy of Blum & Poe,
Los Angeles; BQ,
Cologne; and Andrea
Rosen Gallery, New York

Friedrich Kunath
Cancel everything,
2007/2008
gouache, and varnish
on canvas
25 ¹/₂ x 33 ⁷/₁₆ in.
(64.8 x 84.9 cm)
Courtesy of Blum & Poe,
Los Angeles; BQ,
Cologne; and Andrea
Rosen Gallery, New York

Friedrich Kunath
Untitled, 2007/2008
gouache, watercolor,
and varnish on canvas
78 ³/₄ x 110 ¹/₄ in.
(200 x 280 cm)
Saatchi Gallery, London

Friedrich Kunath
*It seems as men get
older they turn towards
the water*, 2007
gouache on canvas
25 ⁹/₁₆ x 33 ³/₈ in.
(64.9 x 84.8 cm)
Courtesy of Blum & Poe,
Los Angeles; BQ,
Cologne; and Andrea
Rosen Gallery, New York

Friedrich Kunath
*Let the distance keep
us together*, 2007
lightbox, spray paint,
Perspex glass, neon
lamp, metal, and vinyl
letters
21 ⁷/₈ x 29 ¹³/₁₆ x 6 ⁷/₈ in.
(55.6 x 75.7 x 17.5 cm)
Collection of Joshua
Adler, New York

Friedrich Kunath
Rehab, 2007
watercolor and gouache
on canvas
25 ⁹/₁₆ x 33 ¹/₂ in.
(64.9 x 85.1 cm)
Courtesy of Blum & Poe,
Los Angeles; BQ,
Cologne; and Andrea
Rosen Gallery, New York

Friedrich Kunath
Two with nature, 2007
acrylic on fabric
37 ³/₈ x 30 ⁵/₁₆ in.
(94.9 x 77 cm)
Courtesy of Blum & Poe,
Los Angeles; BQ,
Cologne; and Andrea
Rosen Gallery, New York

Friedrich Kunath
Untitled, 2007
mixed media on fabric
41 ⁵/₁₆ x 29 ¹/₂ in.
(104.9 x 74.9 cm)
Collection of Javier and
Monica Mora, Miami

Friedrich Kunath
Untitled, 2007
screenprint on wood, 13
lamps, and 7 clay figures
78 ¹/₂ x 68 ¹/₈ in.
(199.4 x 173 cm)
Saatchi Gallery, London

Friedrich Kunath
Untitled, 2007
watercolor and varnish
on canvas
53 ¹/₈ x 33 ¹/₂ in.
(134.9 x 85.1 cm)
Courtesy of Blum & Poe,
Los Angeles; BQ,
Cologne; and Andrea
Rosen Gallery, New York

Friedrich Kunath
Untitled, 2006
mixed media on paper
22 ¹/₄ x 30 ³/₁₆ in.
(56.5 x 76.7 cm)
Collection of Javier and
Monica Mora, Miami

Friedrich Kunath
Untitled, 2006
oil on carbon paper
45 ¹¹/₁₆ x 35 ¹/₄ in.
(116.1 x 89.5 cm)
Private collection,
New York

Friedrich Kunath
Untitled, 2006
watercolor on canvas
20 ⁷/₈ x 17 ⁵/₁₆ in.
(53 x 44 cm)
Collection of Paul Köser,
Krefeld, Germany

Friedrich Kunath
Untitled, 2004
oil on canvas
12 ⁹/₁₆ x 9 ³/₄ in.
(31.9 x 24.8 cm)
Collection of Johannes
and Bernarda Becker,
Cologne

Maria Lassnig
Untitled (The Assistant),
2008
oil on canvas
78 ³/₄ x 59 ¹/₁₆ in.
(200 x 150 cm)
Courtesy of the artist;
Hauser & Wirth, Zürich/
London; and Friedrich
Petzel Gallery, New York

Maria Lassnig
Untitled (Blase), 2008
oil on canvas
78 ³/₄ x 59 ¹/₁₆ in.
(200 x 150 cm)
Courtesy of the artist;
Hauser & Wirth, Zürich/
London; and Friedrich
Petzel Gallery, New York

Maria Lassnig
Untitled (Political), 2008
oil on canvas
59 ¹/₁₆ x 78 ³/₄ in.
(150 x 200 cm)
Courtesy of the artist;
Hauser & Wirth, Zürich/
London; and Friedrich
Petzel Gallery, New York

Maria Lassnig
*Untitled (Pushing the
Artist Yellow)*, 2008
oil on canvas
78 ³/₄ x 59 ¹/₁₆ in.
(200 x 150 cm)
Courtesy of the artist;
Hauser & Wirth, Zürich/
London; and Friedrich
Petzel Gallery, New York

Sharon Lockhart
Pine Flat, 2005
16mm film; color, sound
138 min.
Carnegie Museum of Art,
Pittsburgh, The Henry L.
Hillman Fund

Sharon Lockhart
Pine Flat Portrait Studio,
2005
19 framed chromogenic
prints:
*Jessie, Breanna, Kassie
Chance
Becky, Damien, Katie
Dakota
Meleah, Travis
Sarah, Sarah, Mikey
Mikey, Sierra
Matthew, Matthew
Sierra
Ryan*
45 ¹/₂ x 36 ¹¹/₁₆ in.
(115.6 x 93.2 cm) each
Carnegie Museum of Art,
Pittsburgh, The Henry L.
Hillman Fund

Mark Manders
not yet titled, 2008
sand, hair, painted epoxy,
iron, painted polyester,
offset print on paper,
wood, and various
materials
31 ¹/₂ x 33 ¹/₂ x 86 ⁵/₈ in.
(80 x 85.1 x 220 cm)
Courtesy of Tanya
Bonakdar Gallery,
New York, and Zeno X
Gallery, Antwerp

Mark Manders
not yet titled, 2008
wood, fabric, and various
materials
27 ⁹/₁₆ x 35 ⁷/₁₆ x 35 ⁷/₁₆ in.
(70 x 90 x 90 cm)
Courtesy of Tanya
Bonakdar Gallery,
New York, and Zeno X
Gallery, Antwerp

Mark Manders
not yet titled, 2007–2008
iron, brass, painted
ceramic, painted epoxy,
wood, offset print on
paper, and various
materials
114 ³/₁₆ x 70 ⁷/₈ x 129 ¹⁵/₁₆ in.
(290 x 180 x 330 cm)
Courtesy of Tanya
Bonakdar Gallery,
New York, and Zeno X
Gallery, Antwerp

Mark Manders
not yet titled, 2007–2008
iron, clothes, shoes,
contact lenses, and
various materials
17 ³/₄ x 41 ⁵/₁₆ x 78 ³/₄ in.
(45.1 x 104.9 x 200 cm)
Courtesy of Tanya
Bonakdar Gallery,
New York, and Zeno X
Gallery, Antwerp

Mark Manders
Fox/Mouse/Belt, 1992
painted ceramic and belt
edition of 3 + 1
5 ¹⁵/₁₆ x 47 ¹/₄ x 15 ³/₄ in.
(15.1 x 120 x 40 cm)
Courtesy of Tanya
Bonakdar Gallery,
New York, and Zeno X
Gallery, Antwerp

Barry McGee
Untitled, 2008
mixed media
dimensions variable
Courtesy of the artist;
Deitch Projects, New
York; and Stuart Shave/
Modern Art, London
Commissioned by 2008
Carnegie International,
Carnegie Museum of Art,
Pittsburgh

Mario Merz
A Mallarmé, 2003
newspapers and neon
21 ¹/₂ x 283 ¹/₂ x 31 ¹/₂ in.
(54.6 x 720 x 80 cm)
Fondazione Merz, Turin

Mario Merz
Untitled, 1977
stuffed lizard, glass,
neon tubing, wire, and
transformer
dimensions variable
lizard:
19 ¹¹/₁₆ in. (50 cm) long
Collection of Frances
Dittmer, Aspen, Colorado

Mario Merz
Fibonacci Igloo, 1972
metal structure with
stuffed fabric, iron wire,
and neon numbers
39 ³/₈ x diam. 78 ³/₄ in.
(100 x diam. 200 cm)
Carnegie Museum of Art,
Pittsburgh, on extended
loan from the Jill and
Peter Kraus Collection,
New York

Mario Merz
Fibonacci 1202, 1970
11 black-and-white
framed photographs,
10 neon signs, and
1 transformer
19 ⁵/₈ x 196 ⁷/₈ in.
(49.9 x 500.1 cm)
Dallas Museum of Art,
fractional gift of
Rachofsky Collection,
2001

Marisa Merz
*Untitled (Living
Sculpture)*, 1966
strips of aluminum
dimensions variable
Courtesy of Gladstone
Gallery, New York

Matthew Monahan
Phantom Limb, 2008
foam, resin, paint, nylon,
metal, and drywall
111 x 24 x 24 in.
(281.9 x 61 x 61 cm)
Courtesy of the artist
and Anton Kern Gallery,
New York

Matthew Monahan
Youth Fenced In, 2008
foam, resin, paint, nylon,
metal, and drywall
102 x 24 x 24 in.
(259.1 x 61 x 61 cm)
Courtesy of the artist
and Anton Kern Gallery,
New York

Matthew Monahan
The Apprentice, 2007
foam, wax, pigment,
resin, graphite, brass,
copper, strap, and glass
87 x 12 x 12 in.
(221 x 30.5 x 30.5 cm)
Courtesy of the artist
and Anton Kern Gallery,
New York

Matthew Monahan
The Feral, 2007
foam, wax, paint, string,
resin, chalk, strap, and
glass
72 x 12 x 12 in.
(182.9 x 30.5 x 30.5 cm)
Courtesy of the artist
and Anton Kern Gallery,
New York

Rivane Neuenschwander
Pangaea, 2008
DVD projection; color,
sound
2 min. approx.
Courtesy of Tanya
Bonakdar Gallery,
New York; Galeria Fortes
Vilaça, São Paulo;
and Stephen Friedman
Gallery, London

Rivane Neuenschwander
I Wish Your Wish, 2003
silkscreen on textile
ribbons and wall with
drilled holes
dimensions variable
Collection of Juan
and Patricia Vergez,
Buenos Aires

Noguchi Rika
The Sun, 2005–2006
18 chromogenic prints
17 ¹³/₁₆ x 25 ¹¹/₁₆ in.
(45.2 x 65.3 cm) each
Courtesy of the artist
and D'Amelio Terras,
New York

Manfred Pernice
"deja vue 12," 2008
mixed media
dimensions variable
Courtesy of the artist;
Anton Kern Gallery,
New York; and Galerie
Neu, Berlin
Commissioned by 2008
Carnegie International,
Carnegie Museum of Art,
Pittsburgh

Susan Philipsz
untitled, 2008
sound installation
Courtesy of Tanya
Bonakdar Gallery,
New York

Susan Philipsz
Sunset Song, 2003
solar-powered sound
installation; 2 trumpet
speakers on 16-inch
stands powered by solar
panels; recording of 2
versions of "The Banks
of the Ohio"
Courtesy of Tanya
Bonakdar Gallery,
New York

Wilhelm Sasnal
Untitled, 2008
oil on canvas
63 x 78 ³/₄ in.
(160 x 200 cm)
Courtesy of Anton Kern
Gallery, New York, and
Fundacja Galerii Foksal,
Warsaw

Wilhelm Sasnal
Untitled, 2008
oil on canvas
15 ³/₄ x 19 ¹¹/₁₆ in.
(40 x 50 cm)
Courtesy of Anton Kern
Gallery, New York, and
Fundacja Galerii Foksal,
Warsaw

Wilhelm Sasnal
Beach Boys, 2007
oil on canvas
78 ³/₄ x 78 ³/₄ in.
(200 x 200 cm)
Courtesy of Anton Kern
Gallery, New York, and
Fundacja Galerii Foksal,
Warsaw

Wilhelm Sasnal
D. Johnson, 2007
oil on canvas
78 ³/₄ x 78 ³/₄ in.
(200 x 200 cm)
Courtesy of Anton Kern
Gallery, New York, and
Fundacja Galerii Foksal,
Warsaw

Wilhelm Sasnal
*European American
Tectonic Plates,* 2007
oil on canvas
78 ³/₄ x 86 ⁵/₈ in.
(200 x 220 cm)
Courtesy of Anton Kern
Gallery, New York, and
Fundacja Galerii Foksal,
Warsaw

Wilhelm Sasnal
Untitled, 2007
oil on canvas
19 ¹¹/₁₆ x 15 ³/₄ in.
(50 x 40 cm)
Courtesy of Anton Kern
Gallery, New York, and
Fundacja Galerii Foksal,
Warsaw

Wilhelm Sasnal
Untitled, 2006
oil on canvas
63 x 78 ³/₄ in.
(160 x 200 cm)
Courtesy of Anton Kern
Gallery, New York, and
Fundacja Galerii Foksal,
Warsaw

Thomas Schütte
Zombie VIII, 2008
bronze
29 ¹/₂ x 33 ¹/₂ x 41 ⁵/₁₆ in.
(74.9 x 85.1 x 104.9 cm)
Courtesy of the artist and
Galerie Nelson-Freeman,
Paris

Thomas Schütte
Zombie VII, 2008
bronze
28 ³/₄ x 44 ¹/₁₆ x 44 ¹/₁₆ in.
(73 x 111.9 x 111.9 cm)
Courtesy of the artist and
Galerie Nelson-Freeman,
Paris

Thomas Schütte
Apple 7, 2007
watercolor on paper
23 ⁵/₈ x 19 ⁵/₁₆ in.
(60 x 49.1 cm)
Private collection,
Geneva

Thomas Schütte
Apple 6, 2007
watercolor on paper
15 ¹/₈ x 11 ¹/₄ in.
(38.4 x 28.6 cm)
Private collection,
Geneva

Thomas Schütte
Apple 5, 2007
watercolor on paper
15 ¹/₈ x 11 ¹/₄ in.
(38.4 x 28.6 cm)
Private collection,
Geneva

Thomas Schütte
Apple 4, 2007
watercolor on paper
15 ¹/₈ x 11 ¹/₄ in.
(38.4 x 28.6 cm)
Private collection,
Geneva

Thomas Schütte
Apple III, 2007
watercolor on paper
15 ¹/₈ x 11 ¹/₄ in.
(38.4 x 28.6 cm)
Private collection,
Geneva

Thomas Schütte
Apple II, 2007
watercolor on paper
23 ⁵/₈ x 19 ⁵/₁₆ in.
(60 x 49.1 cm)
Private collection,
Geneva

Thomas Schütte
Apple I, 2007
graphite on paper
15 ¹/₈ x 11 ¹/₄ in.
(38.4 x 28.6 cm)
Private collection,
Geneva

Thomas Schütte
divorce houses, 2007
watercolor and ink on
paper
15 1/8 x 11 1/4 in.
(38.4 x 28.6 cm)
Anonymous collection

Thomas Schütte
o w, 2007
watercolor on paper
15 1/8 x 11 1/4 in.
(38.4 x 28.6 cm)
Courtesy of Jarla
Partilager

Thomas Schütte
Saure Zitronen, 2007
watercolor on paper
15 1/8 x 11 1/4 in.
(38.4 x 28.6 cm)
Collection of Corinne
Mueller Flick, London

Thomas Schütte
Süssie, 2007
watercolor on paper
15 1/8 x 11 1/4 in.
(38.4 x 28.6 cm)
Courtesy of Jarla
Partilager

Thomas Schütte
Untitled, 2007
watercolor on paper
15 1/8 x 11 1/4 in.
(38.4 x 28.6 cm)
Courtesy of Jarla
Partilager

Thomas Schütte
Untitled (Hank Williams),
2007
watercolor on paper
15 1/8 x 11 1/4 in.
(38.4 x 28.6 cm)
Courtesy of Galerie
Nelson-Freeman, Paris

Thomas Schütte
Untitled (Two Lemons),
2007
watercolor on paper
15 1/8 x 11 1/4 in.
(38.4 x 28.6 cm)
Private collection
Courtesy of Galerie
Nelson-Freeman, Paris

Thomas Schütte
Zitrone, 2007
watercolor on paper
15 1/8 x 11 1/4 in.
(38.4 x 28.6 cm)
Collection of Corinne
Mueller Flick, London

Thomas Schütte
Zombie VI, 2007
aluminum
24 7/16 x 29 1/2 x 42 15/16 in.
(62.1 x 74.9 x 109.1 cm)
Portalakis Collection,
Greece

Ranjani Shettar
Just a bit more, 2006
hand-molded beeswax,
pigments, and thread
dyed in tea
432 x 288 x 144 in.
(1097.3 x 731.5 x 365.8 cm)
Courtesy of the artist and
Talwar Gallery, New York/
New Delhi

David Shrigley
Bone, 2008
bronze
18 1/8 x 3 15/16 x 3 15/16 in.
(46 x 10 x 10 cm)
Courtesy of the artist

David Shrigley
Silver Balls, 2008
7 silver-plated bronze balls
dimensions variable
Courtesy of the artist

David Shrigley
Untitled, 2008
installation of glazed
ceramic objects
dimensions variable
Courtesy of the artist

David Shrigley
Untitled, 2008
installation of glazed
ceramic objects
dimensions variable
Courtesy of the artist

David Shrigley
untitled installation, 2008
mixed media
dimensions variable
Courtesy of the artist

David Shrigley
I'm Dead, 2007
taxidermy kitten with
wood sign and acrylic
paint
overall:
37 x 20 x 20 in.
(94 x 50.8 x 50.8 cm)
kitten and sign:
23 1/2 x 5 1/2 x 9 3/4 in.
(59.7 x 14 x 24.8 cm)
Courtesy of the artist
and the David Roberts
Collection

David Shrigley
untitled drawings,
2002–2007
ink on paper
8 1/4 x 11 13/16 in.
(21 x 30 cm) each
Courtesy of the artist

Paul Sietsema
Figure 3, 2008
16mm film
25 min. approx.
Courtesy of Regen
Projects, Los Angeles

Rudolf Stingel
Untitled, 2008
oil and enamel on canvas
132 x 180 x 2 in.
(335.3 x 457.2 x 5.1 cm)
Courtesy of the artist and
Paula Cooper Gallery,
New York

Rudolf Stingel
Untitled, 2008
oil and enamel on canvas
132 x 180 x 2 in.
(335.3 x 457.2 x 5.1 cm)
Courtesy of the artist and
Paula Cooper Gallery,
New York

Katja Strunz
Aktive stagnation, 2008
screenprint on
honeycomb panel
86 1/2 x 63 in.
(219.7 x 160 cm)
Courtesy of Gavin
Brown's enterprise,
New York; The Modern
Institute/Toby Webster
Ltd., Glasgow; and
Galerie Almine Rech, Paris

Katja Strunz
*A drop in time (five
minutes later)*, 2008
wood, steel st37, and
enamel
112 x 80 3/4 x 14 1/2 in.
(284.5 x 205.1 x 36.8 cm)
Courtesy of Gavin
Brown's enterprise,
New York; The Modern
Institute/Toby Webster
Ltd., Glasgow; and
Galerie Almine Rech, Paris

Katja Strunz
Mirrors against identity,
2008
waxed steel
139 1/2 x 141 3/4 x 38 1/2 in.
(354.3 x 360.1 x 97.8 cm)
Courtesy of Gavin
Brown's enterprise,
New York; The Modern
Institute/Toby Webster
Ltd., Glasgow; and
Galerie Almine Rech, Paris

Katja Strunz
Black Angry Wall, 2006
6 steel st37 cubes and
4 letterpress prints on
paper
overall:
131 x 70 x 15 in.
(332.7 x 177.8 x 38.1 cm)
letterpress prints:
12 1/2 x 10 3/4 in.
(31.8 x 27.3 cm) each
Collection of Charlotte
and Bill Ford, Greenwich,
Connecticut
Courtesy of Gavin
Brown's enterprise,
New York

Katja Strunz
Echo, 2005
12 steel st37 cubes
142 x 87 x 17 in.
(360.7 x 221 x 43.2 cm)
Collection of Amalia
Dayan and Adam
Lindemann, New York

Paul Thek
*Tower and Uncle Tom's
Cabin*, 1976
bronze
94 1/2 x 14 1/2 x 9 1/2 in.
(240 x 36.8 x 24.1 cm)
Philadelphia Museum
of Art: Purchased with
funds contributed by
the Daniel W. Dietrich
Foundation, Mrs. Adolf
Schaap, Marion Stroud
Swingle, and with the
Twentieth Century Art
Revolving Fund, 1990

Paul Thek
Large Pumpkin Pyramid,
from the series *The
Personal Effects of the
Pied Piper*, 1975–1976
bronze
25 x 21 7/16 x 20 1/2 in.
(63.5 x 54.5 x 52.1 cm)
Collection of Daniel
W. Dietrich II, Chester
Springs, Pennsylvania

Paul Thek
Burning Bridge, 1975
acrylic and gesso on
newspaper
23 x 29 in.
(58.4 x 73.7 cm)
Collection of Jennifer
McSweeney, New York

Paul Thek
Dinosaur (Unfinished),
1975
acrylic on newspaper
22 ³/₄ x 33 ¹/₄ in.
(57.8 x 84.5 cm)
Collection of Susan
and Rob White, Wayzata,
Minnesota

Paul Thek
Golden Web, 1975
acrylic on newspaper
22 ¹/₂ x 33 in.
(57.2 x 83.8 cm)
Fundação de Serralves—
Museo de Arte
Contemporânea, Porto,
Portugal

Paul Thek
Pompei World, 1975
acrylic on newspaper
22 ³/₄ x 33 ¹/₄ in.
(57.8 x 84.5 cm)
Collection of Hilary and
Peter Hatch, New York

Paul Thek
Proust Faust, 1975
enamel and acrylic on
newspaper
22 ³/₄ x 33 ³/₈ in.
(57.8 x 84.8 cm)
Fundação de Serralves—
Museu de Arte
Contemporânea, Porto,
Portugal

Paul Thek
Sea Series, 1975
enamel on newspaper
22 ³/₄ x 33 ¹/₄ in.
(57.8 x 84.5 cm)
Collection of Ted Bonin,
New York

Paul Thek
Seven Birds, 1975
acrylic on newspaper
22 ¹/₂ x 33 in.
(57.2 x 83.8 cm)
Private collection,
New York

Paul Thek
3 Prunes, 1975
pastel and acrylic on
newspaper
22 ³/₄ x 33 ¹/₂ in.
(57.8 x 85.1 cm)
The Museum of Modern
Art, New York, The Judith
Rothschild Foundation
Contemporary Drawings
Collection Gift

Paul Thek
2 Birds, 1975
oil paint on newspaper
22 ³/₄ x 33 in.
(57.8 x 83.8 cm)
Walker Art Center,
Minneapolis, Justin
Smith Purchase Fund,
2003

Paul Thek
*Uncle Tom's Cabin in
Flames,* 1975
acrylic on newspaper
23 x 29 in.
(58.4 x 73.7 cm)
Collection Weil, Gotshal
& Manges, New York

Paul Thek
*Untitled (Exploding Bowl
of Cherries),* 1975
acrylic on newspaper
23 x 29 in.
(58.4 x 73.7 cm)
The Museum of Modern
Art, New York, Gift of Jan
Christiaan Braun

Paul Thek
Untitled (One Bird), 1975
acrylic on newspaper
22 x 33 in.
(55.9 x 83.8 cm)
Anonymous collection,
Dallas

Paul Thek
*The Personal Effects of
the Pied Piper,* c. 1975
bronze
dimensions variable
Walker Art Center,
Minneapolis, T. B. Walker
Acquisition Fund, 2003

Paul Thek
*Untitled (Lufthansa
notebook),* c. 1975
paper notebook
8 ³/₄ x 6 ⁵/₈ in.
(22.2 x 16.8 cm)
The Estate of George
Paul Thek
Courtesy of Alexander
and Bonin, New York

Paul Thek
Untitled (Two Figures),
c. 1974–1975
acrylic and gesso on
newspaper
23 x 29 in.
(58.4 x 73.7 cm)
Collection of Jennifer
McSweeney, New York

Paul Thek
Fascist Grapes, 1974
acrylic and gesso on
newspaper
23 x 29 in.
(58.4 x 73.7 cm)
The Museum of Modern
Art, New York, Gift of the
Friends of Contemporary
Drawing

Paul Thek
Potato, 1974
acrylic on newspaper
22 ¹/₂ x 33 in.
(57.2 x 83.8 cm)
Fundação de Serralves—
Museu de Arte
Contemporânea, Porto,
Portugal

Paul Thek
Red Turtle, 1974
acrylic and gesso on
newspaper
23 x 29 in.
(58.4 x 73.7 cm)
The Museum of Modern
Art, New York,
Purchased with funds
given by The Judith
Rothschild Foundation
and Purchase Fund

Paul Thek
*Untitled (Earth
Drawing I),* c. 1974
acrylic on 4 sheets of
newspaper
44 x 66 in.
(111.8 x 167.6 cm)
Collection of Robert
Wilson
Courtesy of Alexander
and Bonin, New York

Paul Thek
Untitled (Green Potato),
1974
acrylic and gesso on
newspaper
22 ³/₄ x 33 in.
(57.8 x 83.8 cm)
The Musuem of Modern
Art, New York, Purchase
through the Vincent
D'Aquila and Harry
Soviak Bequest Fund

Paul Thek
Untitled (Heartman), 1974
acrylic on newspaper
22 ³/₄ x 33 in.
(57.8 x 83.8 cm)
Walker Art Center,
Minneapolis, Miriam and
Erwin Kelen Acquisition
Fund for Drawings, 2003

Wolfgang Tillmans
*Paradise, War, Religion,
Work (TSC, New York),*
2007
4 tables, chromogenic
prints, photocopies,
newspapers, offset
prints, and objects
overall:
37 x 174 x 127 in.
(94 x 442 x 322.6 cm)
Courtesy of Ellipse
Foundation Contemporary
Art Collection, Lisbon

Wolfgang Tillmans
Venice, 2007
chromogenic print
71 ⁵/₁₆ x 99 ¹/₄ in.
(181.1 x 252.1 cm)
Courtesy of Maja
Hoffman, Zürich

Wolfgang Tillmans
Victoria Park, 2007
chromogenic print
71 ⁵/₁₆ x 98 ¹/₂ in.
(181.1 x 250.2 cm)
Courtesy of the artist
and Andrea Rosen
Gallery, New York

Wolfgang Tillmans
flower, 2006
chromogenic print
83 ⁷/₈ x 57 ¹/₈ in.
(213 x 145.1 cm)
Carnegie Museum of Art,
Pittsburgh, The Henry L.
Hillman Fund

Wolfgang Tillmans
Freischwimmer 118, 2005
inkjet print
118 ¹/₈ x 157 ¹/₂ in.
(300 x 400.1 cm)
Courtesy of the artist
and Andrea Rosen
Gallery, New York

Wolfgang Tillmans
Tiere, 2004
chromogenic print
57 x 84 in.
(144.8 x 213.4 cm)
Courtesy of the artist
and Andrea Rosen
Gallery, New York

Rosemarie Trockel
*landscapian shroud of
my mother,* 2008
glazed ceramic and steel
15 ¹/₂ x 109 ¹/₂ x 78 ³/₄ in.
(39.4 x 278.1 x 200 cm)
Courtesy of Monika
Sprüth/Philomene
Magers, Munich/
Cologne/London, and
Gladstone Gallery,
New York

Rosemarie Trockel
I on my sofa, 2007
glazed ceramic, steel,
and mixed media
29 ¹/₂ x 111 ¹/₂ x 50 ¹/₂ in.
(74.9 x 283.2 x 128.3 cm)
Courtesy of Monika
Sprüth/Philomene
Magers, Munich/Cologne/
London, and Gladstone
Gallery, New York

Rosemarie Trockel
*Less sauvage than
others,* 2007
ceramic and glazed
platinum
25 ³/₁₆ x 31 ¹/₁₆ X 5 ¹/₁₆ in.
(64 x 79 x 13 cm)
Courtesy of Monika
Sprüth/Philomene
Magers, Munich/Cologne/
London, and Donald
Young Gallery, Chicago

Apichatpong
Weerasethakul
Unknown Forces, 2007
4-channel video; color,
sound
duration variable
Courtesy of the artist

Andro Wekua
Get out of my room, 2006
wood, wax, hair, fabric,
leather, wax paint,
bronze, and lacquer paint
table:
29 ¹/₂ x 76 ³/₄ x 39 ³/₈ in.
(74.9 x 194.9 x 100 cm)
figure and chair:
45 ¹/₄ x 45 ¹/₄ x 27 ¹⁵/₁₆ in.
(114.9 x 114.9 x 71 cm)
8 silkprints:
12 x 8 ¹/₂ in.
(30.5 x 21.6 cm) each
1 etching:
16 ¹/₂ x 11 ¹³/₁₆ in.
(41.9 x 30 cm)
Courtesy of Gladstone
Gallery, New York, and
Galerie Peter Kilchmann,
Zürich

Richard Wright
No Title, 2008
gouache on wall
dimensions variable
Courtesy of Gagosian
Gallery, New York;
The Modern Institute,
Glasgow; and BQ,
Cologne
Commissioned by 2008
Carnegie International,
Carnegie Museum of Art,
Pittsburgh

Haegue Yang
Three Kinds, 2008
mixed media (venetian
blinds, light, mirror,
and slide projection)
dimensions variable
Courtesy of the artist and
Galerie Barbara Wien,
Berlin
Commissioned by 2008
Carnegie International,
Carnegie Museum of Art,
Pittsburgh

Image Credits

p. 17
Carl Sagan, Linda Saltzman Sagan, and Frank Drake, *Pioneer 10* plaque, 1972
gold-anodized aluminum
6 x 9 in.
(15.2 x 22.9 cm)
Courtesy of NASA
Photo: NASA archives

p. 20
Mario Merz
Luoghi Senza Strada (Places without streets) (detail), 1987
metal tubes, wire mesh, stone, twigs, and neon tubes
78 ³/₄ x 157 ¹/₂ in.
(200 x 400.1 cm)
Courtesy of Gladstone Gallery, New York

p. 20
Paul Thek
Untitled (Earth Drawing I), c. 1974
acrylic on 4 sheets of newspaper
44 x 66 in.
(111.8 x 167.6 cm)
Collection of Robert Wilson
Courtesy of Alexander and Bonin, New York

p. 22
Hurricane Katrina survivors, September 1, 2005
Photo: David J. Phillip, Associated Press Pool
© Associated Press

p. 22
Théodore Géricault, 1791–1824
The Raft of the Medusa, 1818–1819
oil on canvas
193 x 282 in.
(490.2 x 716.3 cm)
Musée du Louvre, Paris
Photo: The Bridgeman Art Library

p. 24
George A. Romero
Night of the Living Dead (film still), 1968
film; black and white, sound
96 min.
Courtesy of Russ Streiner and Image Ten, Inc.

p. 28, top to bottom
Sharon Lockhart
Pine Flat (film still), 2005
16mm; color, sound
138 min.
Carnegie Museum of Art, Pittsburgh, The Henry L. Hillman Fund
Courtesy of Blum & Poe, Los Angeles; Gladstone Gallery, New York; and neugerriemschneider, Berlin

Haegue Yang
Sadong 30 (installation view), 2006
origami objects, various lights, ventilator, drying rack sculpture, plants, wood bench, drinking water, etc.
dimensions variable
Courtesy of the artist and Galerie Barbara Wien, Berlin
Photo: © Daenam Kim

Thomas Hirschhorn
Cavemanman (installation view), 2002
wood, cardboard, tape, aluminum foil, books, posters, videos of Lascaux 2, dolls, cans, shelves, and fluorescent light fixtures
dimensions variable
Courtesy of the artist and Gladstone Gallery, New York
© Thomas Hirschhorn

pp. 41–46
Script from Peter Fischli and David Weiss, *Questions*, 2002–2003, 50th Venice Biennale, 2003
Friedrich Christian Flick Collection
Courtesy of the artists and Galerie Eva Presenhuber, Zürich; Monika Sprüth/Philomene Magers, Cologne/Munich/London; and Matthew Marks Gallery, New York

p. 49, top
Giorgio Agamben, "State of Exception in Today's World of Affairs (from Guantánamo to Auschwitz)," 2005, European Graduate School EGS Lecture, Media and Communication Studies Department, Saas-Fee, Switzerland
http://www.youtube.com/watch?v=KWPf2zIRkho

p. 49, bottom left
"Heidegger and the Future: 'The End of Philosophy and the Task of Thinking,'" 1969, interview with Richard Wisser on German television
http://www.youtube.com/watch?v=Yu_UFHrC02k

p. 49, bottom right
"Adorno about Beckett and the Deformed Subject"
http://www.youtube.com/watch?v=UdmAAUXasXE

p. 52
Chomsky vs. Foucault, Part 1, "Human Nature: Justice vs. Power," 1971, the Netherlands
http://www.youtube.com/watch?v=hbUYsQR3Mes

p. 56, top
"Deleuze on Wittgenstein: A 'Massive Regression' of All Philosophy," extracted from *L'Abécédaire de Gilles Deleuze with Claire Parnet*. Recorded in 1989, broadcast in 1994–1995, Arte Channel
http://www.youtube.com/watch?v=kt24h_la2UA

p. 56, center and bottom
Paul Virilio, "Dromology and Claustrophobia," 2007, European Graduate School EGS Lecture, Media and Communication Studies Department, New York
http://www.youtube.com/watch?v=JtCL0bnqxpQ

pp. 68–69
Doug Aitken
sleepwalkers (installation
view, Museum of Modern
Art, New York, Jan. 16–
Feb. 12, 2007), 2007
6-channel, 7-monitor
video or outdoor
installation
dimensions variable
Courtesy of 303 Gallery,
New York; Galerie Eva
Presenhuber, Zürich;
Victoria Miro Gallery,
London; and Regen
Projects, Los Angeles

pp. 70–71
Doug Aitken
sleepwalkers (video
stills), 2007
6-channel, 7-monitor
video or outdoor
installation
dimensions variable
Courtesy of 303 Gallery,
New York; Galerie Eva
Presenhuber, Zürich;
Victoria Miro Gallery,
London; and Regen
Projects, Los Angeles

pp. 74–76 and 77 top
Kai Althoff
Untitled (installation
views, Kunsthalle Zürich,
Nov. 10, 2007–Jan. 13,
2008), 2007
fiberglass, steel, acrylic,
electric motor, colored
and clear epoxy resin,
carpet, doll, steel grids,
rug, lamp, suit, fabric,
paint, vase, and scissors
dimensions variable
Courtesy of François
Pinault Collection, Paris
© Kai Althoff
Photo: Stefan Altenburger

p. 77, bottom
Kai Althoff
*Ich meine es auf jeden
Fall Schlecht mit ihnen*
(detail), 2007
Courtesy of Kunsthalle
Zürich and Gladstone
Gallery, New York
From the collection of
the artist and part of an
environment
© Kai Althoff
Photo: Stefan Altenburger

pp. 80–81
Mark Bradford
Noah's Third Day, 2007
mixed-media collage on
canvas
36 x 240 in.
(91.4 x 609.6 cm)
Courtesy of Sikkema
Jenkins & Co., New York

pp. 82–83
Mark Bradford
If caught outside, 2007
mixed-media collage on
canvas
102 x 144 in.
(259.1 x 365.8 cm)
Courtesy of Sikkema
Jenkins & Co., New York

pp. 86–87
Cao Fei
RMB CITY 1, 2007
digital chromogenic print
edition of 10
47 $^3/_{16}$ x 63 in.
(119.9 x 160 cm)
Courtesy of the artist
and Lombard-Freid
Projects, New York

p. 88
Cao Fei
*My Future is Not a Dream
03*, 2006
digital chromogenic print
edition of 12
47 $^1/_4$ x 59 in.
(120 x 149.9 cm)
Courtesy of the artist
and Lombard-Freid
Projects, New York

p. 89
Cao Fei
*My Future is Not a Dream
02*, 2006
digital chromogenic print
edition of 12
47 $^1/_4$ x 59 in.
(120 x 149.9 cm)
Courtesy of the artist
and Lombard-Freid
Projects, New York

p. 92
Vija Celmins
Night Sky #1, 1990–1991
oil on canvas mounted
on wood panel
18 $^3/_8$ x 22 $^1/_8$ in.
(46.7 x 56.2 cm)
Collection of Wade
and Angela Thompson,
New York
Courtesy of McKee
Gallery, New York
Photo: D. James Dee,
New York

p. 93
Vija Celmins
Night Sky #6, 1993
oil on linen mounted on
wood
19 $^1/_8$ x 22 $^3/_8$ x 1 $^3/_{16}$ in.
(48.6 x 56.8 x 3 cm)
Walker Art Center,
Minneapolis, Purchased
with the aid of funds from
Harriet and Edson W.
Spencer and the T. B.
Walker Acquisition Fund,
1995

p. 94
Vija Celmins
Night Sky #12, 1995–1996
oil on canvas mounted
on panel
31 x 37 $^1/_2$ in.
(78.7 x 95.3 cm)
Carnegie Museum of Art,
Pittsburgh, The Henry L.
Hillman Fund

p. 95
Vija Celmins
Night Sky #2, 1991
oil on canvas mounted
on aluminum
18 x 21 $^1/_2$ in.
(45.7 x 54.6 cm)
The Art Institute of
Chicago Ada S. Garrett
Fund. 1995.240
Reproduction, The Art
Institute of Chicago

pp. 98–100
Phil Collins
the world won't listen
(video stills), 2004–2007
synchronized 3-channel
color video projection
60 min. approx.
Courtesy of the artist;
Tanya Bonakdar Gallery,
New York; Kerlin Gallery,
Dublin; and Victoria Miro
Gallery, London
© Phil Collins

p. 101
Phil Collins
shady lane productions
(installation view, *Turner
Prize 2006*, Tate Britain,
London), 2006
a production company and
research office established
at Tate Britain, October
2006–January 2007
Courtesy of the artist;
Tanya Bonakdar Gallery,
New York; Kerlin Gallery,
Dublin; and Victoria Miro
Gallery, London
© Phil Collins

p. 104
Bruce Conner
Night Angel, 1975
gelatin silver print
photogram
85 x 39 in.
(215.9 x 99.1 cm)
Walker Art Center,
Minneapolis, Butler
Family Fund, 1989

p. 105
Bruce Conner
Angel, 1975
gelatin silver print
photogram
85 x 39 in.
(215.9 x 99.1 cm)
Walker Art Center,
Minneapolis, Butler
Family Fund, 1989

p. 106
Bruce Conner
Blessing Angel, 1975
gelatin silver print
photogram
85 x 39 in.
(215.9 x 99.1 cm)
Collection of Ann Hatch,
San Francisco

p. 107
Bruce Conner
Kiss Angel, 1975
gelatin silver print
photogram
96 x 40 in.
(243.8 x 101.6 cm)
Carnegie Museum of Art,
Pittsburgh, The Henry L.
Hillman Fund

pp. 110–111
Peter Fischli and
David Weiss
An Unsettled Work,
1987–2004
slide show on hard disk
25 min.
Sammlung Thomas and
Christina Bechtler,
Switzerland
Courtesy of Galerie Eva
Presenhuber, Zürich;
Monika Sprüth/Philomene
Magers, Cologne/
Munich/London; and
Matthew Marks Gallery,
New York
© Peter Fischli David
Weiss

pp. 112–113
Peter Fischli and
David Weiss
Untitled, 2005
105 carved and painted
polyurethane objects
dimensions variable
Private foundation Oslo,
c/o Peder Lund
Courtesy of Galerie Eva
Presenhuber, Zürich

pp. 116–117
Ryan Gander
*Man on a bridge—(A
study of David Lange)*,
2008
16mm film transferred
to HD video projection;
color, sound
duration variable
Courtesy of STORE
Gallery, London; Annet
Gelink Gallery, Amsterdam;
and Tanya Bonakdar
Gallery, New York

p. 118
Ryan Gander
*He walked ahead, leading
her through a blizzard of
characters*, 2008
3,000-word text written
by the ghostwriter Davis
Allsop, screen-printed
directly onto the gallery
wall, which immediately
afterward is replastered
dimensions variable
Courtesy of STORE
Gallery, London; Annet
Gelink Gallery, Amsterdam;
and Tanya Bonakdar
Gallery, New York

p. 119
Ryan Gander
*A sheet of paper on
which I was about to
draw, as it slipped from
my table and fell to the
floor* (detail), 2008
100 15-cm crystal balls
dimensions variable
Courtesy of STORE
Gallery, London; Annet
Gelink Gallery, Amsterdam;
and Tanya Bonakdar
Gallery, New York

p. 122
Daniel Guzmán
El cobrador de impuestos
(The tax collector), 2006,
from the series *La
búsqueda del ombligo*
(The search of the navel),
2005–2007
ink on paper on wood
panel
82 $^{11}/_{16}$ x 70 $^{7}/_{8}$ x 1 $^{3}/_{8}$ in.
(210 x 180 x 3.5 cm)
Collection of Charlotte
and Bill Ford, Greenwich,
Connecticut
Courtesy of the artist and
kurimanzutto, Mexico City

p. 123
Daniel Guzmán
Negro (Black), 2006,
from the series *La
búsqueda del ombligo*
(The search of the navel),
2005–2007
ink on paper on wood
panel
82 $^{11}/_{16}$ x 70 $^{7}/_{8}$ x 1 $^{3}/_{8}$ in.
(210 x 180 x 3.5 cm)
Private collection, Cologne
Courtesy of the artist and
kurimanzutto, Mexico City

p. 124
Daniel Guzmán
Fuck you too, 2007, from
the series *La búsqueda
del ombligo* (The search
of the navel), 2005–2007
ink on paper on wood
panel
82 $^{11}/_{16}$ x 70 $^{7}/_{8}$ x 1 $^{3}/_{8}$ in.
(210 x 180 x 3.5 cm)
Carnegie Museum of Art,
Pittsburgh

p. 125
Daniel Guzmán
Decapitado (Decapitated),
2006, from the series *La
búsqueda del ombligo*
(The search of the navel),
2005–2007
ink on paper on wood
panel
82 $^{11}/_{16}$ x 70 $^{7}/_{8}$ x 1 $^{3}/_{8}$ in.
(210 x 180 x 3.5 cm)
Courtesy of the artist and
kurimanzutto, Mexico City

pp. 128–131
Thomas Hirschhorn
Cavemanman (installation
views), 2002
wood, cardboard, tape,
aluminum foil, books,
posters, videos of
Lascaux 2, dolls, cans,
shelves, and fluorescent
light fixtures
dimensions variable
Courtesy of the artist
and Gladstone Gallery,
New York
© Thomas Hirschhorn

pp. 134–135
Richard Hughes
Tomorrow Came, 2007
fiberglass, epoxy resin,
acrylic paint, enamel,
pigment, and stuffed
pigeon
43 $^{3}/_{8}$ x 16 x 44 in.
(110.2 x 40.6 x 111.8 cm)
Courtesy of The Modern
Institute, Glasgow,
and Anton Kern Gallery,
New York

p. 136
Richard Hughes
The Big Sleep, 2007
jesmonite, pigment,
acrylic paint, modeling
putty, and plastic
9 $^{1}/_{2}$ x 75 x 35 $^{7}/_{8}$ in.
(24.1 x 190.5 x 91.1 cm)
Ovitz Family Collection,
Los Angeles
Courtesy of The Modern
Institute, Glasgow,
and Anton Kern Gallery,
New York

p. 137
Richard Hughes
Love Seat, 2005
fiberglass, polyurethane
foam, dyed clothing,
and bedding
74 x 34 $^{5}/_{16}$ x 34 in.
(188 x 87.2 x 86.4 cm)
Courtesy of The Modern
Institute, Glasgow,
and Anton Kern Gallery,
New York

pp. 140–143
Mike Kelley
Kandors (installation
views, Jablonka Galerie,
Berlin, Sept. 29–Dec. 12,
2007), 2007
Courtesy of Jablonka
Galerie, Cologne/Berlin
Photo: Fredrik Nilsen

pp. 146–147
Friedrich Kunath
Untitled, 2006
chromogenic print
13 $^{3}/_{4}$ x 20 $^{1}/_{16}$ in
(34.9 x 51 cm)
Courtesy of BQ, Cologne;
Blum & Poe, Los Angeles;
and Andrea Rosen
Gallery, New York
Photo: Studio Schaub,
Cologne

p. 148
Friedrich Kunath
Untitled, 2006
watercolor on canvas
32 $^{11}/_{16}$ x 25 $^{5}/_{8}$ in.
(83 x 65.1 cm)
Courtesy of BQ, Cologne;
Blum & Poe, Los Angeles;
and Andrea Rosen
Gallery, New York
Photo: Studio Schaub,
Cologne

p. 149
Friedrich Kunath
Untitled, 2006
mixed media on canvas
41 $^{5}/_{16}$ x 53 $^{3}/_{16}$ in.
(106.3 x 135.1 cm)
Courtesy of BQ, Cologne;
Blum & Poe, Los Angeles;
and Andrea Rosen
Gallery, New York
Photo: Studio Schaub,
Cologne

p. 152
Maria Lassnig
Du oder Ich (You or Me), 2005
oil on canvas
81 1/2 x 60 5/8 in.
(207 x 154 cm)
Courtesy of Friedrich Petzel Gallery, New York
Photo: Larry Lamay

p. 153
Maria Lassnig
Der Tod und das Mädchen (Death and the Girl), 1999
oil on canvas
78 3/4 x 61 in.
(200 x 154.9 cm)
Courtesy of Friedrich Petzel Gallery, New York
Photo: Larry Lamay

p. 154
Maria Lassnig
Untitled (horizontally on two crutches), 2005
oil on canvas
49 1/4 x 39 3/8 in.
(125.1 x 100 cm)
Courtesy of Friedrich Petzel Gallery, New York
Photo: Larry Lamay

p. 155
Maria Lassnig
Untitled (one crutch), 2005
oil on canvas
49 1/4 x 39 3/8 in.
(125.1 x 100 cm)
Courtesy of Friedrich Petzel Gallery, New York
Photo: Larry Lamay

pp. 158–159
Sharon Lockhart
Pine Flat (film still), 2005
16mm; color, sound
138 min.
Carnegie Museum of Art, Pittsburgh, The Henry L. Hillman Fund
Courtesy of Blum & Poe, Los Angeles; Gladstone Gallery, New York; and neugerriemschneider, Berlin

p. 160
Sharon Lockhart
Pine Flat Portrait Studio, Meleah, Travis (Travis), 2005
chromogenic print
artist proofs 2; edition of 6
45 1/2 x 36 11/16 in.
(115.6 x 93.2 cm)
Carnegie Museum of Art, Pittsburgh, The Henry L. Hillman Fund
Courtesy of Blum & Poe, Los Angeles; Gladstone Gallery, New York; and neugerriemschneider, Berlin

p. 161
Sharon Lockhart
Pine Flat Portrait Studio, Meleah, Travis (Meleah), 2005
chromogenic print
artist proofs 2; edition of 6
45 1/2 x 36 11/16 in.
(115.6 x 93.2 cm)
Carnegie Museum of Art, Pittsburgh, The Henry L. Hillman Fund
Courtesy of Blum & Poe, Los Angeles; Gladstone Gallery, New York; and neugerriemschneider, Berlin

pp. 164–165
Mark Manders
Finished Sentence, 1998–2006
iron, ceramic, teabags, and offset print on paper
132 1/4 x 72 13/16 x 33 1/2 in.
(336 x 185 x 85 cm)
Courtesy of the Art Gallery of Ontario, Toronto

p. 166
Mark Manders
Unfired Clay Figure, 2005–2006
iron chairs, painted epoxy, wood, and various materials
59 1/16 x 118 1/8 x 88 9/16 in.
(150 x 300 x 225 cm)
Dakis Joannou Collection, Athens

p. 167
Mark Manders
A Place Where My Thoughts Are Frozen Together, 2001
painted porcelain, painted epoxy, and sugar cube
17 5/16 x 6 5/16 x 2 9/16 in.
(44 x 16 x 6.5 cm)
Courtesy of Zeno X Gallery, Antwerp

pp. 170–172 and 173, top
Barry McGee
One More Thing, 2005
(installation views, Deitch Projects, New York, May 7–Aug. 13, 2005), 2005
Courtesy of Deitch Projects, New York
Photo: Tom Powel Imaging

p. 173, bottom
Barry McGee
Advanced Mature Work
(installation view, REDCAT, Los Angeles, Sept. 14–Nov. 25, 2007), 2007
Courtesy of REDCAT, Los Angeles, and Deitch Projects, New York
Photo: Tom Powel imaging

pp. 176–178
Mario Merz
Cervo (installation views, San Casciano, Tuscany), 1997
stuffed deer and neon
dimensions variable
Courtesy of Gladstone Gallery, New York

p. 179
Mario Merz
Fibonacci Igloo, 1972
metal structure with stuffed fabric, iron wire, and neon numbers
39 3/8 x diam. 78 3/4 in.
(100 x diam. 200 cm)
Carnegie Museum of Art, Pittsburgh, on extended loan from the Jill and Peter Kraus Collection
Courtesy of Gladstone Gallery, New York

pp. 182–183
Marisa Merz
Untitled (Living Sculpture), 1966
strips of aluminum
dimensions variable
Courtesy of Gladstone Gallery, New York
© Marisa Merz

p. 184
Marisa Merz
Tête rose, 1989
polychrome clay
dimensions variable
Courtesy of Gladstone Gallery, New York
© Marisa Merz

p. 185
Marisa Merz
Tête et pièce de bois, 1982
polychrome clay and wood
dimensions variable
Courtesy of Gladstone Gallery, New York
© Marisa Merz

p. 201
Selected photos from Matthew Monahan, "Dog Ears," in *Matthew Monahan: Five Years, Ten Years, Maybe Never*, exhibition catalogue (Los Angeles: Museum of Contemporary Art, 2007)
Photos: Joshua White and Matthew Monahan

p. 209
Toussaint L'Ouverture, 1743–1803. British Library Board. All Rights Reserved (79/0775 DSC)

pp. 219–230
Paul Thek, "96 Sacraments" [Lufthansa notebook], c. 1975
The Estate of George Paul Thek
Courtesy of Alexander and Bonin, New York

p. 242
Matthew Monahan
Alchemy of Pain (detail),
2006–2007
foam, wax, pigment,
metal leaf, paper, glass,
and drywall
67 x 60 x 41 ½ in.
(170 x 152 x 105.4 cm)
Courtesy of Anton Kern
Gallery, New York, and
Stuart Shave/Modern
Art, London

p. 243
Matthew Monahan
Focus exhibition (instal-
lation view, Museum of
Contemporary Art, Los
Angeles, Jul. 26–Oct. 29,
2007), 2007
Courtesy of Anton Kern
Gallery, New York, and
Stuart Shave/Modern
Art, London

p. 244
Matthew Monahan
Untitled, 2006
drywall, paper, acrylic,
wood, plastic, metal,
and beeswax
73 x 16 x 16 in.
(185.4 x 40.6 x 40.6 cm)
Courtesy of Anton Kern
Gallery, New York, and
Stuart Shave/Modern
Art, London

p. 245
Matthew Monahan
Twilight of the Idiots,
1994/2005
floral foam, beeswax,
encaustic, pigment,
quartz, studs, tape, foam,
charcoal on paper, metal,
wood, glass, and drywall
72 x 34 x 97 in.
(182.8 x 86.4 x 246.4 cm)
Courtesy of Anton Kern
Gallery, New York, and
Stuart Shave/Modern
Art, London

pp. 248–249
Rivane Neuenschwander
Secondary Stories
(installation view, Tanya
Bonakdar Gallery, Sept.
7–Oct. 14, 2006), 2006
mixed media
dimensions variable
Courtesy of the artist and
Tanya Bonakdar Gallery,
New York

pp. 250–251
Rivane Neuenschwander
*Quarta-Feira de Cinzas/
Epilogue*, 2006
project in collaboration
with Cao Guimarães
DVD projection
artist proofs 2; edition of 8
5 min. 45 sec.
Courtesy of the artist;
Stephen Friedman
Gallery, London; Galeria
Fortes Vilaça, São Paulo;
and Tanya Bonakdar
Gallery, New York

p. 254
Noguchi Rika
The Sun #1, 2005; *#12,
#10, #13, #5, #14*, 2006
chromogenic prints
17 ¹³/₁₆ x 25 ¹¹/₁₆ in.
(45 x 65.3 cm) each
Courtesy of the artist
and D'Amelio Terras,
New York

p. 255
Noguchi Rika
*The Sun #9, #3, #17,
#4, #2, #11*, 2006
chromogenic prints
17 ¹³/₁₆ x 25 ¹¹/₁₆ in.
(45 x 65 cm) each
Courtesy of the artist
and D'Amelio Terras,
New York

pp. 256–257
Noguchi Rika
The Sun #15, 2006
chromogenic print
17 ¹³/₁₆ x 25 ¹¹/₁₆ in.
(45 x 65 cm)
Courtesy of the artist
and D'Amelio Terras,
New York

p. 260
Manfred Pernice
Parkdose, 2000/2001
concrete and wood
161 ⁷/₁₆ x diam. 90 ⁹/₁₆ in.
(410 x diam. 230 cm)
Courtesy of Anton Kern
Gallery, New York, and
Galerie Neu, Berlin

pp. 261, top, and 262
Manfred Pernice
Untitled, 2008
Courtesy of Anton Kern
Gallery, New York, and
Galerie Neu, Berlin
Photo: Sibilla Calzolari

p. 261, bottom
Manfred Pernice
Fritz Heckert-tub, 2005
concrete, ceramics,
wood, panel with
photocopies
tub:
51 ³/₁₆ x 37 ³/₈ x 12 ³/₁₆ in.
(130 x 94.9 x 31 cm)
panel:
34 ⁷/₁₆ x 80 ⅛ in.
(87.5 x 203.5 cm)
Courtesy of Anton Kern
Gallery, New York, and
Galerie Neu, Berlin
Photo: Günter Lepkowski

p. 263
Manfred Pernice
jubiläum, 2005
ceramics, bottles, plastic,
flowers, 2 buckets
(concrete, paint), carpet,
and table (wood, metal)
31 ⁷/₈ x 26 x 24 ³/₈ in.
(81 x 66 x 61.9 cm)
Courtesy of Anton Kern
Gallery, New York, and
Galerie Neu, Berlin
Photo: Günter Lepkowski

pp. 266–267
Susan Philipsz
The Lost Reflection
(installation view, Skulptur
Projekte Münster, April
2007), 2007
sound installation
2 min. 10 sec.
Courtesy of the artist and
Tanya Bonakdar Gallery,
New York
Photo: Susan Philipsz

p. 268
Susan Philipsz in the
recording studio for
The Lost Reflection,
Berlin, April 2007
Photo: Heinrich Hermes,
Berlin

p. 269
Susan Philipsz
The Dead (installation
view, Ikon Off-site
Project, UGC Cinema,
Birmingham, England),
2000
35mm film installation
21 min.
Courtesy of the artist
and Tanya Bonakdar
Gallery, New York
Photo: Gary Kirkham

pp. 272–273
Wilhelm Sasnal
Untitled, 2007
oil on canvas
21 ³/₄ x 27 ¹/₂ in.
(55.3 x 69.9 cm)
Courtesy of Anton Kern
Gallery, New York, and
Galeria Foksal, Warsaw

p. 274
Wilhelm Sasnal
Untitled, 2006
oil on canvas
62 ³/₄ x 78 ³/₄ in.
(159.4 x 200 cm)
Courtesy of Anton Kern
Gallery, New York, and
Galeria Foksal, Warsaw

p. 275
Wilhelm Sasnal
Untitled, 2007
oil on canvas
21 ³/₄ x 27 ¹/₂ in.
(55.2 x 70 cm)
Courtesy of Anton Kern
Gallery, New York, and
Galeria Foksal, Warsaw

p. 278
Thomas Schütte
Zombie V, 2007
patinated bronze
31 ⁷/₈ x 41 ⁵/₁₆ x 49 ³/₁₆ in.
(81 x 104.9 x 125 cm)
Courtesy of Galerie
Nelson-Freeman, Paris
Photo: Florian Kleinefenn

p. 279
Thomas Schütte
Zombie VI, 2007
aluminum
24 ⁷/₁₆ x 29 ¹/₂ x 42 ¹⁵/₁₆ in.
(62.1 x 74.9 x 109.1 cm)
Portalakis Collection,
Greece
Courtesy of Galerie
Nelson-Freeman, Paris
Photo: Florian Kleinefenn

p. 280
Thomas Schütte
Apple 5, 2007
watercolor on paper
15 ⅛ x 11 ¼ in.
(38.4 x 28.6 cm)
Private collection,
Geneva
Courtesy of Galerie
Nelson-Freeman, Paris
Photo: Florian Kleinefenn

p. 281
Thomas Schütte
divorce houses, 2007
watercolor and ink on
paper
15 1/8 x 11 1/4 in.
(38.4 x 28.6 cm)
Anonymous collection
Courtesy of Galerie
Nelson-Freeman, Paris
Photo: Florian Kleinefenn

pp. 284–287
Ranjani Shettar
Just a bit more (details
of installation at 2006
Biennale of Sydney),
2006
hand-molded beeswax,
pigments, and thread
dyed in tea
432 x 288 x 144 in.
(1097.3 x 731.5 x 365.8 cm)
Courtesy of Talwar
Gallery, New York/New
Delhi

p. 290
David Shrigley
Untitled, 2007
ink on paper
16 1/2 x 11 3/4 in.
(41.9 x 29.9 cm)
Courtesy of the artist;
Stephen Friedman
Gallery, London; Galleri
Nicolai Wallner, Copen-
hagen; Yvon Lambert,
Paris; Anton Kern Gallery,
New York; BQ, Cologne;
and Galerie Francesca
Pia, Zürich

p. 291
David Shrigley
Untitled, 2007
ink on paper
16 1/2 x 11 3/4 in.
(41.9 x 29.9 cm)
Courtesy of the artist;
Stephen Friedman
Gallery, London; Galleri
Nicolai Wallner, Copen-
hagen; Yvon Lambert,
Paris; Anton Kern Gallery,
New York; BQ, Cologne;
and Galerie Francesca
Pia, Zürich

p. 292
David Shrigley
Untitled, 2007
ink on paper
16 1/2 x 11 3/4 in.
(41.9 x 29.9 cm)
Courtesy of the artist;
Stephen Friedman
Gallery, London; Galleri
Nicolai Wallner, Copen-
hagen; Yvon Lambert,
Paris; Anton Kern Gallery,
New York; BQ, Cologne;
and Galerie Francesca
Pia, Zürich

p. 293
David Shrigley
I'm Dead, 2007
taxidermy kitten with
wood sign and acrylic
paint
overall:
37 x 20 x 20 in.
(94 x 50.8 x 50.8 cm)
kitten and sign:
23 1/2 x 5 1/2 x 9 3/4 in.
(59.7 x 14 x 24.8 cm)
Courtesy of the artist
and the David Roberts
Collection
Courtesy of the artist;
Stephen Friedman
Gallery, London; Galleri
Nicolai Wallner, Copen-
hagen; Yvon Lambert,
Paris; Anton Kern Gallery,
New York; BQ, Cologne;
and Galerie Francesca
Pia, Zürich

pp. 296–297, 299
Paul Sietsema
Figure 3 (film stills), 2008
16mm film
25 min. approx,
Courtesy of Regen
Projects, Los Angeles

p. 298
Paul Sietsema
The Copyist, 2005
gouache, watercolor,
and glue on paper
22 1/4 x 16 7/8 in.
(56.5 x 42.9 cm)
Carnegie Museum of Art,
Pittsburgh, Second
Century Acquisition Fund

pp. 302–303
Rudolf Stingel
Untitled, 2007
acrylic on canvas,
triptych
installed size:
132 1/4 x 325 1/2 x 2 in.
(335.9 x 826.8 x 5.1 cm)
each canvas:
132 1/4 x 102 3/4 x 2 in.
(335.9 x 261 x 5.1 cm)
Courtesy of Sadies Coles
HQ, London
© Rudolf Stingel

p. 304
Rudolf Stingel
Untitled (after Sam),
2005–2006
oil on canvas
132 x 180 in.
(335.3 x 457.2 cm)
Whitney Museum of
American Art, New York,
Purchase, with funds
from the Painting and
Sculpture Committee
Photo: Tom Powel

p. 305
Rudolf Stingel
Untitled (after Sam), 2006
oil on canvas
132 x 180 in.
(335.3 x 457.2 cm)
Whitney Museum of
American Art, New York,
Purchase, with funds
from the Painting and
Sculpture Committee
Photo: Tom Powel

pp. 308–309
Katja Strunz
Einladung zur Angst
(Invitation to fear)
(installation view), 2005
various metals, iron door,
and iron chain
dimensions variable
Sculptures
d'Appartement, Musée
Départemental d'Art
Contemporain de
Rochechouart, 2005
Courtesy of the artist
and Gavin Brown's
enterprise, New York

pp. 310–311
Katja Strunz
whose garden was this
(installation view, Gavin
Brown's enterprise,
New York), 2006
mixed media
dimensions variable
Courtesy of the artist
and Gavin Brown's
enterprise, New York

pp. 314–315
Paul Thek
Untitled (Earth Drawing I),
c. 1974
acrylic on 4 sheets of
newspaper
44 x 66 in.
(111.8 x 167.6 cm)
Collection of Robert Wilson
Courtesy of Alexander
and Bonin, New York

p. 316, top
Paul Thek
2 Birds, 1975
oil paint on newspaper
22 3/4 x 33 in.
(57.8 x 83.8 cm)
Walker Art Center,
Minneapolis, Justin
Smith Purchase Fund
Photo: Orcutt & Van
Der Putten

p. 316, bottom
Paul Thek
*Uncle Tom's Cabin in
Flames*, 1975
acrylic on newspaper
23 x 29 in.
(58.4 x 73.7 cm)
Collection Weil, Gotshal
& Manges, New York

p. 317, top
Paul Thek
Dinosaur (Unfinished),
1975
acrylic on newspaper
22 3/4 x 33 1/4 in.
(57.8 x 84.5 cm)
Collection of Susan and
Rob White, Wayzata,
Minnesota
Photo: Bill Orcutt

p. 317, bottom
Paul Thek
*Man by Red Sea,
Contemplating*, 1975
acrylic on newspaper
22 3/4 x 33 in.
(58 x 84 cm)
Collection of Mimi Haas,
San Francisco
Photo: D. James Dee

pp. 320–321
Wolfgang Tillmans
paper drop (Berlin), 2007
chromogenic print
12 x 16 in.
(30.5 x 40.6 cm)
Courtesy of Andrea
Rosen Gallery, New York
© Wolfgang Tillmans

p. 322
Wolfgang Tillmans
flower, 2006
chromogenic print
artist proof 1; edition of 1
83 ⁷/₈ x 57 ¹/₈ in.
(213 x 145.1 cm)
Carnegie Museum of Art,
Pittsburgh, The Henry L.
Hillman Fund
Courtesy of Andrea
Rosen Gallery, New York
© Wolfgang Tillmans
Photo: Christopher Burke

p. 323
Wolfgang Tillmans
Victoria Park, 2007
chromogenic print
artist proof 1; edition of 1
71 ⁵/₁₆ x 98 ¹/₂ in.
(181.1 x 250.2 cm)
Courtesy of the artist and
Andrea Rosen Gallery,
New York
© Wolfgang Tillmans
Photo: Christopher Burke

pp. 326–327
Rosemarie Trockel
*Country Life, New Ceram-
ics and Pottery* exhibition
(installation view, Glad-
stone Gallery, New York,
Oct. 21–Nov. 25, 2006),
2006
ceramics and platinum
grater 1:
102 ¹/₂ x 77 x 2 ¹/₂ in.
(260.4 x 195.6 x 6.4 cm)
pot 2:
13 ¹/₂ x diam. 10 ¹/₂ in.
(34.3 x diam. 26.7 cm)
pot 3:
13 ¹/₂ x diam. 11 in.
(34.3 x diam. 27.9 cm)
pot 4:
10 ¹/₂ x diam. 11 in.
(26.7 x diam. 27.9 cm)
pot 5:
12 x diam. 14 in.
(30.5 x diam. 35.6 cm)
pot 6:
11 x diam. 17 ¹/₂ in.
(27.9 x diam. 44.5 cm)
Courtesy of Gladstone
Gallery, New York, and
Monika Sprüth/Philomene
Magers, Cologne/
Munich/London
© 2006 Rosemarie Trockel
Photo: David Regen

pp. 328–329
Rosemarie Trockel
*Watching and Sleeping
and Composing*, 2007
steel, wood, and glazed
ceramics
26 ¹/₄ x 80 ³/₈ x 50 ¹/₂ in.
(66.7 x 204.2 x 128.3 cm)
Courtesy of Gladstone
Gallery, New York, and
Monika Sprüth/Philomene
Magers, Cologne/
Munich/London
© 2006 Rosemarie Trockel

pp. 332–335
Apichatpong
Weerasethakul
Unknown Forces (video
stills), 2007
4-channel video; color,
sound
duration variable
Courtesy of the artist

pp. 338–339
Andro Wekua
Get out of my room
(installation view, *Andro
Wekua—I'm sorry if I'm
not very funny tonight*,
Kunstmuseum
Winterthur, Jun. 9–Aug.
13, 2006), 2006
wood, wax, hair, fabric,
leather, wax paint, bronze,
and lacquer paint
table:
29 ¹/₂ x 76 ³/₄ x 39 ³/₈ in.
(74.9 x 195.6 x 100 cm)
figure and chair:
45 ¹/₄ x 45 ¹/₄ x 27 ¹⁵/₁₆ in.
(114.9 x 114.9 x 71 cm)
8 silkprints:
12 x 8 ¹/₂ in.
(30.5 x 21.6 cm) each
1 etching:
16 ¹/₂ x 11 ¹³/₁₆ in.
(41.9 x 30 cm)
Courtesy of Gladstone
Gallery, New York, and
Galerie Peter Kilchmann,
Zürich
© Andro Wekua

p. 340
Andro Wekua
My Place, 2006
color pencil, felt pen, and
Tipp-Ex on photocopy
14 ⁵/₈ x 11 ¹/₄ in.
(37.2 x 28.6 cm)
Courtesy of Gladstone
Gallery, New York, and
Galerie Peter Kilchmann,
Zürich
© Andro Wekua

p. 341
Andro Wekua
Without Mirror, 2005
collage, graphite, color
pencil, and felt pen on
photocopy
12 ¹/₈ x 8 ⁷/₈ in.
(30.8 x 22.5 cm)
Courtesy of Gladstone
Gallery, New York, and
Galerie Peter Kilchmann,
Zürich
© Andro Wekua

p. 344
Richard Wright
No Title (installation view,
Richard Wright, Museum
of Contemporary Art San
Diego, Downtown, Jan.
21–Sept. 23, 2007), 2006
gold leaf on glass
dimensions variable
Courtesy of the artist and
The Modern Institute/
Toby Webster Ltd.,
Glasgow

p. 345
Richard Wright
No Title (installation view,
*Strange I've Seen That
Face Before*, Städtisches
Museum Abteiberg,
Mönchengladbach,
Germany, May 7–Sept. 7,
2006), 2006
acrylic on wall
dimensions variable
Courtesy of the artist and
The Modern Institute/
Toby Webster Ltd.,
Glasgow

pp. 346–347
Richard Wright
No Title (installation
views, *Jardins Publics*,
26 London Street,
Edinburgh International
Festival, 2007), 2007
acrylic on wall
dimensions variable
Courtesy of the artist and
The Modern Institute/
Toby Webster Ltd.,
Glasgow

pp. 350–352
Haegue Yang
Sadong 30 (installation
views, Inch'ŏn, South
Korea), 2006
origami objects, various
lights, ventilator, drying
rack sculpture, plants,
wood bench, drinking
water, etc.
dimensions variable
Courtesy of the artist
and Galerie Barbara
Wien, Berlin
Photo: © Daenam Kim

p. 353
Haegue Yang
Blind Room (installation
views, *Brave New Worlds*,
Walker Art Center,
Minneapolis, Oct. 4,
2007–Feb. 17, 2008),
2006–2007
mixed media: lightbulbs,
stands, electrical cords,
and window blinds
dimensions variable
Courtesy of the artist
and Walker Art Center,
Minneapolis
Photo: Gene Pittman

p. 359
Jørgen Leth
The Perfect Human
(film stills), 1967
film; black and white,
sound
12 min.
Courtesy of the Danish
Film Institute, Copenhagen

pp. 379–391
Ryan Gander, "Loose
Associations Lecture," in
Ryan Gander and Stuart
Bailey, *Appendix* (Amster-
dam: Artimo, 2003).
Reprinted with permission
of the artist.

p. 393, top, left and right
center, left
bottom, left and right
Paul Chan, *Waiting for
Godot in New Orleans*,
2007
Photos: Tuyen Nguyen

p. 393, center, right
*Waiting for Godot in New
Orleans*, rehearsal, Gentilly
neighborhood, 9th Ward,
New Orleans, Nov. 28, 2007
Photo: Lee Celano/*The
New York Times*/Redux

Catalogue Contributors and Exhibition Designers

Douglas Fogle, curator of the 55th *Carnegie International*, has been curator of contemporary art at Carnegie Museum of Art since 2005. In this capacity, he has organized exhibitions in the museum's Forum Gallery featuring the work of Luisa Lambri, Ernesto Neto, Phil Collins, Rivane Neuenschwander, and Lowry Burgess. From 1994 to 2005, Fogle was on the curatorial staff of the Walker Art Center in Minneapolis. At the Walker, he initiated a series of exhibitions with emerging artists, solo exhibitions with Catherine Opie and Julie Mehretu, and a number of group exhibitions, including *Stills: Emerging Photography in the 1990s* (1997); *Painting at the Edge of the World* (2001, cat.); *The Last Picture Show: Artists Using Photography, 1960–1982* (2003– 2004, cat.); and *Andy Warhol/Supernova: Stars, Deaths, and Disasters, 1962–1964* (2005, cat.). Fogle's 2007 publications include: "Loving the Alien," in Stephan Berg, ed., *The Absence of Mark Manders*; "Denied Parole: Douglas Fogle on the Art of Ryan Gander," *Artforum*; and "Learning from Lascaux," in Katrina M. Brown, ed., *Richard Wright*.

Heather Pesanti is assistant curator of contemporary art at Carnegie Museum of Art. In addition to her involvement in the 2008 *Carnegie International*, she participated in the reinstallation of the museum's permanent collection and organized Forum Gallery exhibitions on artists Jonathan Borofsky and Rivane Neuenschwander. In 2008, Pesanti was guest curator for *Illustrations of Catastrophe and Remote Times* at the Mattress Factory in Pittsburgh. She is adjunct professor at Carnegie Mellon University's School of Art and a member of Pittsburgh's Cultural District Design Committee. Pesanti came to Pittsburgh from the Museum of Contemporary Art, Chicago, where she was the 2005 Marjorie Susman Curatorial Fellow and was responsible for organizing two installments in the museum's ongoing emerging artists series, *12x12: New Artists, New Work*.

Max Andrews is a curator and writer based in Barcelona, Spain. He is one half of the curatorial

office Latitudes (www.LTTDS.org), whose projects include the exhibitions *Greenwashing. Environment: Perils, Promises, and Perplexities*, Fondazione Sandretto Re Rebaudengo, Turin (2008); *Extraordinary Rendition*, Nogueras Blanchard, Barcelona (2007); the publication *LAND, ART: A Cultural Ecology Handbook* (2006); and the symposium for the 8th Sharjah Biennial, United Arab Emirates (2007). He was a curatorial fellow at the Walker Art Center, Minneapolis (2003–2004), and special projects curatorial assistant to the director, Tate Collection, London (2004–2005). He is a regular writer for *Frieze* and has contributed to books such as *Henrik Håkansson* (2005) and *Day for Night: Whitney Biennial 2006* (2006).

Daniel Birnbaum, a native of Sweden, is director of the Städelschule Art Academy and its exhibition space, Portikus, a leading center for experimental art in Frankfurt am Main. He is the founder (with Isabelle Graw) of the Institut für Kunstkritik and a member of the board of Frankfurt's Institut für Sozialforschung. He was cocurator of the 2003 Venice Biennale and of the first Moscow Biennale of Contemporary Art in 2005. An associate curator of Magasin 3, Stockholm Konstall, he is also the author of many books on art and philosophy, including *Production* (2000), a collaboration with artist Carsten Höller, and most recently, *Chronology* (2007). He is the cocurator, together with Hans Ulrich Obrist and Gunnar B. Kvaran, of *Uncertain States of America*, an exhibition of emerging American artists, with venues in London, Moscow, and Prague. Together with Christine Macel, Birnbaum was the curator of *Airs de Paris* at the Centre Georges Pompidou, Paris, an exhibition that celebrated the institution's 30th anniversary in 2007.

Karin Campbell joined the staff of Carnegie Museum of Art in 2006 and soon thereafter became departmental assistant in the contemporary art department. Prior to her appointment and while earning a bachelor's degree in art history and political science at College of the Holy Cross in Worcester, Massachusetts,

she was an intern in the museum's education department. Her other museum experiences include an internship in the external affairs department at the Hirshhorn Museum and Sculpture Garden, in Washington, DC.

Richard Flood is chief curator at the New Museum, New York. He, along with Massimiliano Gioni and Laura Hoptman, is the curator of the New Museum's inaugural exhibition *Unmonumental* (2007, cat.) at its new site on the Bowery. Flood is currently coordinating the exhibition *Double Album: Daniel Guzmán and Steven Shearer* (2008, cat.). Prior to his 2005 appointment at the New Museum, Flood was chief curator at the Walker Art Center, Minneapolis. During his eleven years at the Walker, Flood organized a wide range of shows, including the group exhibitions *Brilliant! New Art from London* (1995, cat.) and *Zero to Infinity: Arte Povera 1962–1972* (2002, cat.), and solo exhibitions for the work of Robert Gober, Sigmar Polke, and Matthew Barney. Flood was previously curator of P.S. 1 Contemporary Art Center, director of the Gladstone Gallery, and managing editor of *Artforum* magazine.

Eungie Joo is director and curator of education and public programs at the New Museum, New York. She joined the New Museum in 2007, and was previously director and curator at REDCAT, Los Angeles. Her projects there included *Unknown Forces: Apichatpong Weerasethakul* (2007); *Damián Ortega: The Beetle Trilogy and Other Works* (2005–2006 cat.); *Kara E. Walker's Song of the South* (2005, cat.); *Margaret Kilgallen: In the Sweet Bye & Bye* (2005, cat.); and *Taro Shinoda: Buried Treasure* (2004, cat.). Joo was cofounder of Six Months: Crenshaw (2003), a temporary site for exhibition, performance, and collectivity through dialogue and critique. She has published essays on Edgar Arceneaux, Mark Bradford, Sora Kim, Barry McGee, Rigo 23, Lorna Simpson, and Yin Xiuzhen. In 2007, Joo received the Walter Hopps Award for Curatorial Achievement.

Chus Martínez is director of the Frankfurter Kunstverein, a contemporary art center in Frankfurt am Main, Germany. Since her appointment in 2006, she has presented the exhibitions *Esra Ersen, Wilhelm Sasnal*, and *Arturas Raila*. From 2002 to 2005, Martínez was artistic director at Sala Rekalde, a contemporary art exhibition space in Bilbao, Spain. In 2005, Martínez served as curator for *Gravy Planet*, the National Pavilion of Cyprus, at the 51st Venice Biennale. Her earlier curatorial roles included the Barcelona project space of Fundació "la Caixa," where she organized *Lowest Common Denominator*, a

series of five projects that included *Dora García* (Spain), *Begoña Muñoz* (Spain), *Oriol Font* (Spain), *Elmgreen & Dragset* (Denmark/Norway), and *Tobias Rehberger* (Germany). A lecturer at the Royal College of Art, London, the National Academy of the Arts, Oslo, and HISK (Higher Institute of Fine Arts), Antwerp, Martínez is also an art critic and writer for *Afterall*. Her publications include an essay on Jennifer and Kevin McCoy for the British Film Institute.

COMA is Cornelia Blatter and Marcel Hermans. The team maintains studios in Amsterdam and New York. COMA conceptualizes, art directs, designs, and produces various work from print to the Internet to installations. COMA collaborations include the creative direction and graphic design of Vitra's *Workspirit 10; Frame* magazine; the Dutch 2006 children's postage stamp; the exhibition catalogue and font design for *Design Life Now*, the Cooper-Hewitt's National Design Triennial, in which their work was also shown; and monographs on Dutch product designer Hella Jongerius (Phaidon), Sigmar Polke (MoMA), Marilyn Minter (G. Miller), and architect Bernard Tschumi (Architectural Biennial Venice). Winners of multiple AIGA 50 Books/50 Covers and I.D. Annual Design Reviews, they have also been nominated for the Rotterdam and Swiss Design Prize. COMA serve as critics at the Yale University School of Art and give workshops internationally.

The work of the Los Angeles–based architectural practice Escher GuneWardena addresses sustainability, affordability, and the dialogue between form and construction. Published internationally, the firm was represented in *OPEN HOUSE: Intelligent Living by Design (the future house and digital technologies)*, organized by the Vitra Design Museum, Weil am Rhein, Germany, and the Art Center College of Design, Pasadena, in 2006. Winner of the Dwell Home II competition in 2004, Escher GuneWardena was included in the 2003 Cooper-Hewitt National Design Triennial, New York. The firm's interest in contemporary art has led to various collaborations with artists, including installations for Sharon Lockhart, Olafur Eliasson, and Mike Kelley. Current projects include exhibition designs for *Living Flowers: Ikebana and Contemporary Art*, Japanese American National Museum, Los Angeles, and *Between Earth and Heaven: The Architecture of John Lautner*, UCLA Hammer Museum, Los Angeles, cocurated by Frank Escher and Nicholas Olsberg.

Acknowledgments

Douglas Fogle
Curator

A project of the size and scope of the *Carnegie International* would be impossible without the enlightened support of many individuals and organizations in Pittsburgh and around the world. The ongoing and beneficent help of the A. W. Mellon Charitable and Educational Fund, The Henry L. Hillman Fund, and most recently, The Fine Foundation and the Jill and Peter Kraus Endowment for Contemporary Art enable Carnegie Museum of Art to undertake this exhibition. We are grateful to The Andy Warhol Foundation for the Visual Arts, Highmark Blue Cross Blue Shield, Bayer Corporation, the Henry L. Hillman Foundation, the Juliet Lea Hillman Simonds Foundation, the Kraus Family Foundation, the Dimitris Daskalopoulos Collection, Greece, The Fellows of Carnegie Museum of Art, The Pittsburgh Foundation, and the Woodmere Foundation for generously supporting the 55th *Carnegie International*. We also thank Heika Burnison, The Morby Family Charitable Foundation, William I. and Patricia S. Snyder, the Alexander C. & Tillie S. Speyer Foundation, the Buncher Family Foundation, the National Endowment for the Arts, Sibyl Fine King, The Associates of Carnegie Museum of Art, the Beal Publication Fund, the Dedalus Foundation, The Grable Foundation, the Harpo Foundation, and the Trust for Mutual Understanding for generous contributions.

Among our many allies and supporters, Jill and Peter Kraus and Sheila and Milton Fine must be singled out for their ongoing dedication to the *International*'s past, present, and future incarnations. Rarely does one find individuals so committed to exploring the new as they have proven themselves to be. I am deeply indebted to them for their belief in this exhibition. Additionally, as cochairs of the Friends of the *Carnegie International*, along with Maja Oeri and Hans Bodenmann, they have assembled an impressive group of more than one hundred contemporary art aficionados and collectors from all over the world who have graciously assisted in the realization of this exhibition; their names are cited on page 433.

The Carnegie *International* is an ambitious undertaking and would have been impossible without the extraordinary commitment of the entire staff

of Carnegie Museum of Art. Thanks must go first to Richard Armstrong, the Henry J. Heinz II Director of the museum and curator of the 1995 *Carnegie International,* for his unswerving belief in this project as well as his invaluable collegial contributions to the organization of this 55th incarnation of the *Carnegie International.* I am indebted to Richard for inviting me to undertake this time-honored exhibition, for his constant encouragement, and for his inspiring belief in the power of art to make us see the world from different points of view. As director, Richard is ably assisted by Lynn Corbett.

Alongside Richard, Marcia Gumberg and Bill Hunt, the former and current chairs of Carnegie Museum of Art's Board, have demonstrated an unfailing commitment to this exhibition. I also want to extend my gratitude to Maureen Rolla, deputy director, for her ongoing encouragement and sage advice regarding the practical issues of making our vision for *Life on Mars* a reality. She was assisted in this effort by Sara DeRoy.

Under the direction of Christopher Rauhoff, the coordination of Heather Ernharth, and the supervision of Chris Craychee, the exhibitions department staff, consisting of Craig Barron, Rob Capaldi, James Dugas, James Hawk, Eric Jensen, and Dale Luce, and all other members of the workshop crew were responsible for the physical realization of the exhibition. They, along with Edgar Um, technology consultant, deserve our thanks and recognition for the exemplary execution of the show's installation.

Led by Monika Tomko, the registrars' office, including Elizabeth Hansen, Allison Revello, Elizabeth Tufts-Brown, and Stacy Kirk, meticulously organized the complex details of shipping and handling the artworks. Conservators Ellen Baxter, Chantal Bernicky, and Michael Belman safeguarded the condition and care of the objects in the show.

Marilyn Russell, curator and chair of the education department, along with Lucy Stewart, Jordan Crosby, and the entire education department staff, created and implemented a series of exciting programs to engage visitors to *Life on Mars.* Thanks are due also to Arlene Sanderson and her dedicated publications staff, Norene Walworth, Melinda Harkiewicz, and Laurel Mitchell, who brought the catalogue and the printed matter to completion with great élan. Editor Michelle Piranio brought clarity and nuanced expressiveness to the text, while Richard G. Gallin was the discerning proofreader. Photographer Tom Little, the imaging staff, and Bill Devlin, of the museum's technology department, were instrumental in the creation, editing, and coordination of images for this catalogue.

Douglas Fogle

Thanks go also to Renée Pekor, director of development, along with
Emily Henry, for their unflagging efforts in making this exhibition financially
solvent, and to Kitty Julian, director of marketing, Tey Stiteler, assistant
director, Leigh Kish, communications specialist, and Heather Jarrett,
departmental assistant. The New York firm of Jeanne Collins & Associ-
ates served as our national public relations consultant. Will Real, director
of technology initiatives, oversaw the myriad details of the design and
maintenance of the *International*'s web site, which was designed by
Wall-to-Wall in Pittsburgh. The web site is managed by Nick Pozek.

For their unswerving collegial support during the three-year trip to Mars,
my gratitude goes to the museum's curatorial staff: chief curator and
curator of fine arts Lulu Lippincott, along with curatorial colleagues
Jason Busch, Rachel Delphia, Tracy Myers, Raymund Ryan, and Amanda
Zehnder. Our industrious interns Cristina Albu and Robert Bailey made
important contributions to the production of the catalogue, while Terry
Boyd, Matthew Cummings, and Ryan Woodring assisted during the
installation of the show.

The Women's Committee of Carnegie Museum of Art, specifically Janet
Hunt and Mardi Royston, gala cochairs, and Kitty Hillman, head of The
Associates and Ambassadors groups, planned an elegant and memorable
opening. To all those involved in the opening events, we extend our
sincere appreciation.

We are enormously grateful to the lenders, both public and private, who
made works of art available for the exhibition. Their names are listed on
page 432, and we thank them for allowing a larger public to enjoy the
work of such amazing artists.

Central to the conceptualization of this exhibition were the contributions
of our remarkably synergistic architecture and graphic design colleagues.
Frank Escher and Ravi GuneWardena of EscherGuneWardena Architecture
in Los Angeles were brilliant partners in this endeavor. Their discerning and
insightful exhibition design allowed the artists' work to come to the fore.
Cornelia Blatter and Marcel Hermans of COMA, the New York and Amster-
dam-based graphic design firm, were equally astute and innovative in creat-
ing a graphic identity and catalogue that perfectly match the philosophical
demeanor of the exhibition. I could not have asked for better collaborators.

The *Carnegie International* has a time-honored tradition of enlisting a
group of like-minded advisors from the field as curatorial sounding boards

and wonderfully active consiglieri. I was privileged to be able to include in this group three very dear old friends and one fantastic new friend: Daniel Birnbaum, director, Portikus; Richard Flood, chief curator, New Museum; Eungie Joo, director and curator of education and public programs, New Museum; and Chus Martínez, director, Frankfurter Kunstverein. I am deeply indebted to them for their intellectual curiosity, their wisdom, their joie de vivre, and their significant contributions to this book.

Most important, I would like to extend my deeply felt gratitude to Heather Pesanti, assistant curator of contemporary art, and Karin Campbell, contemporary art departmental assistant, who contributed to every aspect of this exhibition and publication and willingly accompanied me on this trip to Mars. Their dedication, hard work, intelligence, and humor inform this project as a whole. Thanks also go to Max Andrews, who, along with Heather, wrote the artist entries for this catalogue.

Among the many individuals and organizations that helped to facilitate this exhibition, special acknowledgment goes to:

Cristian Alexa at Lombard-Fried Projects, New York; Carolyn Alexander and Ted Bonin at Alexander & Bonin, New York; Paule Anglim, Monica La Staiti, and Eli Ridgway at Gallery Paule Anglim, San Francisco; Michael Auping at the Modern Art Museum, Fort Worth; Cécile Barrault at Galerie Nelson-Freeman, Paris; Karyn Behnke, David McKee, and Renee McKee at McKee Gallery, New York; Neal Benezra and Janet Bishop at San Francisco Museum of Modern Art; Stacy Bengston-Fertig and Shaun Regen at Regen Projects, Los Angeles; Rosalie Benitez, Angela Brazda, Max Falkenstein, and Barbara Gladstone at Gladstone Gallery, New York; Sam Berkowitz; Andrew Blauvelt, Elizabeth Carpenter, Pamela Caserta, Doryun Chong, Lynn Dierks, Barbara Economon, Yasmil Raymond, and Philippe Vergne at Walker Art Center, Minneapolis; Tim Blum, Alexandra Gaty, and Jeffrey Poe at Blum & Poe, Los Angeles; Tanya Bonakdar, James Lavender, and Ethan Sklar at Tanya Bonakdar Gallery, New York; Francesco Bonami; Jörn Bötnagel and Yvonne Quirmbach at BQ, Cologne; Gavin Brown, Corinna Durland, Kelly Taylor, and Lisa Williams at Gavin Brown's enterprise, New York; Katrina Brown; Cornelia Butler at the Museum of Modern Art, New York; Chiara Caroppo and Beatrice Merz at Fondazione Merz, Turin, Italy; John Carson and Hilary Robinson at Carnegie Mellon University; Paul Chan; Pamela Clapp and Joel Wachs at the Andy Warhol Foundation, New York; Michael Clifton, Bridget Finn, Christoph Gerozissis, and Anton Kern at Anton Kern Gallery, New York; Sadie Coles and Pauline Daly at Sadie Coles HQ, London; Harry Cooper

at the National Gallery of Art, Washington, DC; Paula Cooper and Steve Henry at Paula Cooper Gallery, New York; Christopher D'Amelio and Lucien Terras at D'Amelio Terras, New York; Jeffrey Deitch and Susanne Geiss at Deitch Projects, New York; Frank Demaegd at Xeno X Gallery, Antwerp; Stephanie Dorsey, Jeffrey Peabody, and Matthew Marks at Matthew Marks Gallery, New York; Brian Doyle, Lisa Spellman and Mari Spirito at 303 Gallery, New York; Russell Ferguson; João Fernandes at Fundação Serralves, Porto, Portugal; Mark Francis and Kay Pallister at Gagosian Gallery, London; Peter Freeman and Stephanie Theodore at Nelson Gallery, New York; Stephen Friedman, David Hubbard, and Angela Kunicky at Stephen Friedman Gallery, London; Madeleine Grynsztejn at Museum of Contemporary Art, Chicago; Andrew Hamilton, Kath Roper-Caldbeck, and Toby Webster at the Modern Institute, Glasgow; Louise Hayward and Niru Ratnam at STORE Gallery, London; Laura Hoptman at the New Museum, New York; Chrissie Iles and Adam D. Weinberg at the Whitney Museum of American Art; Yoshiko Isshiky; Rafael Jablonka and Christian Schmidt at Jablonka Galerie, Berlin; Thomas Jarek and Eva Presenhuber at Galerie Eva Presenhuber, Zürich; Michael Jenkins and Brent Sikkema at Sikkema Jenkins & Co., New York; Branwen Jones and Andrea Rosen at Andrea Rosen Gallery, New York; Mami Kataoka at the Mori Art Museum, Tokyo, and the Hayward Gallery, London; Clara Kim at REDCAT, Los Angeles; Michael Kohn at Michael Kohn Gallery, Los Angeles; Vasif Kortun; Kris Kuramitsu; Jose Kuri and Monica Manzutto, at kurimanzutto, Mexico City; Denise Luiso and Tom Morello; Jeremy Marusek at Lockhart Studio, Los Angeles; Midori Matsui; George Mavrogeorgis; Bjoern Meyer-Ebrecht at Hirschhorn Studio, Paris; Abaseh Mirvali at La Colección Jumex, Mexico City; Lara and Jack Olsen; Dimitris Paleocrasses; Friedrich Petzel Gallery and Andrea Teschke at Friedrich Petzel Gallery, New York; James Rondeau at the Art Institute of Chicago; Beatrix Ruf and her staff at Kunsthalle Zürich; Lauren Ryan and Allan Schwartzman at Allan Schwartzman, Inc., New York; Ingrid Schaffner; Noah Sherburn at Aitken Studio, Los Angeles; Debra Singer, The Kitchen, New York; Monika Sprüth at Monika Sprüth/Philomene Magers, Cologne/Munich/London; Russ Streiner; Ali Subotnik; Deepak Talwar at Talwar Gallery, New York; Barbara Wien at Galerie Barbara Wien, Berlin; Donald Young at Donald Young Gallery, Chicago; and Heidi Zuckerman Jacobson.

Finally, I would like to extend my sincere gratitude to the forty artists whose work constitutes the heart of *Life on Mars*, the 55th *Carnegie International*. Their vision enables us to see the world anew, and for this, we are all profoundly grateful.

Lenders

Joshua Adler
Alexander and Bonin, New York
Anonymous collection (2)
The Art Institute of Chicago
Johannes and Bernarda Becker
Blum & Poe, Los Angeles
Tanya Bonakdar Gallery, New York
Ted Bonin
BQ, Cologne
Gavin Brown's enterprise, New York
César Cervantes, Mexico City
La Colección Jumex / La Fundación Jumex,
 Mexico City
Collection of Robert Wilson, New York
Collection Weil, Gotshal & Manges, New York
Paula Cooper Gallery, New York
Dallas Museum of Art
D'Amelio Terras, New York
Shirley and Ross Davis
Amalia Dayan and Adam Lindemann
Deitch Projects, New York
de Saisset Museum, Santa Clara, California
Daniel W. Dietrich II
di Rosa Preserve, Napa, California
Frances Dittmer
Ellipse Foundation Contemporary Art Collection,
 Lisbon
Corinne Mueller Flick
Fondazione Merz, Turin
Charlotte and Bill Ford
Galeria Fortes Vilaça, São Paulo
Stephen Friedman Gallery, London
Fundação de Serralves, Museu de Arte
 Contemporânea, Porto, Portugal
Fundacja Galerii Foksal, Warsaw
Gagosian Gallery, New York
Galerie Neu, Berlin
Annet Gelink Gallery, Amsterdam
Gladstone Gallery, New York
Glenstone Museum Foundation, Potomac,
 Maryland
Ann Hatch
Hilary and Peter Hatch
Hauser & Wirth, Zürich/London
Maja Hoffman
Jablonka Galerie, Cologne/Berlin
Kerlin Gallery, Dublin

Anton Kern Gallery, New York
Galerie Peter Kilchmann, Zürich
Paul Köser
The Jill and Peter Kraus Collection, New York
Lombard-Freid Projects, New York
Matthew Marks Gallery, New York
Jennifer McSweeney
Victoria Miro Gallery, London
Modern Art Museum of Fort Worth
The Modern Institute, Glasgow
The Modern Institute/Toby Webster Ltd.,
 Glasgow
Javier and Monica Mora
The Museum of Modern Art, New York
National Gallery of Art, Washington, DC
Galerie Nelson-Freeman, Paris
Ovitz Family Collection, Los Angeles
Jarla Partilager
Friedrich Petzel Gallery, New York
Philadelphia Museum of Art
François Pinault Collection, Paris
Portalakis Collection, Greece
Galerie Eva Presenhuber, Zürich
Private collection, Cologne
Private collection, Geneva
Private collection, New York (3)
Private foundation, Oslo, c/o Peter Lund
Yvonne Quirmbach and Jörn Bötnagel
Rachofsky Collection, Dallas
Galerie Almine Rech, Paris
Regen Projects, Los Angeles
David Roberts
Andrea Rosen Gallery, New York
Henry S. Rosenthal
Julia Rothschild Foundation
Saatchi Gallery, London
Sammlung Thomas and Christina Bechtler
San Francisco Museum of Modern Art
Tim Savinar and Patricia Unterman
Sikkema Jenkins & Co., New York
Monika Sprüth/Philomene Magers, Munich/
 Cologne/London
STORE Gallery, London
Stuart Shave/Modern Art, London
Talwar Gallery, New York/New Delhi
Estate of George Paul Thek
Wade and Angela Thompson

303 Gallery, New York
University of California, Berkeley Art Museum
 and Pacific Film Archive
Juan and Patricia Vergez
Walker Art Center, Minneapolis
Galerie Barbara Wein, Berlin
Susan and Rob White
Donald Young Gallery, Chicago
Zeno X Gallery, Antwerp

Friends of the 2008 Carnegie International

Julia and Harrison Augur, *Aspen, Colorado*
James-Keith Brown and Eric Diefenbach,
 New York, New York
Sabrina and Mark Carhart, *New York, New York*
Peggy and Kip Condron, *New York, New York*
Vanessa and Henry Cornell, *New York, New York*
Judy Dayton, *Minneapolis, Minnesota*
Inge and Cees De Bruin, *Wassenaar, the
 Netherlands*
Barbara and Eric Dobkin, *New York, New York*
Jenifer and Mark Evans, *Pittsburgh, Pennsylvania*
Katherine Farley and Jerry Speyer, *New York,
 New York*
Sheila and Milton Fine, *Pittsburgh, Pennsylvania*
Edith and James Fisher, *Pittsburgh, Pennsylvania*
Charlotte and Bill Ford, *New York, New York*
Isabel and Lee Foster, *Pittsburgh, Pennsylvania*
Carolyn Fine Friedman and Jerry Friedman,
 Newton, Massachusetts
Kathy and Richard Fuld, Jr., *Greenwich,
 Connecticut*
Linda Genereux and Timur Galen, *New York,
 New York*
Dorian Goldman and Marvin Israelow,
 Chappaqua, New York
Marcia and Stanley Gumberg, *Pittsburgh,
 Pennsylvania*
Agnes Gund and Daniel Shapiro, *New York,
 New York*
Mimi Haas, *San Francisco, California*
Georgianna and David Hillenbrand, *Pittsburgh,
 Pennsylvania*
Elsie and Henry Hillman, *Pittsburgh, Pennsylvania*
Maja Hoffmann and Stanley Buchthal, *New York,
 New York*
Janet and William Hunt, *Pittsburgh, Pennsylvania*
Priscilla and Richard Hunt, *Cambridge,
 Massachusetts*
Adriane Iann and Christian Stolz, *San Francisco,
 California*
Audrey and Deborah Irmas, *Encino, California*
Karen and Jim Johnson, *Pittsburgh, Pennsylvania*
Ellen and Richard Kelson, *New York, New York*
Miryam and Robert Knutson, *Ligonier,
 Pennsylvania*
Jill and Peter Kraus, *New York, New York*

Marion and Philippe Lambert, *Geneva,
 Switzerland*
Sarah and Eric Lane, *New York, New York*
Toby Devan Lewis, *Shaker Heights, Ohio*
Eugenio López Alonso, Fundación/Colección
 Jumex, *Mexico City, Mexico*
Wendy Mackenzie and Sandy Cortesi, *New York,
 New York*
Susan and Larry Marx, *Aspen, Colorado*
Ann and Martin McGuinn, *Pittsburgh, Pennsylvania*
Abaseh Mirvali, *Mexico City, Mexico*
Jacqueline and Jeffrey Morby, *Pittsburgh,
 Pennsylvania*
Gael Neeson and Stefan Edlis, *Chicago, Illinois*
Brooke and Daniel Neidich, *New York, New York*
Kenny and Gordon Nelson, *Pittsburgh,
 Pennsylvania*
Peter Norton, *Santa Monica, California*
Maja Oeri and Hans Bodenmann, *Basel,
 Switzerland*
Nancy and Woody Ostrow, *Pittsburgh,
 Pennsylvania*
Kathe and Jim Patrinos, *Pittsburgh, Pennsylvania*
Lisa and Richard Perry, *New York, New York*
Amy and John Phelan, *New York, New York*
Cindy and Howard Rachofsky, *Dallas, Texas*
Idamae and Jim Rich, *Pittsburgh, Pennsylvania*
Kristina Rigopulos and William Guttman,
 Pittsburgh, Pennsylvania
Michael Rubinoff, *New York, New York*
Pamela and Arthur Sanders, *Greenwich,
 Connecticut*
Erica and Eric Schwartz, *New York, New York*
Lea Simonds, *Pittsburgh, Pennsylvania*
Patricia and William Snyder, *Pittsburgh,
 Pennsylvania*
Teri and Damian Soffer, *Pittsburgh, Pennsylvania*
Beth Swofford, *Los Angeles, California*
David Teiger, *Bernardsville, New Jersey*
Ellen and James Walton, *Laughlintown,
 Pennsylvania*
Nancy and Milt Washington, *Pittsburgh,
 Pennsylvania*
Gisela and Konrad Weis, *Pittsburgh, Pennsylvania*
Susan and Rob White, *Wayzata, Minnesota*
Ginny Williams, *Denver, Colorado*

Carnegie Museum of Art Board 2008

Carnegie Institute Trustees

Carnegie Museum of Art Staff

Full-time permanent staff as of March 1, 2008

Richard Armstrong,
 The Henry J. Heinz II
 Director
Maureen Rolla,
 Deputy Director

Art and Architecture
Douglas Fogle, Curator,
 Contemporary Art
Heather Pesanti, Assistant
 Curator, Contemporary Art
Karin Campbell,
 Departmental Assistant

Jason Busch, Curator,
 Decorative Arts
Rachel Delphia, Assistant
 Curator, Decorative Arts
Amanda Seadler,
 Departmental Assistant

Louise Lippincott, Chief
 Curator and Curator,
 Fine Arts
Amanda Zehnder, Associate
 Curator, Fine Arts
Ayanna Burrus, Departmental
 Assistant

Tracy Myers, Curator, Heinz
 Architectural Center
Raymund Ryan, Curator,
 Heinz Architectural Center
Mattie Schloetzer,
 Departmental Assistant

Administration
Renée Pekor, Director,
 Development
Lynn Corbett, Executive
 Secretary to the Director
Sara DeRoy, Financial and
 Administrative Manager
William Devlin, Information
 Systems Manager
Emily Henry, Development and
 Administrative Assistant

Conservation
Ellen J. Baxter,
 Chief Conservator and
 Paintings Conservator
Michael Bellman,
 Objects Conservator
Krisann Freilino, Departmental
 Assistant

Education
Marilyn Russell, Curator
 and Chair
Patricia Jaconetta, Assistant
 Curator
Lucy Stewart, Assistant
 Curator
Jordan Crosby, Education
 Specialist, School and
 Teacher Programs
Jillian Gallagher, Program
 Specialist, Children's
 Classes
Mary Ann Perkins, Education
 Associate, Adult and School
 Group Tours
Madelyn Roehrig, Program
 Specialist, Adult Classes

Group Visits and Program Registration
Erik Schuckers,
 Group Visits Coordinator
Robert Luka,
 Education Assistant
Judy Reese,
 Education Assistant

Exhibitions
Christopher Rauhoff, Director
Chris Craychee, Supervisor,
 Installation and Preparation
Craig Barron, Assistant
 Supervisor, Installation and
 Preparation
Rob Capaldi, Art Handler
James Dugas, Art Handler

Heather Ernharth,
 Exhibitions Associate
James Hawk, Jr., Art Handler
Eric Jensen, Cabinetmaker
Dale Luce, Preparator

Marketing and Media Relations
Kitty Julian, Director
Tey Stiteler, Assistant Director
Susan Geyer, Design Services
 Manager
Leigh Kish, Communications
 Specialist
Nick Pozek, Web Project
 Manager
Cecile Shellman, Community
 Liaison Specialist

Office of the Registrar
Monika Tomko, Registrar
Allison Revello, Associate
 Registrar
Stacy Kirk, Assistant to the
 Registrar

Publications
Arlene Sanderson, Head
Melinda Harkiewicz,
 Publications Associate
Laurel Mitchell, Rights and
 Reproductions Coordinator
Norene Walworth,
 Graphic Designer

Technology Initiatives
William Real, Director

Teenie Harris Archive
Kerin Shellenbarger, Archivist
Celeta Hickman,
 Community Historian
John Komninos,
 Scanning Coordinator
Julia Morrison, Cataloger
Peter Scott,
 Scanning Technician
Jermaine Warren,
 Scanning Technician

55th *Carnegie International*
May 3, 2008–January 11, 2009

Carnegie Museum of Art
4400 Forbes Avenue
Pittsburgh, Pennsylvania 15213-4080
www.cmoa.org

Arlene Sanderson, Head of Publications
Melinda Harkiewicz, Publications Associate
Laurel Mitchell, Coordinator of Rights and
 Reproductions
Norene Walworth, Production Coordinator

Editor: Michelle Piranio
Proofreader: Richard G. Gallin
Design: COMA Amsterdam/New York,
 www.comalive.com
Printer: GZD, Germany
Paper: Munken Print White 18, 115 grs,
 and Drive Diamant, 170 grs
Typefaces: Trace and Times New Roman

The paper used in this publication meets the
minimum requirements of the American National
Standard for Information Sciences—Perma-
nence of Paper for Printed Library Materials,
ANSI Z39.48-1984.

ISBN 978-088039051-4
ISSN 1084-4341

Carnegie Museum of Art, Pittsburgh, PA
One of the four Carnegie Museums of Pittsburgh